Neon Wasteland

Neon Wasteland

ON LOVE, MOTHERHOOD, AND SEX WORK IN A RUST BELT TOWN

SUSAN DEWEY

UNIVERSITY OF CALIFORNIA PRESS
Berkeley Los Angeles London

University of California Press, one of the most distinguished university presses in the United States, enriches lives around the world by advancing scholarship in the humanities, social sciences, and natural sciences. Its activities are supported by the UC Press Foundation and by philanthropic contributions from individuals and institutions. For more information, visit www.ucpress.edu.

University of California Press
Berkeley and Los Angeles, California

University of California Press, Ltd.
London, England

Library of Congress Cataloging-in-Publication Data

Dewey, Susan.
 Neon wasteland : on love, motherhood, and sex work in a rust belt town / Susan Dewey.
 p. cm.
 Includes bibliographical references and index.
 ISBN 978-0-520-26690-2 (cloth : alk. paper)
 ISBN 978-0-520-26691-9 (pbk : alk. paper)
 1. Sex oriented businesses—Social aspects—Northeastern States—Case studies. 2. Women dancers—Northeastern States—Case studies. 3. Women—Northeastern States—Social conditions—Case studies. 4. Women—Family relationships—Northeastern States—Case studies. 5. Self-perception in women—Northeastern States—Case Studies. 6. Femininity—Case Studies. 7. Northeastern States—Social conditions. 8. Northeastern States—Economic conditions. I. Title.
 HQ18.U5.D49 2010
 155.3'33—dc22

 2010020856

20 19 18 17 16 15 14 13 12 11
10 9 8 7 6 5 4 3 2 1

For Denise and Melanie,
with much love and great respect

Contents

Preface

Power can be invisible, it can be fantastic, it can be dull and routine.
It can be obvious, it can reach you by the baton of the police, it can
speak the language of your thoughts and desires. It can feel like remote
control, it can exhilarate like liberation, it can travel through time, and
it can drown you in the present. It is dense and superficial, it can cause
bodily injury, and it can harm you without ever seeming to touch you.
It is systematic and particularistic and is often both at the same time. It
causes dreams to live and dreams to die.

—Avery Gordon, *Ghostly Matters*

"There are some lines that, once you cross them, you can't go back again,"
Cinnamon said to me backstage over the dull throbbing of music pound-
ing outside the door. She was explaining how it was impossible for her to
leave her job as a topless dancer, not only because it was the sole source
of economic support for her daughter, but also due to her perception that
she was somehow psychologically altered by her experiences onstage.
Sex work clearly does change one's perceptions of the world, largely
because of the elaborate social and institutional processes that combine
to undermine women's efforts at exercising autonomy. Yet how do some
women come to perceive sex work as the most desirable option out of a
limited menu of life choices? Why did Cinnamon, for example, remain
convinced that topless dancing was the only job open to her? The fact
that such a job has the potential to generate a higher income does not in

itself adequately explain why certain women make the decision to sell their sexual labor rather than take a lower-paid but considerably lower-risk job, while others do not.

Sex work is part of a learned process by which some categories of women are conditioned to believe that their self-esteem, material worth, and possibilities for life improvement are invested in their bodies. This is notably similar to the way that women outside the sex industry also come to see themselves as what feminist theorist Judith Butler has famously termed "embodied subjects" (1993). This deep connection between women and their bodies regardless of class status or professional affiliation underscores how gendered performance is a critical element of sexual labor. Women who dance at adult establishments know that their self-presentation appeals to deeply entrenched stereotypes about women, and they deliberately choose to enact stage roles that they hope will elicit more money from their clients. Topless dancing is thus distinctive from other forms of sex work, in part because of its legality, but also because of its association with more creative forms of stagecraft.

Feminist scholarship on the body as a site of female agency and self-expression underscores the complicated set of behaviors and beliefs that sustain the linkages between women and their sexualized bodies.[1] Such work highlights how women's conflicted relationships with their bodies are a direct result of their attempts to negotiate the conflicted cultural messages that simultaneously encourage physical attractiveness and punish vanity. That so many women engage in this process indicates a need to understand at least some forms of sex work as a performance rather than a set of behaviors that women resort to in a state of destitution. Women who work at establishments like Vixens, the pseudonym I use for the topless bar described in this book, share these notions of performance in their assessments of skill and talent. Their efforts do not escape either clients or managers, who often discuss the amounts of work and energy that some women put into their stage routines. "Some girls get up there and it's like *Flashdance*," one manager explained to me. "You kind of get the feeling that if they had someone to help them in life they could have really done something with that talent." This discourse of limited life opportunities and skills cultivated against the

odds underscores that topless dancing is a complicated form of labor that warrants a unique form of analysis. What follows is an attempt to document what dancing topless means to the women who do it to support themselves and their families in a social environment that in every way clearly signals to them that they have transgressed norms regarding proper femininity and motherhood.

It was August 2002, and I was walking into Vixens for the first time. The dim light yellowed by cigarette smoke felt warm, and the presence of others made me feel safe after an unnerving walk through the poorly lit parking lot. A small rectangular wooden bar with a hollow center occupied the center of the building, which looked more like a large room once I was inside. The bartender was a dark-haired woman in her thirties who did not return my smile, although a man sitting to her left winked at me. Onstage to my right, a bare-breasted woman in a sequined thong was half-heartedly twisting her body as she held onto a metal pole. I did not know then that she moved slowly because she was trying to distribute her energy evenly over the eight-hour shift she expected to work that night.

Partially clothed women hovered near the bar smiling at fully dressed men in their thirties and forties; occasionally a dancer led one of the men into a small curtained room to the left of the stage, near the entrance. Once inside, I later learned, the woman would stand between the legs of the seated man and dance for the duration of a song, usually about three minutes. She would be paid ten dollars for this, three of which she would give to the manager for the privilege of working there as part of a curious labor practice in which dancers are legally known as "independent contractors." This system considers dancers entrepreneurs in their own right and not only frees management from paying them, but also mandates that women in some establishments pay management part of what they earn in tips as reimbursement for providing a space for them to work.

A few clothed women sat at a table in the back, and I introduced myself. "It's slow tonight," one complained, "too many girls." Indeed, there were more women in the room than men, although then I did not know that this was part of a labor practice that employs almost no full-time workers in order to avoid paying any kind of insurance or benefits

and also ensures a greater variety of performers with a wide range of audience appeal. One of the women, whom I later came to know as Diamond, showed me inside a small closetlike space behind them, in which fifty or sixty brightly colored semitransparent garments hung above boots and strapped sandals with five-inch heels. Each cost between eighty and two hundred dollars, and management encouraged dancers to buy several before starting work. "This is an expensive job in the beginning," she said, smiling wryly. "You have to be patient until you start making money."

I interviewed and conducted participant observation with approximately fifty women throughout my time at Vixens, and most of them left the job within just a few months—which is typical in an industry that benefits from the greater variety of performers resulting from high employee turnover. Most of the women came from families that offered them little socioeconomic support, many had not finished high school, and most had young children they were struggling to raise alone. This combination of enormous responsibilities at a relatively young age and limited social and financial assistance in meeting basic needs almost always directly informed women's decisions to work at Vixens, where dancers generally (but not always) earn more than minimum wage and where their late working hours mean they can readily find affordable caretakers with whom to leave their children asleep at home at night.

The lives of most dancers at Vixens thus present a curious paradox that is greatly at odds with popular cultural perceptions of sex workers as immoral, irresponsible, and promiscuous. Most (but certainly not all) Vixens dancers were struggling to meet cultural ideals of "good" mothering and responsible citizenship almost in defiance of the stereotypes that they knew define most outsiders' views of their profession. A wealth of academic and popular texts have emerged in recent years that document the working conditions of topless dancers (e.g., Barton 2006; Egan 2005; Frank 2002; Shteir 2002), but a significant knowledge gap exists regarding how women who engage in erotic labor situate themselves within their biological families and other social networks.

North American women enter the sex industry for a variety of reasons, and it would be dangerous and irresponsible to reduce these to a

set of essentialisms.[2] Just as in most other forms of labor, socialization processes function to make many erotic workers report that they had long expected to hold such a job as a survival measure at some point in their lives, following the patterns they had previously seen female family members or close friends adopt. Yet many young women begin working in the profession after leaving high school and failing to find another job that can provide the same amount of income and relative flexibility, and then later find themselves unable to move on to a different type of work. Women who have engaged in sex work for lengthy periods as their sole source of income can find it particularly difficult to seek out other jobs because employers are, at best, hesitant to view such experiences as translatable skills and, at worst, prone to negative judgments about the nature of such work.

Dancing can also offer the powerfully seductive promise of socioeconomic mobility through the rapid generation of cash income in ways that are impossible to even imagine in other forms of low-wage service work. As one dancer candidly explained in this regard, "No man is ever gonna to walk into a McDonald's where you're working in your stupid little uniform and hand you two hundred dollars just because he thinks you're pretty. You might as well just give up hope and die in a job like that, because it's never gonna get any better." This notion of hope for a better future is a significant motivator for remaining in sex work, even when earnings do not meet expectations and, in some cases, simply amount to minimum wage. Dancers vary enormously in their beliefs about realizable possibilities for the future, although most do subscribe to the notion that theirs is the best choice in a limited menu of life options. However, as we will see, the ways in which this process transpires varies greatly from woman to woman.

It would be dangerous to extrapolate the experiences of individual women to generalize about all erotic dancers, and my documentation of their stories does not constitute a comprehensive analysis of the profession. Yet it is this very danger that presents us with an ethnographic dilemma: how to give a human face to something that at least superficially seems so dehumanizing. If we exclude the individual voices of women, it is as if they are not entitled to any control over their own stories, yet if

we focus exclusively on just a few women in hopes of making their lives representative of myriad experiences, we fail to capture the diversity of real life. My solution to this otherwise intractable problem is twofold: to include detailed accounts from the lives of five very different women, and to present a structural analysis of the cultural elements that shape their lives. In doing so, I hope to tell a story predicated not on naive assumptions of sisterhood and unity in social struggle, but rather on the universal human qualities of desire, hope, and difference.

"Star," "Diamond," "Cinnamon," "Chantelle," and "Angel" are the names chosen by these five women, who take off their clothes for money as part of a North American cultural practice simultaneously socially sanctioned and condemned. Although they are real women who were my close friends, their lives are quite similar to those of dancers who live on the margins of most larger towns and cities in a situation of visible invisibility. They work in a complex and paradoxical profession in which they have false names to disguise their identities yet are expected to show convincing affection for strangers, meanwhile taking off their clothes and hiding their real feelings. Above all, they try their best to support their families in a social milieu that often views them as objects of simultaneous revulsion and desire, fundamentally outside the social order.

This book is about women who work in a stigmatized profession culturally constructed as inherently incompatible with normative frameworks regarding motherhood and family stability. Yet despite this supposed disjuncture, the vast majority of the women I met were actively seeking to create stability even in situations where this seemed both unlikely and untenable. Twenty-five-year-old Cinnamon, for example, frequently referred to herself as "a good person in a bad profession," a description that made clear allusion to the profound ambivalence she still felt after a decade of work in the sex industry. Cinnamon and Star were both the sole economic and emotional providers for their small children when they met while working at Vixens and decided to live together, trading shifts to avoid expensive and often unreliable child care. Their combined household of three children and two attractive women in their mid-twenties was always a flurry of activity and was greatly complicated by the fact that Cinnamon's daughter was just entering her teens.

Her imminent maturity provoked a great deal of anxiety for both young mothers. Chantelle, who was newly pregnant and understandably worried about her future, often sought out Cinnamon and Star for advice on giving birth without health insurance, which she would soon be obliged to do because of her refusal to apply for welfare benefits.

Although these three women actively sought to be what they (and popular culture) define as "good" mothers by providing safe homes for their children, not all dancers were able to do this successfully. Angel was the most troubled dancer at Vixens and rarely spoke of her five-year-old son, placed into foster care by the New York State Department of Social Services soon after his birth due to her struggles with drugs and alcohol. Other dancers tended to avoid Angel, often making caustic remarks about their perception that she exchanged sexual favors for drugs, and on more than one occasion a manager angrily advised her to "just get it over with and go die of some disease somewhere."

Diamond was the only dancer who saw her work as a long-term career rather than a temporary survival strategy, and she was in the process of planning to move to another city with more lucrative topless dancing establishments when I met her. However, Diamond found herself plagued by a series of irresponsible men who had misused her credit cards and left her in significant debt that was nearly impossible for her to repay. She responded to this challenge by donating her ova to a West Coast fertility clinic in exchange for eleven thousand dollars, part of which she planned to use to pay for breast implants that she felt would improve her earning potential. Diamond employed one of the many self-improvement strategies discussed in this book by using her own independent logic as part of a broader plan to select options that she believed would cause the least amount of harm. To Diamond, undergoing weeks of fertility injections and subsequent surgery with unknown long-term effects was preferable to remaining in debt or selling sex, which she perceived as her only other options.

Yet dancers' efforts at autonomy were routinely circumscribed by clients who alternately idealize, demean, threaten, profess love for, and even physically abuse them. Cinnamon's description of entering a state of permanent transgression speaks to the fear of taint that accompanies

sex work, just as it underscores the power society has to mold individual self-perceptions. Dancers thus find themselves simultaneously positioned as sexually desirable and socially repulsive, and their knowledge of their marginal, conflicted social position informs many of their childcare routines and strategies as part of a conscious attempt to be what society characterizes as a "good" mother. I remember trying to calm Cinnamon's roommate, Star, who burst into tears at her young son's birthday party because she could not stop thinking about how the money she had used to buy his gifts had been pushed into her thong panties by strange men.

Star would often engage in lavish spending to ensure that her son had the same possessions as his more privileged peers. I met many women who followed similar consumption patterns with lovers and friends as part of an economy of emotions that sought to establish authority through the ability to spend large sums of money. This kind of behavior constitutes a kind of psychological coping mechanism designed to combat the marginalizing processes at work that label them irresponsible and "bad" mothers. Star believed, perhaps without even consciously realizing it, that buying the accoutrements of provider status allowed her to assert some degree of control and stability in a world otherwise fraught with uncertainty.

It is problematic to imply that women compelled for whatever reason to engage in sex work do not make choices designed to improve their lives materially, but it is even more dangerous to argue that they are agents free of coercion by poverty and other limiting circumstances. Angel clarified this for me rather abruptly one night after I called her a "performer" as part of my belief that it was important to recognize her work as valuable and meaningful. "So when you're performing onstage—" I had begun to ask her in language that now sounds ridiculous to me as well, when she angrily objected. "Look," she said, pointing at her five-inch high heels, "I'm a freakin' stripper, OK? I didn't go to ballet school to learn how to do this. I'm doing this because I can't do anything else." Angel was intoxicated and in one of her notoriously foul moods when she said this to me, but her reproach does point to an important disjuncture between theory and women's lived experience.

She later apologized to me for her brusqueness, but her candor made me realize that there was far more to her situation at Vixens than my initial perceptions had indicated. It bears mentioning, however, that Angel may have felt different about her professional identity had she been asked the same question at another time, just as I may have perceived her response in another way if I heard it today.

Yet it was because of powerful statements like Angel's that I sometimes suspected I was a bit too eager to demonstrate the empowering potential of sex work. My concern about falsely representing sex work as economically liberating became complicated by the opinions of some dancers who were equally adamant that they had found a calling in topless dancing. Diamond recalled aspiring to the profession from the time she was a little girl and spoke fondly of gyrating seductively in the mirror long before entering her teens. In a fairy-tale-like description, Diamond recalled a preadolescent version of herself destined for the erotic stage:

> I was always fascinated by showgirls and their costumes, because I love attention. I love feeling beautiful. What woman doesn't? This is what I've always wanted to do, but when I tell people that, they don't believe me. People think this is a job for drug addicts and high school dropouts, but to me stripping is an art. Women's bodies are art. Think about it, of all those famous sculptures and paintings of nudes, how many are men and how many are women?

Diamond's insistence that her profession constitutes an "art" is much more in keeping with contemporary feminist discourse that recognizes women's right to engage in erotic labor as a choice that should be respected. Sociologist Kamala Kempadoo's pathbreaking collection of scholarly work (Kempadoo 2005, 2004, 1999; Kempadoo and Doezema 1998; Kempadoo, Sanghera, and Pattanaik 2005) has consistently emphasized the importance of not incorporating sexist values into the feminist discussion of sex work and how crucial it is to include perspectives such as Diamond's into narratives on the subject precisely because they complicate our understandings of it. Women like Diamond were definitely in the minority at Vixens, but I suspect I would have met more of them if I had conducted my research in a more expensive establishment

in a larger city where dancers had to invest more money and time in their appearance.[3] At Vixens, the only real criteria for employment were femininity and relative youth. Yet most dancers had complicated views that were less easily classified than the extremes presented by Angel or Diamond, and many were even more conflicted than popular cultural perceptions of sex workers. Cinnamon, for example, was convinced that dancing topless was the only work she could do after spending so many years in adult establishments, but, as part of the seemingly contradictory elements of her "complex personhood" (Gordon 1997), she also truly believed that she was very good at her job. Unlike Angel, she incorporated a discourse of professionalism and skill into her descriptions of performance, and drew clear lines that defined appropriate behavior from her years of experience with clients.

Most women who had danced topless for more than a year described such strategies as essential to maintaining self-respect and personal boundaries. Whereas some women were clear that this was one of the unique aspects of their profession, others were equally emphatic that the behaviors and beliefs they employed in their work were simply exaggerated versions of those that women use in everyday life to negotiate their relationships with men. This notion of the topless dance bar as a microcosm of gender relations (e.g., Rambo-Ronai and Ellis 1989) was striking, and it spoke to the numerous ways in which dancers sought to construct typologies of appropriate behavior for both men and women that were largely in keeping with community norms outside the bar.

Star was very clear about her status as what she called "a normal woman," which she positioned in direct contrast to women who sold sex or its simulation. She was like many of her peers who had internalized popular perceptions of women in their profession, and she was eager to find another means of income generation as soon as she could. Choosing from the rather limited pool of her clients, Star often sought out potential boyfriends who could help her and her children with money, although such endeavors usually failed to yield pleasant results. In fact, she started dancing because the father of one of her children had lost his job and persuaded her to work at Vixens until he found a replacement position. This did not happen for almost a year, and Star eventually asked him to

leave their shared apartment when it was clear that he was interested in other women.

Chantelle, who was dealing with a number of psychological issues common to many mothers-to-be regarding family, was frightened about exposing so much of her body. As the newest dancer at Vixens, she negotiated this fear by building up a kind of support network with other dancers. Such women proved significant sources of advice and caution about how to navigate the difficulties inherent in giving birth as an unmarried woman without a partner and without health insurance. Chantelle thus found herself surrounded by peers who had previously had the same experiences that she was then undergoing, albeit with a mixed set of results. As her narrative at the beginning of chapter 1 demonstrates, she had begun dancing topless as part of a self-improvement strategy she hoped would benefit her unborn child by creating a cushion of savings.

All five women demonstrate clear reasons for entering the profession, and although none of them described their work as forced, very few of the women expressed a desire to continue doing this kind of job for very long. Such differences in perception of the same occupation demonstrate how unhelpful it is to be constrained by arguments as to whether sex work is a choice that should be defined as work or an inherently dehumanizing set of behaviors and a form of violence against women. It is sobering to recognize that the kinds of binary distinctions between "agency" and "victimization" that are often so important to policymakers and social scientists alike often have very little meaning for the vast majority of women who sell sex or its simulation in order to survive.

At the time of my fieldwork, Star, Diamond, Cinnamon, Chantelle, and Angel lived in Sparksburgh—a pseudonym that I, following general ethnographic practice, have chosen to protect their identities. Yet this use of a pseudonym also helps to convey the reality that the kind of economic devastation, exploitative labor practices, and pervasive hopelessness characterizing Sparksburgh is becoming increasingly common as the U.S. economy continues to worsen. The geographic specificities of Sparksburgh—such as extraordinarily long, bleak winters, freezing temperatures, and a serious lack of jobs since the advent of deindustrialization

in the 1970s—are not identifying features. Indeed, these are by and large typical of upstate New York, as many people call the entire New York State region to the west of New York City. In the cases where I refer to news coverage on state regulations of sex work, I have chosen to use articles from newspapers published in Syracuse, a midsize city located exactly in the center of the state and quite representative of the socioeconomic demographics of the region. This compromise allows me to ground my ethnographic research in the broader socioeconomic context of upstate New York without revealing Sparksburgh's location.

Accordingly, this book examines a specific local context that, following increasingly pervasive global patterns, renders feminized labor low paid, part-time, low status, and temporary. The sex industry is a curious exception to this devaluation of feminized labor because it assigns monetary value to idealized forms of femininity that are equally celebrated in other areas of U.S. popular culture. Yet most women can sustain this type of work for only a limited period, after which they must start their earning lives over completely. Dancers are thus fully conscious that, sooner or later, they will have to go back to what women at Vixens call "the straight world" of low-wage labor outside the sex industry. The analysis that follows examines how poor women who work at Vixens, all of whom were born long after the women's movement and the sexual revolution ostensibly increased women's choices, come to understand their sexuality as their most marketable asset. Their stories reveal the complexity of the everyday survival strategies employed by some poor U.S. women in a geographic region that has become a vacuum created by labor outsourcing to the Global South.

Acknowledgments

This book never could have taken shape without the enormous amounts of time, energy, and commitment that executive editor Naomi Schneider generously poured into several versions of the manuscript. Her commitment to privileging the voices of the five women whose stories make up the pages that follow will not be forgotten. Before Naomi adopted the book, editor Jennifer Hammer of New York University Press provided extraordinarily helpful, detailed criticism on initial chapter drafts. Anthropologist Patty Kelly laboriously pored over the text and in the process established the key themes of deindustrialization's legacy and feminized labor that underlie this book. Sociologist Jennifer Wesely also devoted significant amounts of time to reading the manuscript, and her thoughts on the use of women's narratives and her suggestions for further sources and theoretical frameworks were invaluable. Two anonymous

faculty review-board members provided challenging and much-needed critiques that vastly improved the manuscript, particularly by strengthening the book's focus on body work. As always, copious thanks are due to my graduate mentors Susan Wadley and Hans Buechler for all of the energy they invested in me, and also to Maureen Schwarz, who was the first person to recommend that I write a book on the lives of sex workers.

Discussions before and after Patty Kelly's and my panel session, "Moral Borders and the Boundaries of Labor: Culture and Commodified Sexualities in the Neoliberal Era," at the 2009 annual meeting of the American Anthropological Association helped enormously in strengthening my arguments about relationships between sex workers and the state. Warmest thanks are due in particular to Tiantian Zheng, Denise Brennan, Thaddeus Blanchette and Ana Paula da Silva, Annegret Staiger, Gregory Mitchell, Treena Orchard, and Dawn Pankonien. Grateful thanks to Carl Walesa for his careful copyediting, to Lia Tjandra for the beautiful cover design, and to Kate Warne and Kalicia Pivirotto for shepherding the book through production. For stimulating e-mail exchanges and directions to further resources on (and ways of thinking about) the subject, I am grateful to Henry Trotter, Ron Weitzer, Norma Jean Almodovar, Erica Lorraine Williams, Wanjohi Kibicho, Rohini Sahni, Michael Goodyear, Zosa De Sas Kropiwnicki, Kerwin Kaye, M. Catherine Maternowska, and Chimaraoke Izugbara.

This book also benefitted enormously from informal conversations with friends and colleagues, including Robert Dewey, Nissy Stetson-Grace, Beth Benedix, Diane Hightower, Raymonda Burgman, and my sister, Kyla Piscopink. Staff members at the DePauw University Library went above and beyond the call of duty in locating and processing resources at lightning speed, particularly Kathryn Cortland Millis, Mandy Henk, Jamie Knapp, Meghan McCullough, and Megan Hinman. I remain forever in the debt of Mrs. Scamahorn, Tiffany Hansell, and all of the other wonderful employees of New Pathways Preschool, who gave so much love and took such beautiful care of my son, Gabriel, while I was writing. And last, but certainly not least, an enormous expression of gratitude to my colleagues in Gender and Women's Studies and International Studies at the University of Wyoming. Thank you for so warmly welcoming me into such a dynamic and inspiring group of women.

Introduction

CHANTELLE'S NEW JOB

This is a real blue-collar place. At first I thought it was pretty weird that you came here to write a book about us, because I always thought that women with PhDs and all, well, they don't usually come into a place like this. I guess it's different for you, because you grew up like all of us did and so you understand why our lives are the way they are. So this isn't a place where dancers can make a lot of money, because the guys we get in here, they work at one of the plants, some of them don't work at all. This isn't one of the more upscale places like you get in New York City, where the girls are all perfect with implants and stuff, here we're just regular girls trying to support ourselves and our kids. A lot of us didn't finish high school because we came from messed-up families or had kids real young and so we're just doing the best we can.

People don't generally think of dancers as family types, I guess, but we have kids, too. I'm trying not to tell people that I'm pregnant although obviously it won't stay a secret for long. I don't tell any of the guys who come in because that's a pretty big turnoff—to think there's a pregnant woman shaking it for money in front of you. I figure I can work for three or four months and make some money before I start to show, because I really need the money right now and I don't have anybody around who's going to give it to me. I never really thought I'd be a single mom since I grew up without a father around and that was tough for me, but here I am. It's my own stupidity for putting my trust in guys who didn't deserve it.

I've been working here for three weeks now, and it's OK so far. I get really tired because of the baby and because I've never worked nights before, so that's a bad combination. The other girls are pretty nice but a couple of them are real messed up, because this kind of work can do that to you, but probably some of them were that way before they got here. One of them, you know Diamond? She's the prettiest one here. She told me on my first night that I should get wasted before I go onstage because it makes things easier, but of course I didn't because of the baby. I was so scared that night with all those men looking at me, but I just tried to pretend they weren't there when I was onstage and I didn't get much in tips afterwards because I was afraid to talk to them with practically no clothes on.

I'm not going to be doing this forever, so I guess it doesn't bother me as much as it would if I was like some of the other girls here who don't have any plans for the future. Some of them just spend everything they earn because that's easy to do when you get paid under the table, but I'm doing this for my daughter. I mean, it's too early to know what I'm going to have, but I really want a little girl. I'm going to name her Nevaeh, that's "heaven" spelled backwards. I want to raise her right, so she won't end up like her mama, doing this kind of work. But, like I said, I'm not going to be doing this forever. Once the baby comes, then everything changes for me.[1]

PAUL: "MAN, WOMEN HAVE IT *EASY*"

You learn a lot of things working around dancers. Look, I've been married to two of them and been the manager here for three years, and so I can tell you one thing: man, women have it *easy*. You probably think that they're all abused and shit, they try to play it out like that sometimes so people will feel sorry for them. They make more money that way. Dancers,

they're professionals at taking other people's money. They're hustlers. These are girls who don't want to work; they want to party and have men fall all over them like they're the best thing in the world. I don't have a lot of sympathy for them. If I feel sorry for anybody here, it's these poor suckers who come and blow all their money on some of these bitches. We've got some nice girls here, but most of them are just people who can't hold down a normal job for whatever reason. And the guys we get in here, they need to get away for a while, maybe from their wife's or girlfriend's nagging, maybe just from life here with the economy all shot to hell and all. Let me tell you, though, in a place like Sparksburgh where there are no jobs for anybody, these girls are doing pretty well. Don't let yourself feel too sorry for them.

VIXENS: AN INTRODUCTION

Read together, these two narratives raise a host of questions regarding the paradoxical coexistence of such wildly divergent understandings of the same work environment. For instance, why did Chantelle believe that sex work offered the best opportunity for life improvement when there were social-service agencies that could have assisted her? How did the manager of Vixens, Paul, reconcile his belief in the "ease" with which women could support themselves with the harsh economic and life realities faced by the dancers who worked for him? Such perplexing contradictions raise this book's central questions of why some poor U.S. women choose sex work over other low-wage jobs[2] and why they believe that sex work is a first step toward long-term social mobility.

Chantelle was nineteen when I met her, just one year over the legal age requirement to dance topless in New York State, and in the space of just a few short months she had found herself abandoned, pregnant, and with no means of financial support. Like many poor young women without a socioeconomic network to assist her, she was not at all surprised to find herself in this situation, although she was nonetheless disappointed. One of the most striking aspects of Chantelle's life philosophy was that she did not view herself as a victim but rather as a conscious decision maker who was both responsible for her choices and capable of improving her own life. Her perceptions of her new work environment set the

tone for some of the arguments presented in the rest of this book regarding news ways of thinking about sex workers as complete social beings who are also family members and friends.

A twice-divorced father of two young children, the twenty-four-year-old Vixens manager, Paul, was also a key figure in the lives of dancers like Chantelle, and accordingly, he features prominently in the ensuing chapters. In asserting that "women have it *easy*," Paul argues that women are at a distinct economic advantage in Sparksburgh's depressed economy because of their supposed sexual power over men. Sparksburgh is indeed still reeling from the economic collapse and skilled-labor emigration that followed deindustrialization several decades earlier, although, as we will see, most of those who have chosen to stay find themselves eking out a living in an impoverished community of men and women for whom work in any form generally takes place on what they are fully aware are poorly paid, demeaning, and even exploitative terms.

Sex work is one of the many forms of gendered labor that poor people engage in as part of broader, albeit highly stigmatized, survival strategies that continue to be objects of popular cultural fascination in less-than-subtle classist and racist manners. Witness, for example, the plethora of U.S. films, television shows, and other mass-media forms that focus on the regulation of activities such as gang membership, drug dealing, and prostitution as subversive, threatening, and yet somehow fascinating enough to form the substance of endless entertainment.[3] The following analysis seeks to demystify the lives of people who engage in such activities through a combination of ethnographic analysis and self-representation. Accordingly, each chapter begins with an unedited narrative from a Vixens worker, most often from one of the five dancers whose lives this book chronicles. My own ethnographic and personal evaluations are absent in order to maintain the integrity of the women's words, and these narratives function to complement and underscore the key themes of each chapter as part of my strong belief in the collaborative nature of the research process. I have used pseudonyms similar to the "stage names" that dancers, following the standard practice at North American topless dancing bars, choose for themselves in order to keep their identities secret. I have also fictionalized certain elements of their

lives and place of work in cooperation with each of them to render them unrecognizable and thus anonymous.

Feminist anthropologist Lila Abu-Lughod advocates writing "ethnographies of the particular" (1991, 138) that run contrary to what she believes is the anthropological tendency to generalize. This book is one such "ethnography of the particular" in that it draws upon an increasingly vast cross-cultural literature on sex work to show how the "particulars" of topless dancers in Sparksburgh are by no means isolated from the experiences of other sex workers throughout the world.[4] The following chapters thus frame their lives within the broader ethnographic context of sex work while simultaneously doing descriptive justice to the complexities of their individual everyday experiences.

Vixens is housed in a small rectangular building near the New York State Thruway, and in the long winters characteristic of that part of the world, its squat gray walls are the same bleak color as the brittle, snowy skies. It has an air of abandonment and deterioration that it shares with the many small businesses in the region that are perpetually on the verge of bankruptcy or closure: a gravel parking lot, exterior walls in need of repair, muddy snow congealing in forlorn piles outside the door. Traffic sounds form a perpetual humming whirr from the nearby intersections of three major highways, and there are no sidewalks, residences, or shops nearby. Vixens' isolation on Sparksburgh's physical margins virtually guarantees that no one ends up there by accident.

Despite the urban decay surrounding it and the remoteness of the location, dancers consider Vixens the safest and most lucrative of all the erotic dancing establishments within driving distance of Sparksburgh. Women who work there often follow their complaints about low pay, disrespect from clients, and management's general abuse of their labor with descriptions of what they consider inferior working conditions in the region's other topless and nude dancing bars. "If you have to do this," pragmatic Cinnamon explained to me soon after we met, "this is the best place to do it in, because there's no push from management to do more than you want to." Cinnamon was the mother of an adolescent daughter and had worked in a wide range of area erotic businesses for ten years—much longer than any of the other women at Vixens had been in the industry.

Cinnamon's wealth of experience with such establishments was quite paradoxical given that she was only twenty-five years old, and her knowledge of both illegal and illicit adult-oriented businesses stemmed from a life molded by abandonment and the abuse of her trust. "I started doing this because my daughter was starving to death," she said abruptly one night when we found ourselves alone in the dressing room backstage. She was staring at herself in the mirror and smoking a cigarette as she described the path that had placed her in the backroom of a topless dancing bar.

> I had my first baby when I was thirteen, and my parents threw me out of the house two months after she was born. The funny thing is I was too young for welfare unless I wanted to go into foster care and get my baby taken away, and so I ended up in one of the sleaziest nude places pretty quick. You wouldn't even go in there if you saw it, it was that bad, but you have to be eighteen to dance topless and in the nude places they don't care how old you are because half the girls there are hookers anyway.

Cinnamon is one of the women whose lives make up the substance of this book, and her story is particularly representative of how people can find themselves left out of systems designed to help them even in relatively resource-rich states like New York. Too young for welfare benefits as a self-supporting mother and not old enough or educated enough to find formal-sector employment, she quickly began work in an industry that more than a decade later seemed impossible for her to leave. Cinnamon did not feel she was particularly lucky to be working at Vixens, but she understood from experience that her situation could be much worse. She was often quick to tell horror stories of mistreatment at other establishments when Vixens dancers complained about not earning enough money or having to deal with a difficult client.

Such tales frequently centered on the abuse of authority at other establishments by older male managers, who sometimes expected sexual favors from dancers as a condition of employment. Typologies abounded backstage at Vixens that categorized other topless dancing bars as little more than brothels where young women were powerless to control the circumstances under which their bodies were sexually available to

random men. Reasons for this, in the words of Vixens dancers, ranged among individual women from extreme poverty, youth, and entrapment in an exploitative relationship with an employer-cum-boyfriend to drug addiction. This kind of violent folklore partly functioned to mitigate the everyday difficulties Vixens dancers encountered at work, through a process of comparison that sought to remind them just how lucky they were.

"I like it here because there are rules," Cinnamon told me. "In other places, guys who walk in with money get whatever they want." She was voicing a common sentiment among many Vixens dancers about the clear distinction between their work and prostitution. Yet despite their insistence on such boundaries, dancers often complain that clients expect a great deal of physical contact in exchange for tips, their primary source of income, and sometimes this behavior borders on more than just the simulation of sex. Men go to Vixens knowing that they can expect a minimum of three things: first, to watch a bare-breasted woman in a thong wind her body around a metal pole to the steady thumping beat of rhythm-and-blues music; second, to have a drink and perhaps to talk to other men. And third, they can expect dancers to approach them numerous times to offer a ten-dollar private dance, sometimes called a "lap dance" because it involves such close contact between dancer and client, in a curtained area located in a corner of the building near the stage.

Most of these expectations are fairly straightforward, but the third raises important questions, both for dancers and for those interested in their lives, about the blurry lines that divide private from public, genuine intimacy from performance, and, indeed, houses of prostitution from topless dancing bars. It is perhaps not surprising that all three of these issues routinely present dilemmas for dancers, management, and clients alike in the course of an ordinary night of work. A number of precautionary measures discussed later—including the use of security cameras, curtained areas, and clothing to regulate interaction between dancers and clients—function to both empower and marginalize different individuals in the shifting terrain of desire.

Throughout this book, we will encounter women who often appear to make contradictory decisions and engage in behaviors that harm them despite the fact that they obviously have the ability to make other, less

risky choices. Sociologist Avery Gordon terms this phenomenon "complex personhood"—a phrase that underscores how "even those who live in the most dire circumstances possess a complex and often contradictory humanity and subjectivity that is never adequately glimpsed by viewing them as victims or, on the other hand, as superhuman agents" (1997, 4). Put in extremely simple terms, this means that people are rarely truly good or extremely bad, but rather fall somewhere in between at different times and in varying circumstances. Complex personhood also

> means that the stories people tell about themselves and their troubles, about their social worlds, and about their society's problems are entangled and weave between what is immediately available as a story and what their imaginations are reaching toward . . . [because] even those who haunt our dominant institutions and their systems of values are haunted too by things they sometimes have names for and sometimes do not. (Gordon 1997, 4)

Sex workers are powerfully ambivalent social figures and thus constitute the ultimate in complex personhood because their lives necessarily overlap between private and public worlds in ways that problematize conventional notions of fidelity, proper femininity, and even love.[5] Such women are no different from their counterparts outside the sex industry in often finding themselves torn between real and ideal notions of their life situations, although their social worlds are admittedly somewhat more complex because of their work in a profession often kept secret from others. Yet this secrecy is but one aspect of the very nature of work in the sex industry, which operates in tandem with temporality, fluctuating earnings, high risks, vulnerability, and status on or outside the legal margins. When women do this sort of work, they inhabit a border region that exposes the fault lines inherent in cultural notions of sex, gender, and feminine performance.

Dancers at Vixens specialize in the blurring of boundaries between genuine and false affection in their professional personas and use these performance-related skills to survive in a world that is hostile to the everyday aspects of their working and personal lives. Vixens is a place like many others in that it is populated by people who are hesitant to

reveal too much of themselves lest others capitalize on their resulting vulnerability. As we will see, however, the structural lines that divide the strong from the weak and the vicious from the assailed are no less complex than those whose lives are woven together to tell this story.

METHODOLOGY

I began my research with the central question of whether an industry so clearly characterized by exploitative labor practices and discourses of dirt and shame could in fact be empowering for women and the children they supported. I was particularly interested in the question of why women working in topless bars with a predominantly blue-collar clientele and associated lower profit margins chose performance-related work rather than other, less stigmatized low-wage jobs. What happens, I wondered, when men who earn money through their physical labor encounter women who are paid for their sexualized performances? After I met with women workers and their male managers at approximately fifteen topless and nude dancing bars in upstate New York, it became eminently clear that Vixens would provide me with the safest and most hospitable research environment. This was a major concern because, as a twenty-four-year-old graduate student, I was extremely poor, but also too timid to dance topless onstage. My shyness eventually worked to my benefit in that it helped me to function in a work environment where I had to find strategies for interacting with dancers without competing with them for tips from clients. Although R. Danielle Egan (2006), Mindy Bradley-Engen (2009), and Katherine Frank (2002) all successfully worked as topless dancers as part of their ethnographic research on men who visit such establishments, I felt that women would be far less likely to treat me as a friendly equal if I joined them in their highly competitive nightly routine of hustling clients from the audience into the private dance room.

Sex-work-related businesses are notoriously full of intrigues and hostilities between their female employees, and I wanted to avoid becoming inadvertently trapped in such fractious relationships with the women

whose lives I hoped to document. As a result, I became a frequent object of sympathy from Vixens dancers, who criticized what they saw as my stupidity in wasting a good income-generating opportunity and attributed my reticence to low self-esteem. Yet their pity also opened a direct avenue of communication between the approximately fifty women who worked at Vixens during the course of my six months of research, when I spent nearly every night backstage talking to women about their work and family lives. I conducted in-depth, semistructured interviews with roughly fifty women workers on these subjects in addition to gathering information on their average nightly earnings, the number of hours they spent at Vixens, their costs of living, and their work histories. I also gathered about two dozen life histories from the same pool of dancers. So, for instance, when Chantelle described other dancers as "real messed up" and directionless in opposition to herself, my knowledge of fifty women's work histories prior to entering Vixens and their plans for the future helped to provide some depth of perspective regarding her personal opinion.

I have chosen to use five of the approximately two dozen detailed life histories I collected at Vixens during my research, for the simple reason that these women are most representative of those I had nightly interaction with during the six months I spent at the bar. My interviews with approximately fifty dancers revealed as much about Vixens as a labor environment as it did about the characteristics of its women workers. Management avoided scheduling any of the dancers for more than forty hours per week and consequently did not have to pay insurance or other benefits to any of its staff. Although this overemployment of part-time workers can increasingly be found in many other areas of employment (including academia), the fact that dancers are considered to be independent contractors compounds the financial instability of this form of work by completely freeing management from any obligation to pay its workers. Dancers, instead, pay their managers a portion of the tips male clients at the bar offer them in the form of small-denomination bills. This labor environment, combined with other difficulties inherent in hustling strange men for cash, proves unsatisfying for many women who begin work as dancers, with some refusing to return after just a few nights on the job.

My participant observation at Vixens confirmed my initial suspicions about high employee turnover, as a full 20 percent of employees lasted less than one month at the bar before quitting due to concerns about a nightly income lower than initially expected, disagreements with other dancers, fears for their safety—or simply because they grew disgusted with such working conditions. About 25 percent of women stayed on the job for between two and three months before leaving. Women who worked less than three months tended to be younger (between eighteen and twenty-four years old), had never been married, and did not have children to support. It could be inferred that these factors may have granted them greater flexibility to find paid work or financial support elsewhere, although, as subsequent chapters will demonstrate, dancers did not always perceive this as the reality of their situation.

The remaining women worked at Vixens throughout the duration of my fieldwork, and although none had the status of a full-time employee with health insurance and other benefits, most described themselves as able to survive exclusively on the money they earned at the bar. The minority who claimed that they could not manage to live solely upon their Vixens earnings had another source of income, most often a second part-time, low-wage job, such as waitressing or working in another sector of the service industry, or had a live-in partner who provided some additional financial support. The average monthly wage among these women varied enormously, from extreme cases of dancers who quit in frustration after just a few weeks of earning almost nothing in tips from male clients to extraordinarily skilled and beautiful outliers who counted their earnings at an average of $700 per week. Most women, however, earned an amount comparable to what they would earn at a full-time job paying just slightly above the minimum wage, which at the time of my research was $5.15 an hour in New York State.[6]

This income was quickly spent for the vast majority of dancers, since their cost-of-living expenses were correlated almost without exception to their earnings. Dancers simply tended to spend any unexpected income they earned from clients' especially generous tips, even if the money was not necessary to their immediate survival. All of the women I met lived in rental accommodations, most of which were in

Sparksburgh, and accordingly monthly rent payments absorbed at least a week or two of earnings each month. None of the women owned her own home, although some, like Angel and Star, occasionally lived with men who were homeowners. A significant minority of women lived outside Sparksburgh, and some drove an hour or more from neighboring small towns or other areas where they feared a neighbor or some other acquaintance might recognize them if they were to work at a strip club closer to home.

All but one of the approximately fifty dancers had previously held a job outside the sex industry, most of which were in the unskilled, low-wage service sector of restaurants, convenience stores, and cleaning services. Women with children, who made up over half of the dancers, almost universally cited their responsibilities and added financial burden of motherhood as pivotal in their decision to leave their previous jobs in favor of sex work. All of the women insisted that dancing topless was extremely different from prostitution and what they viewed as its potentially dangerous consequences due to its illegality and what they believed to be its higher likelihood of disease transmission and physical violence. Notably, several such women later acknowledged engaging in survival sex in return for accommodation, rent, necessary services, or even child care, although they did not characterize such behavior as prostitution because it did not involve the explicit exchange of cash for sexual favors.

The ages of women who remained employed at Vixens throughout the duration of my fieldwork ranged from twenty to thirty-five, with most between twenty and twenty-six. All women over the age of twenty-six had previously been married, and all of them were either divorced or not currently living with their spouse. Eight of the women had been married more than twice, and one thirty-three-year-old dancer had been married five times. A significant majority of the women had worked in another erotic business before Vixens, and significantly, all described socialization processes that had prepared them for sex work. These descriptions included insistence on their untapped abilities as performers and knowledge of the industry gained from friends or other acquaintances. A few women drew a direct connection between negative or abusive

experiences with men as an antecedent to their work choices, but their numbers were quite small. About half of all dancers knew of women in their family who had engaged in some form of sex work, and, without exception, all were aware of someone in their circle of acquaintances who had done so. All but five came from New York State, with the vast majority from Sparksburgh itself.

I chose to use the life histories and words of Chantelle, Diamond, Cinnamon, Star, and Angel because their lives closely correspond to the experiences of many of their coworkers. Their stories are not intended as typologies, but rather as descriptive analyses of how the structural violence of poverty and, in some cases, serious gender discrimination helped to shape the lives of individual women. Their choices and responses to the circumstances in which they found themselves help to shed new light on the complex ways that many poor women conceive of work, money, responsibilities, and relationships as they try to support themselves and their families as best they can.

At twenty, Angel often described herself as "surprised to still be alive." She looked even younger than her real age on days when she had not been self-medicating with drugs and alcohol. Angel was the most itinerant of the Vixens dancers, and she had no fixed address, preferring instead to stay with various male acquaintances in Sparksburgh. This impressive network of men helped to support her drug and alcohol habit, because she did not have to budget any money for cost-of-living expenses and instead lived day to day. She often wore no makeup and had very few ensembles for work; most of her possessions fit in a small duffel bag that she carried with her from place to place. Angel's lifestyle rendered her extremely thin, and at just under five feet tall, she often looked like a preadolescent girl who had been rummaging through her (presumably much larger) mother's lingerie drawer. Angel's bras and thongs either had been purchased at a time when she was two sizes healthier or were hand-me-downs she gathered as she moved from place to place in Sparksburgh.

Angel wore no makeup except lipstick, which was usually black, and had short, bitten fingernails—all evidence of her transient lifestyle. Angel started dancing topless to make money when she aged out of the

foster-care system at eighteen, soon after giving birth to her son, who was taken into foster care at an early age when she tested positive for drug use. She often blamed her struggles with drugs and alcohol on her mother, whose own drug problem had placed Angel into foster care soon after she reached her teens. Angel's father was unknown, and she was uncertain of her mother's whereabouts. Angel had spent most of her life in Sparksburgh, and her long association with some of its habitual illicit-drug users made it incredibly difficult for her to see her self-destructive behaviors as anything but normal. Other dancers were extremely wary of her, and she was thus deliberately excluded from any kind of friendship or support she might have received at Vixens, largely due to their perception that she engaged in prostitution with men she met at the bar. From the perspective of other dancers, Angel's behaviors reflected on them in ways that had the potential to cause serious harm by making men believe that they could expect to arrange paid sexual rendezvous at the bar.

Star was twenty-four, with straight hair the color of brown sugar that framed her round face. Star spent a considerable amount of time each evening applying cosmetics to her stomach, which she hoped would cover her stretch marks from giving birth to two sons, the first of whom was born when she was nineteen and the second at twenty-two. She came from a small town about one hour away from Sparksburgh, where her parents still eked out an existence on a small dairy farm. Her fractious relationship with her extremely religious Pentecostal family stemmed partly from the pressure her parents placed on her to marry when she became pregnant at eighteen and then to tolerate her first husband's infidelities and compulsive drinking, which she did until she was twenty-one and he left her for another woman. Star began work as a waitress in Sparksburgh and put her baby in a church-sponsored free child-care service during the day. Then she met Don, an itinerant skilled tradesman. Six months after their relationship started, Star found herself pregnant with her second son.

Don signed a lease on an apartment in Sparksburgh for Star and him to move into, and he seemed enthusiastic about fatherhood until he was offered a job in Pennsylvania. Although he continued to send money for several months after he left, Star was quicker to notice the signs of

infidelity the second time around. Don's support payments for his son became more and more sporadic, and eventually Star learned that he had married another woman. Star's parents offered to let her move in with them, but their religiosity and what Star saw in them as an overbearing temperament made this option extremely unattractive, even though she had two young children to support. Instead, Star decided to try her luck at Vixens in the hope that it would be less expensive to leave her two young children with a babysitter during the night while they were asleep than it would be during the day. Soon afterward, she met Cinnamon, who was in the same predicament, and they pooled their resources to create a family. Star had been propelled into motherhood and marriage while still a teenager and insisted that she did not have any plans for her professional future. "I just want to be a mom," she would often sigh. "I could be a really good mom if my life was different."

Like Star, twenty-five-year-old Cinnamon had spent so much of her time simply surviving that it was sometimes difficult for her to think about planning for the future when her present life situation posed so many challenges. Cinnamon had a green Chinese dragon tattooed across her lower back, its long tail slithering around her waist and circling around her navel, where its tip seemed to disappear inside her body. The tattoo had been a rather expensive birthday gift from a former boyfriend, who insisted that it would bring her good luck—something she had not had much of since she became self-supporting at thirteen, shortly after the birth of her daughter. Cinnamon was tall and had the strong, solid legs of a career dancer, with muscles that were accustomed to very high heels and the constant bending and twisting motions that characterized her performances. She dyed her short, bobbed hair black and used a flat iron to make it perfectly straight before she started work, although usually it began to turn curly again after she started to sweat. Her eyes were green, and in the sunlight her pale freckles were visible on the bridge of her nose and scattered across her cheeks.

Cinnamon knew that her parents had moved to Texas and that they divorced a few years after they presented her with a particularly harsh ultimatum for a thirteen-year-old girl: either abort her child or leave home forever. Cinnamon chose the latter option, and she has never been

in contact since. She often mentioned that she does not think about them very much. Between working the night shift and caring for her fourteen-year-old daughter and Star's four- and two-year-old boys, she had to focus her energies as much as possible. Cinnamon was avowedly single and had vague plans to go to nursing school someday, when she finally felt ready to quit dancing and plunge full-time into the bleak prospects open to her in Sparksburgh with no high school education and no work experience outside the sex industry.

Although she had fewer years of experience than Cinnamon, Diamond had the longest tenure at Vixens and was unanimously considered the most beautiful and talented of all the women who worked there. Diamond had danced topless in several of the larger cities in upstate New York and had plans to move to Atlanta or Las Vegas, which are home to more lucrative erotic establishments, as soon as she felt financially stable. Diamond grew up on New York State's Canadian border, and despite her ambitions as she matured, she began to find herself cycling through relationships with men who seemed to all fit the same profile: unemployed, verbally abusive, and quick to take advantage of her income. Her last relationship prompted her move from a neighboring city to Sparksburgh, where she hoped she could start all over again without any physical reminders of the man she left behind. She began working at Vixens soon after her arrival.

Diamond had long strawberry blond hair that she swung wildly around her body when she danced onstage. She was of medium height, with strikingly beautiful features that often attracted comments from clients who could not help but notice how incongruous her presence was in the rather run-down setting at Vixens. "Diamond in the rough, eh?" many of them joked, which secretly made her happy because it reminded her that she was destined for bigger and better things. Diamond was a skilled dancer who clearly loved her job, and she was proud of her cultivated abilities to extract large sums of money from her regular clients, seemingly without consequences. Diamond considered herself a businesswoman and was not shy about her talents; in fact, she constantly reminded other dancers that someday she planned to run her own topless bar, where she would set the rules.

Professionally ambitious dancers like Diamond contrasted sharply with women like nineteen-year-old Chantelle, who hoped to quickly make some money dancing topless and then leave the sex industry entirely. Chantelle grew up in a desperately poor family of five children in a trailer park situated on the outskirts of Sparksburgh. Her relationships with her siblings, who were scattered throughout the country, were sporadically maintained through letters and occasional phone calls. Several of her brothers and sisters lived in West Virginia, where her mother's family still worked in the coal mines. Chantelle felt deeply ashamed of the work she was doing at Vixens and insisted that it was all for her child, who was still a fetus just six weeks past conception.

Chantelle tried to cover her body as much as possible because she felt vulnerable, and she knew that her youth made her seem particularly enticing to men. She did not style her shoulder-length hair any differently than she did outside of work and she wore little makeup, hoping that this lack of self-cultivation in the bar would signal her "nice girl" status to clients. Other dancers tried to help her negotiate the difficulties of learning the job but also were exasperated with what they perceived as her ineptitude. As Cinnamon put it, "Some girls just can't be dancers. You have to be tough, and some people just can't manage that."

Although dancers may recognize certain aspects of their stories in the pages that follow, I have concealed and sometimes altered details of their lives to the extent that they remain unrecognizable to others. This is in keeping with Hans and Judith-Maria Buechler's definition of anthropology as "a series of attempts at contextualizing events and sequences of events" (1996, xix)—in my case, in ways that paint vivid ethnographic portraits of individual women's lives without revealing potentially damaging facts about them. Accordingly, this book traces six months in the lives of topless dancers I grew to know extremely well; it does so in order not only to illuminate broader social issues but also to reveal the agency and work ethic that dancers evince in the face of a stigma that often seriously complicates their intimate and family lives. In some ways, this book situates itself in an ethnographic tradition of life histories that long predates it,[7] but above all it seeks to highlight new possibilities for research and writing that respect the concept of an anthropology of

the heart that cannot avoid empathizing with and loving the individuals who make it possible.

Accordingly, I tried to be mindful not to replicate what Ortega (2006) calls "loving, knowing ignorance"—a propensity she finds among some relatively privileged white feminists to assume that all women engage in similar decision-making processes and cost-benefit analyses. By integrating the minutiae of everyday life into its analysis, this book seeks to fill a gap in the scholarly research on sex workers by answering the question often asked by many of my curious friends and colleagues: "What do they do when they're not onstage?" I felt perplexed by this tendency to define the identity of women workers at Vixens through their erotic labor, thus effectively denying them complex personhood (Gordon 1997) and reducing them to sexualized, performing bodies. I have endeavored both in my research and in my writing to incorporate Donna Haraway's argument for the "situated knowledges" that acknowledge the multiple realities that shape both individual women's lives and popular perceptions of them. Haraway notes that it is important to recognize that "the codes of the world are not still, waiting only to be read," (1988, 593) and argues that all accounts of marginalized populations risk replicating "the god trick" of positivist science, which she believes to assume the possibility of rational, invisible, and omniscient authorial voice free of bias. In warning of the dangers inherent in attempting to see from the position of the less powerful, she notes that the poor (or otherwise oppressed) also have their own personal agendas and that to deny them that reality effectively contributes to their marginalization (1988, 584).

Anthropologists who work with populations engaged in illegal or semilegal activities face a troubling set of related ethical dilemmas that, although extremely minor in comparison to the life crises of those they study, underscore the uneasy nature of relationships formed in the field. Anthropologist Stephen Vanderstaay, writing of his guilt following the murder conviction of a research contact he had grown especially attached to, observes that "professional codes of ethical conduct proscribe harming subjects, but what of watching research subjects harm others?" (2005, 374). Anthropologist Philippe Bourgois, whose research perhaps best exemplifies some of the difficulties inherent in ethnographic research

with marginal groups, notes that the political engagement of many aca-
demics with ideas about social justice "remain textual, removed from
drug addicts, street criminals, angry youths, or any other flesh-and-
blood embodiments of social injustice" (1995, 250). Such "textual" rather
than actual commitments definitely color the discipline at large, so that
guerrilla movements in a rather distant country often become more real
to individual researchers and academic departments than the problems
that plague nearby communities. Vanderstaay has quite rightly pointed
out that "anthropology is not social work" (2005, 371), and yet we as
researchers clearly take on some sort of responsibility when we become
interlopers in the lives of others. How, then, are we to reconcile our pri-
vate desires for fame and recognition with the infinitely more press-
ing issues of the lives of those we write about, especially when those
very issues form the substance of our work? This is precisely why an
anthropology of the heart is needed, in which the premise of objectivity
becomes secondary to the deep and often emotional issues that ethnog-
raphy cannot help but expose. Refusal to explore the sometimes painful
socioeconomic realities of our immediate surroundings in conjunction
with broader processes of global injustice, after all, risks losing the most
fundamental power of the discipline: its vulnerable humanity.

An anthropology of the heart aims to document the intricacies and
contradictions of poor people's lives with dignity, thus aiming to relocate
the identity boundaries of privilege in some small way. It must also be
acknowledged that I, like many other researchers, sometimes felt less
noble emotions toward the people I attempted to understand. Hence this
anthropology of the heart must also recognize the anger, fear, frustration,
and feelings of naïveté that can result from living among people in situa-
tions of real structural violence. Anthropologist Philippe Bourgois writes
of his disgust toward Caesar, a crack dealer whose violence toward his
wife, infant son, and other community members allowed Bourgois "to
understand the contradictory processes whereby victims become the
most immediate administrators of their community's oppression on a
daily basis" (1996, 255). The fact that my own research questions were
especially clearly illuminated because of my work in a space that objecti-
fies women as a matter of course was thus rather incidental to the broader

issues that I sometimes found myself confronting at Vixens. Like most of
the dancers, I knew that I had entered a world that comes with strings
attached, and that these strings have a powerfully enduring ability to
ensnare, and to wound.

Lest I present too rosy a picture of research in what was quite hon-
estly a difficult and periodically dangerous environment, perhaps a brief
ethnographic anecdote will suffice. My car got stuck in the snow in the
Vixens parking lot one night, and I spent fifteen minutes spinning my
tires deeper into the muddy gravel beneath it before three men walked
out of the red steel door on the side of the building. The air was so cold
that my breath was thick like cigarette smoke even inside the car, and the
steady pounding of music from the bar was reverberating in my chest. I
realized that no one inside the building would hear me if I screamed, and
the parking lot was otherwise deserted. I felt a visceral kind of fear as
the group of men walked toward my car, my stomach tightening invol-
untarily as I forced myself not to look at them; it was dark, there was
no moon, and I was miles from Sparksburgh's center. I kept turning the
wheel from side to side and alternately pressing the accelerator and then
the brake in hopes of moving forward, but the tires only sank deeper into
the snow. One of the men knocked heavy and slow on the car window,
and I nearly stopped breathing.

Why was I so terrified? Where was the bravery I had thought would
somehow magically spring forth as a consequence of my ethnographic
curiosity? Moreover, why had I just then recognized what I was: a lone
young woman in the dark, outside an isolated and derelict strip club?
This was fieldwork, after all, so why did I suddenly feel so small and
afraid? I remember thinking that some prominent feminist anthropolo-
gists would probably have characterized this as a moment of ironic
ethnographic truth,[8] but at the time, it felt more like hollow terror than
anything else. Research on sex work can be dangerous and fraught with
uncertainties, particularly for women, and it would be extremely irre-
sponsible for me to ignore this fact as I write. Although I developed self-
protective strategies to compensate for these dangers to my safety as a
woman over subsequent years of research in Eastern Europe and South
Asia, this type of research is not free of consequences. As feminists, we

have a responsibility to acknowledge these considerable risks to future young female researchers, even if it means exposing our vulnerabilities in ways that sociologist Jennifer Wesely terms "negotiating myself" (2006, 146).[9]

That night in the darkness of the Vixens parking lot, the three anonymous men wordlessly assembled behind my car to push me out of the snow—but, as we shall see throughout this book, that story could have just as easily ended very differently.

WHY WOMEN CHOOSE SEX WORK

A number of excellent anthropological works on the global sex industry have emerged in recent years, many of which privilege the voices of sex workers themselves. This literature has raised provocative questions about the feminization of poverty, the limits of individual agency, and, perhaps most profoundly, the complexities embedded in relationships between men and women. Yet studies on sex work as an upward-mobility strategy have tended to focus on the Global South, with excellent ethnographies of everyday life among sex workers in China (Zheng 2009a, 2009b), the Caribbean (Brennan 2004; Cabezas 2009; Kempadoo 1999; Padilla 2007), Latin America (Katsulis 2009; Kelly 2008; Kulick 1998; Nencel 2001), Pakistan (Brown 2006; Saeed 2001), and sub-Saharan Africa (Kibicho 2009; Trotter 2008). In these works, the consensus among researchers is that sex workers often envision their labor as a first step toward a better future on terms that they believe will offer better prospects than other low-wage jobs. This is part of what anthropologist Denise Brennan, in the context of the Dominican Republic, calls "the opportunity myth" (2004, 14), whereby women become sex workers in hopes of eventual upward mobility but generally end up living in increased poverty after they leave prostitution.

Like the Dominican women Brennan describes, dancers at Vixens believe that their hopes for social mobility are most likely to be realized by working in an environment where cash income is determined solely by the dancer's interactions with clients. This system of exchange is

deliberately touted by management as potentially unlimited and allows dancers, in turn, to see themselves as agents and decision makers in a social system that otherwise sends them consistent messages to the contrary. Scholarship has discussed how notions similar to this "opportunity myth" inform everyday life practices among sex workers in the Global South, but this subject has been relatively ignored in research on their U.S. counterparts.

Many of the otherwise very good ethnographies on topless dancing deal exclusively with high-cost establishments where dancers earn a fairly good income. Katherine Liepe-Levinson's work (2002) was the first of these social science texts to interrogate the meanings of striptease as a cultural form, and was later followed by ethnographies from Katherine Frank (2002), R. Danielle Egan (2006), and Bernadette Barton (2006). Anthropologists Frank (2002) and Egan (2006) have extensively documented the complex relationships between topless dancers and their regular clients by drawing upon their own experiences as erotic performers. Both Frank and Egan, building upon the earlier work of sociologist Wendy Chapkis (1997), propose new ways of thinking about monogamy, sexuality, and human relationships in the United States by highlighting what sex work truly means to those who perform it and to those who purchase it. Sociologists Bernadette Barton (2006) and Jennifer Wesely (2002) have both added an important contribution to this literature in their discussions of the difficult emotional labor performed and sense of empowerment gained by erotic dancers, many of whom have limited skills and opportunities to pursue other forms of work.

Accordingly, this book builds upon an increasingly well-documented field of reference to examine what erotic dance reveals about the labor practices and economic realities that shape life for many U.S. residents. It does so in the context of women's lives on the socioeconomic fringe, where quite a few women recount stories of abandonment and abuse akin to those documented by Jody Raphael (2004) in her work on street prostitution. The women who work at Vixens are generally not the glamorous icons of femininity who perform in expensive topless and nude dancing establishments in major North American cities. They are, by and large, women who support children and other family members in an

economically devastated region of New York State that offers a woefully limited number of economic opportunities for unskilled women.

Thus their stories frequently have more in common with ethnographies written about sex workers in the Global South than they do with other contemporary North American accounts of topless dancing. The simple reason for this is that Vixens dancers are barely scraping by financially but simultaneously envision sex work as their only possibility for upward mobility, whether that means repaying a debt or saving enough money to move to a region with greater opportunities for unskilled work. As Denise Brennan writes of Dominican sex workers, "[T]hey, like many poor women, must be prepared to seize any opportunity, no matter how unexpected, inconvenient, or imperfect, to try to pull their families out of poverty" (2004, 169).

Sex work is always embedded in a life matrix of individual choices and responsibilities, and it is thus appropriate to consider the broader factors that influence women's perceptions of their opportunities. Numerous excellent feminist sociological works have described poor women's decision-making processes outside the sex industry as part of what Ellen Israel Rosen (1990) calls an extremely limited range of "bitter choices." Accordingly, arguments presented throughout this book will build upon the growing literature on global sex workers and U.S. women living in poverty to examine the lives of strip-club dancers in a U.S. city still reeling from the economic collapse and skilled-labor emigration that followed deindustrialization several decades earlier. I focus on dancers as complete social beings who are also mothers, partners, and friends, thus presenting the fuller picture of their daily lives and economic struggles that has been missing from many otherwise excellent books on U.S. sex workers.

I focus on Vixens as a work environment that has an enormous impact on the family and romantic relationships of its employees. Dancers are keenly aware that their semilegal status in a job closely associated with prostitution makes them a target of concern on the part of communities, law enforcement, state legislation, and, sometimes, each other. This fraught environment uncannily resembles the life realities of poor U.S. women with children and their decision-making processes described by Kathryn Edin and Maria Kefalas (2007), Paula England and Kathryn

Edin (2007), Kathryn Edin and Laura Lein (1997), Kathleen Gerson (1986; 1994; 2005), and Ange-Marie Hancock (2004). Edin and Lein (1997) note that, according to the U.S. Census Bureau, unskilled mothers and their children typically have the highest poverty rate in the United States. Edin and Lein found that poor mothers often supplement their regular income with some combination of informal employment and money from social networks akin to patterns mentioned by Sudhir Venkatesh (2006) in his study of life in inner-city Chicago.

Edin and Lein notably observe that "low income single mothers have a much broader view of what constitutes responsible behavior than policymakers" because of the conflicting goals they face while parenting in poverty (1997, 5). They go on to observe that poor women are forced to focus on their immediate needs rather than the long-term impacts of their decisions, and they note that poverty blurs lines of propriety in ways that are also difficult for poor women to reconcile (1997, 157). Although Edin and Lein do not focus their study on sex work, it emerges as an almost inevitable consequence of severe economic constraints, so that for the women in their study,

> the mercenary nature of these relationships occasionally made it difficult for mothers to distinguish between serial boyfriends and outright prostitution. One mother explained that her continuous use of live-in boyfriends "isn't for love, and it isn't just for money. I guess I'd call it social prostitution, or something like that." But this language was unusual among women who let boyfriends live with the family. Women who engaged in one-night stands were more likely to talk about "turning tricks", "street walking" . . . when they had no ongoing relationship with the man and received cash in return for sex. (Edin and Lein 1997, 157)

These blurry boundaries continue to perplex both academics and the women whose lives they describe, and for good reason. In the constrained environment that characterizes the lives of many poor women, what Edin and Kefalas term "the absence of other status-granting elements in life (degrees, jobs, money)" (2007, 24) creates a state of norm reversal in which women may sometimes be seen by more privileged observers as making irresponsible, or even destructive, life choices.

As we will repeatedly see in the chapters that follow, all five women whose struggles this book chronicles were doing the best they could to

improve their lives in a situation of structural marginality that functioned to brand them as immoral social outcasts. Anthropology focuses its attention on those who inhabit the margins precisely because so few people in the world occupy positions at the center of power and privilege,[10] and yet it is critical to recognize that the life circumstances of women in this book reveal much about the structural inequalities and violence that shape U.S. life. Dancers described in this book are the visible invisible, who are aware that to reveal what they do at night for money is to invoke a flurry of accusations of unfit motherhood, community destabilization—and even discourses of infection.

Each chapter begins with a narrative from a worker at Vixens and takes on one of the nuanced reasons that some poor women choose sex work rather than a slightly lower-wage job or public assistance. Chapter 2, "Feminized Labor and the Classed Body," opens with a narrative from Vixens manager Paul, in which he explains his belief that dancers are fortunate to be able to take economic advantage of their supposed sexual power over men; of course, economic realities in Sparksburgh tell a very different story. This chapter accordingly addresses the feminization of poverty and concomitant pervasive sexualization of femininity evident in almost all spheres of U.S. life. That women generally earn less than men is compounded in the socioeconomic context of the Rust Belt, where post-deindustrialization labor practices have dramatically increased the number of part-time jobs that offer no benefits. Many (if not most) skilled workers relocate to other U.S. regions for employment, leading to the pan–Rust Belt joke "Will the last person to leave [our town] please turn out the lights?" Those left behind often have neither the skills nor the capital to migrate, and, following broader labor patterns cross-culturally, women are more likely than men to work in low-paid, part-time jobs. The sex industry is a curious exception to this pattern, particularly since it assigns monetary value to idealized forms of femininity that are equally celebrated in other areas of U.S. popular culture. Accordingly, this chapter's final section, "Embodying Inequality: Poor Women and Sexualized Femininity," examines the broader cultural forces that have framed the lives of women who came of age after the Sexual Revolution, and how these increased "choices" and attitudes toward sexuality are interpreted by women from the social milieu characteristic of Vixens.

Chapter 3, "Everyday Survival Strategies," offers a critical analysis of dancers' decision-making processes, some of which had extremely negative effects on their lives. Angel, for instance, had a drug problem so severe that the New York State Department of Social Services placed her infant son in foster care shortly after his birth. Vixens dancers call the low-wage labor market available to them outside the sex industry "the straight world"—an environment they characterize as exploitative, exclusionary, and without hope for social mobility or financial stability. Far from being a completely separate sphere, however, "the straight world" both sets the conditions of their work and informs the way dancers think about their lives. All but one of the women at Vixens had worked outside the sex industry before, and many left for low-wage service-sector work elsewhere before returning with the recognition that they preferred the topless bar with its possibility of periodic windfalls from customers. Some held other low-wage jobs that they hoped would eventually become full-time or offer opportunities for advancement to managerial status that would allow them to leave Vixens. This chapter discusses how Vixens dancers negotiated the straight world and explores dancers' aversion to accepting welfare and other social benefits they could be eligible for if they left the sex industry. Their sense of social exclusion seems to contradict the language of entrepreneurship many use to describe themselves, although when viewed critically these two discourses in fact feed upon each other. Dancers believe that in some ways they exist outside the straight world's social order, as is evident in the institutional failures that so often locate them outside the boundaries of full citizenship, yet they also maintain the belief that its normative frameworks offer them hope for social mobility.

Chapter 4, "Being a Good Mother in a 'Bad' Profession," and chapter 5, "Pseudointimacy and Romantic Love," discuss the emotional worlds of Vixens dancers both in and outside of their work environment. Being the sole economic provider for small children is a major reason that some poor women choose sex work; its flexible hours and possibilities for income generation may seem, at least initially, to exceed what other forms of low-wage employment offer. Accordingly, chapter 4 discusses dancers' roles as mothers and caregivers. The emotional entanglements

that shape their lives with both clients and romantic partners are detailed in chapter 5. Dancers' romantic relationships were inevitably informed in some ways by their job, and defining the boundaries of what they termed "real feelings" accordingly raised serious questions for many such women.

Chapter 6, "Calculating Risks, Surviving Danger," analyzes how dancers maintain themselves in Vixens' fraught and often dangerous environment by developing a set of survival skills that draw upon broader cultural mores that exclude them while simultaneously offering seductive promises of quick income. Dancers interpret broader gendered principles of risk, fair exchange, and emotional labor on terms that help them to justify their exploitative working conditions and social stigmatization. By discursively placing power and control in their own hands, dancers are able to see themselves as agents and entrepreneurs despite pervasive social messages to the contrary.

Chapter 7, "Body Work and the Feminization of Poverty," builds upon the previous chapters' analyses of survival strategies, personhood, and risk to examine some of the troubling questions raised by the feminization of poverty and concomitant monetary value assigned to young women's reproductive potential and sexuality. It also employs the growing social science literature on the indisputably feminized occupational activities that involve intimate contact with the body or its products, including caregiving, cleaning, and, of course, sex work. Like many other body workers, dancers held a pervasive belief that sex work is a temporary solution to what is all too often a lifelong pattern of chronic economic and social instability. This chapter demonstrates why some (but by no means all) dancers believe that they can have a better life if they can manage to endure temporarily difficult, exploitative labor conditions.

In notable contrast to the lives of sex workers documented in the vibrant cross-cultural literature mentioned earlier, Vixens dancers *do* have other low-wage work and social-service provision options that could help them support themselves and their children in lieu of sex work. Yet Vixens dancers often sound remarkably similar to their counterparts engaged in sex work in Asia, Latin America, and Eastern Europe in describing their sex-worker identity as a temporary one that will be

discarded when they obtain the stability that is otherwise so elusive in their lives.

Chapter 8, the conclusion, argues that dancers' individual life choices and their perceptions of sustainable alternatives to work in the legal sex industry must be understood in the context of feminized labor. Demystifying sex work in this way renders intelligible the uniquely gendered forms taken by poverty's violence. Examining life on the margins exposes the stark inequalities inherent in the operations of power, because the intensity of the everyday structural violence that such injustices create becomes impossible to ignore. Studying the socioeconomic fringe is much like looking at a black-and-white photograph in which a vast social landscape is compressed into a tiny square that obliterates all but the most intense shades of gray. This book's analysis of the worldviews of five women whose lives reflect these social realities in rather spectacular form speaks volumes about the exclusionary forces at work in everyday American life.

Almost every North American city has establishments similar to Vixens; they may vary in cost, demographic characteristics, and services available for purchase, but all share the feature of occupying the margins of community life. It is perhaps not surprising, then, that the women who work there also find themselves in a socially isolating profession that they tend to see as a short-term survival strategy amid generalized poverty and limited economic opportunities. The ubiquity of such institutions indicates that they are part of broader socioeconomic processes that simultaneously provide income-generating opportunities to poor young women and keep them in positions of marginality.

Perhaps nothing underscores this reality more than dancers' continual insistence that their work is a temporary solution undertaken to improve their lives in the long term through greater financially stability. Over and over again throughout the following chapters, we will hear stories from women who insist that their exit from the business lies just around the corner, awaiting a repayment of a debt or simply a change in luck. Yet all too often work in the sex industry maintains dancers in the very patterns they wish to escape, so that being on the very cusp of what dancers refer to as "getting out" becomes a permanent life condition.

Feminized Labor
and the Classed Body

PAUL

There's nothing wrong with using the beauty God gave you to make
a little money. Hell, I'd probably do it too if anybody wanted to pay
me money for that kind of thing. See, the kind of girls who work here,
they're here for more than just the money. The money just isn't all that
great in a place like this. Some nights you might do really well and get
like five hundred dollars, but most of the time they get about the same
in tips as a waitress in a fancy restaurant. Thing is, these girls can't get
a job like that because they don't know all about wine and shit that you
have to, to make that kind of money in tips with your clothes on. If you
ask me, though, I think a lot of these girls feel special working here. It's
like some kind of proof that they're pretty or something, that somebody
thinks they're worth something. For some of these girls, that's a really
big deal. They'll put up with just about anything for that, and if you get

a little money for it too, well, you really just can't go wrong from their perspective.

DEINDUSTRIALIZATION'S ENDURING IMPACT

Making what Paul calls "a little money" has become progressively more difficult in Sparksburgh since the advent of deindustrialization in the 1970s. Upstate New York is part of the area often called the Rust Belt—a disparaging but exceptionally apt phrase that captures the landscape of decay so characteristic of a region that has seen almost all of its industries close in past decades as well as an exodus of its young people in search of work. This term entered popular discourse in the 1970s as shorthand for the socioeconomic decline that rapidly ensued in the U.S. Northeast and Great Lakes regions. It was at this time, when manufacturers relocated farther south, that these once-vibrant industrial centers lost their primary economic force.

Deindustrialization in Sparksburgh was part of a larger statewide and national pattern that saw a significant reduction in the North American manufacturing sector. In the twenty years between 1964 and 1984 alone, 176,000 New York State workers were left unemployed when factories were rendered insolvent.[1] In their work on postindustrial landscapes and public memory, historians Steven High and David Lewis have described mills and factories "once the proud symbols of human progress and modernity . . . envisioned [as part of] a place that could run like a machine" (2007, 2). Certainly, this vision of progress did initially seem to function as a successful mechanism toward prosperity, with unionized workers gaining a higher standard of living so that suburban homes and consumer products became the norm for increased numbers of families. Yet this smoothly functioning vision of mechanized modernity in the form of steel mills, assembly plants, and factories slowly ground to a halt as part of the global race to the bottom in search of cheaper labor and increased profits. Between 1969 and 1976, the United States lost 22.3 million jobs, followed by a further 2 million between 1995 and 2002 (High and Lewis 2007, 17).

Sparksburgh and many other towns and cities like it saw one factory after another close beginning in the late 1970s as part of a process that continues today. In 1978, Rockwell International abandoned its power-tool manufacturing plant when it relocated five hundred jobs to Tennessee, leaving behind a cavernous structure that Syracuse city officials considered as a possible site for the new county jail until planners discovered that it featured on a state list of hazardous-waste sites.[2] Allied Chemical Company in Solvay, a town named for the Solvay method of making soda ash, used in the production of certain chemical mixtures, had been an integral part of the community for nearly one hundred years, with a number of progressive policies, including one of the first pension plans in the country and company provision of health care for schools. Fourteen hundred jobs were lost when the plant closed in 1985,[3] and the impact of similar closures on communities throughout upstate New York was devastating, causing one local official to note, "It doesn't take an economist to understand what would happen [to the community] [M]any of the people who worked there—they worked there all their lives, their fathers did, their mothers did."[4]

This devastation followed thousands of layoffs just eighteen months previously by Bristol Laboratories and the Carrier Corporation, both of which were major employers in the region.[5] The shutdown of Allied Chemical Corporation created a ripple effect that resulted in the loss of $38 million in wages and $5.4 million in local and state taxes formerly paid by the company. Thousands of people who formerly provided services to factory employees also lost their jobs, which became redundant when their workplaces lost an estimated $33 million in sales.[6] Approximately two service-sector jobs were lost for every three eliminated manufacturing positions, affecting those employed in restaurants, shops, gas stations, and myriad other businesses throughout the region that were formerly patronized by factory workers.[7] Allied Chemical also left an enduring environmental legacy in the tens of thousands of pounds of mercury it disposed of in central New York's Onondaga Lake over two decades, effectively rendering it unusable until relatively recently.[8]

Just one year later, in 1986, General Electric (GE) cut 870 jobs, reducing its total employment level to just over five thousand people, a 70 percent

reduction in a little over twenty years.[9] Some of the workers had lost their jobs at Allied Chemical a few years before and had found employment at GE immediately prior to the layoffs.[10] In 1987, GE closed its television manufacturing plant, which had been open since 1947, eliminating an additional 790 jobs.[11] In 1988, Rubbermaid Incorporated closed its central New York factory, leaving 467 workers unemployed, some of whom sought work at Church & Dwight, Inc., manufacturing Arm & Hammer laundry detergent, shortly before its plant closure in 2000 after over one hundred years of operation.[12] In 2003, 350 people lost their jobs when Marcellus Casket Company closed its factory, leaving one writer of a letter to an upstate New York newspaper what he termed "jobless, aging and losing ground in the fight to survive."[13] One year later, Carrier Corporation dismissed 1,242 production workers, many of whom found it nearly impossible to find work that paid a comparable amount and reflected their years of experience.[14]

One round of economic destabilization followed another and prompted a generalized shift to the less secure and less well-paid jobs that emerged in the wake of deindustrialization. These economic changes are pervasive and often feature an unprecedented prevalence of untethering the workplace from its workers so that those workers in positions of power and privilege have increasingly less direct contact with or responsibility for those who work at the lowest levels of the same industry. This disconnection results in diminished accountability for the powerful and an increased burden for the least advantaged members of the socioeconomic hierarchy. This separation frequently accompanies a lack of unionization and the rise of part-time positions that require a degree of investment in work akin to that of a full-time employee without offering comparable benefits. Such new labor practices remind workers that they are expendable and not in a position to negotiate the terms and conditions under which they labor.[15]

There is no doubt that these destabilizing economic processes have an equally debilitating effect upon individual people's lives. As sociologist Monica McDermott notes after spending a year as a low-wage worker-observer in two blue-collar American neighborhoods, "[I]n many ways the most tragic aspect of inequality is the toll it takes on the self respect

of those outside the middle and upper classes. Behind the brusque, occasionally arrogant exterior of those who labor for a living resides a well of self-doubt and fatalism" (2006, 155). Yet this toll is also gendered through the male privilege that uniquely dominates most families. Sociologist Lois Weis describes the resulting bleak scenario as one in which "women's lives drown in various forms of abuse, leaving them too emotionally drained in many instances to deal with the festering anger of the[ir] men" (2004, 126). As these labor practices expanded and opportunities for employment decreased, emigration to other parts of the United States became a normal and expected part of attaining adulthood for all those who could find the means to leave the Rust Belt. The result is a depopulated region in which the unskilled are the ones left behind to find whatever work they can, as part of a process of marginalization that sociologist Paul Willis (1981) famously documented in a now-classic work as "learning to labor."[16]

Evidence suggests that increased poverty and lack of formal-sector employment often result in greater numbers of women in the sex industry, albeit in different ways that are specific to a number of cross-culturally variant factors (Beneria et al. 2002; Cabezas 1999; Mayorga and Velásquez 1999; Red Thread Women's Development Programme 1999). Like their counterparts elsewhere, Rust Belt sex workers must confront a number of occupational hazards and culture-bound assumptions about relationships, labor, respect, and privilege. These include their tacit acknowledgment that everyday experiences at work necessarily involve violating mainstream notions of fidelity that in turn create a number of recurring problems in their relationships with romantic partners and their children. U.S. ideologies and market values have a definite impact on the marginalization of sex workers in ways that differ significantly from other cultural contexts less informed by the encompassing ethos of the Protestant ethic and personal responsibility for one's fate.

Women at Vixens embraced the same capitalist ethos as their male counterparts who worked in the few remaining factories in Sparksburgh. Most dancers truly believed that they were doing their best to improve their lives and often shunned welfare benefits that could have helped them and their children, due to their perception that to accept

such assistance would mark them as "lazy." Anthropologist June Nash has documented similar beliefs among American factory workers in her investigations into the lack of a worker's movement in the United States, noting that it is this "final commitment to self-sufficiency and independence that ensures the hegemonic position of corporate capitalism" (1987, 246). Workers thus become part of a system in which they begin to embrace the very forces that oppress them—a process Nash describes as thoroughly embedded in American cultural values:

> [P]aramount is management's assumption of leadership of any initiatives stemming from the rank and file and appearing to have a broad support. Second is the containment of political activism in the unions. Finally there is the grounding of these strategies in generally accepted principles that are part of the American way of doing things. All of these rules require a management that reduces opposition to and reinforces the dominance of management over the work force in the workplace and in the community. (Nash 1988, 115)

The position of factory workers vis-à-vis management bears a number of striking similarities to the structural realities that frame the workplace and life environments of many topless dancers. Both forms of labor depend upon the body as a basic requirement of the job and draw heavily upon gendered notions of work accorded low levels of respect in American popular culture. Although many people in blue-collar communities covet unionized factory jobs and the relatively high hourly pay rates they bring, most workers are conscious of the demeaning stereotypes that position them as just one technological innovation away from losing their jobs. "I'm just a factory worker," one of my many relatives working in Detroit auto-manufacturing plants once told me as he sipped his beer. "A robot could do my job for free, it's just that they haven't invented it yet."

Yet the position of women who dance topless at Vixens and establishments like it remains quite different from the status of men who work in factories, because of the much clearer and pronounced stigma associated with sex work. Popular culture often dismisses factory work as mindless and repetitive, but it remains an icon of American industry and production among workers. Unions still exist to protect factory workers at some

level, but topless dancers find themselves individually responsible for their treatment in the workplace.[17] The sense of public and private shame accompanying sex work functions to discourage unionization or, indeed, any form of labor action by effectively making such women invisible members of society who wish to see their work not as a long-term career but rather as a short-term self-improvement strategy. In what most dancers imagine to be that interim period, women must navigate thick layers of community derision, stereotypes, and legislation that positions their profession as tolerated, but only just.

THE FEMINIZATION OF POVERTY
IN THE GLOBAL FACTORY

Feminized labor is often highly regulated despite the relative lack of benefits and income it provides to its workers, and this regulation increases exponentially with the degree of stigma attached to particular forms of feminized work. Sex workers inhabit a social category that positions them in need of (often nonconsensual) state control and assistance more than any other category of individuals, with the exception of prison inmates.[18] Such interventions have become increasingly common due to broader social shifts in popular consciousness regarding the appropriate role of the state in legislating individual sexual practices. Sociologists have pointed out how the combination of second-wave feminism and an increasingly conservative American electorate have rendered sex work, especially in the forms of prostitution and pornography, the targets of a hotly contested debate over "sexual correctness" (Bell, Sloan, and Strickling 1998). Many such efforts sought to construct a normative discourse of sexuality among both self-identified religious conservatives and self-identified feminists that, in the case of the former, prioritized the heterosexual, nuclear family as the only appropriate form, while the latter dismissed sex workers who did not feel victimized by their profession as "victims of false consciousness" (Bell, Sloan, and Strickling 1998, 353). Such descriptive labels ironically mirror the broader stereotype of sex workers as misguided, unintelligent, and desperately in need of assistance.

In his work on this unlikely alliance between self-identified feminists and what he terms "the New Right," sociologist David Wagner describes the focus of both groups on what he terms "a convergence in the politics of danger" (1997, 161). Wagner argues that this coalescence has roots in the 1970s, when Republican strategists sought to end Democratic majorities in Congress through a policy that "intentionally targeted sexual and family issues as a way of mobilizing conservative religious voters" (1997, 142).

This rather unlikely alliance between two otherwise divergent groups against sex work as a concept and sex workers as a category of people occurred at the same time that increased numbers of adult businesses were opening, both across the country and in New York State. The development of the strip club in its contemporary avatar is part of the dissolution of burlesque theaters following the advent of universal access to television and, especially, VCR technology in the early 1980s—a transformation that is discussed later in this chapter. Clubs that featured what was ambiguously named "exotic dancing" first began to emerge in urban centers in the late 1960s and early 1970s, but they soon found themselves in competition with the privacy and anonymity offered by pornographic videos that could be watched at home, and sought to make their businesses viable by offering more and more physical contact between dancers and clients (Shteir 2005, 317–325).

The push for dancers to perform increasingly sexually explicit acts onstage and with clients has been further fueled by upstate New York's increased economic disintegration. Just as religious conservatives and feminists were mobilizing against sex work in all its forms, increased numbers of poorer women were likely to supplement their income through sex work due to the closure of factories in search of cheaper labor in the Global South (Barton 2006, 25). The connections between the increased number of legal sex-related businesses in New York State and the economic decline in its central and western regions are impossible to miss[19] and can be conceived of as part of the patterns that have forced workers throughout the world to do more for less in order to remain employed. In the specific case of Vixens, this involves increased amounts of physical contact offered by dancers in exchange for less money paid by clients.

However, this phenomenon is by no means limited to topless dancing and in fact characterizes much of women's work cross-culturally. Anthropologist Carla Freeman has described the emergence of what she terms ✳ "pink collar" labor in Caribbean "electronic sweatshops" in which a low-paid, feminized labor force is paradoxically encouraged to wear business attire that absorbs most of their income but capitalizes on their aspirations to social mobility. Freeman describes this process as one in which "work is increasingly fragmented, deskilled and feminized in the race by multinational capital to increase its profits" (2006, 398). This is very much a global phenomenon in which feminized and low-paid forms of work are synonymous, and this becomes especially significant for sex workers, whose profession is often (but not necessarily always) feminized.[20]

Women who work in such unskilled, underpaid jobs throughout the global factory are bound by the unfair, exploitative socioeconomic conditions of businesses that first abuse their labor and then, in turn, brand such women as somehow deserving of such circumstances. Sociologists Patricia Fernandez-Kelly and Saskia Sassen have documented how the shift from manufacturing to service economies in so-called developed countries led to the expansion of feminized labor, which the authors note is characterized by "temporality, comparatively low wages and reduced union membership" (1995, 99). An impressive body of ethnographic literature has emerged on the pervasive popularity of home-based work in which certain aspects of garment manufacturing are subcontracted to individuals who perform the labor in their own homes.[21]

This arrangement saves the manufacturer a significant amount of money by reducing the need for factory space to accommodate workers and largely eliminates benefits and salaries, which are substituted by much-reduced payments issued for piecework. Strikingly akin to how topless dancers are considered "independent contractors" who are paid not by their employers but rather by the men who tip them, home workers receive an income based only on the work they complete regardless of the time it takes to finish, and are not formal employees of the manufacturer.

It is clearly impossible to separate the postindustrial decay of former manufacturing cities like Sparksburgh from the unequal terms on

which corporations previously located in the North operate in the Global South. As the authors of an article in *Feminist Economics* point out, these processes are inextricably linked:

> Globalization also means that . . . less money for men means more women in the sex trade, fewer opportunities for women in the formal sector, more migration to the cities, which means poor living conditions and the devaluation of reproductive work. . . . Feminization of the labor force in the South means that women in Northern manufacturing will be adversely affected. (Beneria et al. 2000, 7)

Such connections between poor women's lives internationally underscore that global capitalism often functions to further marginalize women by relying on gendered notions of appropriate forms of work for women. For example, geographer Victoria Lawson found in her research on home-based work in Ecuador that an overwhelming majority of women performed piecework, whereas a only a small minority of men did (1995, 438).

Almost all forms of feminized labor are characterized by impermanence and unreliability. For instance, anthropologist Patricia Fernandez-Kelly observes that the average duration of a female worker in a Mexican maquiladora is just three years, and for every such worker there are three others available to replace her (1983, 220). This fundamentally global phenomenon can also be seen in India, where the overwhelmingly female employees of outsourced customer-service divisions of U.S. and U.K. companies typically work just a few years at a very low salary (Basi 2009). Many such young women justify these labor conditions by highlighting the temporary nature of their employment as a transitional phase prior to marriage or to pursuing another career following further education. Such women echo the sentiments of almost all of the dancers I have spoken to, most of whom clearly state: "I'm not going to be doing this forever."

Yet women workers are also now part of the formal-sector economy in historically unprecedented numbers, and this relatively recent historical shift has prompted a flurry of popular cultural and political debate about gender-appropriate roles and responsibilities (Coontz 2000, 1998; Hochschild 2003). Recent scholarship documents the impact of the diverse

elements that make up what is often termed "globalization" on wom-
en's labor and sex roles cross-culturally. Ethnographies on the subject
underscore how shifts in female employment patterns directly inform
the social construction of gender, although not always in ways that func-
tion to increase women's ability to direct personal autonomy.

For instance, anthropologist Mary Beth Mills's research (1999) on
rural Thai women who migrate to urban centers to find work in gar-
ment factories documents how their labor fits broader cultural rubrics
of filial piety because of their remittances that often support families. In
her analysis of Sri Lankan women who migrate to affluent Persian Gulf
states for work as nannies and housemaids, anthropologist Michelle Ruth
Gamburd (2000) observes that although their prolonged absence creates
a number of interpersonal tensions within families, such women are
often described as good mothers because they financially support their
children in ways that would otherwise be impossible for them. Leyla
Keough (2006) has noted the same phenomenon in her ethnographic
work on Moldovan women who migrate to Turkey for work and, like
the Sri Lankan women of Gamburd's analysis, must be absent from the
family for a large part of the year.[22]

New forms of women's labor involving migration and its accompa-
nied absent motherhood may indeed redefine gender roles, yet they
often do so by reinforcing the very assumptions that undergird femi-
nized labor in the first place. It is thus critical to highlight the fact that
popular perceptions of feminized labor often work to destabilize wom-
en's income-generation efforts by persistently positioning women as
less qualified, less well paid, and less likely to be effective workers. For
instance, the cultural sanction of women's labor thus frequently takes
place under conditions that define women by their relationships to their
parents, husbands, and children, and in doing so offer little that is gen-
uinely new. This reality is inseparable from the conditions that shape
everyday life for the vast majority of women throughout the world, and
the near cross-cultural presumption of roles in flux permeates nearly all
interactions that draw their central organizing power from gender.

Although women are much more visible in the paid workforce than
they were in past generations, it is critical to acknowledge that work

has not been an empowering force in the lives of most poor women (or, indeed, most poor men) throughout the world. Sociologist Ellen Israel Rosen notes that blue-collar women who work in factories "often see the women's movement as a consequence of class privilege" that they are denied (1987, 17). Rosen raises the important point that what some might view as the oppressively male-dominated orientation of many blue-collar families is in fact a direct consequence of men's lower salaries and women's even more dramatically reduced earning power—a combination that necessitates "resource pooling and . . . emotional security" (1989, 170).

Characterizing blue-collar women's views toward work as a series of equally limited and unpleasant options, Rosen's analysis speaks to the complicated and nuanced ways in which individuals make sense of work. This reality is even more pronounced for sex workers, who engage in a form of labor that many assume relies upon the gross caricature of gendered inequalities for its very existence on the social and legal margins. Recent scholarship suggests that such hardships are, rather unsurprisingly, mitigated for sex workers with higher social status and greater access to resources—particularly higher education. In her ethnography of sex workers and their clients in Western Europe and the United States, sociologist Elizabeth Bernstein contends that prostitution continues to exist even in societies that feature all the indexes of gender equality, particularly women's full employment and equal pay, because of the appeal inherent in purchasing what she terms "the performance of authentic interpersonal connection" (Bernstein 2007a, 24).

Bernstein further suggests that the blurry lines between public and private constitute an erotic space that has taken on a multitude of new forms in contemporary U.S. culture, including an unprecedented diversification of sexual commerce. She contends that such specialization necessitates the participation of what she terms "middle class" women, who possess sufficient cultural capital (including, often, university degrees) to offer their clients services that extend beyond the exchange of sex for money. Bernstein argues that the ability of clients to purchase "bounded authenticity" (Bernstein 2007b, 273)—a temporary space constituted by the illusion of a unique bond between two people—has been a key

reason for the enduring nature of prostitution. Despite these cultural shifts, however, sex work remains heavily stigmatized.

Desire never exists without its concomitant social regulation, and this speaks to the human propensity to eroticize difference, thus taming and subjugating the unfamiliar while simultaneously teasing the boundaries of social acceptability. The fact that class plays a powerful role in silently shaping the social roles filled by sex workers underscores the way in which deeply ingrained ways of thinking about the body, sexuality, and gendered performance cannot be separated from broader structural elements that frame the way labor, agency, and power are understood. As is so often the case in human interactions, behavior that sparks powerful social ambivalence reveals much about the tensions that silently undergird the social order.

EMBODYING INEQUALITY: POOR WOMEN AND SEXUALIZED FEMININITY

Workers at Vixens represent just a few out of millions of women who fill culture-specific roles by dancing in front of all-male audiences in exchange for money. Their experiences alone cannot speak for all women who perform erotic labor, but their lives, performances, and popular cultural representations illuminate much about the culture-bound nature of desire and its aesthetics.[23] Yet their status as sexually desirable women does not insulate them from the intricate socioeconomic forces that shape their working and personal lives. Economic shifts often doubly affect the poor and those otherwise situated on the margins because of the enormous amount of interplay that takes place between what are frequently described as two separate spheres. These "formal" and "informal" economic and social sectors are never truly indistinguishable, and the interplay (and, indeed, interdependence) between them can clearly be seen in a number of areas ranging from political discourse to popular cultural trends.

Yet this binary distinction persists through the mask of social invisibility that sex workers must wear in order to negotiate everyday life. This analysis of the ways in which they wear this mask will repeatedly

illuminate how such women bear the double burden of social stigmatization and the need to conform to gendered social norms that exclude them. As we will see, their relative social invisibility functions to maintain the gendered social order. Why do women opt for participation in a work environment that so clearly discriminates against them while simultaneously exposing them to risks of gender-based violence and ostracism? Sex workers' rights advocate Jo Doezema describes entry into the sex industry as part of a decision-making process in which women are "forced to choose" (1998) work that they might not otherwise perform through a combination of poverty, gender inequality, and life in a socioeconomic system that only infrequently acknowledges the realities of poor women's lives.

Doezema's explanation of sex work as a form of agency within constraint (1998) helps to explain why many Vixens dancers disassociate their profession from other forms of sex work by vehemently insisting that their performances require a level of skill and ability that makes them superior to women who sell sex. This is particularly notable given that, as anthropologist and dance scholar Judith Hanna notes, dance is "the site where action and awareness merge" (1987, 3) in reflecting the beliefs, values, and attitudes of a people. The fact that topless dancers believe it is important to distinguish their labor from more intimate forms of sexual exchange warrants some discussion in regard to the broader cultural issues that help shape this perception among dancers. Why, for instance, do many women who dance topless at Vixens find it convenient to insist that their labor is distinguished from other forms of sex work because of its association with more creative forms of stagecraft? What U.S. cultural traditions are they drawing upon in making such assertions?

Neither dance nor desire arise organically, but are instead culturally constructed in particular historical and sociopolitical contexts. As cultural-studies theorist Jane Desmond notes, dance in any form is

> so ubiquitous, so "naturalized" as to be nearly unnoticed as a symbolic system. . . . Its articulation signals group affiliation and group differences, whether consciously performed or not. Movement serves as a marker for the production of gender, racial, ethnic, class and national identities. It can also be read as a signal of sexual identity, age and illness or health, as

well as various other types of distinctions/descriptions applied to individuals or groups, such as "sexy." (Desmond 1997, 32)

If dance reflects the ethos of a people, erotic dance speaks volumes to what is often left unspoken, including the complex threads that entwine to create erotic desire in a specific cultural context. Erotic dance thus functions as the repository of a society's deepest anxieties, fears, and, above all, notions of group membership.[24]

It is especially significant that poor women's bodies are the site for the enactment of such cultural ambivalence toward sexuality. In her book *Dance, Sex and Gender,* anthropologist and dancer Judith Hanna notes that cross-culturally dance often functions as "a vehicle of liberation from low, dependent status" (1988, xiii), citing the examples of overrepresentation of women and gay men in the dance profession. This argument could be extended to encompass erotic dance as well, following the arguments advanced by sex workers' rights advocates such as Kamala Kempadoo and Jo Doezema (1998), who convincingly demonstrate the reality that sex work is sometimes the only practical option available to poor women. These connections between such diverse elements of human existence deserve equally nuanced analysis that takes socioeconomic realities and culture-bound notions of performances into account. The everyday-life worlds of Vixens dancers are often-fraught as they negotiate life in a society that views them as objects of both desire and derision.

American erotic dance practices result from cultural contact between diverse communities in ways that speak to the elaborate intersections of history, power, and difference in the construction of erotic subjectivity. For example, the isolated rib-cage and pelvic movements that characterize American topless dance have roots in many sub-Saharan African dance forms that are assigned a racialized sexuality in U.S. popular culture through the complex and unequal historical interactions between two interdependent communities. Such sexualization removes the original sub-Saharan African cultural contexts by erasing the association between movement and culture-specific storytelling as part of a process by which, African-American dance scholar Brenda Dixon Gottschild notes, "the black dancing body (a fiction based on reality, a fact based

upon illusion) has infiltrated and informed the shapes and changes of the American dancing body" (Dixon Gottschild 2005,14).

Dixon Gottschild describes this "exotic-erotic syndrome" (2005, 41) as a cultural phenomenon that has manifested itself in diverse arenas—from the nineteenth-century European public display of "Hottentot Venus" Saartjie Baartman's enlarged buttocks (Crais and Scully 2008; Sharpley-Whiting 1999) to the unfortunately enduring contemporary popular cultural depictions of African-American women as hypersexualized (hooks 1999). Movement styles characterized as erotic likewise do not stem from a simple human biological predisposition (such as the innate need to reproduce) but are instead shaped by the cultural hierarchies that inform the society in which they are manifested. Thus whereas certain staple topless dance moves may have completely neutral meanings in many non–North American cultural contexts, they draw erotic power from cultural hierarchies that associate particular diasporic traditions with vibrant sexuality and lack of inhibition. As one U.S. choreographer explained to me, "If you can do ballet and you can do African [dance], you can do anything"—a statement that rather starkly exposes how such hierarchies also characterize formal dance traditions. Its underlying assumption is that ballet, with its associated features of control and ceremoniousness, is the complete opposite of so-called African dance forms, which are popularly characterized by release and informality.[25]

Yet one of the most interesting aspects of this phenomenon is its embodiment, since in the United States such dances are performed predominantly by white women who often have limited life choices because of their lack of education or employment skills that could provide them with enough income to survive. The obvious corollary to this is that erotic labor is a distinctly classed phenomenon, given that erotic dance, like sex work, often becomes the preserve of those who occupy a tenuous social position made even more marginal by their erotic labor.[26] This displacement of desire's public performance to the bodies of a specific category of women has deep roots in the United States in ways of thinking about class and sexuality.

In a related argument, cultural theorist Laura Kipnis contends that pornography is fundamentally a class issue and that this fact is obscured

when certain groups of feminists prioritize sex work as a form of violence against women, thereby isolating gender from its economic context. Kipnis notes that analyzing particular genres of sexually explicit materials offers "a detailed roadmap of a cultural psyche" (1999, 139) in that such publications consistently depict "the iconography of the body out of control, rampantly transgressing bourgeois norms and sullying property and properties" (1999, 136). Kipnis contends that the sex industry presents those in positions of relative privilege with a lurid, insistent reminder of their actions as oppressive agents, as in the magazine *Hustler*, in which "any form of social power is fundamentally crooked and illegitimate" (1999, 139).

Yet such images of the classed body out of control and directly threatening privilege in frightening ways are not unique to pornography and its associated industries.[27] American studies scholar Annalee Newitz notes the presence of what she terms "white primitives" in a host of films, television shows, and other popular cultural venues (1997, 136). Newitz finds that such representations reveal the elements of class stratification that shape American life in ways that remain tensely unspoken but vividly represented in films such as *Deliverance* (1972) and *Kalifornia* (1993). Film-studies theorist Constance Penley believes that this trend has intensified in recent decades, with the 1990s witness to the "media deployment of white trash sensibilities against the class and sexual status quo not seen since the goddesses of burlesque reigned" (1997, 102). Partly in response to this development, a growing interdisciplinary literature critically examines the problematic nature of considering whiteness as a monolithic social category to the exclusion of social class divisions.[28] Sociologist Matt Wray reveals the potential of this type of analysis to expose the otherwise invisible cracks and fissures in ethnic and socioeconomic discourse particularly well. He writes:

> How do we distinguish between the category *white*, the criteria for *whiteness*, and the boundary terms like *white trash* that mark the limits and edges of the category? The potential advantage is that by isolating and focusing on the differences among categories, properties and boundaries, we may be able to offer fuller, more comprehensive accounts of the logic used to determine group membership and belonging, both at the level

of everyday practices of differentiation and at all the levels of technical, institutional administration of difference. . . . In everyday terms, boundaries and margins are where all the action is. (Wray 2006, 143)

Burlesque provides one such particularly interesting boundary, since its history chronicles ways of thinking about gender, class, ethnicity, and sexuality, from its inception to its relatively recent resurgence in cities like New York, London, and San Francisco.[29] Burlesque performances first emerged as a cultural form in the 1890s and experienced continued popularity until the end of World War II.[30] This period is particularly significant because it corresponds to the institutionalization of leisure time in the United States. Leisure time first began to emerge as a commoditized pleasure separate from church or community activities with the advent of North American industrialization (Rosenzweig 1985; Cunningham 1980), which also coincided with the labor migration of significant numbers of unattached young females to cities. These women often worked at significantly lower pay rates than men, and it is likely not coincidental that an increase in the number of women relatively detached from their families and communities occurred at the same time as the emergence of the widespread display of the female body as a popular form of entertainment.

Historian Robert Allen contends that burlesque "emerges at a time when the question 'what does it mean to be a woman?' is constantly being asked in a wide range of forums," including in the performance style that he describes as the "progenitor of modern pornography" (1991, 27). Theater scholar Rachel Shteir describes how burlesque functioned as "a biting working class parody of high culture . . . [that] delighted audiences of all kinds" (2004, 28). Yet this initial class diversity among burlesque fans obscures the fact that such audiences were segregated in order to minimize contact between individuals with different degrees of economic privilege. Allen observes how this initial segregation ended by the late 1800s, when a greater diversity of theatrical forms began to attract more affluent clients—forms including melodrama, ballet, and extravaganzas organized by entrepreneurs like P.T. Barnum. These newly emergent types of entertainment effectively separated more privi-

leged theatergoers from "more boisterous elements of the working class, alcohol, sexuality, assertive masculinity" (Allen 1991, 73).

Burlesque thus became "the bourgeois theater's low other" (Allen 1991, 78), characterized by voluptuous curves and unabashed sexuality. Allen argues that this separation was important for more privileged men, who could thus see their interactions with the lower-status women who worked in burlesque revues as "a [commercial] transaction that opened up an important social distance . . . as a woman who displayed herself for money, the burlesque performer gave up any claim to consideration as a 'respectable' bourgeois woman. She became the low other whom the bourgeois male could safely gaze upon without immediately seeing his wife or her sister in her place" (1991, 151). Burlesque performers often appeared alongside blackface minstrels in traveling circuses as a perverse celebration of inequality that Allen terms "low-other constructions" (1991, 169) that clearly reinforce the "stupidity" and "unruliness" of the performers, thus justifying their oppression and use for entertainment.

Social class and marginal status play at least as powerful a role in the creation of eroticized difference as race does, and this has been a consistent feature of American erotic dance since its widespread advent in the traveling circuses of the early nineteenth century. These events brought any number of curiosities to relatively isolated communities, providing rural farmers and other small-town Americans with an opportunity to interact with the world, albeit on the caricatured terms that often featured cruel displays of marginal individuals, particularly the differently abled (Bogdan 1990).

Many of the women who performed in these circuses as "Oriental dancers"—the then-current euphemism for striptease (and predecessor of the contemporary term exotic dance)—were actually poor young women who had left home in search of new opportunities that were not otherwise available to them. Such women found themselves performing a much-coveted form of femininity through various dances that claimed roots in the "exotic harems" of the Middle East and North Africa (Buonaventura 1998). This follows a pattern documented by historian Robert Bogdan in his analysis of "freak shows" (1990), which historians (Bancel et al. 2008) have described as a Western legacy of "showcasing savages"

that continues today in the form of talk shows and reality television. In their edited volume *Human Zoo: From Hottentot Venus to Reality Shows,* Nicolas Bancel and his coauthors contend that such contemporary cultural phenomena reinforce existing hierarchies in more subtle (albeit equally insidious) ways than in the past.

Such exhibitions of otherness may maintain ideological roots in the dehumanization of those on display, but for its part, erotic dance has also retained its physical structure for over a century. Burlesque performances eventually became independent aspects of the vaudeville shows that emerged from traveling circuses, and these often took place in tents because of their transitory nature. Erotic dancers quite likely used the supporting poles of the tent as props that provided variation in their routine, which was necessarily limited by the small space in which they had to perform. Contemporary U.S. erotic dance establishments always feature at least two poles, usually mounted on a stage, which women also use as support for the thrusting pelvic and rib-cage movements that characterize their performances.

Culturologist Ben Urish observes how the narrative striptease that became a central aspect of burlesque performances by the early 1930s had "at its heart and inception a potentially subversive parody of cultural codes relating to gender, sexuality and courtship interactions" (2004, 157). As Allen notes regarding the eventual demise of the full-figured burlesque dancer in favor of the svelte, almost prepubescent body of the Ziegfeld girl:[31]

> [T]he link between expressive sexuality and inversive insubordination was effectively broken ... the burlesque performer was silenced, and thus her power to point to the system in which she was inscribed became even more limited ... the sexually expressive female was reconstituted through the excorporation (literally and figuratively) of what was left of [the burlesque performer's threatening qualities]. She might have been an icon of sexual modernity for her male and female spectators, but there was nothing daunting or troublesome about the Ziegfeld girl's wholesome, doll-like, decorative sexuality. (Allen 1991, 282)

Allen further observes that burlesque dancers were "unruly female performers" whose "transgressive power was channeled and defused

through their construction as grotesque figures . . . disqualified as objects of [socially legitimate] erotic desire" (1991, 283). Yet it is critical to mention that in contemporary forms of erotic dance such women are not "disqualified" but rather rendered liminal and accorded a social status that occupies an ambivalent position in U.S. society. Indeed, this is part of what makes topless bars sites of such great popular appeal and cultural debate.

Burlesque's decline corresponds with the diversification of entertainment forms in the early twentieth century, so that the growth of movie theaters and cabarets proved difficult competition. As burlesque theaters scrambled to retain audiences, acts became more and more risqué, eventually becoming the topless bars that are a familiar sight in many urban centers today.[32] "New burlesque" emerged in the mid-1990s in metropolitan centers such as New York City and London with audiences often dominated by women and gay men because of the genre's ability to allow "'girlness' to emerge through performance" (Ferreday 2008, 49). This burlesque revival is a kind of drag performance that allows "the historic tension between feminism and femininity to be rethought" (Ferreday 2008, 49) through its display of curvaceous female forms and costumes that emphasize them, complete with performers bearing wildly (and intentionally) ironic names like Dita Von Teese and Miss Immodesty Blaize.

Yet this new burlesque is confined to large urban centers, and its glamorous star performers are vastly outnumbered by women who work in establishments such as Vixens, where the constant pressure to exchange sex for money is both very real and a subject of constant surveillance by managers, law enforcement, and clients alike. Such processes are inseparable from global socioeconomic trends that consistently link feminized labor with low pay and temporality through justification mechanisms that deem women uniquely suited to such work. It must be acknowledged that these mechanisms take different forms that vary based upon individual women's citizenship status, race, social class, level of education, and myriad other factors that shape one's identity. Yet the experience of sexualization is common to all women, as noted by feminist philosopher Sandra Bartky:

> Much of the time, sexual objectification occurs independently of what women want; it is something done against our will . . . the objectifying perception that splits a person into [body] parts serves to elevate one interest above another. Now it stands revealed not only as a way of perceiving, but as a way of maintaining dominance as well. (Bartky 1990, 27)

Bartky's assertion succinctly demonstrates how the tensions faced by dancers in terms of their location on the boundaries of social acceptability are in fact relevant to all women, whose sexuality is often defined for them.

Feminist philosopher Lenore Kuo takes this argument further to note that broader cultural shifts toward increased female sexual autonomy have in fact worked against the vast majority of women. Rather than improving equality between the sexes, Kuo believes that the "Madonna/whore" binary continues to inform contemporary gender relations in insidious ways. Kuo provocatively argues that this dichotomy is heavily and negatively weighted toward the latter for most women as a direct result of post-1970s socioeconomic changes. She observes that "this ease of slippage [between binary categories] is the reason the current construction and treatment of 'the prostitute,' the ultimate embodiment of the whore, reverberates so powerfully in the lives of *all* women; her fate is ultimately the fate of all women" (2002, 53).

Paul's narrative at the beginning of this chapter spoke to the nuanced noneconomic reasons that women choose to work at Vixens as part of broader, pervasive social trends that have increasingly presented an extraordinarily ambivalent vision of idealized female sexuality as simultaneously unattainable and accessible. Combined with the economic devastation that characterizes upstate New York, where some girls grow up to be dancers because it is the most glamorous and exciting career option available to them, it is clear that a complex set of socioeconomic issues are at work. What women experience at Vixens is inextricably linked to the systematic devaluation of women's labor, the pervasive sexualization of femininity, and, above all, women's agency in harnessing these processes while attempting to make them work to their advantage in a system that rarely operates in their favor.

THREE Everyday Survival Strategies

I'll tell you about straight-world jobs, OK? They pay you minimum wage, treat you like complete crap, and that's it. There's no moving up. Everybody stays part-time because they don't want to pay benefits to anybody. You know at Wal-Mart, those people who work there get food stamps? What's the point? Seriously, what's the point of working if you're just going to have to swallow your dignity anyway and live off of New York State? Growing up, my parents just struggled and struggled, and where did it get them? I'll tell you, people think dancers have no self-respect or something, but I say if you wanna see disrespect, go work at Wal-Mart for a month. Have your boss tell you to go line up for food stamps and Medicaid for your kids and whatever else. Look, things aren't perfect in

here for dancers, but out there, for working people, they're even worse. There's no way I'll ever go on welfare. Maybe sometime I'll go back to working minimum wage—but welfare, forget it. I'd be better off dead than living like a welfare queen.

DISTINGUISHING "WORK" FROM "MONEY FOR NOTHING"

Like Star, many blue-collar Americans demonstrate a cultural understanding of wage employment as an inherently negative (and even abusive) part of a life reality that, however monotonous and unjust, places them in what they perceive as the socially respectable category of the hard-working. Low-wage work comes at a heavy price, including the ever-present awareness that, as Star puts it, "there's no moving up" for the vast majority of employees. This is particularly problematic for women struggling to support children alone and at or near the poverty level. As sociologist Lucie White notes, "[R]eal life for parents in the low-wage sector reveal[s] a pattern of mutually reinforcing hardships and impediments that will make it exceedingly difficult . . . to lift themselves and their households even above the official poverty level, much less provide a foundation that reasonably supports human flourishing" (1999, 209).

Such grim realities present a striking portrait of individuals who simultaneously accept and reject popular opinion about poverty and public assistance. Star's sentiments clearly construct work for pay, no matter how demeaning, in direct opposition to those who earn money "for nothing" and thus form a target of disdain and unspoken, simmering resentment. This is hardly unique to dancers: witness, for example, the relative ease with which Republicans can mobilize the otherwise subject population of the white working poor to vote against welfare and other issues designed to assist people in economic difficulties not so different from their own. It is undeniable that this is heavily racialized as well, and Star's use of the pejorative label "welfare queen" thus warrants some further discussion.

The overwhelmingly white majority of Vixens dancers often described women on public assistance as "welfare queens," whom they presumed to be morally bereft individuals unwilling to better themselves. This was very much in keeping with what political scientist Ange-Marie Hancock has termed "the politics of disgust" that underlie popular U.S. understandings of public assistance by reducing welfare recipients "to their most base common denominator" (2004, 119). Sociologists Kenneth Neubeck and Noel Cazenave term this phenomenon "welfare racism"—an insidious process through which

> politicians have blamed black mothers who must rely on welfare for nearly every social problem in the U.S., including violent crime, the illegal drug epidemic, the decline of families, communities and schools, the growth of rampant immorality, and even poverty itself. Black mothers receiving welfare have been cast not simply as prototypical villains, but as a collective internal enemy that threatens the very foundation of U.S. society. (Neubeck and Cazenave 2001, 3)

It is particularly paradoxical that Star would engage in these sorts of othering processes, since she also inhabits the social margins and constantly found herself and her two children on the verge of destitution. Like the "welfare mothers" Neubeck and Cazenave describe, sex workers (and, sometimes, their clients) are also blamed for a host of social problems despite the fact that many of their life realities are simply manifestations of a host of exclusionary institutional and cultural practices (Sanchez 1998; Sanders 2009). Given these shared stigmas, it seems that Star should have been more sympathetic. Yet, as a critical part of complex personhood, perhaps it is not surprising that she so enthusiastically embraced prevailing political discourse that otherwise did not benefit her in any way.

Just six years before Star made her comment about "welfare queens," Congress passed sweeping legislation that famously aimed to, in the words of President Bill Clinton, "change welfare as we know it." As sociologists Joel Handler and Lucie White have observed, this model of "welfare as we know it" emerged in the 1930s to support women and their young children in the absence of a male provider (1999, vii). The

advent of the women's movement and women's increased participa-
tion in the paid workforce, as Handler and White observe, undermined
broader popular support for such policies when their administration
became more complicated and costly after the numbers of unmarried
young mothers rose dramatically. It was in response to overwhelmingly
negative sentiment among the voting public that in 1996 the Personal
Responsibility and Work Opportunity Reconciliation Act (PRWORA)
introduced a two-year time limit for welfare recipients and mandatory
work activities for all adults, regardless of the availability of responsi-
ble caretakers for their children (Henly 1999, 48). Sociologists Joel Han-
dler and Yeheskel Hasenfeld argue that the underlying message of such
reforms is that poverty, nonexistent child care, and other limiting social
factors are all consequences of individual failures regarding "personal
responsibility" (quoted in White 1999, 130–131).[1]

In adopting such rhetoric into her personal worldview, Star effectively
positions herself above mothers with young children who choose public
assistance rather than sex work as their main source of income. It is criti-
cal to note that her ability to do so is in some ways indicative of white
privilege, given that even as a poor woman supporting young children,
she is culturally constructed as "desirable" enough to engage in forms
of sex work like topless dancing that pose fewer risks than, for instance,
street prostitution. Her reasoning is part of a moral economy that is not
specific to sex work but can be generalized to situations that encour-
age individuals to envision struggle as a normal part of everyday life.
Sociologist Joseph Howell characterized this worldview as shared by
those "who felt isolated and left out, people who felt scorned and looked
down upon by whites more affluent than themselves" (1991, 327). This
sense of disenfranchisement has only increased for a greater number of
Americans in the decades since Howell's original research in the 1970s,
as deindustrialization and labor outsourcing continue to de-privilege
U.S. workers.

In her work on the cultural meanings of deindustrialization, anthro-
pologist Kathryn Dudley discusses the sense of backwardness, pity, and
even fear that surrounds displaced factory workers. Dudley terms such
individuals "the new American primitive" (1994, 154), relics who are out

of place in the contemporary world. Yet the plants that once employed them function equally as social figures, and their empty presence marks the conspicuous absence of economic vitality in many Rust Belt towns and cities. Sociologist Avery Gordon might describe their relationship to the local communities they once supported as a form of haunting. In writing of the historical ghosts of social injustices past that continue to inform individual relationships and popular understandings of groups, Gordon notes that "the ghost imparts a charged strangeness into the place or sphere it is haunting, thus unsettling the propriety and property lines that delimit a zone of activity or knowledge . . . [and is also] primarily a symptom of what is missing. It gives notice not only to itself but also to what it represents . . . usually a loss" (1997, 63).

Such haunting imparts in equal measure bitterness and violence that are never far from the surface of everyday social life and thus inform ordinary interactions between individuals. Howell observes that most of the urban blue-collar population he studied "saw themselves as fighters in both the figurative and literal sense . . . [and as] strong, independent people who would not let themselves be pushed around" (1991, 292). Yet this discourse of refusing disrespect is seriously undermined by the reality of their everyday lives: temporary, low-status jobs, fragmentary relationships, poverty, and a sense of alienation from the state. Sociologist Mirra Komarovsky notes that despite this general sense of marginality,

> the dissatisfied men generally blame themselves for their low achievement, usually attributing it to lack of education. Their individualistic ideology deflects blame from society to the individual. There is little projection of blame upon the government, political parties, the "bosses," or any ethnic or religious group. Occasionally they refer to their "bad luck" as some impersonal, amorphous force of circumstances . . . [and] reproach themselves. (Komarovsky 1987, 284)

Such features work in tandem to create an ambivalent relationship to authority that manifests itself most clearly in a worldview that refuses to recognize class privilege as a significant determinant in the degree of life stability one is able to achieve. It is clear that very few people, including dancers at Vixens, grew up in such a system expecting to enjoy working,

as they were by and large socialized to understand work as a cultural category that is necessary despite its accompanying humiliation and angst. The sheer physicality of most blue-collar jobs leaves those who perform them exhausted by the end of the day and prompts criticism of those they perceive to be "lazy" enough to avoid this type of work. After a lifetime of listening to such comments, it is hardly surprising that many dancers began to regard their sexualized labor as distinct from and morally superior to the indignities they associate with public assistance.

Despite their obvious awareness of the dangers and hardships presented by their work environment, many dancers at Vixens described the money they collected in tips from male clients each night as income earned "for nothing" or "for not working"—an association that greatly confused me at first. How was it possible, I asked myself, that women who were clearly engaged in serious physical labor that often placed them at serious risk of injury and abuse did not think they were really "working"? Dancers knew that their rigorous physical labor had consequences for them, and women who had been in the profession for several years or more frequently complained about joint problems that ensued from performing night after night. For some women, such problems were compounded by the frequency with which they employed difficult stage maneuvers executed in six-inch-high heels, such as hanging upside down from or suspending the body around a vertical metal pole and holding the position for several minutes in front of an audience.

The central paradox behind this philosophy of "work" is as follows: had such physical feats been carried out by men on a construction site or in a factory, they would have been classified in the productive category of "real work." As we will see later, many dancers characterize the income they earn as "dirty," which in turn provides greater impetus for some dancers to plan for the future, whereas others, like Angel, begin to increasingly regard themselves as social outcasts with no future whatsoever. Both ways of thinking are extremely conducive to overspending, in that income earned from "nothing" is often regarded with disdain and even a sense of shame.

Dancers at Vixens were by no means unique in this perspective, as other scholars of sex workers' lives have documented how this propensity

toward viewing their income-generating activities as undesirable, marginal, and shameful leads to seemingly irrational spending behaviors and strategies that seem particularly counterproductive for women who express interest in quitting their jobs in favor of less-stigmatized work.[2] It is essential to describe the agency evinced by dancers in making choices designed to improve their lives, yet it is equally important to consider the factors that contribute to such contested notions of self, work, and shame. If, for example, some dancers view their occupation as a temporary strategy on an upwardly mobile continuum toward self- and family improvement, it seems somewhat self-defeating to engage in lavish spending behaviors and drug use. Yet, as is the case with all elements that make up the cultural logic of work in particular professions, this behavior warrants some closer analysis. The social invisibility that poverty incurs is seriously compounded for sex workers, and yet, as we will see, dancers almost universally agreed that sex work was infinitely preferable to the lack of autonomy and self-respect that they perceived to accompany public assistance.

WELFARE AVERSION AND SOCIAL-SERVICE AVOIDANCE

If these sorts of negative characterizations and public contempt are the only alternative for relatively uneducated women like Cinnamon and Star who struggle to support their children alone, it is hardly a surprise that sex work seems a more viable alternative.[3] Indeed, many Vixens dancers described their work as something that could be carefully hidden from children's teachers and other members of the community who have the power to exercise authority over their families. "I'll let my kid starve before I go stand in a welfare line," Cinnamon said emphatically when I asked her why she had consistently refused public assistance despite her long history of raising her daughter alone and in extremely constrained circumstances. She then couched her reasoning further in a tradition of exploited laborers who maintain what they believe to be dignity in the face of oppressive working conditions:[4]

I don't think it sounds bad at all, to say something like that about my kid. I know my daughter isn't proud of what I do, and she's old enough to know she can't tell people about it because of the way people judge, but what would I be teaching her about life if I go stand there in the grocery store with food stamps, or move into public housing and just sit there at home all day living off the state, like some women? I've seen the way everybody looks at the food-stamp people in the grocery store— I know, because I look at them that way myself. At least this way she learns that nothing in life is free, that life isn't easy, because that's a lesson we all have to learn sooner or later.

Cinnamon thus positions sex work as a relatively private alternative to the "public" shame of welfare; her images of standing in lines awaiting welfare-check disbursement and using food stamps at the grocery store evoke a powerful sense of repugnance. Her seemingly illogical condemnation of women who opt to stay at home with their children through welfare rather than perform sex work, which is perhaps even more stigmatized in the eyes of the public, is less surprising when considered in light of the consistent discourse of irresponsibility that has framed much of U.S. welfare policy. Sociologist Viviana Zelizer has documented how the government distribution of "alternative monies" to the poor in the form of public housing and food stamps has historically been informed by the supposition that both could function as "important instructional currency to rehabilitate the morally righteous but technically incompetent poor, [by] teaching them to spend properly" (1997, 120).

Zelizer refers to this as "taming money" (1997, 132), a process through which the poor are taught to assume what she terms "middle class spending habits" as a condition for receiving public assistance. This sort of patronizing philosophy that positions people living in poverty as inherently irresponsible continues to inform much of U.S. welfare policy and in turn serves to encourage women like Cinnamon and Star to avoid what they perceive as a morally reprehensible form of support. Hoigard and Finstad in their work on Scandinavian street prostitutes have noted that almost all the sex workers they encountered had attempted other forms of work prior to making the decision to engage in prostitution. The authors describe the sequence many sex workers experience of finding

low-wage employment in another industry followed by the realization that prostitution is more lucrative and allows for greater autonomy as "a restless cyclical dance in search for a niche for survival" (1992, 77). Yet this "dance" comes with great risks attached to the promise of self-reliance, and many women find themselves engaging in elaborate processes of justification for entering into it in the first place.

Chantelle echoed this focus on survival in her extremely well-reasoned explanation of why she preferred to dance at Vixens rather than accept public assistance in the early stages of her pregnancy. She envisioned the temporary stigma of her work as preferable to what she perceived as the ill-treatment she would receive from doctors and nurses as a welfare recipient. "I know what they'll think," she explained. "They'll think, 'Oh, another welfare mom, living off the state, baby with no daddy'—that kind of a thing. I don't want my child to come into the world that way." Given that no other jobs with benefits were available to her with a tenth-grade education, Chantelle chose to exercise agency by opting to pay cash for medical care rather than accept what she regarded as charity services that she believed came at a precipitous psychic cost.

Dancers at Vixens incorporate popular logic and beliefs about money and morality into their everyday lives in ways that may not always seem to be directly beneficial to them. However, women often embraced this logic in ways that they hoped would provide long-term benefits to their children and themselves. Dancers clearly believe that sex work provides them with greater autonomy and self-respect than public assistance or the forms of low-wage work available to them. Yet many dancers characterized money they earned from sex work as "dirty." How do we reconcile these seemingly contradictory thought processes? Part of the answer lies in what dancers perceive as negative conditions imposed by availing themselves of social services or entering into the low-wage work force outside the sex industry.

As we will see in the next chapter, dancers with children face a particular set of challenges that they share with low-wage working women who have sole responsibility for their young children. Sociologist Lucie White contends that the heavy set of restrictions U.S. states set on the receipt of public assistance functions to reinforce patriarchal social

norms, just as tax laws encourage more-privileged, married mothers to stay at home to care for their young children (White 1999, 132). These insidious institutional processes translate social stigma into policy by placing unmarried, low-income women who have children at a serious disadvantage vis-à-vis their married, higher-income counterparts. Nowhere is this clearer than in the processes dancers would have had to engage in had they decided to support their children through public assistance rather than sex work.

As White points out, such policies explicitly aim to enforce patriarchal social norms by promoting marriage, preventing pregnancies among unmarried women, and "encouraging the formation and maintenance of two-parent families" (U.S. Department of Health and Human Services 2009). Star, Cinnamon, and other Vixens dancers who were mothers of young children qualified for a number of social services that they chose not to avail themselves of because they considered them demeaning, regulatory, and indicative of failure. Yet there were also a number of institutional factors that negatively affected their impressions of social-service provision, despite the fact that dancers, particularly those with young children, could have enormously benefited from such programs.

The first step toward receiving public assistance in New York State varies by geographical location, but in Sparksburgh a single central office handles applications for food stamps, Medicaid, and cash assistance through the Temporary Assistance to Needy Families (TANF) program. After approaching this office, individuals then begin what the Department of Health and Human Services acknowledges is a potentially "confusing and complicated" process,[5] which starts with an application form that determines basic eligibility levels regarding income and number of dependent children. Some applicants qualify for emergency food-stamp or cash assistance, but the vast majority of them are simply scheduled for an eligibility interview with an agency employee. Even before being approved, and prior to this interview, applicants must (at a minimum) be fingerprinted, photographed, visited at home as part of an eligibility verification review, attend group orientation workshops to learn about program rules, and engage in work activities such as a job search or enlistment with a temporary-employment agency. The applicant will not

receive any benefits, unless deemed eligible for emergency assistance, until after the eligibility interview takes place.[6]

Successful applicants qualify for monthly TANF benefits that vary by county in New York State but that for a family of three range from $550 in lower-cost rural areas to $738 in New York City.[7] Many dancers with children could have availed themselves of $242 in food stamps—the average monthly benefit provided for households with children (Meyers et al. 2001, 42). Such women could have also forced their children's biological fathers to remit monthly child-support payments by completing the New York State Department of Social Services' "Application for Child Support Services," a form that gives state employees permission to establish paternity and/or obtain child support for minor children. However, if the biological father needs to be located through a special investigative service, or if legal representation is required for the woman and her child, the woman must agree to pay 25 percent of *each* child-support payment she receives from him to the state or face legal charges.[8]

Women are thus penalized for not meeting patriarchal state expectations, and such sanctions are particularly intense for those who do not know the name of their child's biological father. This is quite ironic given the concomitant rise of assisted reproductive therapies that often involve the use of anonymous sperm or ova donors by those who can afford to pay for such costly services. For women like Chantelle, who was not sure who the father of her baby was, this very similar cultural practice has very different implications in the eyes of the state.

Many dancers could have also applied for public housing in Sparksburgh by filing an application to place them on a waiting list that gives preference to those displaced due to partner violence, fire, and related crises. To qualify for public housing, applicants must list income, job, landlord references, and their address history for the past five years, and they must earn less than a combined total income of $43,900 for a family of three or $34,150 for a single person.[9] With so many possible benefits available to them, why did dancers like Cinnamon, Star, and many others express such strong aversion to public assistance?

Dancers cited several reasons for not applying for public assistance. Most, if not all, dancers had experience with government social-service

provision, and some, like Angel, had a lifetime of resoundingly negative experiences with it. It is important to note that part of the reason women were working at Vixens in the first place was that they felt outside other possibilities for upward mobility, including programs envisioned by the state as beneficial to poor people. In fact, the mandatory work activities required under TANF would have pushed them into the dead-end low-wage labor market they sought to avoid by working at Vixens. This in itself was further complicated for dancers with children, since in most cases it would end the child-care arrangements they had set up for night-time, when it was more affordable because it typically involved leaving sleeping children at a friend's house.

Many women were excessively concerned with the possibility that increased state involvement in their lives via social-service provision might increase their risk of having the Department of Social Services (DSS) take their children away. Cinnamon had countless stories from her decade-long long career in upstate New York's sex industry of biological fathers who had successfully used the "immorality" of their child's mother's lifestyle to obtain custody. In some relationships, this constituted a form of terror, and Cinnamon recounted the story of one man she had dated in her early twenties who threatened to report her to the police for engaging in prostitution—a charge that she believed might have prompted an investigation and the subsequent placement of her daughter into foster care. She told me that this experience was in many ways instrumental in her decision to remain single for her daughter's benefit, noting that "men and women will never be equals, and when a dancer tells the police something and her man is telling them something else, who do you think they're gonna believe?"

This sort of rhetorical reasoning might appear self-defeating, but it was also instrumental in the decision-making processes of dancers like Chantelle and Star, who either did not want to know the identity of their children's biological fathers or did not wish to initiate contact with them. Previous experiences with social-service provision or stories from women who had experienced this indicated that many dancers had a strong belief that DSS would somehow force them to locate their child's father in order to recoup some of New York State's TANF expenditures. The father of

one of Star's two children was unknown, and she felt a strong aversion toward what she viewed as state coercion to locate him. Chantelle shared these sentiments and also viewed this possible state intrusion into her pre-pregnancy sex life as demeaning, insulting, and classist. "Poor people's lives are everybody's business, right?" she sarcastically observed. "Because we don't have the money to cover up our mistakes."

Money was always a critical issue for Vixens dancers, most of whom lived on the verge of destitution at all times. This frequency of near-poverty between lucrative windfalls that were quickly spent was a source of embarrassment for many dancers who believed that those working outside the sex industry would find their decision-making processes irrational. As Star put it, "People think dancers make a lot of money, so I must be stupid to keep doing this, right?" Even during lucrative weeks at the bar, most dancers would follow the general practice among workers whose income depends primarily on tips and underreport this amount at work in order to keep more of their income. Although this lower-than-actual reported income might seem to have worked in their favor when applying for benefits, the stigma of their job made many dancers uncomfortable about disclosing their profession, even in cases where it might have benefitted them.

Dancers without children also believed that they would face obstacles if they chose to apply for public assistance. Angel and Cinnamon were both certain that their encounters with law enforcement would render them outside the category of the worthy poor, since criminal convictions can make applicants ineligible for benefits (Baldwin 2004, 301). Angel had previously been arrested for drug possession, and Cinnamon had been charged with prostitution during a police raid on a nude dancing bar she worked in during her early twenties. It is critical to note, however, that these were simply perceptions: I did not meet a single dancer who had actually applied for TANF, food stamps, public housing, or any other social-service programs in the previous year. It was as if dancers were absolutely certain that their working lives on the cusp of legality would automatically raise the suspicions of authorities.

Trading night work for public assistance would also mean sacrificing the lifestyle that accompanied work at Vixens, particularly in terms

of the adulation from (some) male clients and free alcohol. Many danc-
ers, both with children and without, described themselves as "addicted
to the attention" and simply could not imagine themselves returning to
minimum-wage drudgery after the excitement of working in the stim-
ulating environment of the topless bar. This is in many ways part of
dancers' privilege as attractive women to contest a system that might
otherwise spell defeat for some poor women working in jobs with no
possibility of upward mobility or the occasional cash windfall. Despite
the countless regulations, the social stigma, and the potential for abuse
in their work environment, it offered them the ability to hope, at least for
a little while. As we will see next, however, their work was also a subject
of consuming interest by straight-world authorities.

STRAIGHT-WORLD RULES: REGULATING SEX WORK IN AND OUTSIDE VIXENS

The close association that topless dancing has with the exchange of sexual
favors for money underlies many of the community tensions, regulations,
and laws that define what behaviors can take place inside such estab-
lishments. State and local legislation on topless dancing bars significantly
influences even the physical structure at Vixens, from the use of security
cameras to its location on the Sparksburgh outskirts due to zoning laws
that forbid it from being too close to a residential area. Dancers' workplace
positions are complicated by a number of state and local laws concerning
prostitution and obscenity, many of which are extremely ambiguous in
ways that reflect the moral and social ambivalence that popular culture
holds toward sex work in general. Article 230 of the *New York State Penal
Code*, for example, classifies prostitution as a misdemeanor defined as the
exchange of "sexual conduct with another person in return for a fee,"
without elaborating on what such behavior actually entails.[10] Article 235,
on obscenity, is similarly opaque, holding that

> [a]ny material or performance is "obscene" if (a) the average person,
> applying contemporary community standards, would find that consid-
> ered as a whole, its predominant appeal is to the prurient interest in sex

and (b) it depicts or describes in a patently offensive manner, actual or simulated sexual intercourse . . . (c) considered as a whole, it lacks serious literary, artistic, political, and scientific value. Predominant appeal shall be judged with reference to ordinary adults.[11]

But what exactly is "sexual conduct," and who makes up this population of "ordinary adults"? This obliqueness is problematic given that New York State General Business Law defines an "adult establishment" as a commercial venue in which a substantial portion of the facility is dedicated to "sexually-oriented activities that do not cross the line into prostitution or obscenity."[12]

Some critics have likened such laws and regulations to a form of "mind control" that threatens principles enshrined in the First Amendment (Robins and Mason 2003, 518). Most of the obscenity cases that have appeared before the courts have been defended using the premise that the material or actions under interrogation were nothing more than the exercise of constitutional rights. Nonetheless, courts have demonstrated extraordinary ambivalence regarding what constitutes "obscenity"—a concept that is itself indicative of the kind of culturally liminal space that surrounds female sexuality. Laws and regulations on obscenity are unclear at best, because they call upon courts to use what they term the "contemporary community standard" of appropriate sexual practices when evaluating whether a behavior, document, or film is obscene. In his research on the lack of clarity involved in this standard, sociologist Joseph Scott observes that obscenity is the only crime punishable by U.S. law in which the defendant does not know whether he or she actually committed the offense prior to the jury's decision (1991, 29). Scott's administration of over seven thousand telephone interviews on the subject clearly revealed that individuals in the community are generally unable to assess what a contemporary community standard is in regard to sexuality (1991, 44).

Yet this confusion about the boundaries of acceptable sexual behavior rarely tempers the high degree of public and policy concern about the existence of adult establishments. Anthropologist Jacqueline Lewis, for instance, has described the effective removal of women's agency in the

construction of lap dancing as a "social problem" (2000b, 203) that constitutes an explicit threat to public morality. Lewis argues that the court-mandated ban placed on lap dancing in Canada positioned sex workers as vulnerable and "in need of protection" (2000b, 215), thereby reinforcing broader sexist stereotypes of women as weak, defenseless creatures who were helpless in the absence of male safeguards. A great deal of both moral and legal ambiguity thus surrounds such businesses, whose clandestine, taboo appeal lies at least in part in their fringe location.

In her classic text on cultural notions of taboo, purity, and pollution, anthropologist Mary Douglas famously argues that in the Western European cultural template, dirt is "matter out of place" (1966, 36). Douglas believes that one of the primary functions of culture is to create order out of disorder, requiring social systems to rely on a number of strategies to regulate behaviors, ambiguous actions, and beliefs that fall in the substantial gray area between these extreme opposites. These include branding those who engage in such activities as dangerous and in need of avoidance, or assigning them to a particular category so that they become immediately classifiable. The powerful questions and moral debates raised by topless dancing indicate the uneasiness that surrounds the boundaries between the theoretical concepts of licit and illicit sexual exchange.

These lines are rarely obvious in practice, either, and dancers themselves complain that they are often unable to resist customers who during a private dance want to touch their breasts and hips for extra money, which Vixens management does not consider to constitute "sexual conduct" as defined by the state prostitution law. A manager always sits in the main office to monitor activities in the curtained room reserved for private dances on a television screen via security cameras mounted there, because violations of these rules could result in forced closure of their business if a plainclothes police officer witnessed them or, less likely, a male patron complained to the police. For dancers, the lines between "sexual conduct" and dancing very close to a seated man while seminude are even more complicated by clients who offer more money for explicit services that involve more physical contact.

This ambivalence about female sexuality is also evident in sociologist Amy Adler's analysis of two U.S. Supreme Court decisions on whether

nude dancing should be protected by the First Amendment. Adler posits that these cases were marked by "an unacknowledged apprehension of female sexuality as entertaining, trivial, threatening and sick" (2007, 309). More specifically, Adler finds that the Supreme Court decision that nude dancing fell on the "out perimeters of the First Amendment" in itself reveals that a "stripper's speech occupies a liminal space. Condemned to the border between protected expression and unprotected conduct, her body symbolizes the very margins of constitutional 'speech'" (2007, 311). Such marginality at the legislative level also carries the implicit message that sex workers are somehow unworthy of state protection or, at the very least, not worthy of serious attention.

Even more unclear are the ordinances imposed upon such businesses by zoning laws, which in Sparksburgh do not permit sexually oriented businesses to open within five hundred feet of any area classified as "residential" by the city's zoning office. Sparksburgh is divided into thirty zoning districts, each with its own classification into categories of residential, office, local, business, commercial, or industrial, and topless dancing bars are permitted to operate in all but the first category of these. However, as the New York State Office of General Counsel has noted, municipal zoning regulations raise serious constitutional issues when the regulation regards free expression protected by the federal and state constitutions. Before such zoning regulations can be implemented, it must be demonstrated that such businesses have harmful secondary effects—for example, "urban blight, decreased retail shopping activity and reduced property values."[13]

Municipalities in New York State typically choose between two zoning techniques when dealing with adult-oriented businesses, the first of which concentrates such establishments in a single area and the second of which disperses them by using distance requirements. Sparksburgh has chosen the latter, which in theory avoids what has been termed a skid-row effect but which in practice means that topless dancing bars are located either on the industrial outskirts of the city or in dangerous or dilapidated downtown areas abandoned by homeowners and thus outside the residential classification. The alternative practice of developing "tolerance zones"[14] that legally sanction sex work has been little

explored in the United States, although a high degree of de facto toler-
ance for sex work clearly exists in particular areas of almost all U.S. cities.
Often, these areas are of little interest to policymakers because of their
lack of a voting population and other indicators of civic well-being.[15]

The rationale behind such de facto tolerance zones employs a dis-
course of purity and pollution by situating the family and such busi-
nesses as direct opposites on a continuum of morality and danger. This
discourse of danger situated in the bodies of poor women is by no means
historically recent (Walkowitz 1996; 1980), and yet it is notable nonethe-
less because it positions women who work in such establishments as
enemies of the social order. Sociologist Lisa Sanchez describes sex work-
ers as "sexual outlaws" (1998, 543) who are denied full citizenship and
thus occupy a social role that renders them unworthy of state protec-
tion while simultaneously making them invisible and likely targets for
violence. Sex workers are positioned in a social category that by default
defines them as deserving of poor treatment because of their choice (how-
ever coerced it was by poverty and other limiting life circumstances) to
sell sex or its simulation for money. Conflicted and sometimes polarized
feminist positions on the sex industry function to complicate this even
more by presenting a "unitary truth" about women's sexual and lived
experiences (Munro and Della Giusta 2008, 2).[16]

Vixens is located in an industrial section of Sparksburgh immune to
such zoning legislation because it is extremely far from any residential
area. Yet "industrial section" is something of a tenuous misnomer in a
region characterized by the consistency of its factory closures as corpo-
rations continue their search for cheaper labor in the Global South. My
drive home from Vixens each night was fraught with anxiety after lis-
tening to the stories dancers had told me about infatuated clients who
followed them home on the empty highway during the predawn hours.
I found myself constantly checking my rearview mirror, relieved when
the reflection revealed only the shadowy outlines of abandoned furni-
ture factories in the former industrial zone of the city.

Outright and de facto bans enacted via zoning regulations are nearly
as old as topless bars themselves and have been vociferously encouraged
by neighborhood activists, government officials, and small-business

owners. New York State first passed a law in 1977 banning topless danc-
ing in bars licensed by the New York State Liquor Authority, but in
the absence of a definitive state court ruling following a challenge by
a group of upstate New York bar owners, the law was never enforced.
The New York State Supreme Court declared the ban unconstitutional
on June 10, 1980, when it ruled that the law "amounted to censorship of
a constitutionally protected means of expression that the state had failed
to justify."[17] New York State then appealed to the U.S. Supreme Court,
which ruled in 1981 that individual states did in fact have the right to
ban topless dancing in bars under the Twenty-first Amendment to the
Constitution, which repealed Prohibition and declares the right of states
to control the sale and consumption of alcohol within their borders. A
compromise decision that recognized topless dancing as a form of free
expression protected under the First Amendment then forbade nudity in
bars regulated by the New York State Liquor Authority unless dancers
remain out of reach of customers.[18] Once dancers cover their breasts, they
may touch clients.

The New York State Liquor Authority mandates that women must
stay at least six feet away from clients and wear panties or lower-body
coverings because, as spokesperson Richard Chernela noted, "[o]nce
you remove your pants, you create an inherent disorder."[19] As a result,
inspections by local authorities and the New York State Liquor Authority
resulted in the arrest of dancers who allowed clients to place dollar bills
in their thong underwear while dancing topless in many New York State
strip clubs. The dancers' clients, quite notably, were not charged with
any criminal offense.[20] Social ambivalence toward both topless dancing
and its regulation is evident in newspaper coverage of such arrests, with
numerous upstate New York letter writers and commentators contribut-
ing tongue-in-cheek statements for publications, such as "I'm sure the
city is much safer tonight because of this [police action]."[21]

The choice of language employed in such popular discourse indicates
the depth of contradictory sentiments toward sex workers and, more gen-
erally, women. Chernela's association between the nude lower body, spe-
cifically in reference to women, and "inherent disorder" conjures Mary
Douglas's (1966) discussion of how cultures function to order the world

through classification.[22] City topless dancing establishments responded angrily to this increased regulation on their operations, particularly in the form of a 1993 Sparksburgh Common Council ordinance banning new strip clubs from opening within one thousand feet of a school, church, park, or residence. In a similar case in Syracuse, New York, the owner of an alcohol-free nude dancing establishment successfully asserted in court that the city had conspired to keep his club closed by delaying his planned opening date as well as permit and license applications until after the ordinance was passed.[23] Indeed, most arrangements to deal with such establishments are de facto, with consideration beginning solely when community members complain about them.

Regional provisions in upstate New York that sought to force erotic dancing establishments to move to industrial areas or close began initiation by Syracuse Common Council member Rick Guy in 1995 following a U.S. Supreme Court ruling that former New York City mayor Rudolph Giuliani's closure of Times Square adult businesses was constitutional. Yet many upstate New York officials were skeptical about the utility of this plan, including Syracuse Common Council president (and later two-term mayor) Matt Driscoll, who noted, "The city is crumbling down around us, our finances are a disaster, the roads have potholes and this is how the administration is going to spend its resources?"[24]

Yet some community members and small-business owners remained adamant that adult establishments warranted relocation to a specially designated portion of the city, because of the lowered property values and increased crime that they believed accompany such businesses. One convenience-store owner in a central New York town complained, at a public hearing on the subject, that "the kind of people that go to these places [to] feed their lusts on naked women and drink for hours" posed a threat to his wife and children at night.[25] Community officials who believed that it would simply shift the problem to neighboring communities or further concentrate it in a single location dismissed the relocation proposal.[26]

Such debates ignored the root of the problem, which is that few jobs are available throughout the Rust Belt for professionally unskilled women, particularly those with young children to support. Some acknowledgment

of this featured in the "Business 2000" section of one of what was by then Syracuse's only city newspaper, in which women working lucrative unspecialized jobs were profiled. One described the life of a topless dancer, whose section began with the lead-in "Nervous no more, woman sheds top to build a future" and described the struggles of an eighteen-year-old woman to support herself in upstate New York prior to becoming a sex worker. The newspaper noted her refusal of the higher income she could earn at a nude dancing establishment because at a topless dancing bar "she doesn't have to do anything she would be uncomfortable with."[27]

The sense of discomfort referenced here reveals how dancers regulate their own work in ways that often mirror the discourses of pollution framing state and local regulations. Topless dancers often characterize nude dancers as "dirty" and associate such work with prostitution. Clearly, this is just one aspect of the multiple means by which pervasive social inequalities influence individual women and the elaborate ways in which social and institutional regulations and structures intersect with their everyday lives. Such rules indicate the myriad ways in which structural, institutional, and individual forms of regulation function to shape processes of marginalization for dancers.

Men who frequent strip clubs have increasingly become the focus of academic inquiry, ranging from typologies assigned by sociologists David Erickson and Richard Tewksbury (2000) to anthropologist Katherine Frank's (2002) more long-term ethnographic work. Anthropologists R. Danielle Egan and Katherine Frank (2005) have documented that dancers have their own typologies of clients who patronize their establishments, yet Egan and Frank seem to agree, with Erickson and Tewksbury, who point out that "women present in the strip club hold the power to establish and enforce the norms of micro-aspects of their interactions with patrons" (2000, 292). Nearly all scholarship on men who patronize strip clubs hints, albeit in different ways, that such interaction is socially meaningful to the men.

Dancers at Vixens were far from uniform in their views of men who patronized their establishment, ranging from Cinnamon's deep contempt to the sense of professional accomplishment Diamond drew from her successful management of a crowd of clothed male strangers. Star occupied

a midpoint on this continuum and often alternated between pleasures drawn from being an object of desire and disappointment at insults:

> I love being called beautiful. I guess it's because I never felt special before, but here guys tell you that you are the most beautiful woman ever. The problem is that those guys also have the power to take it away, and I've noticed that some guys sort of enjoy building you up just to tear you down. This one guy last week gave me three hundred dollars in a couple of hours, but before he left he smiled this sick smile and said, "What a waste of money on such an ugly bitch." That really hit me, and I tried to tell myself, 'You're the one with his money,' but in reality he's the one who gets what he wants, and I'm left holding that.

Star's account of the big spender who obviously took pleasure in denigrating her before he left demonstrates the prerogative of control clients are able to exercise with dancers who, as Diamond characterized it, "let their guard down." More experienced dancers might insist that Star was responsible for her own victimization because she took pleasure in the compliments he had sadistically provided as a prelude to his biting insult. Such a situation is unfortunately unavoidable in a profession characterized by so many inequalities, and Diamond summarized this by noting, "You have to keep smiling and pretending you're having a great time, but the minute you forget it's just business, you're really in for it."[28]

The risk of experiencing the sort of insulting behavior that Star was the object of was precisely why dancers often preferred to devote their attention to known clients rather than newcomers to Vixens. "You never know what you're going to get with a new guy," Chantelle complained. "Maybe he just got out of prison and is a serial rapist." Despite this discourse of obvious danger, dancers were also wary of dealing with unknown men who had obviously never been to a topless bar before and did not know the rules. More experienced dancers like Cinnamon and Diamond, who regarded their work as a profession, were particularly good at explaining rules about touching and the exchange of money to newcomers, but women who were themselves new at the job often fumbled in this endeavor.

Despite this obvious preference for men they already knew, dancers generally evinced a combination of pity, contempt, and affection for the

men they routinely encountered at work and whom they termed "regulars." Regulars are essential to a dancers' income, because a woman's potential to skillfully request more money increases exponentially with her knowledge of his personal preferences and weaknesses. Diamond was particularly adept at getting some of her regulars to supply her with large sums of cash to help her repay debts, and positioned this as part of a broader gendered discourse of need:

> Guys like to feel needed. Women do, too, but so much of guys' self-esteem is tied up in how much money they make. In here, they can feel ten feet tall for just a few hundred bucks, whereas at home their wife or girlfriend wants a bigger house and a new car, and that's not so easy. So I tell some of my regulars, "Baby, if I could just pay back my debt I could really make something of my life," and they feel like Mr. Man, like they are helping some poor starving urchin move up in the world. It comes with strings attached, but usually I can deal with those.

These "strings," of course, refer to the increased demands that regular clients feel they are entitled to make on a dancer's time and affections once they have given her money throughout the course of several visits. Diamond's willingness to play the part of what she calls "some poor starving urchin" also comes at a price exacted by men who want to intervene in the carefully constructed artifice of need and innocent desperation she has constructed to elicit their money. This usually comes in the form of a regular who proposes that she move in with him, or even marry him, as a path out of the everyday sadness she often put forth as characterizing her life.

"Some guys like to think, 'What's a nice girl like you doing in a place like this?' kind of thing," Diamond explained, "and sometimes those guys are the most dangerous, because they want to rescue you and think they know what's best for you." Diamond's performance of the exploited innocent in desperate need of money from her regulars conflicted with her broader life plan to dance topless as long as possible, and yet it fit so neatly into gendered typologies of male protection and feminine vulnerability that she often employed it with great success. Yet such men had to be carefully managed lest they become too invested in her "plight," and she noted, "It's not me they fall in love with; it's the idea of a girl they can rescue, who will love them forever and always be grateful to them."

This language of male rescue and assumed eternal gratitude on the part of dancers was so common with regulars that even single women invented particularly aggressive, jealous boyfriends who would be livid if they knew of the clandestine "affair" between the dancer and her regular. "I tell them," Diamond said, "'Baby, I would love to be with you forever, but my boyfriend, he's a bodybuilder, and he'd kill us both.' That usually does it for most guys." The threatening specter of masculine violence thus effectively dissipates whatever noble intentions most regulars perceive themselves to have, although there are usually other men who quickly replace them with offers of eternal love.

Anthropologist R. Danielle Egan has explored the frequency with which clients profess love for dancers while drawing "on discourses of love to make sense of and legitimize their relationships with [them]" and to simultaneously distinguish themselves from other men with more-prurient interests (2006a, 132). Egan argues that regulars' expression of love for dancers "is masochistic and designed to fail . . . in a commodified milieu from women who perform a service" (Egan 2006a, 129). Positioning dancers as the actors who hold the ultimate control certainly does not reflect the reality of less-regulated establishments such as Vixens, where women must remain constantly vigilant in order to protect themselves from potentially dangerous clients.

Following this line of thought, another way of envisioning the same behavioral phenomenon is to note that far from being masochistic, such male professions of love are also eminently safe, because in the contained atmosphere of highly caricatured, performed femininity and masculinity that characterizes strip clubs, women are much less able to reject on the same terms as women in the outside world. Star, for instance, was the target of a particularly persistent admirer who came to Vixens every night for a month, his eyes never leaving her. He clearly saw himself as her protector, and although she appreciated his generosity, he was beginning to rather insistently propose that they spend time together outside the bar, which worried her.

Star suspected that certain men had an ability to ascertain her deep desire to get married to an economically stable partner, and accordingly exploited this knowledge to their advantage. "These guys," she began

in assessment of men like her admirer, "there's something creepy about them that just doesn't feel right. It's like in here they can be the big hero because they know that we can't say the same things some girl outside can." Cinnamon attempted to defuse some of Star's worry by noting that women "outside" also were not able to take money from men as freely and openly as dancers could. But Star remained nervous, unconvinced:

> Guys like him want a hell of a lot more than to look at a naked girl, and that's scary sometimes. They say they love you, but what they really mean is that they want to control you, because you're starting out with total dependence on him. I mean, how many other places do you meet men when you got no clothes on? I think these guys know exactly what they are doing, and I think it's sick.

Star's description of sadistic, "sick" men who simply want to take the inequalities inherent in the topless bar home with them complicates the feeling of power many dancers describe as an accompaniment to their work. This in turn raises questions regarding the sexualized politics of male and female behavior, because to hear dancers like Cinnamon tell it, interactions between clients and dancers at Vixens were little more than gendered relationships in the outside world placed under a microscope. Viewed this way, Vixens was a microcosm of structural inequalities in which women were able to exercise a great deal of power and authority only if they did so on terms defined by sexist typologies (Rambo-Ronai and Ellis 1989).

Feminist theorist Luce Irigaray writes of the manifold ways in which women's individual power is prevented from transcending to broader structures, a point of particular relevance in regard to dancers. The authority that women wield at Vixens is severely limited by their socio-economic circumstances—which, of course, is usually the reason they begin to dance topless in the first place. Irigaray contends that the entire Western philosophical template has been structured in such a way as to render women virtually invisible, noting that

> [the object] is ultimately more crucial than the subject, for he can sustain himself only by bouncing back off some objectiveness, some objective. If there is no more "earth" to press down/repress, to work, to represent, but

also and always to desire (for one's own) . . . then what pedestal remains for the existence of the "subject"? (Irigaray 1985, 112)

Despite the short amount of time she had been dancing, Chantelle had a chilling experience as Irigaray's oppressed pedestal through an encounter with a regular who developed what he regarded as a deep attachment to her. This man, who was in his mid-forties, persistently requested her phone number and would not accept her demure insistence that she would lose her job if she saw him outside of working hours. Chantelle swore that she had seen him sitting in a car parked outside her apartment building at night, and discussed with other dancers the terror that had begun to fill her life, prompting some women to commiserate by sharing similar stories of their own. Cinnamon complained that the stigma of their profession prevented the police from taking them seriously, which worried Chantelle even more. "So if I can't call the police, who is going to help me?" she cried. "This guy who thinks we're destined to be together is sitting outside my house at night, maybe with a gun. He could follow me home tonight and kill me and my baby, he could do whatever he wants."

Cinnamon shrugged rather callously in the face of Chantelle's highly emotional description of her situation. "Welcome to the business, honey," Cinnamon sighed. "For every fifty normal ones you get one complete freak." Chantelle disregarded this and spoke to Paul instead, who advised her to wait a few days until the man realized that she was not interested in him. Fortunately, the man eventually gave up and Chantelle never saw him again, but I could not help wondering what would have happened if her stalker had kept up his irrational routine. How could it be that someone like Chantelle was so completely exposed to the constant threat of intimidation and violence? How could her colleagues be so remarkably nonchalant when the threat was so real?

Indeed, some dancers are often a bit blasé concerning the risks they face, and sometimes place an inordinate amount of faith in rather flimsy self-defense mechanisms such as the use of stage names. These are pseudonyms that protect a dancer's identity, and they are a critical part of her simultaneously developing a performance identity. Cinnamon

had used more than a dozen stage names in her decade of erotic dancing experience and finally settled upon the appellation she used at Vixens after gauging client and dancer reactions to what she called herself:

> When I first started out and I didn't know anything, I just picked a normal name because that's easier. Guys don't hassle you so much if you call yourself "Melissa" or something because they won't keep asking, "Come on, what's your real name?" So I used a couple names like that in different clubs, but as I got better at dealing with men and with the other girls, I decided on Cinnamon, because it's something neutral. It's not super sexy, but it's not an ordinary name either, like you wouldn't name your daughter that. It's good to have a neutral name, because then it's not like you think too much of yourself or anything.

Lest she be mistaken for someone who "thinks too much" of herself, Cinnamon chose a name she described as not inspiring any particular emotion. She laughed as she described dancers she had known throughout her career who had chosen names that did not suit them, such as the slightly overweight dancer who called herself "Baby" and was mercilessly taunted by clients with remarks about her "baby fat."

A dancer's choice of a stage name partially determines how clients treat her but also predicts the kind of relationships she will likely have with others in the workplace. Diamond was given her stage name by Paul, who had been remarkably impressed with her beauty and skill as a dancer, and yet her name was the focus of much teasing and derision from other dancers who were jealous of the benefits she was frequently perceived to have accrued. "Diamond in the rough," Angel would often hiss as Diamond strutted past her onto the stage—a snide comment that referred to Diamond's careful self-presentation in a predominantly blue-collar milieu.

The relative anonymity and sense of freedom that accompany the use of a stage name also informed women's performances, quite literally allowing dancers to become someone else for a night of work. Chantelle, for example, shared particularly poignant reasoning behind her choice of stage name:

> My big sister's name was Chantelle, and she was so strong, I always looked up to her for the way she raised me. She passed away when she

was just twenty-five from cervical cancer. I know that some people might think it's just evil to use her name to do something like what I'm doing at work, but to me it's a way of honoring her, that I'm this beautiful strong woman who can do just about anything to support her baby, just like she did for me. When things are tough in here, I think I have her here protecting me, and that helps because I almost feel like I am her. That helps a lot.

Chantelle couched her choice in a heartrending description of protection and lost sisterly love that speaks to the way dancers envision their work in far more complex ways than most of their clients probably imagine. Chantelle, in her construction of a stage self, differed from Cinnamon, who just wanted to avoid trouble while earning as much money as possible, or Diamond, who sought to distinguish herself as the most beautiful and talented dancer—which in turn speaks to the multiple experiences that inform sex workers' lives.

Women also manage their stage identities with constant awareness of their need to preserve the boundaries of emotional and physical intimacy. Dancers explain how they derive a sense of pride and power from a good performance, establish a minimum standard for their earnings each night, and simultaneously must maintain a presence that is both seductive and sufficiently powerful to enforce rules about deflecting unwanted physical attention from men. This is by no means an easy equation to master and often comes at a very high price.

Dancers frequently complain about clients who wrongly presume that they are prostitutes, and these same women frequently insist on distinguishing themselves from other sex workers who have greater degrees of physical contact with clients. Topless dancers are disturbingly consistent in their stigmatization of prostitutes and nude dancers as part of what they view as a completely separate subculture of drug addicts and vectors of disease. This stereotyping by dancers warrants discussion because it so closely, even bizarrely, mirrors the judgmental assessments often made about topless dancers themselves.

Women at Vixens often went out of their way to distinguish themselves from prostitutes. One slow Tuesday night, Star and I were sitting at the bar discussing how many days it had been since she had last seen

the sun. She paused thoughtfully for a moment and looked at me with a very serious expression on her face. "You know," she said sadly, "I really am a good person. I'm not a whore. You believe me, right?" In many ways, her negative associations with selling sex were part of a pattern of broader insistence by dancers that they were different and infinitely superior because of the boundaries they set with clients. This was one of the otherwise extremely limited forms of self-esteem and pride they were able to salvage in a society that often views them as little more than immoral objects in need of regulation. Dancers had an enormous amount of pride and self-esteem invested in what they were not, rather than what they were, and this often led to bitter arguments between women at Vixens regarding appropriate behavior with clients.

Such moral hierarchies are omnipresent in all areas of the sex industry; and sociologist Wendy Chapkis observes that women are not equally victimized by this stigma, because "those whose work most closely resembles non-commercial sexuality generally occupy a place of higher status . . . [and] a similar status distinction may exist between those who turn quick tricks involving less in the way of emotional labor" (1997, 104). Anthropologist Patty Kelly similarly observes that this sort of competition for "good" status is "linked to conceptions of morality, deviance, sexual norms and even the sense of fair play among competing co-workers" (2008, 157). She describes one sex worker explaining her view of herself as an upright, moral woman by saying, "I am a woman of the street, but with dignity, with shame" (2008, 157).

Given such high stakes and weighty principles, it is not surprising that the growth of this industry has done little to combat its stigmatized nature. Yet when sociologists Holly Bell, Lacey Sloan, and Chris Strickling asked topless dancers about whether they felt they faced social stigma in their work, many interviewees noted: "Dancing isn't really a dirty job—prostitution is a dirty job" (1998, 360). This is notable given that not a single individual defined herself as exploited, but instead pointed to other categories of women who, in their view, were oppressed. Instead of believing themselves victimized, topless dancers emphasized the mutually exploitative nature of the relationship, in which "men are exploited by dancers who promise to fulfill their needs

for sex and affirmation but do not, and the dancers are scapegoated and socially stigmatized" (1998, 363).

Thus what may initially appear as competing discourses—one of state surveillance and the other of state marginalization—are not at all discordant. In fact, the two work in tandem because of the reality that sex work needs state regulation precisely because it takes place on the margins. Topless dancing occupies a unique position among different types of sex work as a legally sanctioned but morally condemned labor practice, and this is strongly reflected in the number of debates over zoning and the presumed deleterious impacts that the sex industry has upon communities. Yet in her comprehensive survey of court cases and urban-planning policies related to exotic dancing establishments, anthropologist Judith Hanna found that neither were such businesses in need of regulation, nor did they create harmful secondary effects on the communities in which they were located. She argues that the benign nature of topless and nude dancing bars is largely due to their self-regulating nature:

> In well-run clubs in most jurisdictions, omnipresent security (doormen, floor men, and video monitors) oversees the facility to be in compliance with the law. In addition, performers monitor each other , and managers terminate a dancer who has contact with a patron outside the club. Men who misbehave are asked to leave the club. (Hanna 2005, 128)

Hanna's assessment on the lack of need for regulations due to the smooth internal mechanisms that police behavior in the club is persuasive, and quite likely correct in the "well-run clubs" she describes. The reality, however, is quite different at establishments such as Vixens, with its less formalized division of roles due to its occupation on the lower strata of the topless-bar indexes of quality.

For instance, Vixens did not have bouncers or any other form of security, and on most nights it fell to the dancers to defend their boundaries when clients became particularly aggressive. Paul would generally intervene in instances when a dancer's physical safety was at risk or a law was clearly being violated, but this intervention took place rarely. Women often resented the idea that they needed protection from anyone and in fact believed that the self-protection mechanisms they developed

on the job through experience and advice from other dancers was far superior to anything offered by legislation or Vixens' policy. This is fairly characteristic of sex workers, who often describe the wide array of self-protection mechanisms necessitated by their profession. Sociologists Kim Davies and Lorraine Evans (2007) find that sex workers engage in gendered behavior by employing the gendered stereotypes that characterize them either as extremely weak or as tough women of the street. Many sex workers find themselves reinterpreting these negative beliefs as tools of resistance and strength. Davies and Evans characterize this process as emotional labor that emphasizes a woman's control of the situation and her ability to assess the likelihood of violence (2007, 538).

The reality that Vixens dancers had only themselves to rely upon was painfully underscored for Chantelle one night when she unknowingly violated the law against exposing her breasts in close proximity to a client and was nearly terminated by Paul for her mistake. Chantelle had not been at fault for the exposure, and even Paul later acknowledged that the problem had not been Chantelle's behavior, but the rather strange New York State Alcoholic Beverage Control Law, which forbids businesses with a liquor license to feature nude performers. The sole exception this law permits is for topless female dancers, who are allowed to expose their breasts below the areola only if they are performing on an elevated platform stage a minimum of eighteen inches above floor level and removed at least six feet from the nearest patron. In practice, this law means that New York State dancers may bare their breasts while dancing onstage, but must cover their breasts with a cloth or other item in order to accept tips from clients.[29] Tips form all of dancers' income at Vixens, and dancers often complained that new clients, especially those who had not visited a topless bar before and were thus unaware of this rule, would withdraw their money as soon as a dancer covered her breasts.

Chantelle's transgression took place on a busy Friday night when Vixens was particularly crowded. Although there were still recalcitrant piles of snow in the far corners of parking lots, men were ready to start going out at night before the bad weather began that winter. A group of about two dozen young men who had arrived half drunk from a bachelor

party were standing near the stage shouting loudly at Chantelle, who had removed the top half of her negligee to reveal her naked breasts underneath. She left the bottom half on, convinced that her third month of pregnancy was beginning to show.

One of the young men beckoned Chantelle toward him, waving a dollar bill in the air. She walked toward him as she carefully pulled the straps of her negligee over her shoulders to cover her chest so as not to violate the law. This proved quite difficult on her six-inch heels, and she struggled to move forward toward the waving dollar bill as quickly as she could. Chantelle began to lean forward toward the man's hand and he rapidly shook his head, retracting his dollar from her reach, much to the amusement of his friends. He refused to pay until he could see Chantelle's breasts up close, and so she bent forward, allowing him to briefly caress her.

Chantelle was in tears within the hour in Paul's office. "What am I supposed to do?" she cried angrily. "When you don't explain the rules to the guys who come in, how am I supposed to, when I am the one standing there naked?" Paul softened his tone with her to explain that she needed to be firm. "Just don't do it, then," he replied rather unhelpfully. Chantelle started to sob, effectively ending Paul's rebuke out of sympathy for her situation but by no means clarifying how dancers who are in positions of both limited power and often desperate poverty are supposed to enforce rules that most male clients are unaware even exist.

Despite the discourses of protection from male management and the legal restrictions placed on their behavior, many dancers were very clear that such regulations did little more than categorize them as prostitutes in need of external control. Most dancers envisioned their work environment as what sociologists Matthew DeMichelle and Richard Tewksbury have described as "the gendered hierarchy involved in the strip club, with men acting as the rule makers and enforcers over the female employees" (2004, 545). Yet these binaries of protected/unprotected and surveilled/ignored find themselves less defined in practice than in theory, sometimes even for the same woman in the space of a single night. Often this took the form of elaborate hierarchies established among dancers that eerily mirrored broader cultural typologies of sex work as dirty.

Dancers at Vixens actively sought to position themselves near the top of a discursively constructed continuum that assigned sex workers higher status based on how little physical contact they had with their clients. Cinnamon, for example, frequently used the word *classy* to describe dancers who did not engage in more provocative undulating onstage and refused to meet clients outside of the workplace. She frequently did so in reference to dancers she perceived to be in violation of appropriate behavioral norms at Vixens, as in "This place is too classy for someone like Angel." This kind of moral competition rendered worker solidarity almost impossible and made it painfully clear that although dancers often live a clandestine existence, they also operate under the same sexist norms that are pervasive in the world outside the bar's doors.

Such discursive hierarchies came into clear focus when management brought women known as "features" into the club to dance for a period ranging from one night to one week. These were women who had featured (hence their descriptive title) in pornographic films and were believed by management to bring in additional business. Such women often looked very much like the other dancers at Vixens, yet their performances were advertised in the newspaper and on the placard outside the bar with tantalizing phrases such as "One night only!" and "Live, in the flesh!"

This notoriety did little to place such women in high esteem with most Vixens dancers, who viewed features as tainted and dirty because of their appearance in pornographic films. Features were typically paid a set fee for a night's work, which was a serious point of contention among dancers who had to work exclusively for tips. An even more significant source of resentment stemmed from women's perceptions that the presence of features in the bar led male clients to expect more explicitly sexual services from them following the features' departure. It also bears mentioning that features who visited Vixens were often highly critical of what they perceived as inferior working conditions, unattractive dancers, and relatively low-income clientele, which further alienated dancers.

A woman who called herself Jasmine was one such feature who performed at Vixens on a Saturday night as part of an effort to counteract a serious slump in business. Although she was a skilled dancer, most of

the women at Vixens refused to speak to her. Jasmine was an extraordinarily beautiful woman who styled herself upon a vampy Bettie Page, with long black hair, large breast implants, and heavy makeup. She had obviously spent a great deal of money, energy, and time on her appearance, and she clearly felt herself superior to the bar she found herself in that evening, which she disparagingly (and rather loudly) referred to as "this dump" several times while backstage with other dancers.

Cinnamon and I watched from backstage as she performed a provocative dance in which she wound her legs around the pole and then held herself upside down for several minutes with her barely clad vulva pressed against it. Her inner thighs gripped the pole as she took dollar bills between her breasts from clients' mouths. The maneuver looked painful, and Jasmine's legs were starting to shake involuntarily after a few moments due to the pressure this position placed upon them. While Jasmine exhibited this gymnastic feat, other dancers were extremely snide in their comments. "I don't want to touch that pole now, God knows what [diseases] I'll get," Cinnamon moaned as Jasmine passed her in the dressing room.

All of the dancers effectively shunned Jasmine that night, which in turn made her presence almost impossible to ignore. Dancers passed snide remarks in her direction all night about drug abuse, including sarcastic speculation about how much cocaine she would buy with the set fee Vixens' management paid her. "Everybody knows features are coke fiends," Star explained to me. "Why else would they do that? It's just prostitution, that's all." While Star may be overgeneralizing, researchers have drawn at least some connections between prostitution and substance abuse. Sociologists Cecilie Hoigard and Liv Finstad (1992) have demonstrated a disturbing correlation between drug prices and the amount street prostitutes charge for sexual services on the street. The authors contend that this "reflects a reciprocal value relation in an illegal economy that is in turn decided by other factors like the supply of women, the supply of drugs, and the country's general price level" (1992, 43).

Certainly most dancers at Vixens were not addicted to drugs, although many did experiment with what they considered low-risk substances such as marijuana, LSD, and ecstasy. Angel, of course, was the exception

to this with her numerous life crises and the erratic, sometimes volatile behavior induced by her drug use, which she often described as necessary to cope with the stress of her job. Such self-medication speaks to the difficulties inherent in maintaining boundaries between prostitution and topless dancing that dancers find to be critical despite popular views that the two are not so different. Jasmine's performance proved to be just such an occasion for self-medication, since very few dancers had earned any money that night. Cinnamon turned to me at the end of the night, flashing the paltry forty dollars she had received in tips, and wryly remarked with a smile, "Well, nothing left to do now but start drinking."

FOUR Being a Good Mother
in a "Bad" Profession

CINNAMON AND STAR: "OUR KIDS COME FIRST"

CINNAMON: What I most want people to know about us is that we work
for a living, to take care of our kids, just like everybody else.
We work.

STAR: We're not welfare queens.

CINNAMON: No, definitely not. People think we're just a bunch of prosti-
tutes, but who are the real prostitutes? Us, or those women
who sit in the projects all day and get food stamps and money
for nothing?

STAR: Or how about those women whose husbands earn all the
money, and then they just sit at home doing nothing?

CINNAMON: With us, our kids come first.

86

STAR: Always, our kids always come first. That's how we met! We both were complaining about how hard it is to find babysitters and how much you have to pay to find somebody trustworthy who is willing to come at night, and then we just decided to move in together. It was a good decision, now we don't have to worry so much anymore.

CINNAMON: So now when one of us works, the other stays home with the kids, like in a real family. Star does all the cooking, and I clean because I hate cooking. We make sure everything is fair, that it's all evenly divided, so in some ways it's a lot, lot better than living with a husband who expects you to do everything.

STAR: We understand each other and respect each other, you know? That's something that's not easy to find in this world. We write down everything we spend and make sure to split everything. Both of us have lived with so many irresponsible jerks that it's really important to us to make sure we know which way the money's coming and going. It's not easy to find someone like her, someone to trust.

CINNAMON: Especially not in this line of work. I got so sick of explaining to babysitters what I did at night, as if it was their business. Now we have each other so we don't have to worry about that kind of crap anymore, don't have to lie and make up stories just to find someone normal to watch our kids at night.

STAR: That's right. If she was a man, I'd marry her in a minute.

POVERTY AND THE MORAL WEIGHT OF MONEY

Cinnamon and Star are hardly unique in their struggles to locate responsible child care while simultaneously asserting a sense of dignity and self-respect as mothers who were the sole source of economic support for their children. Their everyday efforts at finding solutions to these life problems speak volumes about how work in a stigmatized profession culturally constructed as incompatible with motherhood only compounds these issues. Both women devoted considerable amounts of time to thinking about their children's futures and careful budgeting of

their widely fluctuating and unpredictable income, with the tense, ever-present knowledge that they had no one else to rely upon for support.

Both women could each count on earning between $150 and $200 on the nights that they worked, bringing their combined weekly income to between approximately $1,050 and $1,400, which equals a rather high median annual family income of about $70,000. They often spoke with pride, as did many other dancers, about how this sum far exceeded anything they could earn in another profession, and only rarely mentioned this as an ideal sum that presupposed a number of factors that were actually highly variable. The income supposedly earned by Cinnamon and Star initially seems equivalent to that of some college-educated professionals, and yet the reality is that they never earned that much.[1] This was due to the frequency of slow nights, when dancers sometimes earned nothing at all, and the need for one of them to be at home to watch their three children while the other worked. Management also scheduled dancers according to whims and personal preferences, meaning that if Paul was angry with a particular woman he might not schedule her to work all week.

Dancers collect their earnings in tips from clients, and, following general practice among restaurant wait staff and others who work for tips, most of this income is undeclared as taxable. Cinnamon and Star did not know how much they actually earned in a year, but the fact that their joint bank account was routinely overdrawn and that they spent most of the cash they received from clients on basic daily necessities such as groceries and gas for their shared secondhand car underscores how close to the brink of poverty they lived. Nonetheless, both women firmly believed that they were a self-sufficient unit and that, as Cinnamon often phrased it, they "don't need anybody."

Cinnamon and Star were also routinely depleted of funds due to a lack of health insurance, which necessitated visits to the emergency room whenever a member of their family of five was sick, due to their lack of a primary-care physician. Their patent refusal to accept any form of public assistance worked much to their detriment in this regard. When Cinnamon's adolescent daughter needed an emergency tonsillectomy, for example, the cost nearly equaled their combined total income in an

ideal year of work. The hospital agreed to reduce the debt and offered a system of monthly payments when it became clear that Cinnamon could never afford to pay such a huge sum of money, but the fear that someone would get sick and need costly medical treatment loomed large in both mothers' minds.

The combination of fluctuating earnings, lack of assets, and no health insurance left their family of five extremely vulnerable despite a seemingly high combined total income, and the women found themselves teetering on the brink of destitution at all times. As economists Michael Barr and Rebecca Blank (2009) note, such depletion is typical of unskilled workers, who are not insulated by the same kinds of savings plans, insurance benefits, or opportunities for low-cost borrowing as their more affluent peers. Cinnamon and Star also found themselves spending a fair amount of money on cosmetics, lingerie, and shoes to wear at work—the latter of which could cost nearly two hundred dollars if the dancer chose a long-lasting pair that would allow her to safely maneuver her way across the stage.

Nonetheless, the child-care and living arrangements arrived at by Cinnamon and Star worked out exceedingly well during the time that I knew them, and despite the occasional domestic argument about their children, the two women organized household labor, work at Vixens, and joint child care with great efficiency. Yet despite this facade of harmony, Star often made it clear in subtle ways that the arrangement was very much a de facto one that was actually far from ideal, and in this she differed profoundly from Cinnamon, who genuinely believed that she could trust her friend far more than she could trust a man.

The language both women employ in their narrative reveals much about how both believe that the nuclear family is the only "correct" form of kinship, thus positioning Cinnamon and Star firmly outside the secure walls of heteronormativity. In her work on U.S. cultural constructions of what she terms "single mothers," cultural-studies theorist Jane Juffer argues that the tenuous social acceptance of mothers who are the sole economic and emotional providers for their children eerily echoes right-wing discourses of personal responsibility and a horror of dependency (2006, 211). Juffer notes that although the option to parent without a male

partner is now increasingly available to women, this exists alongside "the impossibility of true choice in a society that still assumes a father is central to defining a family" (2006, 229).

Cinnamon and Star subscribed to this sort of discourse in numerous ways and often used justifications characteristic of their profession to defend their self-perceptions as good mothers and responsible citizens. In doing so, they employed a complex set of notions involving unspoken assumptions about gender and social class to position themselves as, to paraphrase Cinnamon, "good women in a bad profession." Accordingly, this chapter discusses the strategies that women like Cinnamon and Star employ in negotiating their roles as mothers, partners, and responsible women in a profession culturally constructed as the antithesis of all three of these roles.

Dancers confront manifestations of powerful social contradictions every day and thus develop a philosophy that assesses money's moral weight and in turn informs nearly every aspect of their relationships with children, peers, coworkers, clients, and partners. A corollary to this moral economy is a tenuous pseudointimacy that can have devastating consequences in their personal lives and relationships yet helps women at Vixens to navigate a complex and ill-lit world in which real motivations are seldom clear.

Sex work is both a learned process and a set of circumstances involving a performed identity that dramatically affects all other aspects of life. Dancers with children beyond the toddler years were particularly aware of the weighty stigma that their profession carried with it. Such women often expressed a conflicted sense of motherly responsibilities and desire for public respect that had profound consequences for their relationships with their families, children, clients, and themselves. Dancers like Cinnamon and Star struggle to balance the demands of family, work, and the internal pressure they feel to meet certain standards of mothering that, all too often, they hope will compensate for the difficulties imposed on loved ones who want to live what dancers usually describe as "a straight life."

Cinnamon and Star begin their narrative by employing a typology of citizenship that contrasts their labor with what they consider the dishonest income of prostitutes and "welfare queens." This sort of negotiation

of stigma painfully illustrates how many topless dancers try (whether consciously or not) to fit into a normative typology of workers struggling to support their families. Their inevitable failure to fit into such typologies often directly informed money management among dancers, including in the relatively stable living arrangements shared by Cinnamon and Star. "We work," Cinnamon asserts early in her narrative—a sentiment that workers in any other profession may not have felt the need to express so strongly.

Many workers at Vixens describe their earnings as "dirty" and thus easily spent, accordingly situating their income within a framework that at first blush seems to contradict the desire expressed by many to save money and eventually quit sex work entirely. This framework is best understood as a "moral economy" because of the intricate ways in which it places differential values on income earned in specific labor contexts. This, in turn, is part of infinitely larger socioeconomic processes that combine to devalue women's work by positioning it in multiple spheres of life as less prestigious, less lucrative, less permanent, and less worthy of serious attention.

Yet further examination reveals that popular understandings of stigmatized work directly inform how this moral economy functions.[2] Angel expressed this underlying logic particularly well when she explained her rationale in spending nearly all of her income on drugs and alcohol, often within less than twenty-four hours of earning it. "I make a lot and I blow it all right away," she said, "because that's the way I feel good about myself. That's my reward, after putting up with all this shit every night."

Angel effectively categorizes her income, thus contextualized within the moral logic of the "reward" rather than a salary, as paradoxically worthless because although she works very hard ("putting up with all this shit"), her labor remains unrecognized as real work. It follows, then, that her income is not distinguished as money earned for performing a genuinely useful task. This phenomenon is compounded by the fluctuating nature of sex-industry earnings, which means that although someone like Angel may earn seven hundred dollars on a particularly lucrative night, she might also take home less than fifty dollars the next day. It is extremely difficult to make financial plans or accumulate savings when

income is so insecure and unreliable, and thus many dancers give up trying entirely.

This sort of life philosophy was first explored by anthropology in Oscar Lewis's much-maligned theory, which postulates that poverty is a self-perpetuating cycle learned through socialization.[3] Lewis famously argues that what he terms "the culture of poverty" is characterized by little happiness in families or relationships because of the limited space available for emotions not directly tied to survival. He describes people weighed down by persistent debt, irregular work, and social exclusion by the more powerful, and for whom life is occupied by persistent fears about meeting basic needs and substance abuse. In the culture of poverty, which Lewis documents in sites as diverse as rural Mexico and blighted London neighborhoods, each bad event is just "one more traumatic experience in a lifetime of trauma" (1975, 45).

This vicious cycle is evident in sex work as well, with short-term benefits very low relative to the long-term costs.[4] Thus, the unpredictable and variable nature of income generation in the sex industry is especially conducive to a moral economy that makes sense of money in complex ways that mirror normative frameworks employed by workers in other stigmatized professions. Sociologist Patricia Adler has argued that some individuals relegated to the social margins because of their illegal or semilegal activities reject delayed gratification and saving in favor of lavish spending precisely because their life choices have made them "abandon the dictates of propriety and the workaday world" (1993, 83). This moral economy situates income earned through socially stigmatized or illegal work as outside the boundaries of society's normative constraints and thus unrestrained from the accompanying logic that prioritizes saving for, or even thinking about, the future (Day, Papataxiarchis, and Stewart 1998). It does bear mentioning, however, that many dancers do not imagine a future in which their present life conditions replicate themselves. This is a sobering reminder of how "thinking about the future" or, indeed, planning for it is in many ways a luxury of those who have the privilege of charting their own life course.

Sociologists Cecilie Hoigard and Liv Finstad have found that sex workers often live beyond their means, even extravagantly, because such

expenditure is directly in keeping with the philosophy of their profession, in which "the central aspects of life unfold under money's power" (1992, 50). The authors contend that this way of thinking about money as a means to demonstrate one's authority (if only temporarily) is related to the lack of positive social roles ascribed to sex workers. Money and consumerism become weapons with which such women can combat stigma, even from their location outside the boundaries of social acceptability. However, dancers are by no means alone in their belief that even if their work marks them as tainted, the fact that cash is readily available to them can garner them some respect as anonymous consumers.

Money clearly possesses a powerful, mystical, magical force that operates in different ways that have been discussed at length in the literature on the anthropology of consumption.[5] Individuals clearly take some pleasure in their newfound ability to engage in forms of economic exchange previously unavailable to them, and in the process new expectations for material comfort become normalized. For sex workers, this can occur in ways that make it nearly impossible for them to leave their jobs because other forms of low-wage work would not allow them to maintain such a lifestyle. Dancers at Vixens often lamented this tendency, although often doing so while engaging in binge spending that left them even more depleted and desperate for additional income.

Anthropologist Philippe Bourgois documented similar excessive spending among crack dealers in East Harlem, making the critical connection between the cultural practices of marginalized communities and those of the more privileged. In discussing why most crack dealers remain perpetually on the verge of destitution, Bourgois observes that their tendency to overspend is

> ultimately no different from the more individualistic . . . conspicuous consumption that rapidly upwardly mobile persons in the legal economy usually engage in. The tendency to overspend windfalls conspicuously is universal in an economy that fetishizes material goods and services. Crack dealers are merely a caricaturally visible version of this otherwise very North American phenomenon of rapidly overconsuming easily earned money. Their limited options for spending money constructively in the legal economy exacerbate their profligacy. (Bourgois 1995, 91)

Indeed, Americans love to spend money. The levels of average credit-card overuse have now reached a critical point throughout the United States, with revolving debt equaling $900 billion—an amount that has increased at a rate of 9 percent annually throughout the past decade (Scott 2007, 567). Recent decades have exacerbated this crisis in poorer households where individuals and their families have less disposable income, making revolving debt a particularly significant issue. From 1983 to 1995, the percentage of low-income households with revolving credit-card debt more than twice their monthly earnings increased from one in thirty to a startling one in eight (Bird, Hagstrom, and Wild 1999, 126).

Many formerly cash-only businesses began to capitalize on this trend, such as McDonald's did in 2004 when it rapidly became the second-largest site (by volume) of credit-card transactions in the United States. Focus-group studies indicate that customers spend 47 percent more when using credit cards than cash, indicating that overspending is by no means limited to those who live on the margins, but is rather part of a particularly American propensity to live well beyond one's means.[6]

If money becomes a way of demonstrating control and authority, however, it can also be a powerful means by which to show love. Some of the most heartrending examples of the difficulties inherent in balancing sex work and family life at Vixens involved precisely this use of money as a means to compensate loved ones for dancers' self-perceived "failure" to live up to the standards of feminine propriety inherent in the roles of mother and partner. Yet dancers were certainly not the only ones affected by the moral weight of money exchanged at Vixens.

Manager Paul often spent extravagantly as a way to alleviate the unrelenting tension he felt regarding child-support payments to his two ex-wives, both of whom were now living with new men called "Daddy" by Paul's biological children. Paul's self-medication through lavish spending often left him with little money at the end of the month, but like any addict he was in a state of near-euphoria bordering on emotional collapse when on a binge, which typically included several nights at an expensive hotel and visits to the nearby casino to gamble.

Paul's relationships with the women in his life had reached a low one night when he decided to take a week off work and empty his bank

account by booking a Jacuzzi suite in one of the nicer hotels near Sparks-burgh. I happened to meet him in his office just as he was preparing to leave, and his face registered a strange combination of exhaustion and extreme anxiety as he told me about his plans. "I've got a Jacuzzi," he noted, smiling weakly. "Want to come over and sit in my Jacuzzi?" As I shook my head, I almost felt a little sorry for him, just as I sometimes did for others Vixens workers, whose lives I saw alternately twisted and empowered by the strange magic of money earned through sex work.

"Susie, don't you want to come over and sit with the strip-club man-ager in his Jacuzzi?" Paul intoned, his voice cracking a little as he put his head in his hands, a few papers with curled edges sliding to the floor near his feet. He sounded as if he were about to cry. "Come on," he said through a forced smile, "you know how this works. I'm just doing my blue-collar hustle." Paul had borrowed this last phrase from Diamond, who used it to describe the various ways she generated income in what she believed to be a hostile and uncaring world. Her earning strategies were legal but, as we will see later, inspired by her need to devise short-term solutions, most of which involved the quick generation of large sums of cash in questionable and often dangerous situations, to endure difficult lifelong circumstances. Diamond's "blue-collar hustle" was thus shorthand for a worldview that prioritized survival with dignity in a situation that otherwise functioned to diminish faith in basic human goodness and justice.

"You don't mind my dirty money do you, Baby?" Paul asked when he realized I was not going to join him. I started to laugh, if only to defuse some of the tension in the room, before I realized that he was serious. Paul buried his head in his hands before I could respond, shak-ing silently for a moment before he gathered his things and flashed me a wicked grin. "Lots of other ladies out there, honey," he said on his way on the door. "I just asked because you were first in line tonight." I left as I saw his watery eyes drifting toward the snapshots of his young daugh-ters tacked to the wall.

As with Paul's, such attempts constituted shaky efforts that some-times laid bare the sadness of the circumstances that underlay them, and this was often brought to the fore in the life shared by Cinnamon, Star,

and their three children. Star lived an extremely frugal existence with Cinnamon, in which both women struggled to save money for their children's college educations while managing a household of five people without any outside assistance. Star used birthdays and holidays as a distinct exception to the tight budgeting that Cinnamon encouraged her to employ, and on those occasions she would often empty her entire bank account to purchase lavish gifts of clothing and toys for her two-year-old and four-year-old sons. "This is the only way I can show them that they can be somebody," she gravely intoned one night as we looked at the mountains of shopping bags she had accrued in anticipation of Easter. "Otherwise, what do they have?"

Star's direct association between material possessions and the social mobility she hoped her young children would achieve speaks volumes to both the ideals of American consumerism and the performance of classed identity. This clearly reveals how structural constraints combine with individual circumstances to shape dancers' lives in powerful ways. Star echoed many Americans in believing that personal success manifests itself through wealth, and her efforts to provide her children with the best material possessions were not at all unlike those of her peers who work outside the sex industry. Nonetheless, the logic that she employed in spending large sums of money on items that were definitely beyond her financial means reveals the conflicted sense of empowerment and entrapment that accompanies such income.

Most of the dancers at Vixens earned much more than their parents or other caretakers had when they were young girls still dependent and living at home, even if the equivalent of their income, if measured evenly over a year of fluctuations, would most likely be found in a secretarial job with health-insurance benefits. Many women felt that they were rich when they earned several hundred dollars in a night, and this definitely informed the way they spent money. However, such income also came with what many women regarded as a heavy moral weight attached to it that all too often prompted them to get rid of it as soon as possible.

"It's like with waitresses," Chantelle explained late one night as she sat counting the small-denomination bills she had collected from men during her shift. "You feel like you have a lot because you're getting paid

in cash instead of a paycheck. It's easier to spend cash because it's right there in your purse, easier than taking it to the bank." The pile of dollars she held in her hands did indeed look like a great deal of money, yet the small denominations amounted to less than three hundred dollars. I asked her what she planned to do with it. "I'm going baby shopping," she smiled, rubbing her still-flat stomach. "It's all for you, Baby. Baby won't care where this money came from, will you?" It took me a minute before I realized that she had begun to talk directly to her abdomen, as if in dialogue with her developing child.

Chantelle had already collected an impressive array of baby paraphernalia that filled her small apartment, making it look more like a boutique than a home. I visited her at home when she was about two months into her pregnancy and was stunned at the amount she had already collected for the baby, whose presence had not even yet visibly registered upon her body. That evening at home, she was wearing a loose pink dress that touched the floor and had no makeup on when she opened the door, and I almost did not recognize her as the same woman I was accustomed to seeing in a sequined thong and six-inch heels. Every corner of her apartment was filled with all the accoutrements of privileged infancy: a crib, a small dresser, a changing table, boxes upon boxes of educational toys, and small blankets stacked neatly in piles of alternating blue and pink.

Chantelle gestured to the blankets: "I bought two of everything, because it's too early to know if it's a boy or a girl, right?" I nodded slowly, a hollow feeling slowly expanding inside me as I realized that she must have spent nearly everything she had earned so far in the month that she had worked at Vixens. "Do you like 'Nevaeh'?" she asked, bursting forth in a torrent of words. "I'm thinking 'Nevaeh' for a girl, it's heaven spelled backwards. Boy names are harder, so I'm not so sure about what to call a boy." Chantelle went through her inventory of everything that she had bought and the list of items she still needed but did not yet have money to purchase.

None of the dancers at Vixens received any form of health insurance, which meant that Chantelle had paid cash for every visit to the doctor she had made so far. Unless she quit dancing and chose public assistance to help her cover the enormous health-care costs that would ensue as

her pregnancy progressed, she would likely face a completely untenable financial situation. "You know," Chantelle said as she started to shake out and then refold the meticulously placed blankets like a stay-at-home mother trying to keep busy during a child's nap time, "my mother could never afford any of this stuff for us kids. I want my baby to have a good life, not to come into the world and just see nothing but being poor." As I listened more closely, Chantelle's overspending suddenly seemed less like irresponsibility and instead resembled the actions of someone trying to assert control in a life situation that held little security or promise for a stable future.

The structural realities of Chantelle's life situation were far from ideal. She could barely manage to support herself in a depressed economy as an unskilled worker with a tenth-grade education. Of the three men who could have been her baby's biological father, she felt that none were likely candidates for social fatherhood, and it had been years since she had spoken to her family. Chantelle was definitely alone in the world, but there in the space of the neatly folded blankets she seemed secure and happy, as if at any moment an entire loving family might burst through the door to complete the domestic scene she had effectively purchased. "I can't help it," she smiled. "I've never had so much money in my life, and I just love the baby so much that I want it to have everything I never did."

Yet the money Chantelle earned at Vixens held a moral weight for her that necessitated its diversion into commodities for the baby's use, thus making the stigma and difficulties of her job what she termed "worth it" in the end. She had already begun overcompensating her baby, the only family she had, with material objects as a result of her inability to measure up to feminine ideals she felt were important, as part of a pattern that we will later see to be quite common among women at Vixens.

The moral weight of money earned by people like Chantelle, who have otherwise spent most of their lives in relative poverty before finding work in a stigmatized occupation, is increased by the belief that theirs is a temporal profession. Star often justified both her lack of health insurance and her refusal to accept public assistance by noting that she would find another job eventually that would offer comparable benefits.

Cinnamon, who had spent most of her life as a sex worker, believed that paying cash or making monthly installments in the event of an especially draining emergency-room visit such as her daughter's tonsillectomy was preferable to the expensive private insurance that was otherwise her only option.

Cinnamon drew upon her own childhood and adolescence in poverty in making her assessment of living without insurance as a calculated risk. In her view, an occasional visit to the emergency room, although very expensive, was far less draining than a monthly bill from a private insurance company. "It's like throwing money away, insurance," she explained. "I'd rather just pay for what we actually use." Notably, this "actual use" often amounted to medical bills that pushed them close to the edge of destitution, as it did following her daughter's medical emergency. Cinnamon's assumption about the limited likelihood of serious illness striking her family thus effectively meant that they would be left indebted and impoverished in the event that someone fell ill. This stood in sharp contrast to the careful budgeting that she otherwise engaged in, and highlights how people with unreliable income and no health insurance are in many ways forced to evaluate the risks facing their families in ways that reflect their lack of stability.

MOTHERING ON THE NIGHT SHIFT

The emotional risks incurred in sex work often destabilize dancers' discourse of moral uprightness in ways that some dancers describe as potentially devastating. This discourse is especially significant for women at Vixens as they negotiate the risk of rejection by their loved ones due to the structural and individual stigmatization of even legal sex work—sustaining as it does a self-image of dancers as workers. Cinnamon, for example, had grown increasingly concerned with her fourteen-year-old daughter Melanie's propensity to wear provocative clothing and spend excessive amounts of time with older boys.[7] Cinnamon clearly felt that her daughter was at risk of becoming a sex worker, something she did not want to happen, and yet she believed that she could not do another

kind of work herself despite what she perceived as its obviously nega-
tive influence on her daughter.

Star and I sat in tense silence during a particularly ugly fight between
Cinnamon and Melanie in which many of these issues came to the fore
with great violence. "I started doing this kind of work so you could eat!"
Cinnamon had shouted at her daughter, who had just announced that
she could wear whatever she wanted out of the house, just as her mother
did at work. Her daughter had simply rolled her eyes in response to
Cinnamon's powerful statement, and this dismissive gesture hurt Cinna-
mon deeply. "How else could I take care of you when I didn't even finish
high school?" Cinnamon asked her. "How?" Cinnamon was on the verge
of tears as her daughter stormed angrily out of the apartment without a
word. She clearly felt that she had lost another one of a series of increas-
ingly heated battles in which her daughter manipulatively assumed a
higher moral authority. She had been careful to raise her daughter with
a sense of economic security as much as she was able, yet in doing so
Cinnamon still operated within a cultural model of risk that had danger
and deprivation as the frames through which she made nearly all of her
decisions. In many ways, this was one of the pitfalls of her profession.

At an individual emotional level, this cultural model of risk func-
tioned for Cinnamon as an accumulated weight, so that Cinnamon's
oft-repeated refrain of "I'm so, so tired" took on a tone that spoke to a
life pattern, but also sounded more desperate each time it was uttered.
It is perhaps not surprising that Vixens' management—like Paul, who
seemed inordinately invested in what he and others like him often termed
"security" and "protection"—also employed the gendered typologies of
"good" and "bad" that Melanie used against her mother. The effects of
such pervasive typologies could sometimes be debilitating.

The totalizing impacts of sex work on everyday life became emphati-
cally clear on the day Star celebrated her son's fourth birthday with a
party she had planned three weeks in advance. Surrounded by presents,
her little boy was just about to blow out the candles on his enormous
cake when she started to shake and whimper. "Are you OK?" I whis-
pered over the sounds of her son's friends clapping and clamoring to
play with his new toys. Star shook her head rapidly and squeezed my

hand, asking to go outside. "I don't want to ruin his whole day," she whispered, her voice cracking in my ear.

By the time we got downstairs Star was hyperventilating and simultaneously struggling to light a cigarette between sobs. I started to cry, too, because the situation was just too much to bear: here was a woman who struggled so much to give her son everything that she believed he was supposed to have, and yet she still felt that she was failing as a mother. "I bought those things," she wheezed between choking sobs, "with money guys shoved in my thong, and I don't even know their names. Their dirty money bought my son his birthday presents, bought him his nice clothes for school." I held her close to me in the car as we both cried, oblivious to strangers passing on the sidewalk and giving us strange looks. After a few minutes, Star pinched her cheek hard and said, "I've got to pull myself together, it's my son's birthday."

We went back upstairs, and no one seemed to have noticed that we had left. Children were still shouting and playing, and Cinnamon was absent-mindedly eating a piece of cake as she watched them. Star's strategies for improving her son's life, making sure he had everything his more privileged counterparts did, were in some ways symptomatic of overcompensation for a job that made her feel deeply ashamed. She had spent nearly a month's income on gifts and arrangements for the party although she could ill afford it, and Cinnamon was obviously isolating herself that day because she thought her friend was spending irresponsibly.

Despite Cinnamon's concern, Star was not alone in her assumption that her son would be better treated if he displayed markers of affluence at school. In her research on the role of children's appearances in their mother's impression management, sociologist Jessica Collett (2005) found that women of all social backgrounds use well-dressed, well-groomed children to enact and conform to identities as "good mothers." This identity management helps to protect and enhance mothers' self-conceptions during the course of everyday social interaction. Similarly, sociologist Sharon Hays finds that children's appearances "are an integral part of their mother's own self-presentation" (1996, 343). Hays argues that the ability to be a "good" mother is inseparable from the

inequities of social class, so that many women find themselves unable to mother their children in a culturally lauded manner:

> [W]hile mothers of all statuses and occupations believe that childrearing is intensive and should be child-centered, adequate financial resources offer women time and opportunity to provide children with what they think children desire or what experts tell them children might need. (Hays 1996, 343)

Hays interrogates what she terms "the cultural contradictions" inherent in social constructions of proper motherhood that result in the inability of women like Cinnamon and Star to be publicly deemed good mothers. This perceived cultural incompatibility of sex work with good motherhood also extends to poor mothers who are the primary caregivers and economic support for their children and thus have to negotiate a social system that is inherently suspicious of their morality and their status as doubly marginal citizens. Sociologists Susan Holloway, Bruce Fuller, Marylee Rambaud, and Costanza Pierola have documented the strategies employed by what they term "single mothers" in poverty to create a life of stability and security for their children. Such tactics generally involve the maintenance of elaborate social networks to ensure proper care and provision for children's needs, acting as an advocate for children who were not shown attention in school, and, sometimes, overcompensation with material possessions (Holloway et al. 2001, 55–62).

Social-work scholar Sandra Kielty's work on British mothers who choose not to live with their children discusses how such women negotiate the stigma of nonconformity with culturally normative ideas about "maternal devotion" (2008, 32). The nonresident mothers in Kielty's study consistently emphasized that their actions were that of a "good" mother, and "it was made apparent that there was an active agent at work with a specific goal in mind" (2008, 37). Such justification mechanisms become particularly relevant for women who are unable to meet cultural standards for "good" motherhood, and often function to inform decision-making strategies regarding children.

Cinnamon had her own internal conflicts about her role as a mother when she was called to a meeting with her fourteen-year-old daughter's

teacher at school over some behavioral issues. The teacher was concerned that her daughter, Melanie, was acting out because of what she glossed as "issues at home." Cinnamon had been livid when she heard this over the phone, and her voice had the kind of controlled rage that she used with particularly belligerent clients at work as she spoke to the teacher. "Is Mel the problem?" she asked, "or is the problem at school?" She agreed to a meeting later that week but was seething with anger over what she regarded as a clear example of discrimination.

"They know," she sighed as she described the incident to me after she hung up. "They know what I do, and they're taking it out on Mel. Those other kids are so freakin' mean, what's she supposed to do?" Cinnamon was in a bind over the teasing her daughter was experiencing at school, which in her view had provoked Melanie into several fights that caused teachers and other authority figures to label her a troublemaker. "What are you going to do?" I asked, and Cinnamon shook her head:

> I have to stick up for her, because who else will? Those teachers think her mom's a stripper so things must be all screwed up at home, they assume that I've got all kinds of men coming and going and am setting a bad example. I'll tell them straight that she's just standing up for herself and then we'll see what happens, because I don't know what else to do. You know, I dropped out of school because I was pregnant with her, but if I'd had someone to stand up for me maybe things would've been different.

Cinnamon's insistence that she had a responsibility to "stand up" for her daughter speaks volumes to her understanding of her small family's marginal position in the world. Cinnamon saw Melanie's propensity to fight with her classmates as a rebellion against unfair stereotyping, a rebellion that was in some ways reminiscent of Cinnamon's own struggle to survive in a world that provided few options to her. Self-sacrifice was an inherent part of Cinnamon's understanding of her work-related decision-making processes, just as she saw her need to advocate for Melanie as part of her motherly duties.[8]

Cinnamon truly believed that she had a responsibility to advocate for her daughter because her own life had been framed by the lack of attention she had received from responsible adults. Clearly, however, her

unmistakably accusatory tone in conversation with Melanie's teachers might have functioned in counterproductive ways by labeling her as an uncooperative parent and thus reinforcing the previously held stereotypes the teachers may have shared toward sex workers. Many dancers held the belief that they were locked into an adversarial relationship with individuals in positions of authority both in and outside Vixens. This sentiment, in turn, helped to foster a sense of solidarity among dancers at times, although it must be acknowledged that this unity was often short-lived.

As we will see in the next section, dancers are among the many individuals who find a sense of rather clandestine community with others based upon their sexual practices. Recent work by queer theorists has examined the rationales evinced by individuals who engage in risky behaviors that place their health and safety in direct peril (Dean 2009; Gray 2009; Johnson 2008). These analyses have demonstrated how although subcultural membership can exert normalizing influences upon individuals who otherwise feel in some way persecuted because of their sexual behaviors or identities, such bonds often remain fraught with anxiety. Similarly, Cinnamon's attempts at being what she termed "a good mother" were informed as much by a belief in her inherent outsider status as they were by her desire to improve her daughter's sense of well-being.

SOCIAL SISTERHOOD AND THE FAMILIES WE CREATE

Many of the difficulties women like Cinnamon and Star face in raising their children in what they regard as a positive way stems from their uncertainty over whether they are doing a good job—as is perhaps the case with all mothers. Yet this insecurity is compounded for sex workers because many believe that their own families failed to provide a strong system of support by setting positive examples. This claim is a problematic one that must be handled with caution because it has sometimes been interpreted to mean that women enter sex work because of prior

experiences with abuse and abandonment (e.g., Farley 2004a). Most scholars who have conducted long-term research with individuals who engage in sex work would agree that it is dangerous to imply that sex workers were somehow coerced into making choices regarding their work because of physical or emotional abuse, since doing so ignores the survival strategies they employ.[9]

Hence although it is desirable to do descriptive justice to women's efforts toward achieving personal autonomy, researchers have also taken note of the frequency with which women themselves describe the structural violence of poverty that leads them to choose sex work (Brennan 2010; Sweet and Tewksbury 2000; Porter and Bonilla 2010). It is certainly true that sex work can be an empowering feminist project for some women (Frank 2002), yet for most it remains, like any other service-sector job, a way to support oneself and one's dependents. This socioeconomic reality helps to explain why so many sex workers "find their social sisters" (Hoigard and Finstad 1992, 80) in their new work environment. This became particularly evident one evening as Chantelle, Star, Diamond, and I were sitting backstage preparing for the night's activities. The atmosphere was particularly convivial because it was Friday, which everyone knew was the most lucrative night of the week. The conversation had somehow drifted to family experiences and rapidly took on the jocular tone that dancers often used to mask particularly painful experiences.

"You know we're all from the same family, right?" Star asked rhetorically and laughed. Diamond smirked and nodded as she leaned forward, widening her eyes to apply a thick layer of brown liner to her upper lids as she spoke. "Ain't that the truth," she said, as if the dancers really had grown up together. "Hey, how about the dad who drinks so much that you have to help him get undressed at night because your mom is too mad at him to talk? Or the brother that takes the car for a week and nobody knows where he went so everyone has to find some other way to get to work?" Everyone was laughing. "I remember that car!" Chantelle exclaimed. "You know, the one where you can look down at the floor and see the road passing underneath while your dad is driving?" "Wait," Chantelle added, putting her hand on Star's shoulder in mock amazement, "we've all got the same dad!"

These shared experiences of socialization partially speak to the reasons that certain types of women make up the bulk of sex-industry labor. Scholars have demonstrated that girls who live in abusive homes are more likely to leave or be pushed away from home, as happened to Cinnamon in her early teens, and that such adolescent runaways have an increased likelihood of engaging in sex work (Rotheram-Borus et al. 1996; Silbert 1981; Simons and Whitbeck 1991). Women from fragile or otherwise dysfunctional family backgrounds have an increased risk of being placed in positions where sex work is the most feasible option open to them precisely because of the precarious socioeconomic situation that often accompanies such dysfunction.

However, none of the traumatic life circumstances some dancers have experienced serve to mitigate the sense of pride and self-esteem dancers gain from their work, even if only occasionally. This sense of professional accomplishment stems from the dual reality that many women at Vixens were quite proud of the economic self-sufficiency their beauty and relative youth offered them in the bar, and that many dancers genuinely believed that they were able to establish a degree of relative power that had previously been unavailable to them in life. Indeed, women at Vixens may have drawn an even stronger sense of social sisterhood from the undeniable reality of their stigmatization through work.

None of this is unique to Vixens, or to sex work more generally. Quasi-familial relationships, which anthropologists and others call "fictive kinship," are especially common among people estranged from their biological relatives and those who find themselves rendered socially invisible. In his work on such bonds among homeless men, sociologist Timothy Pippert notes that although these ties do not have the same duration or weight as relationships socially and legally recognized by the state, they are nonetheless "very central to survival" (2007, 12). Pippert writes that these are above all "relationships of trade and convenience" (2007, 8) and are predicated on a set of rules that help individuals to define what to expect of others. Anthropologists have also noted the creation of such communities among drug and alcohol abusers (Bourgois and Schonberg 2009; Spradley 1999), who rely upon one another for support (and sometimes defense) at the social margins.

Vixens dancers also created such fictive kin groups, which ranged from Cinnamon and Star's caregiving partnership to Angel's diffuse network of male support throughout the city. These extreme examples illustrate that everyone acted to create networks of support that operated within frameworks of rules and rule-breaking embedded in a cultural model of risk that pushed individuals to amass adequate protection without entirely alienating themselves from the gray world in which they earned an income. Many women had social sisters at work who they believed would protect them if a client became too aggressive, since dancers were largely responsible for policing their boundaries on their own and thus had to take the risk of alienating potentially lucrative clients in order to keep their jobs. Chantelle, the newest dancer at Vixens, looked especially to Cinnamon for help when she found herself pursued by a man who would not leave her alone, and Cinnamon in turn drew upon her years of experience in handling such situations. "It's my responsibility," Cinnamon would note in response to such situations. "When I was new and didn't know anything, I needed someone to watch my back, too."

These bonds were by no means limited to dancers. Paul placed the structural burden of risk on the women who worked for him, but he also frequently entered into complex emotional bonds with the dancers. Paul envisioned himself as a kind of benefactor to young women in trouble and thoroughly subscribed to a discourse of hard work and following rules as keys to the maintenance of order at Vixens. Still quite young relative to his position of authority over so many women, Paul often found himself torn between the loneliness that followed his second divorce and the explicitly sexualized attention paid to him by many dancers who sought to build economically rewarding alliances with him. His relationship with Diamond had formed a kind of uneasy solution to both of these problems, and her status as the most beautiful and skilled vis-à-vis others at Vixens helped to enforce the notion that he was unavailable.

Despite the awkward nature of their relationship given the power inequalities involved and the obvious unfairness he demonstrated toward other dancers by giving Diamond preferred working shifts, Paul was adamant that rules had to be followed. I listened as he explained that dancers were not allowed to meet clients outside of working hours

under any circumstances. "Even their regulars?" I asked, having noticed the especially close relationships that many dancers seemed to share with frequent visitors to Vixens. "Especially their regulars!" Paul exclaimed. "Those are the guys they are most likely to give it up to."

Paul's relationship with Diamond was the most obviously mutually beneficial long-term association at Vixens, but he also maintained emotional relationships with other dancers, who sometimes made it painfully obvious that they enjoyed creating a sort of filial relationship with him that they had never experienced in their own families. Dancers frequently engaged in boundary teasing with Paul over what he felt were inflexible rules, and many women clearly enjoyed provoking his anger. Angel slid provocatively into his office one night, her narrow hips shrouded in a filmy red gauze wrap that kept sliding off. Ignoring me, she looked straight into Paul's eyes, leaning forward with a practiced stare that made him sigh with exasperation. He had long suspected that she was using drugs and had heard rumors from other dancers that she was engaging in prostitution outside of working hours. "What?" he asked her, looking down at the numerous changes that had been made to the weekly schedule sitting on his desk.

Angel was impervious to such dismissive behavior and seductively cooed, "Ed wants me to go to the casino with him this weekend. Can I go?" She was clearly enjoying Paul's simmering frustration as she mentioned one of her few regular clients, and unlike me, she did not flinch as he slammed the heavy glass ashtray that held his papers in place onto the edge of the trash can with a resounding thump and then replaced its empty gray-flecked shell on his desk. He shook his head in annoyance and lit another cigarette, as if her question was too trivial to answer. She smiled slyly. "So, can I go?" she asked. Paul's face was red. He felt disrespected and was angered by Angel's request. He looked as if he might hit her, and I wondered what I would do if he actually did.

"I'm not your daddy," Paul said as nonchalantly as he could, shrugging his shoulders rather aggressively as he pretended to fully devote his attention to making adjustments to the schedule on the desk in front of him. "But if I find out that you went, you better find another job, because we aren't running an escort service here, OK?" Angel smiled sweetly

and turned to leave, muttering "Asshole" as she crossed the threshold of the door. "What did you say?" Paul shouted back at her without getting up to follow or even raising his eyes from the papers on his desk. "I'm everybody's daddy in here," he finally sighed to me, looking extraordinarily tired.

Paul's weary acknowledgement of his ostensibly paternal role vis-à-vis the women of Vixens speaks to many of the themes expressed in this chapter, particularly the difficulties faced by dancers in attempting to embrace familial roles that they can never truly hope to fulfill as long as they remain sex workers. His ability to deem himself "everybody's daddy" is, after all, little more than a thinly veiled expression of the privilege accorded to him by a host of gendered cultural practices at work between men and women. We now turn to a discussion of how these practices inform dancers' understandings of heterosexual intimacy both in and outside Vixens.

FIVE # Pseudointimacy and Romantic Love

CINNAMON

OK, rule number one for me has always been: don't date guys from work. The problem there, though, is it's really hard to meet normal people when you work nights anywhere. Doesn't matter if you're in a factory or working security or dancing, it's all the same basic set of issues. Because when you work nights you're just exhausted the next day and you might tell yourself, "OK, tomorrow I'm getting up by ten and I'm going to go grocery shopping" or whatever—when ten rolls around you just can't do it. Your whole body clock just changes itself so you become like, nocturnal, or whatever. Like a bat or something. Going out when the sun is out just starts to feel unnatural.

So somebody like me who decides not to go out with guys from work is going to end up alone, because your opportunities to meet someone are almost nonexistent. It's not like opportunities aren't there. To be honest,

plenty of decent guys come in here, they aren't all freaks. Star gets picked up all the time, but I think it's bound to be a disaster every time, because those dudes never see you as a human being. You'll always be a dancer to them. But then with guys in the straight world, who you might meet outside here at the store or something, there's a whole other set of problems because you have to tell them what you do for a living. If they don't have a problem with it, somebody is going to in their family, or one of their buddies will say some nasty things about you and the guy'll get suspicious. It's bound to happen. I've been there so many times. There's just no getting around it.

"I JUST WANT A NORMAL LIFE": NEGOTIATING STIGMA IN LOVE RELATIONSHIPS

Cinnamon's rather characteristic cynicism toward relationships derived from her previous disappointments with them, but her sentiments are nonetheless relevant to almost all dancers' lives. In a profession where women are expected to be seductive, alluring, and flirtatious as part of their job, questions regarding the lines between real and false intimacy are bound to arise. This is only compounded by the women's working hours, which, as Cinnamon notes, almost place dancers in a separate category of nocturnal beings outside the normal rules of human existence. Accordingly, this chapter addresses the difficulties faced by Vixens workers in maintaining love relationships while simultaneously seeking to maximize their earnings through cultivating the professional bonds of intimacy necessary to attract regular clients. As we will see, this is an exceedingly difficult undertaking that often ends in heartbreak for those in search of enduring emotional connections.

Star, Cinnamon, and I were in the Laundromat very early on a Thursday morning, the day we had discovered to be the least crowded. We sat on green plastic chairs permanently attached to the cracked linoleum floor, watching our laundry spin in indiscernible dark swellings inside the machines. Cinnamon had worked at a bachelor party until four in the morning the night before, and she had her legs drawn up against her while carefully cradling a cup of coffee in the space between her knees

and her chest. She looked frail and exhausted. Star had been home with their three children the night before and had dragged Cinnamon out of bed that morning full of nervous energy, pleading that she needed advice and this was the only time she had to talk to her.

"I never see you," she had whispered as she stroked Cinnamon's forehead. "Come with us, you just have to sit there." I had slept on their couch the night before and half hoped that Cinnamon wanted to stay in bed so I could sleep, too. Eventually Cinnamon pulled on a pair of jeans, put her hair in a ponytail, and got into the car, still groggy with sleep. On the drive to the Laundromat we avoided talking about the specifics of Cinnamon's work the night before, something that the two women had decided upon after the day that Star's precocious four-year-old surprised both of them by asking how to do a lap dance. Since then, the women had settled on a kind of code to use in front of their children that dealt solely with the structural aspects of their work: income earned, hours scheduled, and warnings about Paul's moods.

Star's children chased each other with sheets of fabric softener, running from one end of the Laundromat to the other while shouting noisily. Ordinarily Star would not have tolerated such rambunctious behavior in public, but she seemed not to notice, perhaps because she was too absorbed by her latest relationship crisis and her desire to discuss it. One of the central points of tension and recurrent arguments between the two women was Star's propensity toward serial monogamy, and the frequency with which she chose men who inevitably rejected her because of her work.

Cinnamon often accused her friend of living in a fairy-tale world that would never allow her true happiness. When Star started talking about the new man she had met while getting their second-hand car's muffler fixed the day before, Cinnamon put her hand on her forehead as if this news was causing her real physical pain. "This is what you got me out of bed for?" she intoned, her voice flat and toneless, like an exasperated parent. Star bit her lip and turned her head toward her children, who were still happily papering the place with sheets of fabric softener. She looked to me for support, and I shrugged, unsure of what to say because I already knew the story of her latest romance.

Steve was a divorced thirty-six year-old who lived alone with his ten-year-old daughter in the Irish-American neighborhood where he also worked for a car-repair business. Star had eagerly spoken of his kindness to her and his desire for a new, stable life, which he had expressed to her over coffee one evening after their children were in bed. He complained about his job, which did not pay very much, and commiserated with Star about the difficulties of single parenting. Star knew that he cared for her, and this made her wonder when and how she should tell him about her job. "See, I just want a normal life, too," Star recounted to Cinnamon.

I watched Cinnamon's exhausted face as she patiently listened to her friend relate the story of how they met, Star carefully inserting details that spoke to her perceptions of Steve's good character and understanding nature in the face of adversity. Cinnamon listened to the story of Steve's divorce from an alcoholic woman who was the mother of his child, the abuses he underwent at work from a tyrannical boss, and his plan to open his own garage once he could save enough money to do so. Star looked so hopeful, but Cinnamon appeared defeated and tired, as if she were hearing the same story for the thousandth time, the difference solely in the details. "You just don't get it, do you?" she asked Star. "For us, this is a normal life. You just think you're too damned good for it." Star cast a wary eye toward her children, then looked at the floor.

"Number one," Cinnamon continued, lifting her head from her knees to sip some coffee from her mug, "he's probably Catholic. Number two, he's got a daughter. Number three, he's looking for a mom for his kid." She paused meaningfully, and looked frustrated when Star simply added, "So?" Cinnamon kicked off her slip-on shoes in frustration, and they hit the wall underneath the washing machines with a harsh slapping sound. Star's children stopped their game in surprise before retreating to a far corner to build a fort out of the few movable chairs in the building. Star was not giving up so easily:

I know what you're thinking, that he's going to judge me and all, but this one's different. He really understands, because he puts up with the same kind of crap at work that we do, with him doing all the work and the owner getting all the money. He knows what it's like to raise a kid alone,

because his wife left when his daughter was two. He's going to get his own garage and then everything is going to be different, you know?

"Did he ask you where you work?" Cinnamon asked, ignoring the obvious parallels Star attempted to draw between their occupation and Steve's. Star shook her head and looked at the chipped polish on one of her fingernails. I felt bad for her. "Maybe you shouldn't jump to conclusions," I said. "Maybe he's a really nice guy." Cinnamon pursed her lips and suddenly looked exhausted with life, her face heavy with the weight of experience. "You don't have to tell me about nice guys, OK?" she said, her voice tinged with a smoldering anger. "Because I know how it is. They're nice until it comes time for you to meet their kids or their families, and then all hell breaks loose."

Star looked at the ground, expressionless, and I wanted to defend her faith in love. "Maybe he is different," I said weakly. "And he should understand, because he's got a hard job where he has to suffer, so he should have some sense of unity." I realized I was repeating what Star had just said, albeit employing a rather naive discourse of worker solidarity I had picked up in graduate school. In theory, Steve should understand, but would he in practice? Cinnamon moaned affectedly, as if in pain, and I realized how ridiculous I sounded. Star spoke for her:

> Cinnamon has been doing this for a lot longer than me, so she understands how these kinds of things work out. It's true; maybe somebody like Steve doesn't want his buddies to talk about how his girlfriend's a stripper and all, because maybe he'll think that his job is special because he had to go to trade school to get it, even if right now he has to put up with a lot of crap at work. With us, maybe it's true that we can be really good at what we do, but when it comes down to it, it's not something anybody dreams of doing when they grow up. It's not something a guy wants to tell his friends about.

One of the most salient points in Cinnamon's explanation is the structural parallels she draws between sex work and a variety of blue-collar jobs filled predominantly by men. Although someone like Steve may find himself in an exploitative work environment because he does not own

the garage in which he works, the kind of oppression that he encounters in the workplace is seen to be entirely different from what Star deals with at work due to the added moral weight her occupation carries with it. Indeed, Steve and Star shared many of the same issues in the workplace: both performed the vast majority of the labor while receiving an extremely low percentage of profits from it; both were routinely suspected of dishonesty by their clients; and neither felt they worked in a respected profession. Steve also lamented the lack of a union he could join to help him improve his situation, the need to buy his own expensive tools to bring to work, and the fact that he earned only a percentage of the garage's profits rather than a salary so that on slow days he, like Star, could earn close to nothing.

Yet whereas Steve could characterize these unfair labor arrangements as the product of a system that did not respect his skills, Star could not make such assessments because of her own belief that she did not have any special talent apart from her gender and her youth. Steve thus found himself able to blame an unfair system, whereas Star could blame only herself for her exploitative working conditions. This reality is critical to understanding how women such as Star act to improve their children's lives by being what they understand to be responsible mothers who happen to work in a stigmatized profession. Part of the reason that Star looked to Steve with such hope was that she firmly believed she could create a new life for herself and her children if only she had a stable, income-earning male partner in her life. I often got the sense while listening to her that she thought of her life as a kind of recipe missing just one last key ingredient, a philosophy that left her waiting in an unhappy and unfulfilled present.

Cinnamon's exasperation with Star's recurrent attempts to begin a long-term relationship was largely due to her belief that sex work and a stable, heterosexual partnership were essentially incompatible. Cinnamon had completely given up on men after a series of heartbreaks that had left her convinced that the only way she could live was on her own terms without a relationship; a relationship, she feared, would especially compromise her daughter's future. She explained, "I don't want some idiot man telling my daughter, 'Your mom's a stripper' if we have a fight,

because that happened when she was younger and I'll never forget it. I just held her for a long time afterwards, and I promised myself that kind of thing would never happen again."

That Cinnamon would choose celibacy over even the possibility of a committed relationship with a man underscores how strongly the stigma of their work functions to shape dancers' lives. Sociologist Mindy Bradley's research on how dancers manage the stigma of their work in relationships with men showed that many such women live a terrible paradox in which they are condemned for the work that often provides the sole family income. Many women described relationships with willfully unemployed men who had little problem spending their incomes while simultaneously using the stigmatized nature of dancing to maintain control over the dancer through guilt and subjugation, thus creating a situation in which a dancer is forced by a loved one into "apologizing for her own victimization" (Bradley 2007, 393).

As Cinnamon pointed out in this chapter's opening narrative, night work changes nearly every aspect of one's life by reversing the body's circadian rhythms in ways that make it nearly impossible to interact with others. Dancers at Vixens often equally blamed their working hours and their job's close association with prostitution for the frequency with which they found themselves in relationships with abusive or otherwise unworthy men. This was not confined to dancers alone: Paul often lamented the lack of what he termed "normal people" in his life. Paul was rather atypical of Vixens employees in that he shared an extremely close relationship with his mother, a teacher in a Sparksburgh elementary school. Paul had not experienced poverty's tumultuous effects in the ways most of the dancers had, although his father had abandoned the family when he was still quite young.

Despite Paul's relative socioeconomic and gender privilege, he still found it exceedingly difficult to meet women who were not dancers. Paul started working at Vixens in his early twenties, when he opted to remain close to his mother in Sparksburgh rather than relocate to a larger city where he would have had more opportunities to pursue his career as a deejay. He struggled with his mother's disapproval, but he also recognized that his only real marketable skill lay in music, for which

Sparksburgh did not offer many profitable outlets. This genuine love of his work under any circumstances undoubtedly drew him to Diamond, who shared his professional ambition to eventually work in what each regarded as a more salubrious environment.

Paul frequently complained that the only women interested in him were dancers, a category of women he described as "messed up." His two failed marriages to dancers had informed this perception, but it was striking how closely his descriptions of relationships doomed to failure resembled those of the dancers. As Paul explained in reference to his attempts to meet women outside the sex industry (whom he tellingly glosses as "normal girls"):

> If I tell a normal girl where I work, before the words are even out of my mouth she'll get this horrified expression on her face. She'll think I'm a pimp or something and run away as fast as she can. It doesn't matter how much I explain that I'm just doing this because it gives me freedom to make my music, she'll think it's just a line. Or her girlfriends will get to her and she'll think I'm a bad guy without ever even getting to really know me. I guess that happens to the girls who work here, too, but that's just how it is in this business. That's why I always end up with dancers, or I guess you could say, why they always end up with me.

This description of life in a sort of pariah parallel society framed nearly every aspect of Vixens workers' romantic lives. While Paul might describe his position as potentially threatening and dangerous to women with jobs outside the sex industry, dancers lamented what they perceived as the low quality of men who were willing to enter into relationships with them.

It was as if Vixens employees were forced almost against their will into either emotional solitude or serial monogamy, with each relationship ending in ways quite similar to the one before it. This kind of emotional poverty, however, was compensated in some ways by their rich, diverse practice of pseudointimacy with clients. For many dancers, this was one of the most rewarding aspects of their work, and they felt extremely proud of how they cultivated skills that allowed them to convincingly fake affection toward, and thus extract more money from, even the most repulsive clients.

PSEUDOINTIMACY IN THE WORKPLACE

Guys come in here because they want some kind of relationship without strings attached, cheap attention, because it is cheap to come here. People think guys spend all kinds of money in here, but for the kind of feeling they get, it's cheap. They leave feeling like they are the king of the world, because we know how to make them feel that way, because that's our job. We can take some total loser and make him feel like we are so lucky that he condescends to talk to us. Yes it's because we want his money, but it's more complicated than that. Sometimes I think what we do in here is just as hard as dealing with, like, your baby's daddy or some guy who keeps calling because he thinks he loves you. But in here, we're the boss. We set the rules and the guys have to follow them. How many other women can do that?

Chantelle had been working at Vixens for only two months when she made this revealing comment on the nature of her work, which she characterized as both empowering and challenging. Indeed, the most straightforward and simultaneously ambiguous relationships that dancers at Vixens had was with their clients, men who sought their company for a variety of complex emotional reasons of their own. Dancers faced a difficult task each night as they set about the management of desire, and the result was that many dancers regarded their work as the most intricate and skilled job they had ever performed.

"Once you get them where you want them," Angel said, smiling, as she slowly narrowed a space she had made between her thumb and forefinger until there was almost no room between them, "then they'll give you whatever you want. The hard part is getting them there, to that point where they have to respect you and do what you say." Coaxing strange men into such a state requires a practiced approach that presents a combination of resistance to sexual advances to protect the dancer and feigned attraction to keep the client's attention and encourage him to spend more money. Women at Vixens had to be careful not to let clients think that they were sexually available but also had to demonstrate sufficient interest in the men as individuals to make each of them feel unique and special, a combination virtually guaranteed to bring forth more money.

"It's not so different from dealing with men in normal life," Cinnamon shrugged, "because they're all the same, they all want sex. The only difference in here is that they think they have a better chance of actually getting it. But in here, the lines are also a little clearer than in the outside world: he keeps paying, and you keep paying attention." Cinnamon's concise summation of the topless bar resembles the view of many dancers, who affected a cynicism about relationships with men that often long predated their work at Vixens. Cinnamon, for example, routinely dismissed men's attentions directed toward her in any context as self-interested, aggressive, and, above all, unwanted.

"It gets easier as you get older," she explained as we left Vixens together late one night, "it really does, just like everything else." Cinnamon had been working in the sex industry for over a decade when she made this assessment and had been part of numerous relationships with men during that time that required negotiating skills not so different from those she had to employ at work. Her expertise in handling the sometimes sexually aggressive attentions of strange men at work and her earlier experiences managing the unpredictable moods of abusive relatives and partners were in many ways a direct function of a life spent in poverty. Over time, it seems, Cinnamon and many others like her developed a set of survival skills that gave them a particularly astute ability to evaluate the vagaries of those she was dependent upon for her income.

Cinnamon was hardly alone in her belief that experience made a difficult job easier. "It just takes lots of practice," Diamond had reassured a sobbing Chantelle, who had been rejected by almost every man she had approached to enter the private dance room with her that night. "It's not about how you look, it's about how you make them feel." Diamond most strongly subscribed to the notion that dancers have a unique professional ability to create and destroy a sense of power in men at will, an ability that is the source of their income. The greatest paradox of this, of course, is that most dancers can develop these skills only over time, which necessarily accompanies the aging process that in turn makes them less desirable to men who frequent topless bars in search of sexualized youth. Yet when I discussed this point with Cinnamon, she insisted that this was not necessarily the case:

It does get easier as you get older, because the older you get the more relationships you get into with different kinds of men. You start to learn, as you get older, how to handle this type, that type, just like with little kids—little boys, really. So by the time you've been doing this as long as I have, you can just look at a guy and know what he wants, what he's all about. And it's easier in a place like this, because the guys we get in here, they're not expecting a *Playboy* centerfold, so it doesn't matter so much if you're a little older.

Cinnamon thus positions her skill as one akin to an expert salesperson's ability to rapidly assess what a patron entering any sort of business might like to obtain there. Her view of her work framed it in a discourse of skill and power that almost completely disregarded the men who provided all of her income. By likening her clients to little boys, Cinnamon rather clearly dismisses the possibility of being put in a situation of risk and danger by men encountered at work. I initially believed that this was a self-defense mechanism she had constructed to preserve her sense of boundaries and safety, but I noticed later that Cinnamon never received unwanted advances from clients precisely because she had become so expert at creating an aura of untouchability that was simultaneously extremely erotic for her clients and lucrative for her.

Indeed, women at Vixens rarely contextualized their relationship with male patrons by using the language of submission and domination. The reality was much more complicated, with women emphasizing their skill at negotiating their relationships (however brief) with such men. Sociologists Craig Forsyth and Tina Deshotels have described this ability as "strategic flirting" (1997, 125), a set of behavioral cues used to elicit more money. The authors argue that dancers exercise a great deal of control in their performance of femininity, and they suggest that the gendered lens that scholars have used to examine sex work has resulted in the characterization of women who describe such work as "empowering" as suspect because their labor involves the performance of submissive femininity (1997, 138).

Similarly, anthropologist Elizabeth Wood has put forth "the attention hypothesis," in which, she argues, "interactions in strip clubs rely on dancers as interactive subjects rather than as sex objects" (2000, 6),

with their willingness to engage in friendly companionship by far their most alluring attribute. Indeed, women's income-generation potential at Vixens was directly determined by their ability to skillfully manipulate greater sums of money out of men without incurring accusations of fakery or insincerity. Diamond felt that her greatest professional triumph occurred early in her dancing career when she was able to master a set of convincing expressions:

> I worked on my eyes and my smile a lot when I first started. I practiced in the mirror at home—you have to practice, like with anything, otherwise you won't get better at it. So early on I learned how to say things with my eyes that would be dangerous to say with words, so now I know how to say "You're really turning me on" with my eyes, even if I think the guy I'm dancing for is completely disgusting, but I also know how to say "Don't fuck with me." The second one is probably more important, because I can give that look with my eyes while I'm still grinding in some guy's lap and he won't freak out the way he would if I said it with words. The weird thing is, usually they think it's pretty hot when I do that.

Diamond's description of her mastery over these skills is couched in a discourse of management, and although she does not explicitly acknowledge it, her silent mode of communication reveals the tightrope she walks in her work between the culturally prescribed roles of victim and temptress. The fact that she has the "pretty hot" ability to express contempt for an unwanted advance with a carefully managed facial expression while still performing a highly sexualized dance demonstrates the silent respect that her mastery over her profession garners from men.

The services dancers provide to their clients in the form of pseudointimacy often shape their lives by depleting the amount of real intimacy they are able to experience. This happens because of the complicated ways in which dancing topless affects family and romantic relationships outside the workplace, so that these two sets of behavior begin to mirror each other. At work and at home, dancers find themselves walking a fine line between genuine and performed intimacy, and some women at Vixens to describe this tension as the reason they felt they needed some form of male comfort outside their work environment. "You'd think we'd get enough of that at work, right?" Angel sarcastically teased one night as we

discussed her ongoing relationships with a number of men who seemed to drift in and out of New York State's correctional facilities with alarming frequency for a variety of drug-related offenses. She then added, laughing, "Some of us just can't seem to get enough. 'Please, hit me again!'"

Angel had an impressive network of casual male acquaintances that provided her with accommodation, transportation to work, and controlled substances on a regular, albeit rotating, basis. Her life contested many stereotypes about drug users as disorganized in this regard, since Angel had no fixed address and had to be ever vigilant of her prospects for housing, which could sometimes change very quickly if one of her partners found a new woman of interest to him. This external chaos and vulnerability belied what Angel saw as a life lived as she pleased, with whomever she wanted. "And when I get sick of them," she shrugged dismissively in reference to the men in her life, "I just up and leave and move on to the next one." Yet Angel's apparent independence coexisted with her desire for perpetual partnership with men, if only to maintain some sense of emotional authenticity:

> Sometimes I feel so sick, you know? Some asshole will touch me at work or call me a disgusting name, and I just feel bad. Just bad. When I can just relax and get high with some guy I trust, somebody I know, I feel like I can release some of that burden to him, get rid of how fucking sick I feel sometimes, living this life.

Angel's description of feeling "sick" granted an almost tangible quality to the emotional weight of her work experiences, which she in turn felt she could transpose onto a sympathetic male partner. Yet these men all too often turned out to be sources of additional sickness and burden to Angel in return, such as the crack user who set all of her clothes on fire one night in a parking lot during a jealous rage, leaving her with nothing but what she was wearing. I often got the sense that Angel regarded such events as building on one another until they demanded release, and her self-medication with drugs and alcohol allowed her a temporary outlet.

Sociologist Judith Rollins describes this feeling of experiencing humiliation over and over again among domestic workers by using the idea of *"ressentiment"* (1987, 225), which captures the propensity of accumulated

hurt to wound the afflicted again and again through memory. Even Dia-
mond, who saw topless dancing as a career that she wanted to sustain
for as long as possible, was emphatic that dancers had to be very care-
ful to release what she described as the "negative energy" that resulted
from disrespectful clients, unreliable partners, and fragmented families.
She adamantly refused to let bad experiences at work or in life penetrate
the emotional armor she had carefully constructed around herself as a
means of protection:

> I don't let anyone inside me, that's for me alone. Sometimes I let a guy
> think that he's really got me, but it's an act. Women are such actresses,
> because we have to be. That's why I don't understand about women who
> look down on us women who dance, because all women do this with their
> men. You give some, but you try to take more, because that's the only way
> a lot of women can get by. The minute you let down your guard, though,
> that's when the danger starts, because guys just use you up when they
> think you're vulnerable. That's just how it is, and if you don't find some
> way to let all that negative energy out, it just eats you up.

Diamond's description of men who will "use you up" if women do
not carefully police their emotional boundaries gets at the core of her
professional strategy for dealing with men. However, it also underscores
the likelihood that dancers' work personas will overlap with what they
often regard as their "real" selves—in other words, how women make
sense of a work environment and a world in which they discover that
their commoditized sexuality is the only means they have to generate
income. Yet it may be somewhat naive to characterize dancers' emo-
tional lives as clearly bifurcated between "genuine" intimacy given to
loved ones and "fake" affection shown to clients. Quite a few dancers,
for example, saw Diamond's very public and volatile relationship with
Paul as what Cinnamon called a "typically tawdry girlie-bar romance."

Cinnamon and I were sitting in a dark corner at Vixens one night
smoking cigarettes and passing the time gossiping about the relation-
ships of our mutual acquaintances. Cinnamon regarded herself as some-
how above the ordinary desires for love and happiness that shaped
the lives of everyone else at the bar, and she somewhat paradoxically
resented women who she felt unfairly used their sexuality to gain an

advantage. "See how Diamond is with Paul?" she whispered. "She's gorgeous and probably could do a lot better, but she lets him think that he's the only one because she gets money that way. They're both stupid, though, because nobody benefits that way, it's just a temporary situation that will make everything seem worse when it's over." Cinnamon's assessment of Paul and Diamond as "stupid" both accepts and critiques such sexual privilege as transient and finite in nature, and speaks to a lifestyle characterized by fleeting commitments.

Yet this assessment of the vagaries of male desire did not prevent Cinnamon from accepting the possibility that some people really did desire genuine, unconditional love. "See how Angel has a different guy every week?" she asked, inhaling deeply on her cigarette. "It's like she's scared to let somebody love her, kind of like cutting off your nose to spite your face kind of a thing. That's what this life does to you, teaches you that you don't deserve the best things." It is striking how often dancers characterize their work as a lifestyle rather than a job, and many describe theirs as a profession that takes over nearly every aspect of their existence due to its position on the margins of legality and public morality. Despite Cinnamon's dismissal of the psychically debilitating aspects of sex work, she was as quick as other dancers to acknowledge the ease with which real emotional bonds could develop in the workplace.[1]

Just as in the straight world, clients and dancers at Vixens formed friendships, fell in love, lost interest in one another, and, of course, often felt betrayed when expectations were not fulfilled. Not all of these relationships were mercenary in nature. "Some guys are so cute, you wonder what they're doing here," Star noted, "but they're just shy or whatever, so you kind of feel sorry for them." Star had a much more liberal opinion of Vixens' clients than did Cinnamon and many other dancers who had worked for a longer period of time and had a dimmer view of such relationships as doomed to failure. Cinnamon and Diamond focused primarily on the ability of clients to generate income in choosing whom to approach in the bar, whereas Star, Chantelle, and others who were generally less experienced might choose to talk to a man they found attractive, as they might in a nonwork social situation.

Cinnamon and Diamond were especially fond of recounting Vixens' folklore of wealth, which described extraordinarily affluent clients (none of whom I ever encountered) who were free with their cash and their high praise of dancers' beauty. Competition over less-affluent men who were frequent visitors was extremely fierce, as regulars are a highly desirable source of income. Such arrangements vary from everyday visits in extreme cases to once a month, depending on the amount of money a client has to spend and how often he can manage to visit. Some of these regulars clearly believed that the dancer they favored was theirs alone, and declined all overtures from other women, choosing to leave if their preferred dancer was not at work.

Dancers sought out regulars and, in some cases, potential partners in a number of ways that mirrored the diversity of the women and men in the bar. Like actresses, each dancer had to be unique and accordingly cultivated a stage name, clothing style, dance music,[2] and professional identity that sought to attract a particular type of client. Some women, like Angel, would actively solicit a customer from the stage through eye contact followed by seductive body movements once she caught his attention, but most women tried to maximize their likelihood of doing business with more than one man in the course of a night's work. On any given night, between six and fifteen dancers would be at Vixens, and the self-directed, tip-based nature of earnings necessitates a great deal of competition for men who do not necessarily have a great deal of money to spend. One of the many reasons for the high employee turnover at Vixens and establishments like it is that this earning structure could leave a shy or reticent dancer like Chantelle with no income whatsoever at the end of the night.

"You have to make it look natural," Cinnamon said in an exasperated tone to Chantelle as she tried to explain how to hustle men in the audience for tips without appearing too obviously interested in taking their money. Cinnamon's privileged status at Vixens, like Diamond's, resulted from her relatively high income from client regulars. Chantelle simply looked bemused. "How can guys not see through this?" she asked. Cinnamon shrugged and explained, "They don't want to. It's just like, how many people want to admit that their marriage is a mess? That's part of

the reason why guys come in here—because they don't have to ask too many questions." Despite Cinnamon's pragmatic assessment of gender relations at work, men who fill the role of regular are clearly aware of these issues and do in fact ask these questions. This is precisely why relationships with regulars are so complicated: men do not want to appear too stingy with their cash, but they also do not want to feel as if they have been cheated by a skilled professional. Indeed, as feminist theorist Carol Pateman noted in an early work on the flawed assumption that men pursue sex workers in order to assert dominance:

> Men do not want solely the obedience of women, they want their sentiments. All men, except the most brutish, desire to have, not a forced slave but a willing one, not a slave merely, but a favorite. An employer or a husband can more easily obtain faithful service and acknowledgement than a man who enters into the prostitution contract. (Pateman 1988, 207)

Hence the reality that regular clients were often just as likely as male partners in the straight world to express jealousy. Diamond and Cinnamon were particularly skilled at maneuvering their regulars' professions of love and angst about the reality that other men could be in such close proximity to their favorite dancer, but at the root of all these behaviors and posturing lay the key reality that women at Vixens were never exempt from the kinds of courtship norms that framed life in the outside world.

EMBRACING HETERONORMATIVITY?

The belief in the possibility of upward mobility embraced by Vixens workers functioned as a powerful motivator in many of their choices and actions. Perhaps the most heart-wrenching manifestation of the desire for what Star and others characterized as "a normal life" is the frequency with which dancers sought out heteronormative family situations even when there were other options available to them that might prove more sustainable in the long term. Nothing illustrates this propensity more clearly than the breakup of the family of two women and three children that Cinnamon and Star had painstakingly pieced together.

As we saw earlier in this chapter, Star first met Steve the mechanic when she was getting the secondhand car she shared with Cinnamon repaired. Like her, Steve was the sole biological parent, at home with his daughter following his divorce. Star and Steve also shared a number of other characteristics: both wanted to move away from professions little respected for their levels of skill and honesty; both hoped for a stable heterosexual family life at some point in the interests of their children; and each worried about insurmountable obstacles facing them in the way of doing both. Cinnamon nonetheless saw the relationship as doomed to failure from its inception because of the added moral weight that topless dancing carries with it; in her view, no amount of commonalities in terms of unfair labor arrangements, oppressive managerial structures, and suspicious clients would ever mitigate the fact that Star took off her clothes for money.

Nonetheless, Star held a powerful faith that their relationship could be made to work, and within three months of meeting Steve she and her two children moved into his house, creating a second blended family. Cinnamon was deeply distraught but not terribly surprised when this happened. "I knew this day was going to come eventually," she calmly explained to Star, "and you're like my little sister, so I can't deny you happiness." Her expression of goodwill was soon outweighed by the practical realities of life, including her need to support Melanie, her increasingly unruly adolescent daughter. Cinnamon lamented the fact that their relatively stable family unit had not been good enough for Star, and even called her several times at Steve's house to tell her that she was still welcome to come back with her children.

"I'm not trying to guilt-trip you," Cinnamon calmly intoned to Star during one such phone call, "but I love you, and I just want you to stop and think about what you're teaching your kids." Star remained silent, deferring to Cinnamon's life experience as she explained her belief that while men might come and go, women bear the weight of responsibility. "And I know she's not your daughter," Cinnamon said, her voice cracking a bit as she tried not to cry, "but this sends Melanie a message, too, about the way to treat people who really love you." Star hung up on her, but not before angrily asking Cinnamon, "What do you know about who

really loves me?"Since Cinnamon had long since given up on men as an untrustworthy, abusive, and generally useless category of human beings, she was unfazed when Star and her children moved back in with her after spending less than a month with Steve. Their reunion was nonetheless short-lived, and was fraught with frequent arguments about money, particularly because of the debt Cinnamon incurred following Star's sudden departure. Cinnamon criticized Star as immature and irresponsible, frequently adding the line "and you've got two kids to support" to her ever-growing list of frustrations with their strained friendship. Star, on the other hand, named her job at Vixens as the real obstacle to a sustainable long-term relationship with a man, and remained resolute in her desire to quit. This opportunity came just a few months later when Star quickly married an Iraq-bound soldier from a nearby military base, and she left Vixens entirely when, much to her delight, she learned she was pregnant with her third child.

Star's strong desire to meet heteronormative definitions of family further underscores the temporality of feminized labor. Whereas Star clearly expressed the short-term nature of her job as an interim survival measure before getting married, Cinnamon's lengthy experience with sex work presented her with another set of difficulties related to feminized labor: its limited likelihood for long-term upward mobility except in rather extraordinary circumstances. Yet Cinnamon found herself facing an almost completely untenable set of life realities as she fell deeper and deeper into debt following Star's second departure and concomitant lack of contribution to the household budget.

Cinnamon had ten years of experience as a sex worker despite the fact that she was only twenty-five years old, and yet she had never considered applying for a managerial position. Vixens managers received a salaried income, in sharp (and significant) contrast to dancers, who earned all of their money from tips that fluctuated radically depending upon a host of variable factors far beyond the dancers' control. Cinnamon was very lucky in that her need for a reliable income coincided with the bar owner's decision to hire another manager. She was so highly respected among other dancers for her fairness that she permanently took on the position. This decision proved particularly advantageous in her personal

life as well. "I don't leave work exhausted anymore," she explained, contrasting grueling six- to eight-hour shifts on stiletto heels with her new responsibilities sitting behind a desk filing papers and watching the closed-circuit camera.

Her extra energy greatly benefitted her daughter as well, who began to see her mother as a role model now that she held the more glamorous title of manager. Cinnamon even decided to pursue a long-shelved plan to attend nursing school part-time, and began studying for a high school equivalency exam toward this end. "It feels weird to have my clothes on in here," she reflected, "but it's really nice in a lot of ways." It was clear that Cinnamon missed her friend Star very much, but she also critically reflected on what she viewed as a series of positive changes Star's departure had forced her to make. Cinnamon noted:

> Maybe Star leaving was the best thing that ever happened to me and my daughter, because otherwise I never would've thought, 'Hey, maybe I can do something different with my life.' It's funny, you know, how sometimes you get caught in a way of doing things and it can be hard to get out of it. What she did was really hard on us, when she left, but we had a good life together while she was around, and I can't really blame her for what she did. I know, deep down, all she really wants is love. She's just like anybody that way, really.

As with any elements subjected to harsh exposure for an extended period of time, love, loyalty, and self-respect can take different forms for sex workers. All three of these otherwise intangible elements become conspicuous in both discourse and practice because they otherwise appear in such woefully short supply. This is why dancers like Cinnamon often talk about the manifold ways in which they practice emotional fidelity against the odds, underscoring how cultural norms outside of establishments like Vixens clearly inform the subcultural activities that take place within its walls. As we will see in the next chapter, however, engaging in any of these work-related behaviors comes with a number of associated dangers and psychic costs.

SIX Calculating Risks, Surviving Danger

ANGEL DUST

Want to know how I got my stage name? Same reason I'm in here, really. It was at another club, the one where I first started dancing. It was about two years ago, right after I turned eighteen. My boyfriend kicked me out and I had no place to stay, so I thought, "Well, let's try this." When I got inside I got scared, real scared. My mom had a lot of boyfriends when I was growing up, and some of those guys thought they were my boyfriend too, that's the easiest way to put it. That messed me up pretty bad, so I don't really talk about it. I guess people think that by the time I got inside a strip club I should have been used to that kind of shit after all that happened to me growing up. Looking back, I don't know why I felt so scared that first night.

The guy who brought me there on my first night, he was a friend of my boyfriend, the one who kicked me out. That guy was a lot older than

me and he would always help me out a little whenever I asked him for it. That night when he dropped me off I said I thought I needed something, you know, to help me get through it, so we smoked a joint in the car before I got out and I thought that would help me relax, but right after he left I knew there was some serious shit in it, because everything got blurry and I felt real hot. It did some crazy stuff to my mind, like I seriously thought that all my mom's ex-boyfriends were there waiting for me to go onstage and take my clothes off. Let me tell you, it freaked me the fuck out because I never felt like that before.

I've been drinking since I was a little kid, and I learned how to roll a joint when I was ten. My mom used to think that was cute, like "Look what my kid can do" kind of thing. But this shit he put in our joint, it was too much for me. I was scared, real scared. I didn't have any way to get home or a home to go to anyway and I was pretty confused, slurring my words and all, so I took off my clothes and got up there on the stage. As soon as I stood up on those super-high heels in front of all those men, I felt really weak and sick. First I thought it was because I wasn't used to it because I never wore those kind of shoes before, but then it was like all my muscles just melted and starting shaking, like I couldn't control it, and I passed out on the stage. They thought I was having a seizure, but I didn't know what was happening to me.

Needless to say, I didn't last another night at that club. They told me not to come back again once they figured out how high I was. That night some girl, another dancer, was sitting with me backstage, and when I came to, she told me, "Don't mess around with that crystal supergrass, it'll kill you," and then I knew what happened. Since I was new, she said I should make my stage name "Angel" if I found another club to dance in, which I didn't understand until I found out what was in that joint. So I'm not like the angels in heaven, I'm Angel as in PCP, angel dust. Real funny, right?

I worked at a couple of other clubs after that, some good and some not so good. People always say that this is the best job for girls who like to party, and that is true. Guys buy me a lot of drinks here at work, and a lot of times I don't have to buy my own shit because despite what people say it isn't hard to get dope in here, any kind you want. Here at Vixens they like to pretend it's a classy place and so they say things like "Oh, you can't go to the casino if one of the guys you meet in here asks you, you can't meet them outside the club," but it's all a bunch of crap. What's the difference, when all we do here is grind in some guy's lap anyway? It's just like those stupid security cameras that are supposed to be "protecting" us. In here, everybody watches out for herself, because nobody else is going to do it for you.

It's dangerous and scary and messed up, but these other dancers are a bunch of bitches and they like to pretend that they're better than me or something. The difference between me and them is that I'm not a hypocrite. I don't try to hide things. How it works is usually a guy who is kind of a regular, like you've done a couple of private dances for him and he remembers you when he comes in, he'll say something like, "I really want to get to know you better, spend some time alone with you." Usually they won't come right out and say what they want because they're afraid of cops and shit like that, so they'll say something like, "Want to come to the casino with me next weekend?"

The first time some guy here asked me that, I was so stupid, I thought, "Wow, I've never been there before, I'd really like to go," but, needless to say, we didn't really go to the casino. Instead we ended up in one of those no-tell motels off the thruway. It was a little weird at first, but I just told myself, "Honey, this is something you've done a million times before for free, so might as well get something out of it now." I just pretended like it was a big joke, because it was kind of funny, right? Like any other guy you'd meet in a bar or someplace, they usually pretty much come right out and say what they want, but this guy, he felt like he had to pretend he really wanted something else. So I told him he was pretty special because he was my first trick, and he looked at me like he didn't know what to say, and I just burst out laughing because I guess he thought it was some big honor or something.

Sometimes it's just easier to laugh about shit that hurts, you know, because what's the alternative?

PROSTITUTION AND THE MORAL HIERARCHIES OF SEX WORK

Angel's self-consciously blasé tone illuminates the pain and instability underlying her nonchalant language, but it also speaks to the cultural model of risk that dancers employ at work and in their everyday lives. This cultural model operates at, and is partially a function of, the intersection of the kinds of poverty, abuse, and desperation Angel describes,[1] and yet it also closely corresponds to gendered typologies of power and control evident in U.S. popular culture. Jobs in the sex industry are fairly distinctive among unskilled forms of labor because they are generally short-term in nature yet carry a strikingly enduring emotional burden.

This chapter discusses the cultural model of risk that dancers employ in decision-making processes with clients and their perceptions of sex work. Most women at Vixens cultivated fictive kin networks both to enrich their lives and to minimize risks, but such relationships were complicated by the moral competition dancers employed to distinguish themselves from prostitutes. Clients who offered dancers money for sex often used the telling euphemism of "going to the casino"—a phrase that neatly encapsulates the powerful legislative and popular cultural ambivalence surrounding sex work and its associated risks. The negative consequences of such dangers led dancers to describe their work as a temporary solution to what is all too often a lifelong problem of socioeconomic instability.

As we saw earlier, dancers at Vixens were adamant that their work necessitated the development of a survival skill set that allowed them to relate to the outside world. Many women believed that they had an infinitely superior ability to make rapid character assessments, particularly about men, in comparison to women who did not work in the sex industry. Yet work inside Vixens also demanded that women subscribe to a unique cultural logic that permitted them to maintain their personal boundaries and a belief that theirs was a temporary solution to an otherwise irresolvable life dilemma.

This cultural logic operated by balancing popular notions of shame and dignity within a survival discourse of moral uprightness, so that someone like Chantelle could reconcile her discomfort with dancing by couching it within a discourse of self-sacrifice for her unborn child. Even dancers who did not have children often expressed their attitudes toward their work through descriptions of economic need tempered by the lack of family and other forms of social support that had encouraged many women to seek work at Vixens in the first place. These expressions typically invoked young children, debt, and lack of education or other employment-related skills rather than choice, and were complex and often contradictory. Not surprisingly, as we will see, the lines between the individual and structural risks incurred in dancing are rarely clear.

This cultural model of risk and sexualized danger helps to explain what women and men at Vixens believe themselves to be risking through

their presence there, and it illuminates the reasons they feel these hazards are worthwhile. It operates on simultaneously structural and emotional levels, the first of which considers legal, health, and safety risks, while the latter varies from person to person as a function of past experiences and hopes for the future. As is the case in most human decision-making models, the perceived benefits of a particular act or behavior must be understood to at least temporarily outweigh the risks. Yet this process becomes infinitely more complicated and nuanced in a profession that operates on a number of risk-based assumptions by all concerned.

It is obvious that dancers take the greatest risks of all, and this book is replete with examples of how women struggle to balance their need for a higher income with the sometimes terrible consequences it incurs. Male clients also take risks at Vixens that are minor in comparison but remain significant nonetheless, since many, if not most, men who visit Vixens are either married or in relationships with women who do not know about their patronage of such establishments. As we will see, sometimes the risk some men perceive to be involved in such secrecy and subterfuge is for them the most exciting aspect of visiting a topless bar.

Experienced dancers like Cinnamon often laughed as they related stories of men who quickly metamorphosed from overconfident whisperers of clandestine offers of money for sex to nervous teenage boys when dancers refused. Cinnamon had the habit of naming frequent visitors to the bar with dollar amounts, and a man she called "Mr. Five Hundred Dollars" was the target of her recurring scorn. Whenever he entered the bar, she would rather loudly announce to all within range that he had come to the wrong place, redirecting him by using the name of a nude dancing bar in the area that she believed to be staffed by dancers who also sold sex.

Men like Mr. Five Hundred Dollars do take risks in asking Vixens dancers for paid sex, an act that is clearly highly eroticized for them. But of greatest interest here is that such men simultaneously request the dancer to take such risks as well. This fact was a consistent concern for management at Vixens. Managers like Paul are aware that such risk-taking behaviors exist, even in the relatively benign form of Mr. Five Hundred Dollars, and discussions about them are common. This cultural

model of risk and sexualized danger sets both unspoken and clear rules at Vixens and is predicated on the assumption that such risk-taking behavior is part of the eroticized typologies of masculinity and femininity that keep them in business.

Paul swept through the door just as Mr. Five Hundred Dollars had struck up a conversation with me, causing the man to look up, set down his pool cue, and then walk out the door in great haste when he saw Paul's large hand wave in my direction. Paul was still taking his coat off as he pulled me toward his office, asking curiously who I had been talking to by the pool table. "That's Mr. Five Hundred Dollars," I said matter-of-factly. Paul laughed and sat down in his office chair, his considerable size shrinking the small room a bit. I perched on his desk and waited for him to explain. Paul was one of the first people I grew close to at Vixens, and, as he did with many of the dancers, he fulfilled a kind of big-brother role for me by offering life advice.

"Let me guess," he said, still laughing at the irony that someday, unbeknownst to the anonymous man with the pool cue, this offer would appear in a book, "he asked you to go to the casino with him?" I shrugged ambivalently, although I was eager to learn more. "What is it with these guys?" he said, laughing, and opened the top drawer of his desk to remove the large bottle of alcohol that steadily shrank in volume every night. "I don't know how word got around that this is what they are supposed to say, but they all think it's their secret code, like they're all James Bond or something." Paul laughed as he gestured expansively in the run-down and cluttered space of his office, a mock grandiose expression on his face. "Welcome to my love palace, where nobody can tell you no. Well," he added, "they're supposed to say no, but some girls don't. I guess that's their cheap thrill these guys get, the idea that girls in here can't say no." I started to laugh, too, imagining Mr. Five Hundred Dollars' green eyes squinting in traffic as he drove home to his wife and children, confident that he had willfully faced risk and danger, only to walk away.

Yet as Angel alludes to under the gloss of "dangerous and scary and messed up," the exchange of sex for money is structurally accompanied by an increased risk of disease transmission and violence because of its illegal and thus necessarily secretive nature.[2] Yet such an exchange is

also often lucrative, a fact that encourages women like Angel to characterize it as but one more aspect of the unequal relationship between men and women that has framed their entire lives. The characteristically forthright language Angel employs in the narrative that opens this chapter belies what are clearly very painful memories behind her nonchalant recounting. Her struggles with drugs and alcohol were very much informed by a life shaped by dislocation and recurrent trauma, much of which was induced very early on by her mother's numerous male friends. Angel had in many ways inherited her lifestyle from her mother, a self-described "biker mama" who had raised Angel in a highly unstable environment replete with violence and drugs and was involved in a series of relationships with men who provided her with drugs in exchange for her companionship.

Angel's self-mocking narrative of her struggles with homelessness, abusive men, and addiction to various controlled substances closely correlates with popular perceptions of sex workers as out of control and irresponsible. Although this book is careful to contest such stereotypes, it would be incorrect to suggest that drug and alcohol abuse are not a problem for some women. Management at Vixens frequently used the example of women like Angel to further their argument that dancers are irresponsible, untrustworthy, and in need of constant surveillance—a line of reasoning that may seem paradoxical given the risks that such women face, rather than pose, in the workplace.

The owner of Vixens, who called himself Big Don, liked to emphasize to dancers, clients, and city officials that his was what he termed "a high-class establishment." His insistence on monthly staff meetings attended by all dancers was often a focal point of derision for women, who mocked what they saw as Big Don's efforts to convince himself that he was running a business like any other in Sparksburgh. One such meeting focused specifically on the frequent police raids that had threatened to close several other topless and nude dancing bars in the region, and Big Don worried that his embattled relationship with local officials would cause the police to be extra-vigilant in their scrutiny of Vixens.

"Now, we're all a team here," Big Don intoned to the ten dancers who were crowded into the cavelike space of his office, "and being on

a team means that we have responsibilities to each other." Diamond nodded seriously and shot a less-than-obvious glare in the direction of Angel, who rolled her eyes and stared back without blinking. Big Don went on to elaborate on the series of police raids at a number of nude clubs, which Cinnamon took exception to by noting, "We're not whores like those girls, Big Don. Why are you even talking to us about this, like we don't know how to handle ourselves in here?" Cinnamon was voicing a common sentiment among topless dancers, who believe that nude dancing is far below the kind of work they do and very close to prostitution.

Big Don, who did not like interruptions during these meetings, lit a cigarette and sighed. "Look," he said, "the point is that you girls have to watch each other, to make sure that nobody gets too dirty. If the cops see one of you girls screw up, then everybody loses her job. It's that simple." Cinnamon sat silently staring at Big Don, rapidly tapping one of her red-heeled platform stilettos as a steady rhythmic expression of her disgust. Big Don avoided her gaze and addressed the rest of the group: "Each of you girls need to decide if you want to be a team player here, and if you don't, you need to get another job." Silence followed.

Dancers had often heard this speech about their responsibility to report excessive contact between dancers and clients to management, and many clearly felt insulted by the insinuation that they were always under peer supervision. "So, Big Don," Angel hissed in a mock-seductive voice, "what if I just want to be a player?" High-pitched laughter and groans at Angel's obvious pun circulated throughout the room, easing the tension just a bit. Big Don pointed a thick finger at Angel and said, "I'm watching you, player. Now you girls go make some money," prompting the room to empty much more rapidly than it had filled.

Part of dancers' resentment of such meetings and supervision was the unspoken albeit core reality that dancers were still required to evince a degree of investment in their work akin to that of a full-time employee, despite receiving none of the benefits. This is but one of the ironies of their precarious job status, which requires them to be "team players" who constantly evaluate themselves and others to ensure adherence to codes of behavior that are rarely clear to anyone. Positioning employees

as the guardians of appropriate standards functions to further mask the operations of pervasive labor practices in which workers are increasingly reminded that they are expendable, easily replaced, and thus not in a position to negotiate the terms and conditions under which their labor is carried out.

These issues were made only more complex and pressing by fears about police raids, which mirrored concerns at Vixens on the part of management and dancers alike regarding the perceived ease with which dancers could become prostitutes. This was not unfounded given the frequency with which dancers were offered sums of money from clients for sexual services, with amounts ranging from a rather insulting twenty dollars for oral sex in the parking lot to fifteen hundred dollars for a weekend of sexual activity at a nearby motel. Dancers often complained that such offers were demeaning and showed deep client disrespect for them, as well as a naïveté about how Vixens functioned as a business. "Usually when guys ask you to leave with them," Cinnamon explained one night, "it's either the ones who haven't been to a strip club before and so they don't know the rules, or the ones that are your regulars, who think they have a real relationship with you."

Cinnamon's insistence that almost all women at Vixens were offered money in exchange for sex mirrored that of other dancers, most of whom felt that it was an unpleasant, if unavoidable, aspect of the job. Star complained that she did not like the idea of men thinking of her as a prostitute, and felt that the actions of just one dancer could construct an image of Vixens as a brothel:

> It's not us, the good dancers, who do stuff like going to the casino with guys after work. We're not allowed to do that, and we wouldn't want to do that anyway because we're not whores. Girls who do that, who prostitute themselves, they're mostly junkies or just completely desperate, and guys pick up on that. They know who they can ask and get it from—I mean, they ask everybody, but they know that it's more likely that they can get it from someone like Angel, not me or Cinnamon. When those girls are here with the rest of us, though, even if it's just one of them, it ruins everything for all of us. Guys start to talk to each other and the word gets out, and before you know it they all expect more than is even legal, definitely more than we're gonna give up.

Star embraces popular stereotypes that correlate prostitution and substance abuse as part of a process that separates "those girls" into a wholly negative category opposed to "the good dancers."[3] Such dichotomies illustrate how dancers subscribe to many sexist understandings of appropriate gendered sexual behavior despite popular perceptions of them as morally transgressive women.

SURVEILLANCE AND "PROBLEM DANCERS"

"I'm so fucking sick of being everybody's daddy here." Paul regularly complained in reference to what he perceived as his need to constantly watch those he and others called "problem dancers." Paul's assessment of his relationship to the dancers as "everybody's daddy" was in some ways quite accurate, albeit perceived in different ways by women at Vixens. Many resented the imposition of what they saw as arbitrary restrictions on their behavior and insulting policies that assumed they would engage in prostitution unless openly discouraged from doing so by management. All of this framed Paul's quick explanation of legal boundaries that he provided to new dancers on their first night of work. "I'll pretend you're a new girl," he said to me after he sat down and asked me to stand in front of him. "This is what I tell them. So," he began, in the same practiced, authoritative tone a cop would use when reading Miranda rights to a newly handcuffed suspect,

> do not let anyone touch you. You are breaking the rules if you do, and you will be terminated. Do not show your breasts except on the stage. Cover your chest when you bend to take a tip onstage. In the private dance room, there are security cameras we have for your protection. Someone is always watching to make sure no one gets too dirty, dancers or the guys in there. If you let anyone touch you, you will be terminated. It is your responsibility to make sure that these rules are followed, and we will not warn you again.

When Paul finished, I felt even more confused about where the boundaries were drawn between appropriate and inappropriate behavior. Did he really believe that a dancer could perform all night and not

be touched by anyone, regardless of whether she wanted to be? Clients expected to see breasts in the private dance room and to, at the very least, touch a dancer's waist and hips as she undulated in front of him. His statement was so contrary to the everyday behavior I experienced at Vixens that I suddenly understood why so many dancers felt angry about regulations that seemed to make no sense. Paul must have noticed this in my expression, because he added, "We have to say that, because some of the girls we get in here have no self-respect and they think they can get away with anything. We have to make them think that there are consequences."

Paul sounded like the exasperated father of a bevy of delinquent teenage girls as he spoke, and he clearly envisioned himself in a role that was not so different. Much of this discussion regarding punishment, consequences, and rules that must be followed was embedded in a barely concealed contempt for women, who were regarded as either incapable of or unwilling to follow rules. It was this nebulous nature of rules and rule-breaking that had initially popularized the use of closed-circuit cameras in topless bars. The use of surveillance cameras as control and monitoring mechanisms is not unique to topless and nude dancing establishments, and indeed most North Americans have become accustomed to the idea of being silently observed by a stranger via closed-circuit television in shopping malls and even on some neighborhood streets as part of crime-reduction efforts.[4] Yet the placement of these cameras in businesses such as Vixens as silent recorders of women's highly sexualized performances for men raises a number of complex questions regarding distinctions between public performance and private desire, beliefs about the need to restrain otherwise uncontrollable female sexuality, and, above all, the power of the gaze to normalize certain behaviors while marginalizing others.

Vixens had just a single camera mounted in the private dance room, primarily because Vixens was what sociologists Matthew DeMichelle and Richard Tewksbury have described as a "dive strip club"—meaning that it had a primarily blue-collar clientele, made limited efforts to reduce physical contact between clients and dancers, and was located in a dilapidated area (2004, 541).[5] Management at Vixens used the

surveillance camera mounted in the private dance room as a tool to determine whether dancers were displaying inappropriately sexual mannerisms or behaviors toward clients that could result in the bar's closure. The power that male management asserts over women's behavior—and, indeed, assumptions about such behavior—are keenly felt by dancers and often resented as a significantly negative statement about their moral standards. I first saw the presence of this camera during a conversation with Paul during which I noticed that a small black-and-white television on his desk was showing a particularly explicit scene. I was distracted by the sight of a nearly naked woman's back obscuring the rest of a male form, leaving only a pair of blue-jeans-clad legs visible.

"What are you watching, Paul?" I asked. I saw that there was no DVD player nearby, laughing a little as I added, "Can't you get enough of this stuff?" He rolled his eyes and shook his head as if surprised that I really did not know. "That's the view from the camera in the private dance room," he noted, and as I leaned closer I realized that I recognized the partially nude bodies of women I knew, although they were difficult to distinguish from one another because of the private dance room's semi-darkness. These images were transmitted to Paul's desk from a black-and-white camera similar to the ones used to monitor and prosecute shoplifters in department stores, but in this context, the screen displayed images of young women gyrating over male customers.

It is tempting to label Paul an agent of the state in enforcing patriarchal restrictions on women's behavior, especially given the pressure many dancers felt, as the sole income earners in their families, to accede to client demands. Yet to do so effectively removes the complexity of a situation in which male clients feel entitled to expect sexualized attention in establishments like Vixens but women (and their managers) are responsible for ensuring that it does not take on an "overt" form. Somewhat paradoxically, dancers who often have the greatest need for money to support their children are those who are the most likely to cross the blurry boundary into what New York State law defines as the "overtly sexual" realm.[6] Thus, the ambiguity that shapes almost every aspect of their work extends to dancers' personal lives as well, because dancers in severe economic need were the most likely to behave in ways that most

closely resembled prostitution. Confused, I asked Paul how he deter-
mined what was "overtly sexual."

"You can just tell when you see it," Paul said as he pulled a large bottle
of Jägermeister liqueur from the top drawer of his desk and proceeded to
drain the remainder of its contents into a coffee cup that read "Niagara
Falls!" in large blue cursive letters. "You just know, particularly with
these girls with no self-respect. So we have to watch them so they don't
try too much with the guys who come in." I was quite disturbed by this
discourse of men protecting other men (and themselves, after all) from
prosecution, and I asked about the dancers' safety. Paul sighed thought-
fully and in one of his more revealing moments added, "You know, a lot
of these girls have been sexually abused, so the only way they know to
feel good about themselves is to have a man want to touch them and tell
them they are pretty. It's freaky, but that's how it works."[7]

Paul's complex assessment, albeit simply phrased, revealed an under-
standing of the nuanced reasoning at work behind women's decisions to
dance at Vixens, which were not always as simple as the need for money.
He pointed at Star's tiny black-and-white figure on the screen, and we
both watched her dance silently for a man whose face was obscured
by her back. "You see how she doesn't push things?" Paul asked me. I
shrugged, unsure what he meant. "She's not leaning forward too much
so he can think that he's allowed to touch her, and she's not grinding
right into his lap. She's just kind of got her leg balanced on his. It's taste-
ful." All I could see on the screen was Star repeatedly tossing her long
hair with her fingers as she slowly swayed to the repetitive rhythm-
and-blues song being played in the bar. Paul noticed my confusion over
Star's "tasteful" presentation, which clearly obscured from the camera's
view anything inappropriate she may have been doing, and continued:

> Some girls, the problem dancers, they think that they can make more
> money if they really grind into some guy's lap and practically have sex
> with them in there. Some of them are like that, they don't care, and it
> affects how guys perceive this place. It's kind of like working at the
> gas station: the minute you start giving out free car washes with every
> fill-up, guys drive in expecting it every time and complain when they
> don't get it.

Paul's use of client expectations for service-oriented work at a car wash as an analogy justifying why dancers needed to restrict the amount of physical contact they had with clients is significant because it effectively removes the aspects of intimacy that so many men obviously seek at Vixens. "Star's not washing his car, Paul," I said in response. "Not actually," he said, "but in a manner of speaking, she is, since she's performing a service for money." I wondered whether the man seated on the couch in front of her seminude body thought about it the same way.

"What do you do with these things?" I asked Paul, imagining a surreal collection of endlessly repetitive videos gathering dust in a closet. "No, it's not taped or anything, that's too expensive for us. That's an idea, though," he added, laughing before switching to a more thoughtful voice. "Because I bet we could sell DVDs of this online for a bunch of money." He still looked as if he was seriously considering the idea a few minutes later when Diamond walked in and asked what we were talking about. I couldn't resist telling her in order to gauge her reaction. "Paul is going to make his first million selling DVDs of the private dance room," I said, and he shot me a mock-angry look.

Diamond wrinkled her face in an exaggerated expression of disgust. "You should use them to blackmail some of these jerks, send them to their wives," she responded without smiling. She was clearly having a bad night, although it was rare for her to let such feelings show due to her fear that others might notice and exploit the situation to their benefit. Diamond looked almost as serious as Paul had just a few minutes before about the idea of selling the tapes. "Think about it," she said, pointing a long, acrylic-nailed finger in my direction. "Some guys would pay a lot of money to avoid it getting out that they were in here. I bet some of them don't even know that camera is there."

Diamond pushed Paul's shoulder with mock force and moaned that her feet were aching and she had PMS. As she began to describe her symptoms in lurid detail, Paul stood up from his wobbly chair and left the room, mumbling something about women and hormones on his way out. Diamond smiled at me as she plopped down into Paul's chair and sighed with relief at the prospect of sitting down for a while. She seemed to revel in the momentary victory she had won by embracing the power

of her marginality, first by her half-serious idea about blackmail and then by disgusting Paul with open talk about her menstrual cycle. She leaned back in the chair and stared at the television for a few seconds before turning to me.

"These things make me mad," she said, echoing a sentiment I had heard many times from dancers, "because Paul thinks we are stupid enough to believe that they are watching us to make sure no one gets hurt, but really they just want it to look like everything's legal in here." I nodded. Star was still undulating on the screen, and Diamond began to echo Paul's praise of her expert handling of the man in front of her: "Watch how she's got her high heel right on his thigh." Diamond gestured toward Star's outstretched leg. "That guy probably thinks it's really hot, like she might touch his crotch next, but she knows that if he tries anything she can slam that spike heel right into his balls."

Diamond's description was reminiscent of an expertly choreographed dance in which each partner had completely different notions of the other's intention. Whereas Paul praised Star's sexual self-restraint as he watched the screen, Diamond notably underscored the self-defense mechanisms Star kept ready just in case the anonymous man seated in front of her tried to touch her in unwanted ways. "See, Star can handle herself in there," Diamond explained, "but other girls don't know that you can't let your guard down or those guys totally take advantage of it." Almost in illustration of this, Chantelle soon entered the private dance room with a middle-aged man in tow who immediately put his hands around her naked waist before he even sat down.

"Look how eager he is!" I exclaimed. Diamond shrugged: "They're all like that, that's why you have to show them who's the boss." Chantelle took a step backward and began to shake her hips in front of him. Again, the man's hand almost immediately began exploring her body, this time emerging in the space between her slightly open legs, and this visibly angered Diamond. I could not help wondering how Diamond had forgotten that she probably also experienced this kind of behavior repeatedly when she started dancing, and I sympathized with Chantelle's inexperience in a way that Diamond could not. Yet where I saw naïveté, Diamond saw willful stupidity.

"Chantelle doesn't know what the fuck she's doing. Move his hand away, you stupid bitch!" Diamond slapped the side of the television as if she were trying to inculcate her years of professional knowledge into Chantelle's performance. "She's lucky Paul didn't see that. I'm going to talk to her later. I don't think she understands how the camera works." Diamond did not resolve to talk to Chantelle later about ways to resist unwanted touches purely out of genuine sympathy for her, but rather because, as Paul and many other dancers often pointed out, dancers need to constantly monitor their own behavior lest clients start expecting to cross the same lines with all women at Vixens.

Anthropologist R. Danielle Egan describes how some topless dancers work under such consolidated managerial control that such women "start to watch themselves because they never know when the camera is watching" (2004, 306). The establishment documented by Egan was far more sophisticated than Vixens in terms of its income-generation potential for dancers and in its use of multiple cameras that could observe dancers at almost any time in any location, whereas dancers at Vixens knew that they could be watched only while performing in the private dance room. However, dancers in both Egan's field site and at Vixens employed the cameras as tools to enhance their agency. Egan documents how, for example, dancers negotiate the presence of cameras both by finding ways to conceal prohibited activities, such as taking extra money from clients, and by deflecting unwanted physical contact by naming the camera's presence, rather than their own discomfort, as the reason for rejection (2004, 313).

Yet the inescapable reality of the camera's constant presence was just one more clear reminder to Vixens dancers of their precarious social position as both sex workers and poor women. Dancers displayed a great deal of ambivalence toward the camera that most often spoke to their resentment of management's insistence on its protective function, which many of them considered both patronizing and infantilizing. Most Vixens dancers were keenly aware that they were responsible for their safety at work and were careful about regulating behavior within the bar in ways that almost never involved reference to the surveillance camera. This stemmed in part from the very clear understanding women

had of management's lack of interest in assisting them on their terms. Indeed, sociologist Kim Price has argued that topless and nude dancers self-regulate much of the activity that takes place in such establishments by relying on "worker solidarity" (2000, 26) in the refusal to reveal certain body parts, in punishing those who do, and in teaching new dancers about boundaries, and that such solidarity serves as a much more effective safeguard than state and club regulations. Indeed, dancers at Vixens who were aware of but unwilling to enforce the same physical boundaries as other women did not receive any sort of support from their coworkers.

Angel was the dancer most frequently called into Paul's office to be reprimanded for what employees at Vixens glossed as "getting too dirty." She would frequently wrap her legs tightly around a client's waist in the private dance room so that her lower body was pressed against his in a manner that unmistakably resembled intercourse. "Angel doesn't dance," Paul groaned one night as we watched her employ her signature move on yet another man, "she screws." He left his office soon after to give her yet another warning to the effect that this was *really* the last time he was going to warn her.

Angel often loudly complained to anyone willing to listen that such restrictions were silly, trivial, and even counterproductive. "I'm just trying to support myself, like everybody else in this place," she shouted backstage as she stood only inches from an angry Diamond, who had just threatened to break her nose if she saw her leaving the bar with another man she had wrapped herself around in the private dance room. "No," Diamond hissed, "you're just going to blow it all getting high after work. I've got plans for my life. A lot of us have kids to take care of, and we don't want whores like you in here. Maybe you don't care, but we do." Angel exploded and started verbally abusing everyone, as if to deflect their accusations, and then quickly ran out of the room.

Structurally, dancers police each other's behavior with the assumption that "worker solidarity" (Price 2000, 26) creates some form of protection and emotional sense of safety and, perhaps, even fictive kinship, but such behavior also functions to create hierarchies and discord (as it did between Diamond and Angel) because it draws upon gendered

typologies of appropriate straight-world behavior.[8] Indeed, the most profound risk that dancers—like Angel, willfully, or like Chantelle, unintentionally—face is the anger of other dancers, but women also risk losing income if they refuse to push boundaries.

In all fairness, both Diamond and Angel had valid points of view, yet there were no written rules as to what a dancer should and should not tolerate with a client in the private dance room. I chose the silence after Angel's explosive departure to tentatively broach the question of how women learned where these invisible boundaries were drawn. Star was quick to answer. "It's not like someone has to explain it to you, you just know," she said. "It's like how you just know in your gut if a guy is dangerous when you're walking alone at night or something. You just know."

Star was quick to ally herself with Diamond rather than Angel, since such alliances are a critical means by which dancers maintain a sense of control and safety in a sometimes fraught work environment. Everyone acted to create systems of self-support that operated within frameworks of rules and rule-breaking embedded in a cultural model of risk that pushed individuals to amass adequate protection without entirely alienating themselves from the gray world in which they earned an income. Star had quickly followed more senior dancers like Diamond and Cinnamon in assigning some sort of mysterious female intuition with the responsibility for determining when a client would go too far in his spoken or unspoken requests for physical intimacy. Cinnamon offered the most revealing appraisal of how women developed this ability to quickly determine men's real intentions and appropriate responses to them:

> Honestly, life teaches you. When people treat you bad your whole life, then you kind of learn to expect that, but you also figure out how to hustle back a little bit, because you have to if you're going to survive. You learn a lot about people's characters and about what's inside them when you don't have anyone in your life you can depend on. So, yeah, I guess that's the long version of how you get to the point where you just know when some guy in here is going to try to push it with you, and how you're going to respond without making him mad so you'll still get his money so you can pay your bills. That's the hustle in here, but that's also the hustle out there, in life.

In Cinnamon's opinion, the way that dancers "just know" is yet another cumulative by-product of a life framed by the need for quick response to fear and constant volatility.

GETTING OUT

Women at Vixens remained ever attuned to the reality that their ability to take work-related risks would not last forever. The difficulties they faced in balancing the destabilizing nature of living a life that many U.S. social institutions and cultures regard as tainted and undesirable often prompted dancers to formulate alternate plans for the future. Some-times, as in Angel's case, these were sabotaged by recurring problems associated with alcohol or drug abuse, but for women like Diamond, who planned to move on to a more prestigious dancing career at a lucra-tive establishment in a larger city, or Chantelle, who was saving money by dancing before her pregnancy became visible, it was easy to visualize a path toward greater financial and emotional stability. This planning ahead was in no small part due to the stigmatization that their work situation entailed, but such strategizing is more complicated than it may initially appear.

In their study of different types of women who work in topless danc-ing bars, social-work scholars Lacey Sloan and Stephanie Wahab (2004) conclude that women were most likely to leave sex work when they tired of the work or when someone else began providing financial support—a generalization that could probably be applied to most professions. The authors conclude that the varying motivations and perceptions of work by women grouped into the categories of survivors, workers, noncon-formists, and dancers suggests "a continuum of experience with vary-ing degrees of choice, and demonstrate[s] the limitations of dichotomous thinking when it comes to understanding the lived experiences of women in the sex industry" (2004, 1). Women Sloan and Wahab characterized as "nonconformists" described being drawn to the stigmatized aspects of topless dancing, and "dancers" felt they had found a professional call-ing. Both of these groups were most likely to leave dancing when the

work became boring to them. "Survivors" and "workers," conversely, were far less educated and thus quit the sex industry only when another option for financial support became available to them.

Certainly dancers at Vixens evinced similar motivations and reasoning, and these did not remain static throughout the time that I knew them. Indeed, some women embraced multiple categories described by Sloan and Wahab. Diamond, for example, readily described a complex sense of her professional self that involved a long history of difficulties with men as well as her love of performance and dislike of authority figures. She genuinely believed that dancing topless was part of a broader path toward self-improvement that ensured she would not be placed in a marginal and exploitative life situation again.

"I want to save money so I don't become like some of those other girls, all strung out and half dead," Star explained, using a similar line of reasoning. "The thought of becoming like that absolutely terrifies me, really freaks me out." Unlike many other dancers, Star thoroughly subscribed to the heterosexual fantasy of monogamy and domesticity, which she finally managed to achieve when she married her Iraq-bound soldier. It was quite remarkable that she continued to have such faith in monogamy, given the routine evidence her clients supplied her with that marriage was anything but a stable, admirable, and secure institution. Almost all of the men I encountered at Vixens were married and eager to criticize their wives as unattractive, undesirable, and overweight, which they constructed in direct opposition to the women they met inside the club, who were without exception relatively slim, young, sexualized, and, perhaps most notably, unable to make the kinds of demands that their wives could.

Why did Star so desperately want to enter into marriage, an arrangement that was so resoundingly dismissed at Vixens as devoid of love, desire, or fidelity? As discussed in chapter 5, her joint child-care and living arrangements with Cinnamon were already extremely stable and reliable, and in fact fulfilled all the same structural functions as heterosexual marriage exceedingly well. Star and Cinnamon had the kind of stability and trust that almost none of the men they met at work shared with their wives, and so it initially seems unclear why Star would so

strongly desire to get married. However, she was emphatic that to her marriage meant stability:

> It's completely a cliché but I want to get married again. I want a house and babies and a husband who makes all the money. I want my boys to have a good life, one that's better than I could give them. Some guys come in who want to rescue us, I suppose they think we will be eternally grateful to them. It never works out, though, because they always get jealous. I mean, they know who those guys are who come in, and they know how they think because they used to be one of them!

Acknowledging her desire for marriage as "completely a cliché," Star nonetheless insists that getting married is the only route to a better life for her and her young sons.

Cinnamon and Star frequently argued about Star's propensity to date men she met at work, with Cinnamon consistently insisting that getting married to one of them would be tantamount to opening herself to a lifetime of emotional abuse. Cinnamon knew from experience that men who initially found the idea of a relationship with a topless dancer alluring and exciting sooner or later gave in to jealousy, something Star alludes to in her discussion of the difficulties inherent in sustaining a relationship with a man. However, she resolutely defended her position by noting that a relationship was her only possible exit strategy as well as her reason for wanting to leave the profession as soon as she was able:

> Having a relationship is not easy for dancers, that's why I want to quit. Maybe it is naive to think I can meet a guy in here and have it last, but I've had so much heartache being a single mom already and then having to explain my job on top of that. Guys don't understand that we aren't hookers. I want out of this business because I've seen too much already. I look at some of the other girls, like Cinnamon, who I love and is my sister, and I see that this business just makes you so hard and cold. You lose faith in love when you see all those men leave their wives and children at home to come here, it makes you feel bad. You get cynical. I don't want to lose my faith in love. My boys are still little and I'm twenty-six, so there is still time for me. It's like a little window of time, but I really do believe that if I got married to a guy with a steady job I could fix everything, make it all right.

Star's pitiful summation of losing faith in love speaks to the contradictory set of messages dancers receive both at work and as women who have been socialized to believe that heterosexual monogamy in marriage is the most desirable form of relationship. Her belief that she could "fix everything" once she found a life partner who could support her and her children seems almost heartbreakingly naive when taken in conjunction with the kinds of experiences she had every night at work with men who had left their wives and partners at home to watch other women dance seminude for money. Nonetheless, Star's desire to get married was part of a profound set of social, gendered pressures and expectations that were definitely part of how she hoped to resolve the stigmatized aspects of her life.

Cinnamon was much more cynical as a product of her years of experience as a topless and nude dancer, and she often described herself as "completely jaded." She was the most likely to be heard uttering some variation of "Men are assholes, what do you expect?" backstage when another dancer complained about ill treatment by a client. In fact, I heard her say this so often that I began to subconsciously associate the phrase with her. She laughed for several minutes when I confessed this to her, and when she finally stopped I asked her if, given her strong dislike for the gender she catered to at work every night, she ever thought about doing another kind of job. Cinnamon nodded seriously, and it was clear that she had spent time pondering the subject, but she was quick to mention that more than a decade of experience in the sex industry and her lack of a high school education made it difficult for her to envision a practical path toward another kind of future.

"I've been doing this so long," she explained, "it's like, this is me. I've been doing this since I was fourteen, this is how I've brought my kid up. I guess maybe I'd like to be a nurse. I'm good at stuff like that, taking care of people. But that's a long road, you know?" Clearly women realize that topless dancing is not a profession that respects seniority, since the industry benefits from the variety resulting from high employee turnover and, in most establishments, prioritizes youth over skill.

Chantelle, of course, had the most pressing temporal constraints on her work of anyone at Vixens due to her pregnancy, and she planned

to quit as soon as she entered her second trimester. Gesturing to Cinnamon one night as we sat backstage discussing her plans to leave in a few months, she noted, "I'm not like these other women who wind up doing this for years. I grew up Baptist, right?" The distancing technique Chantelle employed vis-à-vis Cinnamon was as much a self-preservation mechanism as a statement about being in a situation she felt was beneath her dignity. Paul sometimes joked about this propensity of topless dancers to dismiss each other and the profession in general, thus elevating themselves to a higher moral level in their own minds. "It's like in prison," he laughed as he lit a cigarette. "Everybody you talk to is innocent, and only the other guys are really bad. In here every dancer thinks all the other girls are sluts except her. Maybe they have to think that way, who knows?"

The need to engage in such psychological coping mechanisms and behaviors reveals why so many women who begin dancing out of financial necessity simultaneously demonstrate a strong desire to leave the profession as soon as possible. Scholarship on how dancers mitigate this bifurcated self, one part of which must reluctantly engage in a certain form of work, reveals a number of techniques that help to preserve a sense of individuality and personal morality in a situation that often proves destabilizing to both. Sociologists William Thompson, Jack Harred, and Barbara Burks, for example, have assessed how topless dancers manage the stigma of their work by using cognitive and emotional dissonance to the extent that dancers sometimes referred to certain actions and behaviors by using their stage name rather than their real name (2003, 568).

Sociologists Holly Bell, Lacey Sloan, and Chris Strickling (1998) have also shown that the agency involved in dancers' work is mitigated by its stigmatized nature. While many dancers the researchers spoke to often indicated that although they "did not care" (1998, 356) what the outside world thought of their work, letting others know what they did to generate income was an entirely different matter. Indeed, children and loved ones were often cited as the reason for leaving the profession. Yet, as we saw earlier, they were equally mentioned as the reason for staying in it.

Diamond was by far the most professionally ambitious of all the Vixens dancers, regarding her work as part of a long-term career in which she

was likely to succeed because of what she considered to be innate talent. Her plans for social mobility were extremely clear-cut, and she often made lists of life goals that she hoped to achieve, such as visiting several European capital cities and owning a house of her own. Despite countless setbacks and life lessons to the contrary, Diamond believed that she was definitely on an upward trajectory from which she could not be deterred by debts, bad ex-boyfriends, or abuse from male clients at work. Diamond had a powerful belief in planning that sustained her through what she saw as a work environment that was far beneath her skill and ability level.

"There are different markets," she explained to me as we drove to the mall one afternoon to search for stiletto-heeled boots that we heard were on sale. "Like how you wouldn't open a Mercedes dealership here because there aren't a lot of people who can afford to buy them." She checked her reflection in the mirror, wiping away an errant smudge of lip liner as she spoke. "In Atlanta or Miami, there are much-higher-end places where there is room for growth. So when guys come in and ask me, 'So, diamond-in-the-rough, huh?'—like I haven't heard that one before—there is some truth to it. I'm better than that place." We were driving on a highway framed by the hollowed-out shells of former factories, some of which were closed over a decade before. It was early December, and already formidable mountains of snow had frozen into grayish brown heaps in the parking lots and tiny front yards of housing projects that dotted the empty landscape.

Diamond was undeterred by such bleakness and continued her monologue, which I had heard several times over the past few months: "Ultimately, I'd like to have my own club because there aren't a lot of places run by women, let alone dancers. I think all my experiences would really help me be a success in that, but first I've got to get a better sense of what it takes, and that's why I have to move." Diamond had a strong belief in the power of negative experiences to forge individual strength. Diamond kept talking, characteristically describing herself as ambitious and hardworking in the face of adversity. "I feel like I've always been trying, but a lot of shit always got in the way, my whole life," she said. "That's exactly what it is, just shit, and by that I mean messed-up families, losers who don't want to work and just lay there on my couch all day playing

video games they bought with my credit cards. I've learned, you know, with time, that the only person I can control is myself, so that's what I'm focusing on now, self-control." Diamond thus envisioned her path toward financial and, more important, emotional independence as centered on her ability to manipulate situations to her advantage—a cultural logic that over time had become increasingly hard and inflexible, as she explains:

> When I was younger, I used to think that maybe I'd meet some guy I could trust, and we could work on moving forward together, but now I see that's not gonna happen. Seems like every time I put my trust in someone, he uses that trust, abuses that trust, to pull me back, to pull me down from what I should be doing. And I'm twenty-five now. I think that's more than old enough to "know better," as they say.

Diamond framed her worldview around a remarkable resilience that was based upon the assumption that she alone was responsible for her future and only she could help herself navigate a sea of unreliable boyfriends, male clients, and various other individuals who could potentially offer her assistance. Her cynicism thus had a pragmatic quality to it that was both rare and exceptional, and I admired her ability to see past the temporary struggles of the present. She dismissed my compliment and noted, "I've been married and divorced, worked at all kinds of jobs, and I know that this is the best I can do. This is what I'm good at and where I make the money, and it's just what I know."

Diamond was very much an exception in terms of both her ambition and her elaborate planning for the future, but so much organization also had a hint of desperation about it because of its fantasy quality that suggested everything would improve once she relocated. "After four years of dancing," she added, "I better know what I'm doing." Diamond was not referring to skilled levels of performance, but rather the necessary coping strategies that all dancers must develop in order to maintain a sense of emotional and physical autonomy. Almost all dancers I met were quick to underscore how they were part of a profession that demanded a special ability to distance oneself from the work, since the failure to do so occurred at the risk of losing one's very self.

It is hardly surprising that with so much at risk, few dancers fail to develop this necessary, albeit unclearly defined, set of abilities. These strategies for self-protection are notably predicated on the assumption that the dancer is in control, a belief that may be true in many cases but certainly not all. They also invoke normative gender roles about female sexuality that position women as innately responsible for sexual aggression perpetrated against them, and it is thus not surprising that dancers frequently use the adjectives "good" and "bad" to describe each other.

Angel was almost always cited by other dancers at Vixens as the woman who encompassed all the qualities of a "bad" dancer: she went home with men she met at the club, was rumored to be a prostitute, and was seriously struggling with drug and alcohol addictions that threatened to kill her on more than one occasion. These problems had physically marked Angel, and her excessive thinness was often described by dancers, management, and clients alike as akin to that of an AIDS patient in the final stages of decline. This analogy was, of course, particularly sobering in light of the realities of her life.

"I don't have a future," she replied brusquely to my question about her life plans, and then lit a cigarette. I paused and then did the same, hoping that she would continue, and then I felt surprised when she asked me if I was waiting for her to say something. "How can you believe that you don't have a future?" I asked her, confused because she had spent part of the early hours of her shift that night talking to me about plans to take a high school equivalency exam that would improve her employment prospects in the formal sector by at least a bit. She looked me in the eye and shook her head:

> Would I be here if I had some great ambition to be somebody? I come here, make a couple hundred bucks, and then I go get high. That's my life. I'm not ashamed. Look, a lot of people are hypocritical, but I'm not one of them. Everything I've tried I've fucked up completely. I dropped out of school because I was pregnant and sixteen. Then my little boy got taken away because I couldn't quit getting messed up. I guess I'd like to get a GED, but what's the point when the only job I'm going to get is at Burger King? It's too easy to get used to the money here, and I've never thought I was going to make it to old enough to quit doing this, the way I live. I'm surprised some days that I've made it to twenty.

Angel's problems with drugs and alcohol routinely seemed to sabotage her life like free agents rather than the choices that they were, and she almost always described herself with negative adjectives not unlike the kinds of abusive words particularly offensive clients might use with dancers.

Angel's jokes about her propensity for self-destruction were usually ignored by other dancers, as was she, and it was sometimes frustrating to watch her accelerated decline so ignored and disregarded by others. Her recurring bouts of intoxication, so severe that she occasionally fell off the stage or passed out in a client's lap during a private dance, were becoming a serious enough concern that Paul, under pressure from other dancers, was beginning to consider dismissing her. This was contrary to practice at Vixens, which generally sought to employ as many young women as possible because of the frequency with which dancers unexpectedly quit and also because of the desirability of variety. Management was able to maintain this variety through high employee turnover because of the large population of professionally unskilled young women available in the region. Like quite a few Vixens dancers, many sex workers cross-culturally often characterize their position in such a stigmatized profession as a short-term solution to a temporary financial crisis (Brennan 2004; Brents, Jackson, and Hausbeck 2009; Day 2007; Kelly 2008). Yet the belief in this temporality is often what leads to the most abusive working situations in the first place. Despite such clear understandings of their marginal position in the world, dancers consistently viewed sex work as part of their self-improvement strategies. As we will see next, many women conceive of their sexual labor as part of a greater path to independence and, as Star so succinctly put it, "a whole new beautiful life."

Socioeconomic instability has been a familiar part of life in upstate New York State since the advent of deindustrialization. The choice of the casino as a kind of code to propose the exchange of sex for money is significant in that it reveals a great deal about the perceptions of risk and sexualized danger shared by many Vixens visitors. The casino made reference to by men who seek to purchase illegal sexual services at Vixens outside of working hours is located approximately thirty miles away from the bar and can be reached by car in about twenty minutes.

It opened in the early 1990s as part of economic-rejuvenation efforts designed to create desperately needed jobs and generate income for the Native American community on whose land the casino was located,[9] and it is, in many ways, a disturbing burst of affluence and artifice in the midst of rural poverty.

The casino referenced by Vixens patrons functions as something of an escape for the local population and yet presents a vivid scene of desperation well-matched to the gray postindustrial landscape outside: human arms robotically pulling slot-machine levers, dizzy-patterned carpet, and electronic sounds. One Tuesday afternoon Star and I were sitting alone at Vixens drinking beer as she complained about how little money she had made that day. Day shifts were always slow and not very lucrative, and Star felt particularly frustrated since Cinnamon had the flu and was at home with their three children. "Hey," she said, elbowing me and smiling conspiratorially, "want to go play some roulette?" I shrugged, we got into her car, and we were soon smoking cigarettes as we watched the dismal gray landscape pass us on the New York State Thruway. Thick forests depleted of foliage stuck out from the snow like broken equipment left behind on an abandoned construction site, their darkness reflected in the colorless sky.

Star started speaking in the artificially deep masculine voice that she often used to mock particularly annoying men she met at work, putting her hand on my leg for effect as she drove. "So, uh, what's your real name?" she said as she squeezed her grip tighter on my thigh. I felt a shiver go through my body as she laughed. "Come on, why so shy?" she added, deepening her voice further still. "Don't tell me this is your first time doing this." I laughed in an attempt to dissipate some of my discomfort, remembering that I was sitting next to my friend Star and not some anonymous man, but she automatically sensed that something was wrong. "I'm freaking you out, aren't I?" she asked, "I'll stop. Sorry, I just think it's so funny."

"What?" I couldn't help it. "What is so funny?" She shook her head: "I guess maybe it isn't so funny, it's just weird to think about what goes through men's minds when they are in that kind of situation, like they think they need to make small talk." Star, who just days before had

vociferously complained to me about how Angel's refusal to abide by the rules against meeting clients outside of working hours negatively impacted "good dancers" like her, was a bit too expertly imitating what a man might say en route to a paid sexual encounter. Before I could stop myself, I turned and asked her, "How do you know?" She burst out laughing, although I wasn't quite sure what was so funny. "Seriously?" she asked. "Don't you ever wonder how it would be?"

Star's strange ambivalence about sex work manifested itself alternately as a subject of humor and as a topic of serious concern, and this disturbed me deeply. I tried to imagine how many women I saw every day at Vixens secretly made trips like this despite their public condemnations of such behavior, listening to the kind of male language mocked by Star as they thought about what the money would buy.

"Come on, you're getting all serious again," Star complained, pushing me a little as she pulled into the enormous casino parking lot, which was disturbingly full at 3 P.M. on a Tuesday. She beamed after checking her lipstick in the rearview mirror. "I love gambling," she announced. "I love it. Cinnamon thinks this is such a total waste and I know that's right, but I love the idea that I could walk in there with twenty bucks and come out with enough to buy a house." I felt strangely unsettled as I followed Star into the palatial casino, its bright colors and sheer glittering immensity strangely out of place in the rural area that surrounded it with gray ramshackle farmhouses.

I watched as Star bought twenty dollars' worth of chips and headed to the roulette table, placing a bet on the number seven, the day her first baby was born. As the croupier spun the wheel Star stood completely still, her eyes on the small metal ball as it made its rotation around the numbers, and I felt dizzy and sick. I thought about risks and their value, the risks I was taking by continuously placing myself in a space of such obvious sexism and danger. I thought about Chantelle's concern that one of her new regulars had followed her home and often parked his car outside her apartment building at night. "It's too dark to see what he's doing," she explained to me fearfully one night. "What if he has a gun?" I began to worry about my nonchalance toward the place I where spent so much of my time.

As I watched the ball spin, the look of eager anticipation on Star's face impossible to miss, I wondered what forces combined to make it worthwhile for women to gamble with their lives in a business that was so clearly working to destabilize them in so many ways. Did they really know what they were dealing with when they received these offers of money for sex—amounts that they could otherwise earn only through a week of work at another similarly low-wage job? Every one of the dancers I met had a horror story akin to Chantelle's about a client who just would not take no for an answer, sometimes by insisting that he had fallen in love and wanted to rescue someone as sweet and innocent as her from such a morally bereft place as Vixens. Sometimes these stories ended in death.

Suddenly the roulette ball landed on sixteen, and Star snapped her fingers in reluctant resignation. "Better luck next time," she said.

Body Work and the Feminization
of Poverty

DIAMOND

We blue-collar girls never have any trouble popping out the babies. No
one I knew growing up ever had any trouble getting pregnant—it was
something girls tried to avoid because getting pregnant ruins your life.
I never want children, ever. Maybe something is wrong with me, but all
I've ever seen in my own life is that having a man's child ties you to him
forever, even if he leaves you, and I don't think I can trust a guy that much
after everything I've been through.

 People always say it goes back to your childhood, right? My dad was
in Vietnam and I think the whole experience messed him up pretty bad,
so we all ended up suffering for it. He had a regular job and all, but he
would get smashed and totally flip out every month, like all that pent-up
anger just had to come out. As much as I hated him and couldn't wait to
get out of his house, I ended up with a bunch of guys just like him when

I was still real young. It's the same story for me every time: I always feel like something is going to change and it's going to be different, but they all end up being just the same dude who wants to control everything.

I'm twenty-five now, and I'm pretty much finished with men unless they have something I want that they can give to me. The way I figure, if you don't have high expectations then no one can let you down, right? I've got about $8,000 in credit-card debt that Jeff—that's the last guy I was with before Paul—ran up on the cards that were in my name before he moved out. I make about $150 a night here, sometimes $300 or $400 on a really good night, and so after rent and everything else I need in a month, I just can't pay that much money off anytime soon. I just want a clean break from him, a new life where I don't get bills for things I didn't even buy or do. There are only a few ways for someone like me to get so much money that fast, and since I'm not a prostitute and I don't want to rob a bank I decided to answer one of those ads fertility clinics put in the newspaper.

I sent in pictures of myself and filled up a ten-page application about how much I wanted to help another woman have a baby, as if I really believe that. Seriously, do these people actually think that I would shoot my body full of drugs and go through all that pain for some people I'll never even meet if I didn't need the money? The whole thing takes about two months, and I'm almost done with it. I don't know the couple getting my eggs, which is just as well since I didn't say where I work when I applied to do this. I just wrote "student" where the form asked for my occupation. People tend to judge, you know? The shots hurt a lot and I have real bad mood swings, plus I'm really scared of the surgery, the part where they take the eggs out. I've never had anesthesia before.

They told me that there are "no known adverse effects"—that's exactly what they said—but I know it's not true. This is one of those things where a few years down the line all of a sudden doctors will be like, "Oops, we didn't know—sorry you're going to die!" Right now, I try not to think about all that. I'm getting eleven thousand dollars for doing this, so I'll use most of it to pay back my cards that Jeff ran up, and the rest I'm going to use to get implants. I want to move to Atlanta or Miami. There are really good clubs there where I can make way more money than I do here, but I need to save up first and I need implants anyway if I'm going to work in a more upscale place, because there you have to look like a Barbie doll.

The only thing that really bothers me about this is when I have to go to the clinic for checkups. I don't feel like I'm having someone's baby or anything, but when I sit there I'm always the youngest one because a lot

of those women there waited too long to have kids and that's why they're having trouble in the first place. So there I am, the only one sitting by myself without a nice husband, and since I look younger than I am, they know that I must be a donor. They all sit there with their nice husbands who just came in from the office and still have their ties on, looking all concerned, while those women just sit there and glare at me. It's like they hate me because I have that power to make babies and they don't.

"A CLEAN BREAK": BODY WORK AMONG VIXENS DANCERS

The intimate connections Diamond draws between feminized vulnerability and the monetary value assigned to her sexuality and reproductive potential, both at work and at the clinic, raise profoundly troubling questions. Accordingly, arguments presented here will build upon this book's earlier discussions of survival strategies, personhood, and risk among Vixens dancers to examine the demarcations between supposedly altruistic forms of body work, such as Diamond's ova donation, from other types of work intimately connected with poor women's bodies, including sex work. These blurry boundaries stem from the moral ambiguity expressed toward these practices in law, in popular opinion, and sometimes even by those directly involved. Such labor is stigmatized due to its location on the legal and ethical peripheries; yet, as Diamond's narrative suggests, this type of work can also be construed by those who perform it as strength-giving in situations of relative disempowerment. Diamond's role as an ova donor made her feel like an object of disdain and contempt, yet this negativity was partially mitigated by her belief that her decisions placed her on an upwardly mobile path.

Diamond truly believed that her ova donation was a necessary, quick solution to the pressing crisis of a debt that she otherwise had no means to repay and looked forward to what she called "a clean break," a new phase of her life free from further exploitation by men she trusted. Her long history of abuse by men she had loved and trusted, including her father, shaped both the path to her decision and what she saw as the road away from further trauma. If she could just manage to repay her

debts and move to another city to start a new life, Diamond thought, she would be able to establish a sense of control over her own life that had thus far eluded her.

Social scientists have only relatively recently begun to seriously consider the intersections Diamond describes between embodiment and labor, coining the term *body work* to broadly conceptualize the complex social terrain upon which these intersections take place. Sociologist Carol Wolkowitz broadly defines *body work* as

> a move toward conceptualizing paid work that takes the body as its immediate site of labor, involving intimate, messy contact with the (frequently supine or naked) body, its orifices or products through touch or close proximity. This kind of paid body work is a component of a wide range of occupations, for instance care assistants, dentists, hairdressers, maids, undertakers and yoga instructors . . . [This definition acknowledges] the centrality of these kinds of body work to postindustrial national and global economies. (Wolkowitz 2006, 8)

This set of occupational activities, as noted by sociologist Debra Gimlin (2007), has been characterized by several strains of thought in related social science literature, each uniquely highlighting specific facets of body work.[1] Gimlin astutely notes that in all professions, "bodies, body work, and sexuality too are sold, both to the employer and by the employer, explicitly in the case of prostitution, less so in the case of the 'attractive' secretary or the 200-lb. doorman" (2007, 355). Thus body work involves the maintenance or modification of one's appearance yet is also characterized by "distancing techniques," such as surgical gloves, uniforms, or the delegation of unpleasant tasks to lower-status individuals, "whereby status in a profession is marked by distance from the body" (Twigg and Atkin 2000, 391, cited in Gimlin 2007, 358).

Gimlin further observes that body work also involves the management of emotions in occupation-specific ways that are clearly gendered. This is particularly notable in the cases of flight attendants (Hochschild 1983), beauty queens and actresses (Dewey 2008a), and beauticians (Gimlin 1996), all of whom must engage in unique interactions with their interlocutors to present the facade expected of their particular occupational

role. Most significantly, Gimlin highlights how "the work environment is literally 'written on' the body, including those of workers who attend to other people's bodies. . . . [E]xperiences have a corporeal reality that is inevitably embedded in the flesh" (2007, 363). These intimate connections between bodies and the labor they perform is especially salient for poor young women like Diamond, who have little else to rely on for their everyday survival. Queer theorist and former sex worker Amber Hollibaugh powerfully underscores the embodied nature of blue-collar work for women, noting, "[It was] that gift of being young that got me through. I could dance, clean houses and office buildings, and work the graveyard shift at the . . . factory, all three if I had to. It was my only safety net. I could make my body work. It would get me a paycheck week after week" (2001, 170).[2]

As implied by Hollibaugh's use of the body as a "safety net," women who engage in the types of body work Diamond did to quickly repay debt are thus extremely unlikely to make demands on the kinds of conditions such work involves because of their limited alternatives for income generation. Diamond saw herself as unable to dictate many of the terms under which her reproductive labor was sold, and she worried that to argue too much with those who held authoritative, decision-making roles vis-à-vis the conditions of her provision of services would risk her losing an opportunity for income generation altogether.

Diamond understandably resented what she regarded as the patronizing way she was treated at the fertility clinic, yet she did not complain to the nurses or doctors because she feared that she would not be able to collect the eleven thousand dollars they promised to pay her after her ova were removed. During her visits, doctors would routinely ask Diamond for permission to double the dosage of ovarian-follicle-stimulating hormones she was injecting herself with on a daily basis, since medical professionals are required to obtain patient consent before radically increasing the amount prescribed. However, doctors would "ask" Diamond for her permission by reminding her that the contract she had signed with the clinic explicitly stated that she would not be paid unless the ova extraction was successfully completed. Diamond clearly resented this coercive strategy but saw no alternative other than

to agree, particularly given that she had already invested so much phys-
ical suffering through daily injections and weekly medical examinations
without pay.

Diamond emphasized the provisional nature of her situation at least
in part because of the negative emotions she associated with visits to
the fertility clinic, strident criticisms from her sexual partner (and man-
ager) Paul that she was "selling children," and the harsh short-term and
largely unknown long-term effects of the fertility drugs she injected
daily. Diamond and others like her thus tend to see such employment as
a short-term solution to a temporary problem even though it is often part
of a much broader life pattern of instability and poverty, as to do other-
wise would be tantamount to admitting defeat by joining the ranks of the
victimized. Anthropologist Loïc Wacquant documents an almost eerily
similar philosophy among aspiring boxers in inner-city Chicago, who
follow Vixens dancers in refashioning their exploitative relationships
with promoters and managers as opportunity amid scarcity, "thankful
for the chance that the latter grant them to play this queer lottery with
one's skillful body" (2002, 188). Echoing Diamond's motivations for
engaging in potentially harmful ova donation, Wacquant's boxers clearly
resist the constraints of their everyday lives, albeit in dangerous ways
that can cause severe long-term physical damage.

Legal forms of body work most directly associated with sexuality and
reproduction are simultaneously framed as both legitimate, because of
their legality or semilegality, and illegitimate because of the profits they
generate. This reality necessitates the development of a unique cultural
logic that allows such body workers to negotiate their participation in
a stigmatized realm that often must be kept secret in order for them to
claim membership in other aspects of social life. Mothers who work in
the sex industry, for example, are often hesitant to reveal this fact to their
children's teachers and other authority figures because they are aware
that their labor positions them as suspicious characters tainted with any
number of untrustworthy qualities. Sociologist Carol Wolkowitz notes
that ever-increasing numbers of individuals who perform various types
of body work, including nursing, caregiving, and sex work, come from
migrant or subjugated communities as part of what sociologist Arlie

Hochschild calls "the wrenching global inequalities at the heart of paid body work" (cited in Wolkowitz 2006, 149).

These individuals are essential to the smooth functioning of a capitalist economy and yet remain branded with a stigma that is often perpetuated as much by body workers as it is by those who benefit from their labor. For instance, it was Diamond's reproductive work that was most critical to the fertility clinic's successful operation, and yet she and other ova donors like her remained the least well paid and most disrespected of anyone associated with the fertility business. The nature of stigmatized body work is such that its laborers are primarily poor women who lack other opportunities for income generation—a fact that is only partially mitigated by the complex justifications that characterize both individual and broader cultural understandings of fair exchange.

Legal theorist Margaret Jane Radin (1996) notes that the inherent uneasiness surrounding cultural practices as diverse as organ donation, sex work, and surrogate motherhood stems from related sets of behaviors and beliefs that characterize each. Such phenomena, Radin argues, push intimacy into the same anonymous patterns that characterize a free-market economy by applying the same logic of supply and demand to areas of human interaction that are publicly deemed "private." It is important to note, however, that the recipients of body workers' reproductive and sexual labor are themselves not necessarily imbued with a sense of all-encompassing privilege entitling them to such services. Anthropologist Marcia Inhorn cautions against oversimplifying fertility-related exchanges into a hypercapitalist model that "overprivileges reproductive agency, [thus] underestimating the amount of free will and lack of free choice that so often characterize women's lives as they operate within multiple sets of structural and cultural constraints" (2003, 17). Clearly, limitations imposed by embodiment are common to all humans and extend far beyond the realm of poverty.

Body work often takes an emotional toll on its laborers because it firmly situates them in the blurry space between private and public, thus attaching both a stigma and a mystique to their labor. Both sex workers and women who intimately engage in conception and childbirth-related tasks for pay share an extreme ambiguity in that both areas are highly

gendered, heavily classed, and service based.[3] This underscores how such work is simultaneously attractive to poor women due to the high income many believe it generates and repugnant because of the avaricious, self-interested motives its recipients are often believed to share. As such, these inherent contradictions reveal much about the nature of this labor as well as U.S. cultural values ascribed to income, work, and class status.

Transience characterizes many forms of body work, since almost none of its numerous variations allow for any kind of long-term career prospects or serious material advancement because of the heavy toll it takes on the physical selves of those who perform it. Such relatively short-term work is thus paradoxically marked by extremely long-term psychological and physical effects, the latter of which have yet to be medically ascertained for ova donors. Like Diamond, many women who engage in such activities are clearly aware of these effects (or the possibility of as-yet-unknown risks), and still they choose to participate on what they know are unequal terms because they hope that the risks incurred will eventually be outweighed by the gains. This belief system is hardly unique to dancers and has parallels in many populations that rely upon their physical selves in work environments that pose high risks to their health and safety.[4]

Body workers like Diamond, Cinnamon, Angel, Star, and Chantelle develop and embrace unique cultural logics that help to both justify their choices and offer rationalization for what they know are gross injustices framing their everyday lives. A number of factors contribute to the cultural logic that informs decision-making and risk-analysis processes among such women, including a desire for a better life for themselves and their families, the realization that other work is not as flexible (despite being much less stigmatized and dangerous), and, most revealing, the belief that no other options are available to them. This is why some women so consistently seem to choose work that poses the greatest risks to their overall well-being. Rather than simply "not thinking," such women are in fact thinking very clearly as they make pragmatic plans of action in severely limited circumstances.

It follows that "security" is conceptualized by individuals in extremely different ways, especially during individual periods of serious economic

instability. Yet how do women like Diamond come to believe that participation in particularly dangerous forms of body work is their best option in an extremely limited range of other choices, and how do they make sense of their decision in the context of their broader lived experience? To answer these questions, we will now explore how the resulting social stigma incurred by their participation intersects with the sense of agency and power that income generation produces. This intersection, in turn, sometimes functions positively by allowing women to think about possibilities for their futures in new and different ways that would have previously been impossible.

For instance, Diamond's choices were informed by a sense that she was doing the best she could to succeed in a constrained environment with odds heavily stacked against her. She knew that the structural factors of inequality and social exclusion that framed her life created the context for a string of problematic relationships with men beginning with her father and continuing to her on-again, off-again sexual partnering with Vixens' manager, Paul, and had combined to place her at a distinct disadvantage. Nonetheless, Diamond was undeterred and thoroughly embraced a variation of the Protestant ethic that gave priority to repayment of credit-card debts incurred by an ex-boyfriend in her name, social mobility to a more prestigious and lucrative work location, and legal (albeit stigmatized) forms of income generation.

Diamond's employment of these essentially U.S. values helped her to assert that she should not be judged since she was, after all, working hard to move herself up the socioeconomic ladder. She is hardly alone; most women at Vixens used the same sorts of typologies to justify their work as worthy of respect due to its legality and distinction from prostitution. Diamond thus engaged in a risk analysis of her limited life options that closely followed the logic of desperation and hope in that she knew that she was exposing her body to unknown long-term consequences by selling her ova to a fertility clinic but simultaneously believed that this was preferable to prostitution or theft, which she cited as her only other options for income generation. Diamond thus employed a separate and unique cultural logic in facing an unknown future that was itself framed by expectations of behavioral patterns and likely situational outcomes

that had been accrued over a lifetime of inequities. Perceptions of risk must necessarily be negotiated by all individuals as part of everyday lived experience cross-culturally, yet sex workers face a number of unique dangers that necessitate distinctive psychological and emotional processes of justification. In his research on Australian street prostitutes' perceptions of the risk of HIV infection during unprotected sex with boyfriends versus the risk during condom sex with clients, anthropologist Charles Waddell found that such women effectively conducted a risk analysis in which the benefits of making a boyfriend (as opposed to a paying customer) feel valued and trusted through unprotected sex were worth the physical risks of infection that such behavior incurred. Waddell contends that this "cognitive repertoire" (1996, 77) enables prostitutes to distinguish *work sex*, characterized by condom use and the exchange of cash, from *nonwork sex*, which does not share these features.

Although the prostitute women in Waddell's study incurred significant risk from engaging in unprotected sex with nonpaying, chosen partners, they developed a cultural logic that allowed them to justify and rationalize their choice as sensible. This process was characterized by the belief that both they and their partner had a mutual desire to remain uninfected, and it combined with confidence in their ability to recognize infection through a partner's past and current behavioral patterns. Waddell also found that such women were likely to judge the risk of HIV infection as less important than the need to demonstrate emotional commitment through unprotected sex as part of a broader plan to eventually quit selling sex and enter into a monogamous relationship with their chosen partner. Many women felt that they were even less likely to be infected than women who did not sell sex because they believed themselves to be better judges of character due to their exposure to a wide variety of men (Waddell 1996, 80).

Diamond incorporated a similar framework into her life decisions by developing a rationale that assumed risk for the greater good as part of a finite path toward self-improvement and empowerment. "If I can just pay off my debts," she reasoned, "then I can concentrate on saving money to move to a place where I can make more money, and then I won't need anyone." Her ideal of not needing anyone was not so much a

declaration of her self-sufficiency and independence as it was a reflection of her feeling that such a situation would mean freedom from further abuse of her trust. Like the Australian prostitutes described by Waddell, Diamond also felt that her work as a self-described "hustler" uniquely enabled her to generate funds quickly, although in her case clearly the recipients of her ova, and the fertility clinic that they paid for Diamond's services, benefited far more than she did.

In so very many ways, this kind of cultural logic is about the power of hope to sustain individuals in difficult circumstances, and a key question stemming from it is how this hope is conceived of and realized. Why did Diamond put her life at risk to repay debt and undergo breast augmentation, a surgical procedure that further ensured that she would continue to do work that she knew was sometimes dangerous? The short answer is that she hoped her life would improve through temporary suffering, because such is the hope to survive, to temporarily improve one's circumstances precisely because the future is so desperately uncertain.

"Look," Diamond explained to me as we sat drinking gin one night and watching a pair of dancers tentatively embrace onstage, much to the delight of a group of men seated nearby, "there are much worse things I could do, like being a prostitute. It's true that I'm selling a part of myself, but it's for a baby. It's not cheap, because I'm not cheap. Yes, I'm doing it for the money, but I'm also helping someone to have a baby. They benefit and I benefit." I was unsure how to react because I, like her, understood that it was not quite that simple.

EVERYDAY "RITUALS OF SUBJUGATION"

In her seminal book *The Body in Pain*, literary theorist Elaine Scarry refers to what she terms "the reality-conferring function of the body" (1987). "Whatever pain achieves," she writes, "it achieves in part through its unsharability, and it ensures its unsharability through its resistance to language" (1987, 4). Pain thus mandates an emotional isolation that positions the sufferer at a considerable social distance from others, most notably those inflicting the pain. The infliction of pain, Scarry argues, is

an effective means of social control and oppression precisely because it renders the pained temporarily unable to make judgments that extend beyond measures designed to relieve the source of their suffering. Scarry formulated her theory of pain in the context of torture and warfare, yet its underlying theme of entrapment in the body through physical suffering is also directly relevant to individual victims of the structural violence and physical vulnerability imposed by poverty.

In her work on the feminization of poverty in the United States, feminist scholar Vivyan Adair draws upon this notion of pain and physical suffering as instruments of oppression by making direct connections between poverty's physical manifestations and its concomitant stigma. What Adair terms "the (not so) hidden injuries of class" (2001, 451) serve a powerful albeit hidden purpose by maintaining social hierarchies that explicitly disadvantage poor women. She notes:

> The bodies of poor women and children, scarred and mutilated by state-mandated material deprivation and public exhibition, work as spectacles, as patrolling images socializing and controlling bodies within the body politic. . . . [The poor woman is] juxtaposed against a logic of "normative" subjectivity as the embodiment of dependency, disorder, disarray and otherness. Her broken and scarred body becomes proof of her inner pathology and chaos, suggesting the need for further punishment and discipline. (Adair 2001, 480)

Adair's description constitutes very familiar terrain for Vixens dancers, all of whom grew up in impoverished and often fragmented or otherwise unstable homes. The unique forms of body work performed by Vixens dancers undeniably leave a powerful legacy imprinted upon their physical and emotional selves in ways that are not always immediately clear, even to the women themselves. Women who, like Cinnamon, have spent the larger part of their adult lives performing what is undeniably the very arduous physical labor of dancing for hours at a stretch in very high heels often experience many of the same long-term joint-deterioration and pain-management problems as lifelong manual laborers on construction sites. Injuries incurred in such women's youth worsen with age and combine with a lack of health insurance and affordable medical care to put their bodies at increased risk.

This "tortured body history" (Inhorn 2003, 186), produced through years of bodily manipulations and physical hardship, serves to underscore precisely why Diamond's decision-making processes made so much sense to her in the context of her life experiences, despite the undeniable risks they incurred. The frequency with which she experienced Scarry's "unsharable pain" (1987, 4) through physical abuse, long hours performing repetitive movements onstage in five-inch heels, and years of exposure to cigarette smoke and limited sunlight had convinced Diamond that her body was both a prison and a vehicle of liberation. This became particularly clear one afternoon as I sat with her on the living-room floor of her apartment and she silently lifted her shirt to massage her stomach, which was often seized by painful cramps induced by her regular self-injections of fertility drugs. Angry red bumps formed a constellation against her artificially tanned skin, marking the spots where she pushed hypodermic needles into her body at least three times a day—and sometimes more often at particular points in the drug cycle that she was undergoing in conjunction with the fertility clinic.

Part of this tensely silent introspection, in which Diamond absentmindedly caressed her injection-scarred lower abdomen, stemmed from the previous night's events, when a man Diamond was with in the private dance room noticed the needle marks above her thong and called her "a junkie whore." He had pushed her away with such force that she landed on the ground, momentarily stunned into immobility and silence. Paul, who had been observing all of this via the security camera in his office, rushed in to determine who was at fault. "She probably has AIDS," the man shouted in justification to Paul over the pounding rhythm of a song rendered unidentifiable by a problem with the sound system that night. Paul shoved the man against the wall harder than he really needed to and told him not to disrespect women like that, to which the man burst into nervous laughter before hurrying out the door. For a brief minute, Paul and Diamond were alone in the private dance room; she was still recovering from the shock of being thrown on the floor, and he was still dealing with the news she had revealed to him earlier that day of the decision visible in the tiny needle marks all over her stomach. "Are you happy now?" Paul hissed to Diamond before rapidly turning

to leave her alone on the floor. He did not speak to her again that night, and Diamond was beginning to worry that he was thinking about abandoning her altogether.

Diamond was not personally or professionally unaccustomed to male violence, but there was something about the exchange between the man and Paul that made her burst into tears. She later attributed her inability to stop crying to hormones, but there was much more to it than that. Part of her felt like she was so close to moving on with her life and finally getting everything together, and yet that man's push to the floor was a firm reminder that there was still a considerable distance between her and Atlanta, Miami, or any number of other American cities that she believed held infinitely better prospects for the future. An admonishment of her status as both a woman and an individual on the social margins, it left Diamond feeling pushed down, as she had felt many times before.

Feminist philosopher Sandra Bartky would likely term the man's violent shove a "ritual of subjugation" (1990, 27), an activity used by men to "remind" women of their status. The forms that such rituals take are greatly intensified for dancers like Diamond, who some men believe exist in a parallel world outside the normative bounds of gendered behavior. Notably, Diamond's tales of a lifelong pattern of sexualized embodiment are remarkably similar to those documented by sociologist Jennifer Wesely in her article "Growing up Sexualized" (2002), in which she documents how topless and nude dancers conceptualize the processes and events that made them aware of themselves as sexual beings. Wesely persuasively argues that both before and during their work as dancers, "women learned to use their sexualized bodies to feel powerful . . . [and yet] these objectified constructions perpetuated feelings of powerlessness" (2002, 1189). Wesely explains that all women are subjected to objectification through mass-media images and other popular cultural messages and that these are only compounded for physically abused girls and young women, who understand women's sexuality as a source of both vulnerability and self-protection in unique ways (2002, 1191).

Wesely's notion of "playing a game that women cannot win" (2002, 1198) was both supported and resisted by women at Vixens, whose accounts often evoked a precarious tightrope walk between power and

subjugation. Dancers like Diamond, for instance, saw their work as long-term and sustainable, yet they also resented the subject position its stigmatized nature conferred upon them as individuals. Despite such conflicted terrain, Wesely's model of socialization into sex work from an early age does much to explain the socioeconomic demographics of dancers at Vixens: the vast majority of women had limited support and contact with their parents or other family members who had raised them, all were poor, and many had been beaten by their loved ones. That such women should form the bulk of those engaged in body work is hardly surprising given that quite a few of them spent much of their early lives learning to keep adult secrets regarding violence, alcohol, and drug abuse—and, to some extent, the uniquely North American shame associated with poverty.

This became patently evident early one Friday night during a dancer shortage at Vixens, which came as a wonderful surprise to the six women who had come to work despite the terrible snowstorm outside that was threatening to become a blizzard. All too often, there were more women than men inside the bar, a strategy management designed to ensure maximum competition for tips from male clients or, as Paul more bluntly summarized it, "that the girls don't get too overconfident making money and turn into princesses who won't follow rules." Despite the weather, the usual array of blue-collar workers and the occasional tie-clad office professional were steadily trickling in, kicking the snow off their shoes in heavy clumps that would eventually melt into the stained red carpet beneath their feet. Everyone had wet socks and was eager for a beer. There were the usual jokes about women who were nearly naked despite the harsh weather outside. "Hey, you girls got no clothes on, and it's cold out there!" one man in his early forties exclaimed in mock surprise to Cinnamon, who had heard this at least six times already in the last three hours.

Just before the man had finished laughing at his own joke, Diamond pulled Cinnamon's arm and told her she needed to talk privately. "Are you two sisters?" the man asked Diamond. "Yeah, we're all sisters in here," Cinnamon responded more brusquely than usual, and we three women went backstage together. She was slightly annoyed that Diamond interrupted her before she was even tipped, and I quickly spoke up

before she could comment on Diamond's lack of consideration, although it was unlikely that the two most experienced dancers at Vixens would waste time in a fight. "What's wrong?" I asked Diamond. She looked like she was going to cry, and Cinnamon embraced her. Diamond explained that she had entered a new stage of the fertility cycle as part of her ova donation and that she had to begin a different course of drugs that night. "I'm scared," she told Cinnamon and me. "That needle is freaking huge. All the ones I had to use before were really small."

Diamond covered her breasts with an ex-boyfriend's white shirt that she kept backstage as she reached into her bag to retrieve a small vial half filled with powder, a container of sterile water, and an enormous syringe. "Shit," Cinnamon said, stepping away from the syringe, "that thing is huge!" Diamond lost her composure completely and started to cry. I hoped that Paul was not going to knock on the door and ask what we were doing. "It's not that big," I said, widening my eyes at Cinnamon as an indication that she should change her shocked expression, which was making Diamond even more upset. "How much longer do you need to do this, anyway?"

"I've got two more weeks to go," Diamond said as she swallowed and sat up straight, looking first at Cinnamon and then at me as she continued: "I want you to do it, I'm too scared. I can't put that thing inside me." Cinnamon threw her hands up in the air with palms facing out as if in self-defense. "No way, no freaking way," she said. "I stay the hell away from those things." Diamond turned to me, balancing the intimidating syringe on her open palm. "You?" she asked. Her voice sounded like it was about to break, because from where we were sitting she could also hear Paul's voice announce that she was supposed to be the next dancer onstage. "Diiiiiii-a-mund," he drawled over the microphone, repeating her name so the men in the audience would shout and get excited.

"OK, Mommy, here we go," said Cinnamon as she grabbed the syringe from Diamond's palm before I had a chance to react. "How much water do you need in this thing?" she asked, expertly snapping the lid off the needle and pulling sterile water from one of the vials into the plunger before injecting the bottle of powder with the liquid. Diamond tried to

take the vial from her to mix it herself, but Cinnamon pulled it back. "Don't shake it," she intoned seriously as she pushed Diamond's hand away. "It'll get little bubbles in it, and that can mess up your veins, you can die that way." Diamond groaned weakly.

"You have to put it where no one will see," I whispered as quietly as I could, almost to hide the sadness of what we were doing to our friend. Cinnamon nodded and pointed to the front of Diamond's thong, her hand cupped forward in a beckoning gesture I had seen men use with her before. Diamond sighed audibly, closed her eyes, and pushed the green sequined material of her undergarment aside while Cinnamon pushed the needle into the space just above her pubic bone. Biting her lip, Diamond suddenly started breathing in sharp little inhalations. We knew that she was in pain.

"How much are these people paying you for doing this to yourself?" Cinnamon asked after she pulled the syringe out of Diamond's flesh. "Is this shit worth it?" Diamond was still reeling in pain from the width of the needle, which, as predicted, left a dime-sized red circle that she quickly covered with the front of her thong. She shook her head, but Cinnamon refused to drop the subject. "Come on, how much?" she repeated, and when an answer was not readily forthcoming, she said, "Show yourself some respect, Diamond. Seriously. Don't let people do whatever to you just because they can."

"Shut up," Diamond hissed in response, holding up a palm to silence Cinnamon. "Just shut up."

"I'm just saying, that's all," Cinnamon replied as she mimicked Diamond's hand gesture. "I know. I know what I'm talking about. You've got to keep some respect, OK? There are ways."

Cinnamon left the room, and Diamond turned to the mirror to retouch her streaked eye makeup as if nothing had happened. I knew that she did not want to talk about it, that this was one of those moments that needed to be shoved into a deep recess of her heart—to be unearthed for discussion much later, and then only after a few drinks. I wondered how this story would sound when she retold it to someone else years later, and how long she would cry, remembering such pain. "I'm on next," she said slowly to herself while staring straight ahead at her reflection in the mirror. "Diamond is on next."

Cinnamon's repetition of the word *respect* in her advice to Diamond underscores how dancers actively seek to establish a sense of human dignity despite the consistent need to negotiate the blurry boundaries of their work. After all, "respect" sometimes becomes particularly important only in conditions of profound disrespect, in which its absence is conspicuously felt. This phenomenon has also been documented in other studies of marginalized working populations, including crack dealers (Bourgois 1995) and factory assembly-line laborers (Hamper 1992). Cinnamon's firm assertion to Diamond that "there are ways" of maintaining respect in conditions of inequality that some might characterize as exploitation speaks to the powerful set of self-defense mechanisms that the marginalized must develop in order to survive.

In everyday practice at Vixens, the obverse of "respect" entails dancers' refusal to engage in sexual acts that involve body-fluid exchange with clients, their verbal (and sometimes physical) retaliation for disparaging comments made about their sexuality or physical appearance, and their expressions of strong disapproval of women who violate these norms. Angel, for example, had few friends or allies at Vixens because she was frequently seen leaving with male clients after her shift finished, which caused many dancers to infer that she was exchanging sex for money. She was shunned by other women and was often referred to as a "ten-dollar hooker" with a disturbing frequency, suggesting that other dancers sought to distance themselves from even the possibility of becoming like Angel in the future.

As the newest dancer at Vixens, Chantelle initially had serious difficulties warding off unwanted physical contact from male clients, especially in the private dance room, where dancers and men are in very close proximity. Chantelle was unsure of how to firmly insist to particularly aggressive men that parts of her body were off-limits, and certain clients seemed to seek her out solely for this reason. "It's like they can tell I'm new and I don't know what I'm doing," she tearfully complained backstage one night and was quickly rebuffed instead of receiving commiseration from other dancers. "You better learn to say, 'Baby, please don't do that' in a way that they understand—'Keep your hands to yourself, asshole'—or get another job," Cinnamon snapped at her, "because if you let them touch you, it affects all of us."

Chantelle soon understood that her acceptance by other dancers at Vixens was directly dependent upon her ability to rapidly learn the policing mechanisms that would politely but firmly establish her boundaries with men. Star pitied Chantelle and privately confided to me, "I feel sorry for her, because she doesn't know how to teach them to treat her with respect," by which she meant that Chantelle had not yet recognized the importance of establishing physical and sexual boundaries with men that garner the kind of "respect" that dancers believe distinguishes their work from other forms of sexual labor.

At Vixens, the practice of establishing "respect" with clients and fellow dancers operates in tandem with the "disrespect" that women routinely believe they experience from nondancers at Vixens. This is remarkably consistent with anthropologist Philippe Bourgois's findings about cultural constructions of self-worth and dignity among marginalized urban drug dealers, for whom "the material base for this determined search for cultural respect is confined to the street economy" (1995, 326). Dancers similarly lamented how their carefully constructed set of moral hierarchies and norms often meant little to the men they interacted with on a nightly basis, many of whom consistently sought the paid sexual exchanges that dancers viewed as firmly outside the purview of their work.

In addition to what they regarded as this disrespect from clients who did not understand their distinction from prostitutes, many women I met who had been dancing topless for several years were adamant that the failure to clarify appropriate behavioral boundaries with men could be psychologically damaging. Sociologist Bernadette Barton noted similar sentiments among topless dancers who formed the basis of her research, some of whom likened clients to "energy vampires" (2002, 597) with the belief that their ability to pay was tantamount to the privilege to abuse and disrespect. Barton describes an ordinary night at a strip club as one that "vacillates between exciting financial rewards and degrading comments, with the threat of physical abuse and societal stigma as a constant backdrop . . . a roller coaster ride of male scrutiny, adoration and rejection" (2002, 594).

Such vacillation is precisely why Diamond abruptly dismissed any possible discussion of the pain she experienced following the injection,

choosing instead to focus on her reflection in the mirror while repeating "Diamond is on next" as a sort of strengthening mantra. Her anticipation of the audience's desire for her nearly naked body onstage in the aftermath of an extreme emotional low helped her to insulate her real feelings in order to steel herself against the night of work that followed. Diamond felt that establishing emotional boundaries at work was as important as setting clear physical boundaries, since such sentimental barriers could sometimes mean the difference between indifference and emotional collapse. After all, this line of reasoning holds, real control is relative only to the amount of power one can exert over oneself.

ALTRUISM AND BODY WORK'S BLURRY BOUNDARIES

Women of all socioeconomic backgrounds have a much more intimate relationship with body work than men because of the higher frequency with which they engage in (both paid and unpaid) caregiving work. Drawing on political theorist Carol Pateman's notion of "the sexual contract" (1988) that supports women's reduced earning and decision-making power vis-à-vis men, sociologist Lisa Adkins observes that for the vast majority of feminized labor, "women are expected to serve as a repository for male desires, in turn necessitating particular ways of dressing and making up that ensure that they are seen as heterosexually available" (cited in Wolkowitz 2006, 82). In their work on female flight attendants, sociologists Melissa Tyler and Phillip Hancock refer to this process as the creation of a "decorative organizational body" (2001, 58) with particular norms for expressing a culturally prescribed form of femininity that is submissive, attentive, and, above all, altruistic.

This naturalization of female altruism in many forms of feminized labor is even more clearly illuminated when juxtaposed against forms of body work typically associated with men. Sociologist Lee Monaghan, for instance, describes nightclub bouncers as exhibiting a "masculinist hierarchy of values . . . [employing] the molding and presentation of their bodies for the purposes of territoriality, through the use of uniforms and body and facial idiom to indicate impenetrability" (quoted in

Wolkowitz 2006, 85). This description of masculinized body work exists in near-polar opposition to feminized body work, which relies upon the culturally ingrained notion that altruism is a natural component of being a woman.

Such naturalization of altruism makes the limits of acceptable or expected behavior even more unclear for women who perform body work at Vixens. As women who must evince sexual attraction toward clients and yet simultaneously remain constantly aware of the acceptable limits for physical interaction with them, dancers walk a nightly tight-rope of constant negotiation. Sociologist Jennifer Wesely (2003) describes dancers' constant policing of emotional and physical boundaries by characterizing such lines as "fluid" in that they are constantly established and reestablished during work interactions with male clients. She notes that these shifting boundaries have a number of emotional consequences for dancers, since the boundaries of "just dancing" almost invariably expand with time to other sexual acts as part of a "relaxing of limits" (2003, 497). Clearly many (but by no means all) men enter topless or nude dancing establishments with the belief that sex can be purchased inside, and in some ways such businesses depend upon this somewhat erroneous assumption for their survival. Dancers thus find themselves in a position of conflicting interests, because they must maintain the facade of sexual availability without encouraging what they (and others in positions of power over them) determine to be excessive physical contact.

These blurry body boundaries extend to prostitution as well, and legal scholar Ann Lucas has documented how some women who exchange sex for money find themselves disproportionately concerned with physical boundaries in everyday interactions that do not explicitly involve the market exchange of sexuality. "I take whatever measures are necessary to maintain my boundaries," one prostitute asserted to Lucas in defense of how she punched a stranger in the face after he stroked her hair on a bus (2005, 519). That such boundaries become so critical is in itself salient, yet the question remains as to where individual dancers feel that their physical and emotional boundaries should be set. After all, one of the most powerful and alluringly mysterious aspects of human sexuality lies in the unclear distinctions between acceptability and taboo.

Despite this, most dancers were very clear about what constituted acts of disrespect, as we saw previously. Certainly the importance ascribed to "respect" can be construed as an example of agency on the part of Vixens dancers, and numerous scholars have drawn attention to the diverse ways that individuals working in particularly exploitative conditions assert autonomy against the odds. Anthropologists Aihwa Ong (1987) and Ngai Pun (2005), for instance, have documented such mechanisms of resistance among female factory workers despite heavily constrained socioeconomic circumstances. Dancers at Vixens do exert agency, and yet, as psychologist Andreas Philaretou contends, it is clear that topless dancers are constantly at risk of "becoming overwhelmed by their pseudo-sexual occupational selves at the expense of their real selves" (2006, 44).

Clearly, defining the constitution of the "real" self is problematic under any circumstances, but in this context it refers to the aspects of a person that are not hypersexualized in the way a sex-related business mandates. This has definite consequences for dancers' sexual relationships, and by far the most discussed and hotly contested pairing that occurred during my time at Vixens was the on-again, off-again love affair between Paul and Diamond. As we have seen, the heavy weight of stigma attached to sex work also shapes the lives of men like Paul, albeit in ways that are quite distinct from the power it exerts over women. Paul despaired that he would never be able to find a woman who genuinely loved him as long as he worked in a topless bar, and yet his efforts to find other work had been curtailed when prospective employers drew assumptions about his occupation. All Vixens employees were likewise marked by outsiders as somehow socially tainted, which stemmed in part from the unspoken norms governing behavior at the bar that directly capitalized upon gendered social norms in the outside world.

In her article that explores relationships between employees at a strip club, anthropologist Jacqueline Lewis (2000a) examines the individual and collective strategies used by all club workers to deal with an environment that relies primarily on income received in the form of tips from male clients. She finds that although dancers are in the best income-generating position due to their greater contact with clients, they are heavily dependent on disc jockeys to play music that suits their

abilities and to announce them in favorable ways, and waitresses to seat more-affluent clients near where they are working. She argues that the structural elements of strip-club income generation result in a system of alliances between staff members designed to generate maximum profit in a tipping system that encourages competition between, rather than allegiance among, employees (2000a, 310).

Given this complex nexus between occupational status, privilege, and the concomitant inequalities operating in tandem with these, it is hardly surprising that many other dancers were resentful and jealous of Diamond's sexually exclusive relationship with Paul. Star, for example, characterized their attempts to conceal their affair from other workers at Vixens as "cheap and pathetic," noting, "Everyone knows that Diamond is the hottest one here, and that Paul gives her all the good shifts because he's sleeping with her. It's not like some big secret even though they seem to think it is." Diamond did indeed greatly benefit from her sexual relationship with Paul, but the two also clearly shared some affection for one another, the depth of which became increasingly obvious the closer Diamond came to finishing the ova-donation cycle.

Poverty and social stigmatization deeply complicate one's emotional life, often functioning out of necessity to redefine what love and loyalty mean to marginalized communities. This level of complication is greatly compounded when children—those ultimate symbols of love, loyalty, and altruism—become involved. Diamond was both surprised and disappointed at Paul's extremely negative reaction to her decision to become an ova donor. Whereas Diamond saw her choice as a simple transaction not unlike those she regularly engages in at work, Paul clearly believed that she had crossed a line into another moral territory entirely.

One slow Tuesday night everyone inside Vixens could not help but overhear the extremely loud argument that was taking place between Diamond and Paul in his office. She was supposed to be working, and other dancers were already shaking their heads and muttering snide comments about the privileges Diamond's relationship with Paul had granted her. His engrossment in their conversation was such that he forgot to reload the CD changer, and as a consequence the music had stopped and everything they said and did was clearly audible at quite some distance. All of

a sudden, everyone in the bar heard what sounded like a chair crashing to the floor, followed by Paul's booming voice. "What you do at work here is straightforward," he bellowed. "It's for money for something that starts and finishes. What you're doing now is sleazy. It's going to make you think about it every day for the rest of your life, wonder where that part of you is. It's like you're selling something sacred!"

Hearing this without necessarily being aware of their argument's subject, dancers backstage and men in the audience alike began to wonder if they should knock on the door to intervene. Complete and unnerving silence ensued for almost a full minute before we heard the sound of a slap, followed by an angry Diamond rushing out of Paul's office and into the parking lot. She later explained to me that she hit him out of frustration and anger. "What right does he have to tell me what to do with my body?" she asked me on the phone later that night. "He's not my fucking pimp."

Clearly, what was "straightforward" to Paul in terms of Diamond's income-generating activities at Vixens was much more intimate and personal to her than what she regarded as the rather anonymous act of ova donation, in which she had no contact with the recipients of her reproductive labor. Paul's strong ambivalence is nonetheless echoed in popular cultural and scholarly debates on the subject, as is his belief that she was "selling something sacred." Paul's choice of religious terminology to describe what he perceived as the morally outrageous offense Diamond committed by offering her ova in the marketplace speaks to a connection between fertility and magic that is historical and has been dealt with particularly well in medical historian and sociologist Naomi Pfeffer's work (1993). In her important text on the commercialization of the U.S. fertility industry, economist Deborah Spar (2006) notes that although scientific innovations such as fertility drugs and ova donation are new, the sentiments underlying them (namely, the desire to produce children) are as old as humanity. Paul and Diamond were thus engaged in a very old cultural debate that night in his office at Vixens as part of a polemic that has increasingly developed greater medical and social implications for those involved at all levels.

The scientific advances that enabled Diamond's body to produce a significant number of ova to be fertilized, implanted, and grown to a

full-term pregnancy inside another woman's body raise largely unaddressed questions about the association between poverty and particular forms of body work. These connections are particularly evident for poor women, who form the bulk of those who engage in the gendered work that sociologist Arlie Hochschild (1983) famously described as "emotional labor." Hochschild originally employed this term in reference to the counterfeit emotional investment flight attendants must demonstrate toward passengers as one of the requirement of their job, and yet such behavior clearly applies to many other, less prestigious forms of body work as well: ova donors must evince a sincere and altruistic motivation behind their decision; topless dancers must successfully convince male clients of their sincere interest in them; and prostitutes must demonstrate convincingly authentic physical intimacy with their customers.

Diamond routinely spoke to me about what she saw as the ridiculousness of the application process to become an ova donor, which involved multiple forms that detailed personal life goals in short essay format. She resented having to feign emotional investment in a stranger's family life and felt angry that it was considered inappropriate to be motivated solely by the desire for money to repay debt. Diamond thus played along with the fertility clinic's unwritten rule of assumed altruism by pretending to have no interest in financial gain. Early on, a nurse at the clinic had privately advised her, "Honey, if they think you're just in it for the money, even if that's all you really want, you won't get chosen to be a donor. Write something in your application about wanting to help another woman, that'll improve your chances."

The nurse's advice to Diamond underscores the deeply held gendered cultural norms that help to sustain the fiction that poor women are not uniquely motivated to engage in body work such as ova donation by a pressing economic need. The relatively recent emergence of "tissue economies" (Waldby and Mitchell 2006) marks a period in which the ethical (and, indeed, financial) issues surrounding the exchange of organs, blood, and bodily tissues are the subject of highly charged moral debates. Anthropologist Nancy Scheper-Hughes describes this process as "the division of society into two populations, one socially and

medically included and the other excluded, one with and one utterly lacking the ability to draw upon the beauty, strength, reproductive, sexual or anatomical power of the other" (2002, 4). It was perhaps with such a sentiment in mind that Paul described this emotional labor as "creepy" in the context of Diamond's impending ova donation—because he felt it crossed an imaginary line between public and private. This imaginary line is, of course, a critical site for feminist interrogation, since many of the justifications that underlie such exchanges highlight the inequalities that make them possible in the first place, particularly in terms of what anthropologist Margaret Lock has termed the "sense of entitlement to 'spare parts'" among recipients of such donations (2007, 230).[5]

The association between poor women and reproductive labor is by no means limited to recent technological advancements. So-called wet nurses were women hired by families of means to breast-feed their infants prior to the invention of infant formula. In a cruel twist of fate, they were often unmarried women who had given birth to children they could not care for—a socially vulnerable position that pushed them into a relationship with a much more affluent family. This was especially the case among young women who had given birth outside of marriage and were thus ostracized by their family and the community. Although the exchange of obviously classed reproductive labor for money involved in this seems particularly straightforward, such an unequal work situation simultaneously underscores the inequalities that help to define culturally acceptable forms of family life.

The same contradictory social constructions and justifications that underlie beliefs about the family also characterize sexuality. Anthropologist Katherine Frank (2002), for example, has documented how male strip-club patrons justify their behavior by lamenting the lack of "real" women in the outside world. Such "authentic femininity" thus must be purchased in order to validate masculine authority, and anthropologist Anne Allison (1994) has also dealt with how this phenomenon functions in similar ways in Japanese hostess bars. Although sex work itself is also a very old concept, the relatively recent advent of assisted conception has prompted a cultural debate about the family that helps to frame how donation is described by agencies and clinics.

Although the men Diamond met at work followed Frank's and Allison's patterns of justification, the reasoning employed by the recipients of her ova was in all likelihood not entirely different. Altruism is considered an essential criterion for ova donors, and sociologist Rene Almeling (2006) described how altruistic motivations such as helping another woman to have a baby were consistently cited above financial need by ova donors, whereas the opposite was true with sperm donors. Anthropologist Helena Ragoné (1999) argues that this is part of a broader construction of motherhood as self-sacrificing, although the perceived need for such altruism may also have something to do with the much more involved process of ova donation relative to sperm donation. Thus whereas men might seek Diamond out at work because she is a "real" feminine woman who is quick to smile and do what they say (within limits), fertility clinics desire women like her who are willing to participate in the lie that the income they receive from their "donation" is secondary to their altruistic motivations to help infertile women bear children.

"What a bunch of shit," Diamond lamented one afternoon as we sat together on her living-room floor, marveling in quiet horror at the enormous box of medication that she had just brought home from the fertility clinic. It was both remarkable and sobering to think that all of it would be injected into her body over the next four weeks, and we were rendered speechless by the coercive power of poverty to make such a prospect acceptable, even attractive. In some ways, however, Diamond was lucky: her beauty, whiteness, and ability to carefully reveal and conceal details of her life (such as her stigmatized occupation) all worked to her advantage to obtain a higher fee from the fertility clinic—qualities in women that can work to their benefit in such settings, as legal scholar Kari Karsjens has pointed out (2002).

"What a bunch of shit," Diamond repeated, staring open-mouthed at the box of vials and syringes in front of her. "But it isn't going to be like this for me forever." Despite her rather obvious misgivings, Diamond presents a clearly articulated view of her beauty and youth as salable assets as part of a U.S. cultural practice regulated by the laws of the free market, with buyers, sellers, and brokers. Yet even this pragmatic attitude could not prepare her for what happened next when she went

under the care of doctors in one of the West Coast's most exclusive fertility clinics. She related the story to me when she returned to Sparksburgh, still bloated and sick from an overdose of fertility drugs administered by a greedy group of doctors who wanted to maximize their profits by cultivating and extracting as many healthy ova as possible.

The problems began shortly after her arrival on the West Coast several days prior to her scheduled ova extraction. For the first time in her life, Diamond felt she was not in control of her own body, and the experience had been terrifying. The legal contract she signed with a third-party broker when she began the ova-donation cycle mandated a complex set of rules for payment disbursement that she did not fully comprehend at the time. She signed in haste because she knew that she desperately needed the eleven thousand dollars the broker would pay, and that such a large sum of money would not be forthcoming under almost any legal circumstances she could quickly arrange. Repaying the debt resulting from her former boyfriend's misuse of her credit cards was in her view an important symbol of her resiliency.

At the time of Diamond's ova donation, most U.S. states did not allow brokers, clinics, or individuals to pay ova donors for their genetic material directly and instead permitted them to be financially compensated for their time and travel at certain stages of the cycle, as stipulated by the agreement signed between the donor and the recipient. In Diamond's case, the broker's contract stipulated that she would be paid following the successful delivery of "a reasonable number" of healthy ova. Desperate for money and thus disinclined to ask about the possible repercussions of this arrangement, Diamond later suffered severe complications after what turned out to be an extremely painful surgical procedure.

Paul was uncomfortable with Diamond's decision from the very beginning and only reluctantly agreed to accompany her to the West Coast for the procedure. The day before her ova were scheduled for extraction at the clinic, a doctor asked to meet with her privately in his office. "I'd like your permission to keep you on the medicine you are taking for just one more day," he said before she even had time to sit down. When Diamond hesitated, he reminded her, "You know, you can't get paid if the procedure isn't successful." His message was extremely clear

to her and needed no additional interpretation. Exhausted from the long journey from New York, physically ill, and distressed by her lost earnings at Vixens and the possibility that she might not receive any money at all for her ordeal, Diamond agreed. When she awoke from anesthesia two days later, a hollow-tipped needle had extracted twenty-nine ova through her cervix, a number equivalent to what her body would have normally taken over two years to produce.

The first thing she remembered was sobbing uncontrollably. "It was so scary," she said. "Imagine waking up and you're screaming, without knowing why. The nurse said to Paul in this really patronizing voice, 'She's having an emotional wake-up.'" Paul was not so sure. Diamond kept crying after they returned to their motel room, and her abdominal pain became so severe that she curled into the fetal position in the bathtub and remained there for several hours. "You should sue those sons of bitches," Paul told her as he stood over her in the bathroom, unsure what to do. "Right," Diamond moaned without opening her eyes, "and who do you think is going to win?"

Doctors at the fertility clinic insisted that Diamond was simply experiencing some minor complications, but she and Paul were horrified by the physical transformation her body had undergone since the surgery. Her stomach had swelled so much that she looked like a woman ready to give birth, and she felt dizzy and nauseous every time she stood up. The doctor calmly explained that Diamond was suffering from ovarian hyperstimulation syndrome, a relatively rare complication with unknown causes that young women taking fertility-enhancing medications are at a higher risk of developing. The most immediately noticeable side effect is rapid weight gain due to excessive fluid retention and buildup around the artificially enlarged ovaries, which can result in difficulty breathing when the lungs do not have sufficient space to expand. In more extreme cases, it can cause organs to fail if they are compressed by the retained fluid.

Two days after the ova extraction, Diamond had accumulated approximately one and a half gallons of extra liquid in her body that equaled over ten pounds in additional weight. She felt sick, disgusted, and betrayed by the clinic, but she also believed that she was powerless to

do anything about what had happened. The doctor told her that it was completely safe for her to travel back to New York and that her next menstrual period would flush out all of the excess fluid. In the meantime, he said, she should eat salty food and protein to help eliminate the liquid buildup. What the doctor did not explain, however, was that the long-term consequences of such complications remain unknown. He also did not mention that it was highly likely that the extra day of fertility medication he had requested her to take had resulted in her condition.

Diamond and Paul did not return to New York immediately. Instead, they spent a week in a motel room talking about the future and reflecting on the courses their lives had taken. They spent most of their time lying in bed eating Chinese takeout, the TV providing a constant soothing backdrop to fill up their silences. Sometimes they walked, and when they looked around they compared what they saw with the world they had left behind. By the time Diamond had fully recovered and expelled the ocean accumulated inside her, they had decided not to go back to Sparksburgh at all. Diamond and Paul were by then convinced that they could make a better life for themselves by starting over completely.

Both of them had been living for years on the premise that their circumstances were going to get better, although they had received precious little in the way of substantiating evidence of this improvement. Diamond and Paul were approaching their mid-twenties and attaining a kind of harsh clarity that made the world seem an unfair place, and both hoped that beginning a new life together might give them a new perspective. Of course, each had his or her own strategic reasons for moving: Diamond saw great potential for earning money in the much more lucrative topless bars of nearby Las Vegas, and Paul wanted to be as far away as possible from his fractured former families. Then there was, of course, the persuasive reality of warm weather. When I last saw Diamond, she had returned for a brief three-day visit to pack up her apartment and pick up her car. Paul told his second former wife she could have everything in his apartment as long as she emptied it out by the end of the month. He even told her that, as payment for her efforts, she could keep his security deposit.

As we have seen in the preceding chapters, the abruptness with which Diamond and Paul made their dramatically life-altering decision to

relocate is rather characteristic of the way Vixens workers seized oppor-
tunities that suddenly became available to them with little or no advance
notice. Their new life on the opposite side of the country did indeed offer
more possibilities for income generation than Sparksburgh ever could
have, and so both of them deemed their move a great success. Diamond's
initial perception of her beauty and youth as catalysts that could hasten
her entry into a new life failed to acknowledge the countless ways in
which poverty's violence inscribes the bodies of poor women, and she
paid a heavy price for this misrecognition. In retrospect, however, her
position on the blurry boundaries between private and public as both
ostensibly altruistic ova donor and pragmatic sex worker demonstrates
the richly complex nature of her decision-making processes and strat-
egizing for a better life. What Diamond and Paul might term their "clean
break" marked a significant departure from the economic woes of the
Rust Belt, and yet the terms on which they were able to carry it out were
firmly situated on the blurry ethical, legal, and moral boundaries that
surround many forms of body work. And, in Diamond's case, the long-
term results of her decision remain unknown—fodder for yet another
bout of uncertainty to keep her awake after a long stint on the night shift.

EIGHT Conclusion

RECONCEPTUALIZING FEMINIZED LABOR,
DEMYSTIFYING SEX WORK

The last time I saw Cinnamon, she was smoking a cigarette and singing
the words to a Johnny Cash song in an almost comically affected bari-
tone voice. It had been years since I had last seen Vixens' gray exterior,
and I sat in the empty parking lot for a few minutes before getting out
of my car, wondering whether I should even bother going inside. Sex
work in any form features a rate of employee turnover that is probably
unsurpassed in any other vocation,[1] so it was quite unlikely that anyone
working there would know me. After all, it had been almost five years—
a span that far exceeds the careers of most dancers—and so it would
almost be like walking in for the first time all over again.

The ground beneath my feet was frozen as I stepped out of the car, and the cold silence made the sound of my footsteps reverberate slightly. The late afternoon sky was the familiar gray-black of industrial steel, and it occurred to me that little about the place looked very different. I shivered, thinking of the enormous changes that had taken place in the lives of the women in the relatively brief span of time that I knew them at Vixens. Some were dead, some were happy, and some I had never heard from again. I thought about this book and wondered whether I had somehow frozen a period of their lives that some of them would rather forget, whether I had unintentionally captured their spirits in ways that permanently suspended them in their sometimes brutal struggles for survival. It was an uneasy feeling.

A few heads turned as I walked in. There were again more women than men inside, just as during my first visit years before. Most of the dancers looked bored, and I did not recognize any of them. I made my way to the back office and found an exhausted Cinnamon sitting at a desk inside. I was both delighted and disheartened to see her as the sole familiar face. "That's me," she said, "I'm the last one standing." After more than a decade and a half of sex work, Cinnamon had recently put aside her long-term plans for nursing school after her earnings dropped dramatically. She, like many other Sparksburgh workers, feared that her recent reduction to part-time managerial status meant that she would likely soon become unemployed. "Lately it's scary empty in here every night," Cinnamon complained as she shook her head and passed me a cigarette. "Nobody ever had any money in Sparksburgh, but now nobody can even pretend to have any money."

Just weeks before, Congress had voted to sponsor a seven-hundred-billion-dollar buyout of investment banks' bad debts after a crisis arose from an unprecedented number of sub-prime-interest-rate mortgages that had been issued to people with minimal or even poor credit histories. Every level of society felt the impact of this predicament: retirement accounts evaporated overnight, unemployment rose, people lost their homes, and social-service agencies such as food pantries were overwhelmed by demand. It soon became clear that the situation was only going to get worse. Signs reading "For Sale" and "Foreclosure" became

familiar punctuation marks on Sparksburgh streets, previously limited employment opportunities vanished almost entirely, and many people began to wonder whether things could possibly get any worse.

In the words of President George Bush, Congress had acted to "help prevent the crisis on Wall Street from becoming a crisis in communities across our country."[2] That towns and cities like Sparksburgh had been in a perpetual state of economic crisis since the advent of deindustrialization in the 1970s apparently did not bear mentioning. In the parking lot of Vixens that day, hesitating a bit before finally deciding to go in, I felt as if I were standing on a piece of frozen land that threatened to drop off the earth entirely. The entire country had recently recognized itself as an economic disaster zone, which made the frozen wasteland outside Vixens seem all the more bleak and desperate.

I went back to Vixens because I wanted to understand how this most recent form of economic devastation would impact poor women in Sparksburgh, particularly those who choose sex work as a mode of survival. The wave of even more job losses and business closures in an already long-suffering region of the United States does not bode well for the relatively professionally unskilled women who make up the bulk of Vixens' labor force. Most of these women had little formal education beyond middle or high school, and they had been just barely getting by during the time of relative prosperity that had marked my research several years before. It was thus hardly coincidental that Cinnamon characterized herself as a boxer might in the wake a particularly brutal round of violence. Nonetheless, even she felt terrified by what the future might hold if Sparksburgh continued on its slow downward descent.

As "the last one standing," Cinnamon would soon enter into her second decade of life as a sex worker. Star, Chantelle, Diamond, and the rest of Cinnamon's former colleagues had all embarked upon new life paths, some of which strongly conformed to the heteronormative notions of womanhood and family discussed at length in chapter 5. It was no great surprise that she had begun to worry; although she had seen countless women come and go during her many years of experience, she was beginning to wonder what she would do in the event that Vixens was forced to close due to lack of business. Now that she was approaching her forties,

she had begun to realize that a managerial position similar to the one she had held for several years at Vixens might not be so easy to find at another establishment, and she was only too aware that going back to dancing nude or topless at her age might not prove very lucrative. Competing with a group of younger girls and women at another bar would prove very difficult, and it was highly unlikely that she could find a straight-world job without any previous non-sex-work experience on her résumé amid so many other recently unemployed professional applicants.

Cinnamon had good reason for apprehension. At a very basic level, the economic downturn means that more poor women will find themselves pushed into doing work that they would otherwise not consider doing in order to support themselves and their families.[3] Rising unemployment and costs of living mean that male clients have less money to spend, which in turn creates greater competition among dancers. This limited scope for income generation also pushes women to provide more and more sexual services for less money as a routine part of their job. As always, the lives of poor women on the margins are testaments to just how much has gone wrong at the center.

Throughout the pages of this book, we have listened to poor women describe universal human problems: struggles with loved ones, the desire for their children to have a better life, and the need for respect in a world that often disperses it only reluctantly. The fact that these women are sex workers plays a central role in shaping their lives, yet it does not completely define them as individuals. Many such women believe that their work has granted them a unique ability to judge character, even if they would rather be working in another profession that does not enforce such a powerful set of often marginalizing consequences for relationships and future work opportunities. It is not coincidental that dancers often express pride in their knowledge of human nature, an intimate expertise they have gained in order to simply survive.

It is true that these women lead complicated lives and work in a heavily stigmatized profession on the margins of society. It is also true that most of them would rather be doing something else and acknowledge that their work has a definite impact on how they perceive themselves and, in turn, how others view them. Most of all, it is clear that the women

of Vixens and their millions of counterparts across the globe clearly have much to teach the world about love, loyalty, and the power of the human spirit to persevere and hope in the face of adversity. Whether the world chooses to listen, however, is another matter entirely.

The operations of power take myriad forms in the lives of poor women. From post-TANF welfare programs that stress economic self-sufficiency on impractical terms that fail to account for women's child-care responsibilities to labor practices that virtually guarantee the global feminization of poverty, neoliberal economic policies work their strange and terrible magic in infinite ways. These everyday forms of structural violence are compounded for sex workers, whose lives present evidence that focuses the stark inequalities inherent in these practices even more sharply due to the heavy weight of social stigma framing them. Their stories, although situated at the social and legal margins of life in the United States, consistently speak to the exclusionary forces at work that impact everyone, albeit in very different ways.

Such women do not exist outside the cultural context in which they work, and stories from their lives presented here have repeatedly under-scored how they are in fact integral parts of their communities. Yet women like Diamond, Cinnamon, Star, Chantelle, and Angel are fully aware of their incorporation on extremely unequal terms into society. Every passing day reminds them of the diverse processes by which those who profit from or enjoy their labor systematically render them invisible in order to maintain the careful fiction of the distinctions between pub-lic and private. These include city officials, who win suburban votes by taking a stance against the group of labor practices glossed as "the sex industry" by relegating it to unsafe, abandoned industrial areas; own-ers and managers, who benefit from favorable state labor laws that do not require dancers to be paid; and, of course, clients, who alternately adore and despise them. Sex workers are consequently rarely seen as full human beings, and are instead culturally constructed variously as social problems in need of containment or objects of pity too uneducated to know what is best for them.

As the preceding chapters have shown, individual women who engage in sex work routinely attempt to ignore the glaring evidence of

these inequalities in favor of focusing on ways to improve their lives through increased income generation, marriage, or leaving the business altogether. Yet refusing to recognize the unequal terms of their work is arguably the most viable option, given that to do otherwise would be tantamount to endorsing their own victimization. This process is more complicated than false consciousness and involves the active negotiation of several contradictory subject positions at once, so that women who are irresistible objects of anonymous and transgressive male sexual desire at work automatically find themselves transformed into mothers and care-givers after a ten-minute drive home. Dancers' simultaneous rejection and acceptance of the fictions of taint that surround their profession are an integral part of this unequal system, so that women construct elaborate moral hierarchies that keep them in positions of relative privilege, even if only in their own minds.

This intricate dance between the state and the individuals who make it up is also generalized to the broader politics of the region. After all, are the displaced Sparksburgh factory workers who blame high New York State taxes for the relocation of their former plants both to other U.S. states and to the Global South really any different from the Vixens danc-ers who construct elaborate moral hierarchies that punish individual women who sell sex? Neither group of workers blames the neoliberal practices that create such unequal working conditions in the first place, yet both are clearly marginalized from systems that work against them. Nonetheless, both sets of workers simultaneously choose to buy into myths that perpetuate their own oppression.

Central to the operations of this system is the manner in which such people are not simply "left out" but are consciously placed at the margins because society deems them unworthy of inclusion. This book has attempted to render visible the complex set of labor practices and sur-vival strategies that frame life for poor women who choose sex work out of a rather limited menu of options available to them for income generation. Mining the intimate details of five such women's everyday lives lays bare the severe institutional and social sanctions they face and also illuminates the underlying power of hope to sustain them through what can sometimes be dangerous, difficult working conditions. Yet

their experiences, desires, and fears are unique to each of them and caution against a singular understanding of what these labor practices mean to those who engage in them.

These ethnographic portraits present nuanced ways of thinking about the significance of feminized forms of labor, motherhood, and romantic love in poor women's lives. Hence it is in some ways insignificant that the women featured in this book exchange sexualized performances for men's money. Women at Vixens, like many other low-wage service-industry workers, labor without health insurance or other benefits, have little job security, and are fully aware that, no matter how hard they work, they will always be infinitely replaceable. As with many other forms of body work, the blurry legal and moral boundaries between acceptable and illegal activities makes dancers ever vigilant of both themselves and their colleagues in ways that sometimes effectively disrupt any bonds of solidarity that have developed between them. Yet dancers are simultaneously tied to the whims of male managers, who are in positions of gender privilege that allow them to characterize themselves, as Paul did in chapter 4, as "everybody's daddy."

These exploitative labor practices are pervasive for poor women outside of Vixens as well, leading Diamond, who had decided to donate her ova in exchange for eleven thousand dollars she could use to repay debt and get breast implants, to open her narrative in chapter 7 with a description of female fertility as a sort of prison. "Getting pregnant ruins your life," she observes, in sharp contrast to the desperation of the infertile, albeit more economically privileged, older women whose image she so powerfully conjures up in describing her sense of awkwardness as an unaccompanied young woman seated in the fertility clinic's waiting room. Diamond senses the women's resentment, noting that "it's like they hate me because I have that power to make babies and they don't." Yet as the account in chapter 7 of the severe complications Diamond experienced following the ova extraction demonstrates, that "power" she describes is a fraught and ambiguous one that did in fact allow her to create a new life for herself on the West Coast, but only after she risked death in order to do so.

Women who work at Vixens thus engage in a constant struggle in their negotiation of a type of work that constitutes both a barrier to and a path

toward self-improvement. All of the dancers featured in this book viewed their job as a temporary solution to what was all too often a lifelong pattern of social and economic instability. They were conscious of the somewhat brief window their relative youth presented them with in terms of opportunities for income generation, and sought to capitalize on these assets while it was still possible. Nonetheless, it must be acknowledged that the vast majority of women believed that their work imposed a serious tax in the form of stigma, which was most keenly felt in family and romantic relationships. Chapter 4 detailed the painful toll that this stigma could exact on dancers' emotional lives as they struggled, and often failed, to meet what they believed were definitions of "good" motherhood.

Chapter 4 recounted Star quietly slipping out of her four-year-old son's birthday party to cry when she thought about her method of income generation. Watching him open his presents, she recalled how she had bought them "with money guys shoved in my thong, and I don't even know their names. Their dirty money bought my son his birthday presents, bought him his nice clothes for school." Cinnamon also experienced this conflicted mix of pride in otherwise unobtainable purchasing power on the one hand and shame associated with sex work on the other—particularly when her adolescent daughter, Melanie, was marked as a problem student at her school.

Many Vixens dancers lived a paradoxical existence by earning income from the exchange of affection for money and yet experiencing few long-term stable emotional bonds in their own lives. But the extreme conditions characterizing their subculture place the inequalities that shape life in the United States into a sort of striking bas-relief, since the exchange of intimacy in the free market mirrors many elements evident in the feminization of poverty. We have seen that many Vixens dancers employ a version of the Protestant ethic in their firm belief that the exploitative conditions under which they work are but temporary obstacles on their path toward eventual upward mobility. "I'm not going to be doing this forever," newly pregnant Chantelle explained in chapter 1—a sentiment echoed by other women in numerous variations throughout the book.

Women like Chantelle do express a strong desire to leave sex work because of temporal concerns about children, pregnancy, or the aging

process, but their eagerness to do so also stems from their ongoing dif-
ficulties in interacting with male clients. Managers actively encour-
age dancers to subscribe to the notion that they are selling a service
to men—a model that most, if not all, dancers embrace as an effective
means of separating genuine sentiments from pseudointimacy, issues
developed at length in chapter 5. Yet this traffic in human emotions is
a complex one fraught with uncertainty and danger, precisely because
these emotions do not translate quite as easily as dancers insist they do
into market frameworks. Clients sometimes mistake dancers' attentions
for genuine love, and this is particularly true among frequent visitors,
who receive specialized attention from women at Vixens because they
provide a regular source of income.

In chapter 3, the experienced Cinnamon admonished new employee
Chantelle for her very real fear about a male client who had become a
stalker by saying, "Welcome to the business, Honey. For every fifty nor-
mal ones you get one complete freak." This casual acknowledgment of
the dangers faced by dancers contrasts dramatically with the vehement
insistence by dancers and management alike that theirs is just another
service-industry job. Clients are clearly aware of the stigma tax and
resulting social isolation that dancers accrue through their work, and
some, like Chantelle's stalker, take brutal advantage of dancers' rather
dangerous working conditions and stigmatization precisely because
they know they can act with relative impunity.

Chapter 3 illustrated how unclear state obscenity laws, social ambiva-
lence about female sexuality, and zoning restrictions that relegate estab-
lishments like Vixens to desolate former industrial parts of Sparksburgh
create a sometimes lethal combination of factors that render danc-
ers responsible for their own fates both in and outside the workplace.
Women must constantly monitor their own bodies to ensure that they
have not exposed too much or allowed clients to touch prohibited areas,
and they have the almost impossible task of explaining rules that they
themselves do not fully understand. This physical isolation in the shad-
ows of Sparksburgh's empty factories combines with dancers' need to
self-police in creating a situation that favors abusive clients or, indeed,
men who think they have some sort of entitlement to dancers' attention

after they finish work. None of these issues are unfamiliar to women who are not sex workers, but they are definitely compounded for dancers, who believe that the police will not take their claims of harassment seriously.

Despite such considerable dangers, quite a few dancers subscribe to the model of risk and return documented in chapter 6, in which women at Vixens embrace the discourse of free-market capitalism to describe their exchanges with clients. "There are different markets," Diamond explained in regard to the hierarchies of erotic dancing establishments, some of which she and others viewed as little more than brothels. Diamond aspired to work in one of the extremely lucrative topless dancing bars in a major U.S. city such as Las Vegas or Atlanta, which were worlds away from Vixens in terms of standards and possibilities for income generation. Her clear explanation of these hierarchies could certainly be applied to almost any variety of business, and yet there is clearly something else at work that allows these transactions in human sexuality to be so neatly translated into the market model.

Topless and nude dancing venues are theoretically the perfect hyper-capitalist model, featuring nonexistent labor costs, cash income (much of it untaxed), no unions, and a constant supply of workers preconditioned to follow the rules without complaint. In practice, of course, the reality is much more complex, and few dancers would argue that theirs is an ideal form of work for these very reasons. Income is unreliable, social stigma pervasive, clients sometimes dangerous or threatening, and dancing offers absolutely no illusions of long-term support. Fundamentally, this system functions to the benefit of those in positions of ownership and to the detriment of their workers—a familiar (and by now quite clichéd) characterization of the anticapitalist argument.

This lack of pro-labor policies is also firmly enshrined in New York State law, which considers dancers "independent contractors" who are not formally employed by the bars in which they perform.[4] This means that owners of such establishments are not required to pay them a salary or provide health insurance or any form of benefits. Some bars even charge women a "stage fee" ranging from fifty to one hundred dollars to perform, as part of a curious labor practice in which the workers pay to use the means of production. The New York State Department of Labor

defines independent contractors as workers who "are free from supervision, direction and control in the performance of their duties. They are in business for themselves, offering their services to the general public."[5]

Dancers fall into the "independent contractor" category of state labor law because they are considered as meeting the following specific criteria of this definition: they pay their own expenses, assume risk for profit or loss in providing services to clients, and are (ostensibly) free to refuse work offers.[6] The first is certainly true, because dancers must incur significant, nonreimbursable expenses in costumes, cosmetics, high-heeled shoes that are attractive yet allow the wearer to dance for hours, and other paraphernalia. Dancers also have the right to refuse to dance privately for clients, although in practice women are unlikely to assume the risk of not earning any money by refusing work offers.

This rather laissez-faire approach on the part of legislators reveals the ambiguous position of women workers at Vixens and other establishments like it, since in many ways we see assumptions about their lack of entitlement to state protection in their classification as "independent contractors." Such discourse closely replicates divisions between "good" and "bad" women that frame everyday gendered experience in positioning women who fall into the latter category as deserving of any bad treatment meted out to them. Yet sex workers undeniably come to accept such labor conditions as normal or even acceptable for a number of reasons, some of which were analyzed in the discussion of "social sisterhood" (Hoigard and Finstad 1992) at Vixens in chapter 4.

Chapters in this book have maintained a consistent focus on sex work as part of a broader matrix of life realities for many poor U.S. women. It is thus essential to acknowledge that their agency in choosing such work also comes with the need to assign them some responsibility for their choices and actions. After all, such women cannot be fully seen as actors unless they are also simultaneously held accountable for their actions. If sex workers are to be fully recognized as complex social beings performing a highly variegated form of labor, a key question must be answered: how can researchers and activists envision sex work as part of women's short-term survival strategies and long-term self-improvement plans without replicating the very processes that enable the feminization of

poverty in the first place? The answer lies in reconfiguring understandings of feminized labor, including sex work, to get at a more holistic understanding of the myriad ways in which women's bodies and sexualities are themselves uniquely situated at the ambivalent intersections between private and public domains in both individual relationships and state regulations of them.

"I'll let my kid starve before I go stand in a welfare line," noted Cinnamon, who had consistently refused public assistance despite her long history of supporting herself and her daughter alone and in extremely constrained economic circumstances. Her condemnation of women whom she and her colleagues called "welfare queens" is unsurprising when considered in light of the consistent public and political discourse of irresponsibility that frames much of U.S. welfare policy. Anthropology encourages critical examination of unintended policy outcomes that reveal a sharp disjuncture between intention and effect, such as the strong welfare aversion described by Cinnamon. Making sense of the lives of poor women, including those who choose sex work, is critical to understanding how policies and discourses affecting these women function to disempower them in certain ways while inadvertently empowering them in others. An examination of the disjuncture between policies and their outcomes shows how and why public service institutions are failing to construct effective assistance measures for the very populations they seek to serve.

Sex work is always embedded in a life matrix of individual choices and responsibilities, and it is thus appropriate to consider the broader factors that influence women's perceptions of their opportunities for income generation. As chapter 3 detailed, a number of institutional realities translate social stigma into public policy by placing unmarried, low-income mothers at a serious disadvantage. This is particularly clear in the processes women must undergo to support their children through public assistance rather than sex work. Women at Vixens who were mothers of dependent children qualified for a number of social services that they chose not to avail themselves of because they considered them demeaning, regulatory, and indicative of failure. Most of these women had some experience with government social-service provision, and it is

important to note that they chose sex work partly because they felt out-side other possibilities for life advancement, including those envisioned by the state as beneficial to poor people.

Many women at Vixens were excessively concerned with the possibility that increased state involvement in their lives via social-service provision might increase their risk of having the New York State Department of Social Services (DSS) take their children into state custody. Cinnamon had countless stories from her decade-long career in upstate New York's adult businesses of biological fathers who had successfully used the "immorality" of their child's mother's lifestyle to obtain parental custody. In some relationships, this threat constituted a form of terror, and Cinnamon recounted the story of one man she had dated who had threatened to report her to the police for engaging in prostitution—a charge she believed could have prompted a DSS investigation and subsequent placement of her daughter into foster care.

Such reasoning was also instrumental in the decision-making processes of dancers who either did not want to know the identity of their child's biological father or did not wish to initiate contact with him. Previous experiences with social-service provision, or stories from women who had had such experiences, caused many women at Vixens strongly believe that DSS would somehow force them to locate their child's father in order to recoup some of the state's welfare expenditures. Chantelle shared these sentiments and viewed this possible state intrusion into her pre-pregnancy sex life as demeaning, insulting, and classist. "Poor people's lives are everybody's business, right?" she sarcastically observed. "Because we don't have the money to cover up our mistakes."

Indeed, being the sole economic provider for young children is a major reason that some poor women choose sex work, due to its flexible hours and possibilities for income generation that, at least initially, may seem to exceed those of other forms of low-wage employment. The preceding analysis of five women's lives demonstrates that sex work mirrors many aspects of the feminization of poverty and the uniquely embodied forms it takes through caregiving, emotional labor, and numerous other tasks associated with women's work. Yet despite these connections to other

labor practices, sex workers clearly interpret broader gendered principles of risk, fair exchange, and emotional labor on terms that help them to justify their exploitative working conditions and social stigmatization. By discursively placing power and control in their own hands, sex workers are able to see themselves as agents and entrepreneurs despite pervasive social messages to the contrary. Cinnamon and her colleagues might add that such benefits far outweigh those offered by public assistance under current public-policy frameworks.

The complexity of such decision-making processes in regard to sex work presents a need to incorporate complex personhood (Gordon 1997) into studies of the subject in order to acknowledge the full range of motivations evinced by sex workers as actors and agents. Sex work must be reconceptualized as part of a limited menu of income-generation options from which women choose those that will best benefit them in the long term. Most of the women at Vixens had previous experience in low-wage service-industry jobs prior to entering legal forms of sex work, mirroring patterns of entry demonstrated elsewhere in the United States (Barton 2006, 24–40; Brents, Jackson, and Hausbeck 2009, 142–163). As with other forms of low-wage work in the service industry, the alternatives available to women at Vixens featured what they regarded as equally exploitative labor practices performed under circumstances that were just as unpleasant and even less well paid.

It is not coincidental that women at Vixens often construct sex work in direct opposition to alternatives such as public assistance or low-wage service jobs. Cinnamon and Star clearly articulated this point of view in the opening narrative of chapter 4, in which they contrast what they earn at Vixens with the "money for nothing" accumulated by "welfare queens" and stay-at-home mothers who are supported by husbands or other male partners. Similar sentiments emerged in chapter 3, in which Star dismisses the low-wage service jobs available to her outside of Vixens, noting, "You wanna see disrespect, go work at Wal-Mart for a month." When viewed in this light, sex work seems less an undertaking fraught with morally loaded, titillating intrigue than just one more limited option available to poor women as they seek to forge a path toward self-reliance (da Silva and Blanchette 2009, 18–20).

This reality speaks to the myriad ways in which individuals carve out spaces of power and hope for themselves within systems that clearly work to oppress them. Yet women's stories throughout this book have also underscored how these limited spaces of empowerment can also be forms of oppression in themselves, such as in the tales of failed serial relationships and attempts at heteronormativity presented in chapter 5, or the limitations placed upon sex workers who are also mothers and caregivers, discussed in chapter 4. These tales have highlighted how, despite all else, sex work is but one aspect of women's complex life matrices, in which their embodiment as women, socialization as poor women who understand work as something inherently unpleasant and abusive, and status as unskilled workers shape far more aspects of their complex personhood than sex work.

Despite these rather obvious connections to the monotony and generalized disrespect faced by poor women working in other service-industry jobs, sex workers continue to share a uniquely maligned mystique that positions them as simultaneously sexually desirable and socially repulsive. Although recent years have witnessed a dramatic outpouring of feminist scholarship on sex work (Bernstein 2007a; Day 2007; Kempadoo 2005, 2004; Kuo 2002; Munro and Della Giusta 2008), much of this literature unintentionally reinforces the social stigmatization of sex workers by depicting them solely through their income-earning activities. This burgeoning research has convincingly demonstrated that sex work is embedded in a complex social matrix that often centers upon sex workers' perceptions of their individual choices and responsibilities (Agustín 2007; Bott 2006; Dewey 2008b; Weitzer 2009).

A limited amount of academic work has presented sex workers as complete social beings by depicting with appropriate complexity the full picture of their daily lives and economic struggles (Barton 2006; Brennan 2004; Kelly 2008; Raphael 2004; Wesely 2003, 2002; Zheng 2009a). Accordingly, the preceding chapters have sought to fill a significant gap in the literature by examining how individual biography intersects with structural position to condition certain categories of individuals to believe that their self-esteem, material worth, and possibilities for life improvement are invested in their bodies and sexual labor. Such beliefs

inevitably combine with sex workers' knowledge of their marginal, conflicted social status to inform many of their decision-making strategies. The use of five women's life histories has helped to illuminate the processes by which sex workers are able to see themselves as agents and entrepreneurs despite pervasive social messages to the contrary.

Yet this mystique continues to surround sex work in public policy, with very real and dangerous consequences for sex workers. One particularly striking example of this tendency appeared before the New York State legislature in January 2008 as a proposed amendment to state labor laws that ostensibly sought to protect dancers "from becoming victims of severe forms of human trafficking" (New York State Assembly 2007). The traffic in women into prostitution, otherwise known as sex trafficking, has become the subject of increased international and national concern in the first decade of the twenty-first century in ways that often mirror popular perceptions of sex workers as coerced or otherwise in need of rescue and redemption (Agustín 2007; Dewey 2008b).

Throughout the world, responses to this phenomenon have consistently grouped women into the distinct categories of innocent victims of trafficking on the one hand and, on the other, guilty whores who choose prostitution out of a set of other feasible options presumed to exist. This dichotomy sets a dangerous precedent for leaving the vast majority of sex workers in the latter category and thus considered unworthy of state assistance or protection measures. Given that the vast majority of individuals in the world lead lives that are infinitely more complicated than the simple binaries of "choice" and "coercion," such policies operate in a context completely detached from reality.

Efforts to develop a dance-performer permit and registry system in New York State mirror such patterns and couch themselves in similar discourses. This legislation would require dancers to have an employment permit issued by the New York State Department of Labor, valid for three years, although violation fees for dancers would be relatively low and range from twenty dollars for a first-time offender to fifty dollars for every offense after that. Bar owners would be required to keep a copy of all such permits, and could be subject to fines between one and two thousand dollars for failing to do so. Legislators assuaged concerns that this

permit system might create a "permanent record" for topless and nude dancers by including a provision that expunges the permit records from the state system every three years (New York State Assembly 2007).

The bill found justification in the premise that victims of sex trafficking are unlikely to volunteer information to law enforcement even during the course of a police raid due to possibly violent repercussions by management or other exploitative figures. Citing statistics that suggested that a significant majority of runaway or "throwaway" children and adolescents engaged in commercial sex, the bill referenced the need to address the population it termed "victims of trafficking" in the United States. Legislators thus hoped to ensure that "dance performers are aged appropriate, legally documented and not victims of severe forms of trafficking" (New York State Assembly 2007) through a statewide system of registration.

Although this legislation was perhaps well intentioned, its sole subject of concern revolved around the working conditions of women forced into sex work against their will, with the presumption that state regulation would alleviate the problem. It refuses to acknowledge the possibility that unscrupulous employers or other individuals could also coerce women into registering for a permit, and hence this regulation seems destined to further marginalize undocumented and underage female workers by pushing them into clandestine prostitution rather than the relatively safer environment of erotic dancing establishments. Ignoring the realities of poverty, lack of skills-based education, and the need to support children, such efforts effectively render undocumented or underage girls and women who would rather be working stigma-free in a job outside the sex industry as somehow responsible for any bad treatment they receive.

Registration policies thus position dancers as objects of state concern only when it is politically expedient to do so—in other words, when they are women who do not seem to have transgressed gendered sexual norms by making choices that subvert social norms regarding female sexuality. For many dancers, the idea of their sex-worker status being registered with the state is tantamount to social exposure and increases their perception that they are targets and objects rather than subjects free to make their own choices. Sex work is certainly not the only area in

which we see this phenomenon occur, and these patterns characterize many forms of neoliberal labor practices whereby state regulation often manifests itself in ways that singularly benefit the interests of those who have the power to make the rules.

Despite this rather ambiguous positioning of such women as in need of rescue and regulation by the state, analyses of their everyday lives presented throughout the book stress the myriad ways in which they clearly envision themselves as masters of their own destinies. Sex workers are not social isolates who exist in some sort of cultural vacuum separate from dominant ideologies surrounding femininity, the family, and relationships. As products of their cultural milieu, many sex workers embrace the same gendered codes about spending, debt, and public assistance as their peers in other low-wage jobs. Indeed, one of the most striking features of their narratives and descriptions of their everyday lives both in and outside of the workplace is the consistency with which they describe themselves as attempting to gain control of life circumstances that are realistically far beyond the scope of their abilities to change. All of the women featured in this book led lives shaped by the structural violence of poverty, in which survival was often a matter of seizing opportunities for income generation as they became available. In their eyes, sex work presented possibilities for social mobility through short-term income generation, which was deliberately (and cleverly) couched in the hypercapitalist discourse of risk and return by managers seeking to attract workers with the empty promise of potentially unlimited income.

GENDERING POVERTY'S VIOLENCE

Violence is a constant theme throughout this book. Most of the women whose lives are documented in the preceding chapters have long histories of experience with structural and sometimes physical violence—experience that marks their bodies, shapes their decision-making processes, and, in some cases, keeps them in a constant state of anxiety about what the future will bring. Although much of this violence is related to sex work and the risks it carries with it, such risks undeniably exist in tandem with (rather than separate from) the broader cultural norms that

contribute to the demand for such labor in the first place. This is par-
ticularly true when illegal or semilegal forms of income generation take
gendered forms among poor people, thereby pushing far more women
than men into sex work and greater numbers of men than women into
violent crimes and, by default, the prison system.

Dancers at Vixens made frequent forays into what they termed "the
straight world," only to return to work at the bar several weeks later,
disheartened by the low pay and generalized disrespect that inevitably
accompanied the unskilled service-industry jobs they found. Many such
women who came back to Vixens, some after periods as long as several
years away, complained that they had been "spoiled" by the occasionally
higher income provided by sex work. "Once you get used to this kind of
money," the ever-pragmatic Cinnamon intoned, "you get stuck in this,
because you feel stupid if you go back to working for minimum wage."

Nonetheless, the vast majority of Vixens dancers lived perpetually
at or near the poverty level due to their fluctuating earnings and need
to purchase costly shoes and garments for their performances onstage.
Many women clearly stated that the frequency with which dancers
returned to Vixens had less to do with becoming accustomed to a higher
income than it did with being able to find work that offered flexible
hours and earnings with which they could actually afford to support
themselves and their children. It is self-evident that the feminization of
poverty has a great deal to do with the fact that the vast majority of sex
workers are female. Many such women are raising their children alone
and, like their childless female counterparts, find themselves at a seri-
ous economic disadvantage that encourages them to engage in work
that they are fully aware takes place on other people's terms. This is
why the same women who left Vixens with the hope that they could, as
Star and others sometimes phrased it, "get my life together" returned
when they realized that their only alternatives did not really offer a sus-
tainable solution after all.

Clearly, poor men also experience this roller coaster of alternating
between semilegal or illegal forms of work and genuine attempts at being
what they regard as a fully incorporated member of society through a
full-time wage-based job. Yet despite these similarities between poor
women and poor men, women are far more likely to be incorporated

into these same labor markets in unique ways that reflect their lower sta-
tus vis-à-vis men. Privilege works in complicated ways, and thus even
the poorest and most vulnerable populations help to weave the intricate
webs in which they so often become ensnared. For instance, Angel and
her network of male acquaintances spent a great deal of time abusing
alcohol and drugs together, even occasionally sharing living spaces, and
yet they still lived in very different worlds. Both shared the experience
of poverty's structural violence in the specific forms of limited (or non-
existent) health care, unstable living arrangements, and relative social
invisibility, but Angel's gender made her far more likely to be victimized
by physical and sexual violence than her male peers.

So much of poor people's planning for the future relies upon dis-
courses that privilege the power of hope as a survival strategy. In the
stories that make up this book, desperately unhappy women, many of
whom were struggling to support their children and themselves, inevi-
tably described how life was going to change for them once they saved
enough money, left a bad relationship, or embarked upon some other
equally transformative path. It sometimes seemed that the amount of
determination a woman expressed to eventually leave sex work was
inversely proportional to the likelihood of her actually being able to do
so, whether due to debt, lack of formal education or skills training, or a
number of other seriously inhibiting factors. So many sex workers envi-
sion themselves as perpetually on the cusp of leaving, and this belief
carries with it a sustaining force that helps individuals to negotiate the
everyday inequalities that frame their existence. As we have seen, a
number of socioeconomic realities combine to make women understand
that their upwardly mobile path toward a better life also comes with
powerful strings attached.

Nothing illustrates this point more clearly than the rapid series of hor-
rible events that facilitated Angel's death from a drug overdose that may
have been a suicide attempt. Life always seemed to move faster at Vix-
ens, where feminized poverty and its concomitant instability constantly
render human bonds fragile, tenuous, and conditional. Angel certainly
knew how to make her way through this parallel universe and took
pride in the number of places throughout the city she had temporarily

called home, as if the fact that so many men were willing to let her live with them was some sort of index of her worth.

Angel was twenty years old when she died after a lifetime of social exclusion despite her frequent encounters with state agents. Her story dramatically underscores how individuals who are the focus of the greatest institutional concern are paradoxically those who are also the most consistent targets of spectacular institutional failures. In and out of foster care since her childhood, Angel lived in a world that was framed from the beginning by a system ill equipped to truly assist her. Drug and alcohol abuse were a significant problem for her mother, who also occasionally relied upon prostitution to support her habit. These predictors of vulnerability resulted in Angel's early introduction to self-medication through various controlled substances and those who populate the networks that facilitate it, resulting in her giving birth to a child fathered by an unknown supplier. Angel gave the baby boy up for adoption after the Department of Social Services seemed likely to take permanent custody of him anyway, and she rarely spoke about her son when she was sober.

The last time I saw Angel she was intoxicated, nearly naked, and about to get into a strange man's car in the Vixens parking lot. She was clutching an old coat Paul had thrown in her direction after informing her that she had come to work high before, and this was the last time. "Just let her go kill herself somewhere else," Cinnamon had explained to Paul matter-of-factly, waving a finger for emphasis as she pulled him away from the door. The people of Vixens had clearly dismissed Angel as beyond assistance as part of a broader pattern in her life. It took quite some time before I fully understood that Paul was hardly the agent that provoked her death that night but simply the final nudge after her years of being pushed toward the edge. Life had been shoving Angel out in the cold long before she met Paul.

WOMEN AT THE EDGE OF THE WORLD

"All women are whores," Cinnamon used to say and then pause for dramatic effect, until someone inevitably asked her what she meant. "We

have to be," she would usually reply, "and it doesn't matter how rich you are or how good a job you got. That's the way the world is." It took some time before I fully understood what she meant. At first, I thought she was simply employing the moral typologies that allow dancers to distinguish themselves from prostitutes as part of a broader system of temporary self-empowerment that helps to diffuse some of the social stigma surrounding their profession. What Cinnamon actually meant was that gender outweighs even forms of privilege that remained far beyond her reach, including economic stability.

Cinnamon had really been talking about the structural inequalities inherent in being a woman. Women at Vixens clearly understand that sex work is just one aspect of an infinitely larger process by which all women learn (and even teach others) that their labor is less valuable. As Cinnamon concisely pointed out, this phenomenon transcends class and occupational status and can be used to describe the life situation of many women. Women throughout the world are socialized to provide the vast majority of unpaid labor, including child care, food preparation, and other caregiving work. Such responsibilities are often incompatible with higher-paid and more secure jobs, so that women are much more likely than men to find themselves doing unpaid infrastructural work in the home than earning a salary through formal employment.

The resulting economic power imbalance also establishes unequal decision-making abilities in families, so that even within a shared-single-income couple, men and women have very different access to resources. As a result, we see that although relatively privileged stay-at-home mothers benefit from the lifestyle accorded by an employed father, such women are rarely able to maintain a similar standard of living in the absence of a male income. Female-headed households in the United States remain far more likely to live in poverty than those headed by men,[7] and accordingly this situation becomes worse further down the socioeconomic ladder.

The very same social values that enable the devaluation of stay-at-home mothering, feminized labor, and, indeed, women's bodies also function to further marginalize female sex workers. As sociologists Cecilie Hoigard and Liv Finstad note in their study of street prostitutes,

the amounts sex workers earn is relative to other forms of work open to them in the same ways that women's wages are often much lower than men's. "Women have their own money less often than men," they write, "[and] if they have their own money, it is often less money than men" (Hoigard and Finstad 1992, 47). This unequal situation is exponentially compounded for poor women, who have even less access to resources than their male peers. Sociologists Susan Holloway, Bruce Fuller, Marylee Rambaud, and Costanza Pierola observe that for poor women parenting without male support, "confidence and a solid feeling of efficacy—sensing that you can challenge or influence events in your own life—are necessary building blocks of empowerment. These cornerstones often crumble under the weight of poverty" (2001, 53).

Women's unequal status in the labor force (and in society more generally) extends even to traditionally "female" practices such as mothering, so that state and popular understandings of how to parent correctly necessarily involve the presence of a male father. Mothers at Vixens faced a serious dilemma because the perceived cultural incompatibility of sex work with "good" motherhood did not at all reflect their actual desire to improve their families' lives through increased income generation and more flexible working hours. Although parenting is a complex endeavor for all families, women whose lives are more "public" by virtue of their work as performers and their status as poor women find themselves under increased scrutiny by the states as well as their peers. This is why so many dancers worried constantly that the New York State Department of Social Services would use their work as a justification to take their children away.

As is the case with so many issues related to gender injustice, women at Vixens faced the same set of problems dealt with by all women, but at an exponential level. It was almost as if their lives were highly focused representations of the gross inequalities that are otherwise muted by education, social-support systems, and in myriad other ways for more privileged women. Many dancers accordingly saw themselves as uniquely predisposed to seeing the world as it truly is, without any illusions. This book began with the story of Chantelle, who began dancing topless at Vixens when she discovered she was pregnant. Her biological family

was fragmented and uninterested in assisting her, and she believed that her only option for quick income generation lay in sex work. She struggled seriously with her choice, and during the second trimester of her pregnancy she went to live with distant relatives in her mother's native West Virginia. From the hills and mountains that formed the landscape of her new home, she said, "It's like looking at the edge of the world." Indeed, Chantelle's life had consistently put her and others like her at Vixens into a permanent state on the precipice, from which it was very difficult to go either forward or back.

Notes

1. Excellent examples of this variety of scholarship can be found in philosopher Susan Bordo's (1993) work on the Western European and North American cultural constructs that have historically enabled the deep sense of dissatisfaction many women feel toward their bodies. Yet women who choose to celebrate femininity as a highly prized and difficult-to-cultivate attribute that is itself a form of symbolic capital often embrace such constructs as empowering. Numerous academic works have detailed how this phenomenon manifests itself through plastic surgery (Davis 1995), disordered eating (Brumberg 1988), and beauty pageants (Banet-Weiser 1999; Dewey 2008a).

2. For an excellent general overview of trends in social science research on the sex industry, including work that discourages such essentialisms, see Weitzer (2009).

3. Some examples of the labor practices at high-end adult establishments can be found in Frank 2002; for a discussion of typologies related to strip-club quality, see DeMichelle and Tewksbury 2004, 541.

CHAPTER ONE: INTRODUCTION

1. Chantelle was certainly not alone in this sentiment. Anthropologist Sophie Day notes on her work with London sex workers, "As [some women] became pregnant, they envisaged moving into easier and better times; sex work would, after all, hold only a limited place in life as a whole" (Day 2007, 163).

2. Despite pervasive beliefs about sex work's supposedly lucrative nature, scholarly research has demonstrated that the vast majority of sex workers live at or near the poverty level. Ample documentation of this reality can be found in social science studies on the subject (Benoit and Millar 2001; Day 2007; DeRiviere 2006; Raphael 2004) and also appears, albeit anecdotally, in studies of women living in poverty (Edin and Lein 2007, 1997; Venkatesh 2006) throughout North America. Hoigard and Finstad have observed the direct correlation between the price of heroin and the price of street sex (1992, 42–47), and Brents, Jackson, and Hausbeck note that even legal forms of prostitution are made less than lucrative for sex workers due to the elaborate charges and earnings structures in place at legal brothels (2010, 169–173). In the specific context of erotic dance, see Bradley Engen for discussions of highly variant earnings in different types of establishments (2009). Analyses of more lucrative forms of sex work can be found in studies by Bernstein (2007b); Koken, Bimbi, and Parsons (2010); and Lucas (2005); as well as in Vivian Zelizer's (2007) fascinating sociological analysis of the commodification of intimacy.

3. See Casper and Moore 2009 for an excellent discussion of this phenomenon, particularly in the context of the television show *To Catch a Predator,* and Curry 2001 for a sociological analysis of viewer responses to the "police show" genre of U.S. television.

4. For particularly engaging ethnographies on the everyday lives of both male and female sex workers, see Brennan 2004; Brown 2005; Day 2007; Kelly 2008; Kulick 1998; Nencel 2001; Padilla 2007; Prieur 1998; Schifter 1998.

5. Numerous scholars have investigated the notion of "the prostitute as social symbol," whereby she is represented in popular culture not as an individual person but rather as a repository and manifestation of moral decay. See, for instance, Bell 1994; Kuo 2002; Hershatter 1999; Jeffreys 2008, 2009. Indeed, Julia O'Connell Davidson also follows this tradition in recommending that

pervasive contemporary moral panics about child sex tourism be analyzed "against the backcloth of much deeper anxieties about the ordering of social and political relations in late-modern Western societies" (O'Connell Davidson 2005, 2).

6. New York State Department of Labor. "History of the Hourly Minimum Wage in New York State," www.labor.state.ny.us/stats/minimum_wage.asp.

7. See, for example, Radin 1920; Lurie 1961; Shostack 1981; Nash 1992; Buechler and Buechler 1996.

8. Feminist ethnographic practice consciously interrogates positionality. For good examples of this tendency, see Dorinne Kondo 1986; Kamala Visweswaran 1994; Ruth Behar 1997, 1993.

9. Feminist ethnographers have been concerned with related issues for a number of years, although more work is needed to elicit a clearer understanding of how positionality functions in different ways for individual researchers. It is by now almost a cliché when discussing the complexities inherent in ethnographic methods to include essayist and social critic Susan Sontag's assessment of anthropology as a "total profession" that necessitates complete life devotion akin to that of a painter or a sculptor. Although widely criticized, this description clearly remains a salient evaluation of the only academic discipline to insist upon complete immersion in the subject of one's study. Anthropology is unique in that it necessitates the creation of a whole new self that anthropologist Takeyuki Tsuda has likened to "identity prostitution, the selling of one's self for instrumental advantage" (1998, 110). Colin Turnbull notes that actors who must successfully "become" the character they play onstage face many of the problems that anthropologists do because of the way that ethnographic research necessitates the development of a new field self in keeping with gendered norms appropriate to the society under study (1996, 17). This is especially complicated for women, who are cross-culturally more likely to face danger in the field due to their near-universal lower status that places them at risk of sexual violence. Diane Wolf (1996) has noted that feminist dilemmas revolve around power, and in the field, these stem at least in part from differences between the researcher and those she studies in terms of race, class, nationality, life chances, and geographic location. She raises similar questions about the ability of anthropologists to "tell" the kinds of stories that so often characterize our field notes and published work by using our own interpretations.

10. Many social scientists would argue that this consistent focus on the poor and dispossessed also stems from concerns about social justice and equality. Nonetheless, it must be acknowledged that, for the vast majority of people, pervasive, worldwide contemporary socioeconomic inequalities function to worsen, rather than improve, their lives.

CHAPTER TWO: FEMINIZED LABOR
AND THE CLASSED BODY

1. Edward Cleary, "When the lights go out at New York's Industries," *Syracuse Post-Standard*, May 7, 1985, p. A-9.

2. Don Cazente, "Dilapidated Rockwell building considered as new site for jail," *Syracuse Post-Standard*, July 7, 1989, p. A1.

3. Gary Gerew and Patricia Rycraft, "Syracuse works planted roots in Solvay over 100 years ago," *Syracuse Herald-Journal*, April 23, 1985, p. A5a.

4. "Move would sap tax base," *Syracuse Herald-Journal*, April 23, 1985, p. A5a.

5. Elizabeth Kolbert, "The talk of Syracuse: New York's old 'Salt City' struggling to overcome setbacks," *New York Times*, June 16, 1986, www.nytimes.com/1986/06/16/nyregion/the-talk-of-syracuse-new-york-s-old-salt-city-struggling-to-overcome-setbacks.html?scp=1&sq="The+talk+of+Syracuse"&st=nyt.

6. "Allied closing causes 'ripple effect' for area businesses," *Syracuse Herald-American*, December 21 1986, p. A14.

7. Cleary, "When the lights go out," p. A-9.

8. Kolbert, "The talk of Syracuse."

9. Sue Weibezahl Naylor, "GE layoffs worry officials in 3 towns," *Syracuse Herald-Journal*, April 27, 1990, p. A12.

10. Adelle Banks, "Dislocated GE workers may pursue jobs through several other avenues," *Syracuse Herald-Journal*, November 12, 1986, p. A10.

11. Steven Billmyer, "GE picture tube business fades to black," *Syracuse Herald-American*, May 10, 1987, p. E7.

12. Rick Moriarty, "Geddes detergent factory to close," *Syracuse Herald-Journal*, July 29, 2000, p. A1.

13. Walter Zbyszewski, "I'm jobless, aging and losing ground in the fight to survive," *Syracuse Post-Standard*, May 6, 2005, p. A-13.

14. Charley Hannagan, "Seven workers that Carrier cut loose," *Syracuse Post-Standard*, April 8, 2007, p. A1.

15. Examples of these new labor practices are presented in Newman 2000; Paap 2006; Wilson 1997.

16. For a more contemporary discussion of this phenomenon in a U.S. context, see Weis 2004, in which the researcher returns to the field to document the lives of the blue-collar population she interviewed fifteen years earlier.

17. For a promising exception to this general rule, see Julia Query and Vicky Fulani's 2000 documentary, *Live Nude Girls Unite*, about San Francisco exotic dancers who led a successful unionization campaign.

18. This is cross-cultural in nature: my research on sex trafficking was conducted with an international organization that generously allowed me to attend

meetings at the senior planning level, sometimes in conjunction with government officials in Armenia, Bosnia-Herzegovina, and India. Over and over again, the most consistent theme I saw in all three of these countries was the almost complete lack of sex-worker participation in these processes; instead, sex work was often "discussed" by "experts" who had never met a sex worker, let alone performed this sort of labor themselves. These kinds of exclusionary discussions about women who do sex work continue to take place in community meetings, on zoning boards, and even in Congress—all operating on a set of untested assumptions about the realities of other women's lives.

19. For an interesting study of this growth in the post-deindustrialization period by town planners in a New York State community similar to Sparksburgh, see Ellicottville Town and Village Board 1998.

20. This socially entrenched paradigm of sex work as an exclusively female profession is increasingly being challenged in new scholarly research on male sex workers (and men who have sex with men) by Kerwin Kaye (2010), Mark Padilla (2007) and Gregory Mitchell (2009).

21. For further reading on the gendered economics of home-based paid work, see Brooks 2007; Standing 1989; Mies 1999; Safa 1995.

22. Labor historian Alice Kessler-Harris's work (2006, 2003a, 2003b) is an excellent source for discussions of this gendered phenomenon in a U.S. context.

23. A number of excellent ethnographies and theoretical texts from the University of Chicago's "Worlds of Desire" book series eloquently speak to the social construction of desire, particularly Carrillo 2002; Green 1999; Herdt 1999; Sang 2003; Setel 2000.

24. Outside the North American context, researchers have documented the ambivalent social status of women who perform eroticized dance in Cyprus (Karayanni 2009), Egypt (van Nieuwkirk 1995), India (Tambe 2006), Japan (Segawa 1993), Korea (Pilzer 2006), the Middle East (Buonaventura 1998), and Pakistan (Saeed 2001).

25. Literary scholar Sieglinde Lemke has made particularly interesting forays into this area. In *Primitivist Modernism* (1998), she argues that Western European and North American notions of modernism drew heavily on ways of being, thinking, and living then considered "primitive." Lemke draws upon a rich body of examples from the Jazz Age to discuss the sexualized exoticism upon which African-American dancer Josephine Baker based her dance career. Yet even more interesting is her analysis of the widespread U.S. mimicry of what had previously been exclusively African-American dance forms. She quotes African-American author Rudolph Fisher, writing in 1927 about what he called "the Nordic invasion" of Harlem as affluent whites flocked to jazz revues and cabarets to dance. This influx caused Fisher to remark that it was "almost as if a traveler from the North stood watching an African tribe dance then suddenly found himself swept

wildly into it, caught in its tribal rhythm" (1998, 91). Dance scholar Brenda Dixon Gottschild remarks that the sense of abandon, sensuality, and danger associated with such dancing reflects the racist mechanisms through which "the black dancing body has served as the screen upon which white fears and fantasies are projected" (2003, 41) as part of what she terms "the love-hate relationship that characterizes oppression" (2003, 15). Whether it is the articulated torso and pelvic movements of some African diasporic dance forms in the United States or their counterparts around the world, certain movements are clearly eroticized because of the historical weight and cultural connotations they carry with them.

26. To paraphrase turn-of-the-century French author (and erotic dancer) Colette, erotic dance is "the profession for those without a profession." She writes: "Que voulez-vous que je fasse? De la couture, de la dactylographie ou le trottoir? Le music-hall c'est le métier de ceux qui n'en ont appris aucun. [How do you want me to make my living? Sewing dresses, typing, or streetwalking? The music hall is work for those who haven't learned any other]" (Colette 1910, 3).

27. Nor are they unique to everyday life. See Black 1997 for an engaging discussion of bodily functions and associated humor in blue-collar families.

28. Particularly good discussions of the meaning of whiteness in a North American context can be found in Conley 2000; Hartigan 2005; Hill 2004; Ignatiev 1996; Lott 1995; Roedlinger 1991; Wray and Newitz 1997; Weis 2004; Wray 2006.

29. For a lavishly illustrated general introduction to the styles associated with burlesque, see Glasscock 2003. Photographs of star performers in the "new burlesque" appear in Bosse 2004.

30. Of course, it is difficult to precisely date the rise and fall of a popular cultural form. Allen (1991) believes burlesque died out shortly after World War II, whereas theater scholar Rachel Shteir dates it "from the Jazz Age to the era of the Sexual Revolution" (2004, 1).

31. For more on the Ziegfeld girl as cultural phenomenon, see Mizejewski 1999.

32. Although burlesque theaters could still be found in the early 1960s, their lessened popularity also relates to the fact that, as anthropologist Gayle Rubin notes, "from the late 1940s until the early 1960s, erotic communities whose activities did not fit the postwar American dream drew intense persecution" (1994, 270).

CHAPTER THREE: EVERYDAY SURVIVAL STRATEGIES

1. Even more provocatively, Handler and Hasenfeld argue that PRWORA and related welfare reforms "can be understood as the enactment of a public moral ritual, through which the broad societal [child and elder] care crisis

is symbolically represented and magically controlled. Viewed as such a ritual, welfare reform instantiates the societal care crisis as the moral failing of a small group of outcast individuals, welfare mothers. These figures are then subjected to punitive sanctions through which they are given the opportunity to correct their own failing. In response to these sanctions, they can choose to become self-sufficient by producing enough income to get off the dole, while caring for their own children without complaint. Alternatively, they can rebel against the sanctions, and refuse to become self-sufficient. If they choose this path, they are free to disappear" (quoted in White 1999, 130–131).

2. In her study of British migrant women dancers on the Spanish resort island of Tenerife, sociologist Esther Bott found that such women were "caught in a cycle of earning and spending, without ever saving money . . . everything earned in a night's work would be spent before work commenced the following evening, mainly on food, cocktails and drugs" (2006, 37). The women in Bott's study envisioned themselves as choosing an option highly preferable to what they perceived as their sole alternative, which the dancers she spoke to described as "[being] working class . . . getting pregnant and becoming a single mother" (2006, 30).

3. Day (2007, 87) observes that many London sex workers entered the profession because "they longed to remove themselves from the subordinate relationships experienced at home and in school and, for some, the 'straight' labor market; they wanted to escape, to accumulate real things and transform their lives." For more on migration and sex work motivated by desires for a better life, see Day and Ward 2004; Dewey 2008b.

4. For more on this rhetorical style, see Kideckel 2008; Ries 1997; Puckett 2000.

5. Department of Health and Human Services, "Applying for benefits: What families must do," http://aspe.hhs.gov/HSP/app-process03/Chapter3.htm

6. Ibid.

7. Liz Schott and Zachary Levinson, "TANF benefits are low and have not increased with inflation" Center on Budget and Policy Priorities, 2008, www.cbpp.org/pdf/11–24–08tanf.pdf.

8. The terms of these services are clearly indicated on the "Application for Child Support Services" form itself, available on the New York State Department of Social Services Web site, https://newyorkchildsupport.com/pdfs/DSS-2521.pdf.

9. These applications are city- and town-specific. For more information, see the New York State Division of Housing and Community Renewal Web site, www.dhcr.state.ny.us/Forms/.

10. *New York State Penal Code*. Article 230.00. Prostitution.

11. *New York State Penal Code*. Article 235.00. Obscenity, and related offenses.

12. See New York State Office of General Counsel, Legal Memorandum LU03, "Municipal regulations of adult uses," www.dos.state.ny.us/cnsl/lu03 .htm for more information.

13. Ibid.

14. Tolerance zones have been successfully established in many areas of the world. In her work on one such tolerance zone in Mexico, anthropologist Patty Kelly documents the elaborate regulations that frame life for women who work in the Zona Galactica, a state-owned brothel. Kelly notes that government involvement in creating this area for the legal sale of sex is intimately connected to broader notions of appropriate behavior. City officials thus attempt to "remove prostitution from public view . . . [and] make invisible the men and women who are 'premodern' symbols of social decay and disorder, while making visible the power of the state" (2008, 67). Anthropologist Angie Hart describes the informal creation of such areas through lack of police interference and through social norms that tacitly sanction men's patronage. Hart characterizes red-light areas in Spain as bounded by popular perceptions of the "illegitimacy of time [spent there] and space [what is done there]" where "an ambiguous state of affairs exists between clients, families, and prostitutes" (1997, 96).

15. This contrasts dramatically with spatial debates on cross-border migration for the purposes of prostitution, as witnessed in heated debates among and between feminists, policymakers, and international organizations alike on sex trafficking. For more on such debates, see Agustín 2007; Dewey 2008b; Fitz-Gerald 2008; Zheng 2010.

16. Munro and Della Giusta believe that these polarized feminist positions create a situation "that proves problematic, in different ways, when presented as an abstract position that claims universal applicability to all women and all commercial sex. Despite their heated disagreements, each of these positions falls into a significant epistemic pitfall by presuming the existence of a unitary truth, not only of the practice of prostitution but also of female (and, indeed, male) sexuality itself. There is a tendency in these accounts both to disengage from the diversity of sex markets (and the sexual services they encompass) and to artificially abstract the licit/illicit industry dichotomy from the messiness of its operation in the global (capital) economy. In addition, the threat of essentialism looms large here, as other forms of discrimination (race, age, class and so on) that may also feature in the commercial sex transaction are 'trumped' by the preoccupation with gender/sex difference" (2008, 2).

17. Linda Greenhouse, "Court upholds ban on topless dancing in bars," *Syracuse Herald-Journal*, June 23, 1981, p. A-2.

18. Jay Goldman, "Agent raps court's topless bar ruling," *Syracuse Herald-Journal*, June 24, 1981, p. C-4.

19. Don Harting, "Just keep your shirts on: New topless bar in Clay raises neighborhood's ire," *Syracuse Post-Standard*, October 25, 1990 , p. 3.

20. Lori Duffy, "Adult theater workers face prostitution charges," *Syracuse Post-Standard*, September 22, 1995, C1.

21. Jim O'Hara, "Dirty dancing draws arrests," *Syracuse Herald-Journal*, September 22, 1995, p. B3.

22. Historian Thomas Laqueur's (1992) thorough discussion of the Western European cultural association between women and disorder spans several centuries and provides an excellent analysis of how the two became associated.

23. Gloria Wright, "Guy denies crusading against nudie club," *Syracuse Post-Standard*, February 4, 1993, p. B-2.

24. Frederic Pierce and Mike McAndrew "City puts sex trade on notice," *Syracuse Post-Standard*, June 13, 1999, pp. A1, A14.

25. Lauren Wiley, "Topless dancing in DeWitt draws ire," *Syracuse Herald-Journal*, March 27, 1996, p. B4.

26. Frederic Pierce, "Council regroups on adult businesses," *Syracuse Herald-Journal*, January 20, 2000, p. B3.

27. Frederic Pierce, "Business 2000," *Syracuse Post-Standard*, February 14, 2000, p. B8.

28. Sociologist Bernadette Barton describes this as part of a process through which "good and bad experiences rapidly transform into their opposites over the course of a single evening, making the strip bar a volatile and unsettling space for performers" (2002, 582).

29. New York State Alcoholic Beverage Control Board. Law 106, subd. 6-a.

CHAPTER FOUR: BEING A GOOD MOTHER
IN A "BAD" PROFESSION

1. Anthropologist Sophie Day notes that the relatively high income earned by some sex workers actually translated into a low real income because of "the added financial penalties of discrimination that raised rents and the costs of saving and investing," which combined to make the women in her study "complicit in destroying the very fabric of their future" (2007, 144).

2. Indeed, hierarchies are constructed not only of how much money a sex worker makes, but also what she has to do to get it. Sociologist Wendy Chapkis writes, "The high class call girl may be seen as an 'expensive date,' while the street prostitute remains no more than a 'whore.' The illusion of affluence not only elevates a sex worker above the status of cheap whore, it also provides an acceptable justification for her involvement in the trade" (1997, 104). See also Bernstein (2007b) for further discussion of this phenomenon.

3. Although Lewis's theory has been much maligned, recent poverty-alleviation measures are again beginning to incorporate his ideas. See Rosenberg (2008).

4. For instance, economist Linda DeRiviere's research on Canadian sex workers found that "a small earnings premium is the only direct benefit of prostitution at a personal level. However, such benefits are short-term relative to the individual's available working years, and the off-setting costs . . . are huge" (2006, 379). Her findings among this particular sex-worker community revealed that an overwhelming majority of women's earnings diverted to partners and self-medication through drugs and alcohol. DeRiviere found that 37.2 percent of earnings went to partners, 46.6 percent went to drugs and/or alcohol, and 8.5 percent were lost due to violence.

5. That money holds a powerful mystique is particularly true for the poor, as anthropologist Michael Taussig (1983) has noted in his work on how Bolivian and Colombian laborers use discourse centered on the devil and demonic possession to describe new capitalist processes that so obviously benefit a small number of people to the detriment of the vast majority of society. Taussig makes the provocative argument that these relationships are carefully masked by all participants in societies long privy to capitalist practices that deprivilege labor, and that groups new to such processes have a unique ability to see them for what they really are. Useful works relevant to the anthropology of consumption include Appadurai 1988; Bourdieu 1984; Burke 1996; Farquhar 2002; Miller 1998.

6. For more on the focus group study that gathered this information and efforts by child-centric businesses to encourage credit-card use, see "Should kids be playing with credit cards?" *CBS News.com*, November 27, 2007, www.cbsnews .com/stories/2007/11/27/earlyshow/contributors/daveramsey/main3543883 .shtml.

7. Cinnamon was not alone in her concerns about Melanie; such behavior in adolescents has become increasingly pervasive in all spheres of American life. See Levy 2005 and Paul 2005 for general discussions of this phenomenon.

8. Anthropologist Patty Kelly notes that this "moral value attached to properly caring for one's children" (2008, 161) strongly organizes the work and family lives of sex workers in Mexico. Anthropologist Lorraine Nencel has also observed this tendency in Peru, where "the flip-side of the whore is the impoverished . . . abandoned mother who is forced to prostitute to guarantee her children's well-being and a chance for a brighter future . . . motherhood is given a priceless significance in the performance of their identity" (2001, 222). Similarly, Sophie Day's ethnographic work reveals that London sex workers often spoke about their children as the only deserving recipients of their income, often in direct opposition to partners or family members, who would become "spoiled" by such money. "Maternal sentiment," Day writes, "was considered

to be creative, productive and non-commercial by definition . . . to spend money on children seemed to be an unambiguous moral good and virtually defined good parenting" (2007, 166).

9. Debates regarding whether sex work in any form is inherently abusive or a potential form of empowerment for its practitioners have now been ongoing for several decades. As Carol Wolkowitz pointedly notes in regard to sex-work abolitionists (whom she terms "radical feminists"), "This view of the natural purity of women's bodies has enabled radical feminists to forge a problematic alliance with traditional moralists. . . . Even if radical feminists do not condemn the guilty sinner in the way traditionalists would, they share an outlook in which women are constantly being 'duped, tricked or lured' into prostitution by people traffickers. This in turn enables them to hold onto the idea of women as essentially innocent. . . . [and] explicitly refuses to recognize any continuities between prostitution and other kinds of (dirty, humiliating, intimate) work or to take on board the (also dirty, humiliating and sometimes intimate) kinds of work that women, and too often children, might well have to turn to in order to support themselves. Not only does their position seriously underestimate the relative rewards of prostitution as an active choice, whatever the cost, but there is an almost willful refusal to acknowledge [that] providing realistic alternatives to prostitution is linked to almost intractable wider socioeconomic constraints, and not just issues about women's rights" (Wolkowitz 2006, 126).

CHAPTER FIVE: PSEUDOINTIMACY
AND ROMANTIC LOVE

1. Work in hostess bars conducted by anthropologists Anne Allison (1994) in Japan and Tiantian Zheng (2009a) in China clearly illustrates how sex workers function as brokers and symbols of male prestige, serving as a conduit for the male expression of material success. Zheng in particular observes that such an environment is particularly conducive to the formation of mutually beneficial relationships, and many hostesses aspire to leave their profession through such an alliance. Yet, just as historian Henry Trotter (2008) points out in the case of dockside prostitutes in South Africa and Denise Brennan (2004) observes in the Dominican Republic, such enduring bonds between men and women who meet in the context of a paid encounter are rare. Many Vixens dancers continued to hope for such a successful relationship in spite of the limited likelihood of its ever occurring, but they simultaneously remained cautious about the potentially destructive consequences of failure.

2. See Egan 2006b for a discussion of dancers' music choices as a form of resistance.

CHAPTER SIX: CALCULATING RISKS,
SURVIVING DANGER

1. For more on the impacts such patterns of violence have upon girls and women, particularly sex workers, see Lowman 2000; Nixon et al. 2002; Raphael 2004; and Raphael and Shapiro 2004.

2. The epidemiology of disease transmission to and by sex workers is discussed in Katsulis 2009 (Mexico), Steinfatt 2002 (Thailand), Waddell 1996 (Australia), and Albert 2002 (in legal U.S. brothels).

3. Bourgois notes similar hierarchies among crack dealers as part of "the profound moral—even righteous—contradictory code of street ethics that equates any kind of drug use with the work of the devil, even if almost everybody on the street is busy sniffing, smoking, shooting or selling" (1995, 40–41).

4. Post-Foucaultian theorists such as sociologists Monica Casper and Lisa Moore term the frequency with which cameras are now used to monitor populations of concern as "a new ocular ethic" in which "bodies are made invisible or rendered hypervisible in novel ways . . . for sundry and often insidious purposes" (2009, 179).

5. Yet research on the more expensive and well-appointed establishments often called "gentleman's clubs" documents the dramatic impact that greater numbers of surveillance cameras had on all participants in such establishments. In her work at one such topless dancing bar, anthropologist R. Danielle Egan (2004) noted that cameras were used to monitor behavior but that they also gauged monetary exchange between dancers and clients to ensure that dancers gave management the correct portion of their tips each night.

6. New York State Penal Code. Article 235.00. Obscenity and related offenses.

7. Paul's connections between sexual abuse and sex work eerily resemble aspects of arguments against classifying venues like Vixens as workplaces (e.g., Barry 1996; Farley 2004b; Jeffreys 2009). Notably, however, very few Vixens dancers used this kind of reasoning in their explanations for entry into sex work. Such a sharp discursive disjuncture between dancers and managers would provide fertile grounds for future research.

8. Day observes that many sex workers whose lives she has studied express a desire not to socialize with their peers outside of working hours in order to maintain a bifurcated existence between their lives as prostitutes and their position as women (2007, 26).

9. There are seven federally recognized Indian tribes in New York State, three of whom have lawful gambling establishments that are untaxed and are self-regulated by the tribe in conjunction with the National Indian Gaming

Commission. The U.S. Congress passed the Indian Gaming Regulatory Act in 1988, which acknowledges that Indian land is not under state law and thus state gaming regulations do not apply there. Consequently, 207 tribes have opened 330 gaming facilities in twenty-eight states (www.racing.state.ny.us/Indian/FAQ.html).

CHAPTER SEVEN: BODY WORK AND THE FEMINIZATION OF POVERTY

1. Almost all social science work on the body is indebted to or informed by the work of philosopher and historian Michel Foucault. Anthropologists Margaret Lock and Judith Farquhar neatly summarize this encompassing influence as follows: "Foucault's accounts of the particular ways of speaking about and of disposing bodies within the institutions [asylums, hospitals, prisons], built spaces, and communities of Europe in the eighteenth and nineteenth centuries have provided a carnal and material dimension to the genesis of the modern individual. Foucault argues that the commonsense individual did not simply emerge by throwing off the shackles of a confining medieval past, learning after centuries of darkness to express its essential autonomy and originality; rather our very modern sense that the individual is a natural linkage of material body and 'soul' came to be hegemonic only quite recently through the practical work and writing of institutions of medicine and population management" (2007, 8).

2. Amber Hollibaugh's powerful statement reflects far more than her own experiences as an impoverished young woman relying on her body for survival, speaking also to the significant and pervasive class divisions that continue to characterize North American life. She writes: "Middle-class women look untouched in their twenties and thirties. Their hands have not been burned by a restaurant's deep fat fryer or wrinkled from daily plunging into ammonia and baby shit. Their hands have opened books, sold blouses in the summer, written college entrance exams, washed out their own underwear and nightgowns. At eighteen, I was cleaning out office buildings at night, wringing mops and scrubbing endless corridors with huge pails of ammonia and waxing machines. Then, starting at 9:00 or 10:00 P.M., I would dance in a club, lighted low enough that the condition of my hands didn't matter, only the quantity of bare skin that was showing. I worked in restaurants, hamburger joints, A&Ws, donut shops, cocktail lounges, if I wasn't dancing or stripping. And all of it, in one way or another, depended on my youth and quick thinking—for tips or hiring or getting by. Back then, it was my insides that felt old. The tiredness was in my legs from working two or three jobs at a time, the weariness that settled in young from worry and the hustles. Still, my body got me by—my body and my wits" (2001, 169–170).

3. Although sex work and the newer forms of reproductive technologies do not share the same amount of popular cultural fascination, they do share a heavily classed nature. This was unmistakably brought to the fore in a flood of angry and disappointed responses to the *New York Times Magazine* article "Her Body, My Baby," by *New York Times* reporter Alex Kuczynski, which chronicled what the author termed her "adventures in surrogacy with a woman whose daughter used ova donation as a way to pay for college" (2008). The cover featured a photograph of the immaculately groomed author standing next to a heavily pregnant, barefoot surrogate in inexpensive, ill-fitting clothes. Excerpts from a particularly cutting letter to the editor in response to this story noted this classed connection: "If prostitution is unethical, immoral and illegal, why is it OK for one woman to pay for the use of another woman's body? . . . Our immorality seems so malleable in the hands of those who feel entitled" (Wilson 2008).

4. In his work on impoverished aspiring boxing champions in inner-city Chicago, anthropologist Loïc Wacquant notes that the beliefs that are "inscribed deep in the bodily dispositions of the fighter, in the normalcy of exploitation, in the 'agency' of corporeal entrepreneurship and in the possibility of individual exceptionalism help produce the *collective misrecognition* that leads boxers to collude in their own commercialization. . . . As for the unusual *intensity* of the exploitation in that economy, it is a direct function of the social and ethnoracial distance between exploiter and exploited as well as of the gaping disparity in the volumes and types of capital they possess: on the one side, fighters typically own little more than their trained organism and the moral valiance needed to valorize it in a rough and risky trade; on the other side, managers and promoters virtually monopolize the specific competencies and assets required to run the business. The near-total absence of regulation by the bureaucratic agencies of the state, in turn, is an expression of the marginal and tainted status of the trade in the universe of professional athletics and popular entertainment, as well as of the correspondingly low class and ethnic position of its practitioners and consumers (2002, 191).

5. Lock also comments upon the unprecedented nature of such exchanges by noting, "It was not until the first part of the twentieth century that medical knowledge advanced sufficiently that blood could be transfused, and then, later, solid organs were transplanted, bringing about a confusion of body boundaries and body parts never before possible. . . . Because of the anonymity that has been imposed on donors, many of whom receive nothing more than a brief note of thanks from an organ-procurement agency, their altruism has gone virtually unmarked by many recipients and even by some transplant teams. On the contrary, a sense of entitlement to 'spare parts' is evident among a good number of people involved with the transplant enterprise" (2007, 224, 230).

CHAPTER EIGHT: CONCLUSION

1. I use the word *probably* here with some amount of caution. Due to the highly variegated and often clandestine nature of sex work, there are no quantitative studies that can be reliably used to determine whether this is case with absolute certainty. It is nonetheless notable that all of the qualitative literature on sex work features a consistent emphasis on both the temporary nature of this form of labor and the lengths to which sex workers go in order to conceal their occupation from others, often by combining it with another income-generating activity. This qualitative research indicates almost without exception that neither sex workers nor those in positions of authority over them view sex work as more than a temporary option; when combined with the high degree of associated stigma, this provides a powerful incentive for sex workers to search out other economic opportunities. There are, of course, exceptions, and Cinnamon's lengthy experience as a sex worker is but one example.

2. David Herszenhorn, "Bailout Plan Wins Approval," *New York Times*, October 31, 2008, www.nytimes.com/2008/10/04/business/economy/04bail out.html?scp=5&sq=Congress%20votes%20for%20bailout&st = cse.

3. In their work on the legal brothels of Nevada, sociologists Barbara Brents, Crystal Jackson, and Kathryn Hausbeck clearly note the strong connections between the (pre–economic downturn) growth of feminized low-wage service jobs and the number of women willing to enter legal prostitution. With regard to what they term "paths to brothel work," they note: "Changing labor markets tells a big part of the story of how women come to the brothels. The service sector has grown tremendously. Women comprise the vast majority of workers in this new economy. Most service sector jobs are notoriously low paying. Indeed, much of the growth in the inter-mountain west has been in service jobs. Lower skilled service jobs (jobs that require some skill but not formal knowledge via college or specialized training) include call-center, retail, food service, financial services, care work, hospitality, sales, tourism and public welfare jobs. The financial instability of working in lower paid service sector jobs creates a pool of women workers who may seek alternative ways to make ends meet. Many of the women working in Nevada brothels come from these types of jobs" (2009, 155).

4. Legal brothels in Nevada also consider sex workers independent contractors. See Brents, Jackson, and Hausbeck 2009; Albert 2002.

5. New York State Department of Labor, "Independent Contractors," www .labor.state.ny.us/ui/dande/ic.shtm.

6. Ibid.

7. For a more detailed discussion, see Holloway, Fuller, Rambaud, and Pierola 2001.

Works Cited

Abu-Lughod, Lila. 1991. Writing against culture. In *Recapturing Anthropology: Working in the present,* ed. Richard G. Fox, 137–162. Santa Fe.: School for Advanced Research Press.

Adair, Vivyan C. 2001. Branded with infamy: Inscriptions of poverty and class in the United States. *Signs* 27:451–481.

Adler, Amy. 2007. Symptomatic cases: Hysteria in the Supreme Court's nude dancing decisions. *American Imago* 64, no. 3: 297–316.

Adler, Patricia. 1993. *Wheeling and dealing: An ethnography of an upper level drug dealing and smuggling community.* New York: Columbia University Press.

Agustín, Laura María. 2007. *Sex at the margins: Migration, labour markets and the rescue industry.* London: Zed Books.

Albert, Alexa. 2002. *Brothel: The Mustang Ranch and its women.* New York: Ballantine Books.

Allen, Robert. 1991. *Horrible prettiness: Burlesque and American culture.* Chapel Hill: University of North Carolina Press.

Allison, Anne. 1994. *Nightwork: Sexuality, pleasure and corporate masculinity in a Tokyo hostess club.* Chicago: University of Chicago Press.

Almeling, Rene. 2006. "Why do you want to be a donor?": Gender and the production of altruism in egg and sperm donation. *New Genetics and Society* 25, no. 2: 143–157.

Appadurai, Arjun. 1988. *The social life of things: Commodities in cultural perspective.* Chicago: University of Chicago Press.

Baldwin, Margaret. 2004. Living in longing: Prostitution, trauma recovery and public assistance. In *Prostitution, Trafficking and Traumatic Stress,* ed. Melissa Farley, 267–314. New York: Routledge.

Bancel, Nicolas, Pascal Blanchard, Gilles Boetsch, Eric Deroo, Sandrine Lemaire, and Charles Forsdick. 2009. *Human zoos: From the Hottentot Venus to reality TV shows.* Liverpool: Liverpool University Press.

Banet-Weiser, Sarah. 1999. *The most beautiful girl in the world: Beauty pageants and national identity.* Berkeley: University of California Press.

Barr, Michael, and Rebecca Blank. 2009. Savings, assets, credit and banking among low income households: Introduction and overview. In *Insufficient Funds,* ed. Rebecca Blank and Michael Barr, 1–22. New York: Russell Sage.

Barry, Kathleen. 1990. *The prostitution of sexuality: The global exploitation of women.* New York: New York University Press.

Bartky, Sandra. 1990. *Femininity and domination: Studies in the phenomenology of oppression.* New York: Routledge.

Barton, Bernadette. 2006. *Stripped: Inside the lives of exotic dancers.* New York: New York University Press.

———. 2002. Dancing on the Möbius strip: Challenging the sex war paradigm. *Gender and Society* 16, no. 5: 585–602.

Basi, J. K. Tina. 2009. *Women, identity and India's call center industry: Close calls and hang ups.* London: Routledge.

Behar, Ruth. 1997. *The vulnerable observer: Anthropology that breaks your heart.* New York: Beacon.

———. 1993. *Translated woman: Crossing the border with Esperanza's story.* London: Beacon.

Bell, Holly, Lacey Sloan, and Chris Strickling. 1998. Exploiter or exploited: Topless dancers reflect on their experiences. *Journal of Women and Social Work* 13, no. 3: 352–368.

Bell, Shannon. 1994. *Reading, writing and rewriting the prostitute body.* Bloomington: Indiana University Press.

Beneria, Lourdes, Maria Floro, Caren Grown, and Martha MacDonald. 2000. Globalization and gender. *Feminist Economics* 6, no. 3: 7–18.

Benoit, Cecelia, and Alison Millar. 2001. Dispelling myths and understanding realities: Working conditions, health status, and exiting experience so sex workers. Prostitutes Empowerment, Education and Resource Society/

British Columbia Centre of Excellence on Women's Health. http://web.uvic
.ca/~cbenoit/papers/DispMyths.pdf.

Bernstein, Elizabeth. 2007a. *Temporarily yours: Intimacy, authenticity and the commerce of sex.* Chicago: University of Chicago Press.

———. 2007b. Sex work for the middle classes. *Sexualities* 10, no. 4: 473–488.

Bird, Edward, Paul Hagstrom, and Robert Wild. 1999. Credit card debts of the poor: High and rising. *Journal of Policy Analysis and Management* 18, no. 1: 125–133.

Black, Laurel Johnson. 1997. Stupid rich bastards. In *Critical whiteness studies: Looking behind the mirror,* ed. Richard Delgado and Jean Stefancic, 387–395. Philadelphia: Temple University Press.

Bogdan, Robert. 1990. *Freak show: Presenting human oddities for amusement and profit.* Chicago: University of Chicago Press.

Bordo, Susan. 1993. *Unbearable weight: Feminism, Western culture and the body.* Berkeley: University of California Press.

Bosse, Katharina. 2004. *New burlesque.* New York: Distributed Art Publishers.

Bott, Esther. 2006. Pole position: Migrant British women producing "selves" through lap dancing work. *Feminist Review* 83:23–41.

Bourdieu, Pierre. 1984. *Distinction: A social critique of the judgment of taste.* New York: Routledge and Kegan Paul.

Bourgois, Philippe. 1996. Confronting Anthropology, education and inner-city apartheid. *American Anthropologist* 98, no. 2: 249–258.

———. 1995. *In search of respect: selling crack in El Barrio.* Cambridge: Cambridge University Press.

Bourgois, Philippe, and Jeff Schonberg. 2009. *Righteous dopefiend.* Berkeley: University of California Press.

Bradley, Mindy. 2007. Girlfriends, wives and strippers: Managing stigma in exotic dancer relationships. *Deviant Behavior* 28:379–406.

Bradley-Engen, Mindy. 2009. *Naked lives: Inside the worlds of exotic dance.* Albany: State University of New York Press.

Brennan, Denise. 2004. *What's love got to do with it? Transnational desires and sex tourism in the Dominican Republic.* Durham: Duke University Press.

———. 2010. Sex tourism and sex workers' aspirations. In *Sex for sale,* ed. Ron Weitzer, 307–324. New York: Routledge.

Brents, Barbara, Crystal Jackson, and Kathryn Hausbeck. 2009. *The state of sex: Tourism, sex and sin in the new American heartland.* New York: Routledge.

Brooks, Ethel. 2007. *Unravelling the garment industry: Transnational organizing and women's work.* Minneapolis: University of Minnesota Press.

Brown, Louise. 2005. *The dancing girls of Lahore: Selling love and saving dreams in Pakistan's ancient pleasure district.* London: Fourth Estate/Harper Collins.

Brumberg, Joan Jacobs. 1988. *Fasting girls: The emergence of anorexia nervosa as a modern disease*. Cambridge, MA: Harvard University Press.

Buechler, Hans, and Judith-Maria Buechler. 1996. *The world of Sofia Velasquez*. New York: Columbia University Press.

Buonaventura, Wendy. 1998. *Serpent of the Nile: Women and dance in the Arab world*. New York: Interlink Publishing Group.

Burke, Timothy. 1996. *Lifebuoy men, Lux women: Commodification, consumption and cleanliness in modern Zimbabwe*. Durham, NC: Duke University Press.

Butler, Judith. 1993. *Bodies that matter: On the discursive limits of sex*. New York: Routledge.

Cabezas, Amalia. 2009. *Economies of desire: Sex and tourism in Cuba and the Dominican Republic*. Philadelphia: Temple University Press.

————.1999. Women's work is never done: Tourism and the sex trade in Sosúa, the Dominican Republic. In *Sun, sex and gold: Tourism and sex work in the Caribbean*, ed. Kamala Kempadoo, 93–124. Oxford: Rowman and Littlefield.

Carrillo, Héctor. 2002. *The night is young: Sexuality in Mexico in the time of AIDS*. Chicago: University of Chicago Press.

Casper, Monica J., and Lisa Jean Moore. 2009. *Missing bodies: The politics of visibility*. New York: New York University Press.

Chang, Iris. 2000. *Disposable domestics: Immigrant women workers in the global economy*. London: South End Press.

Chapkis, Wendy. 1997. *Live sex acts: Women performing erotic labor*. New York: Routledge.

Colette. 1910. *La vagabonde*. Paris: A. Michel.

Collett, Jessica. 2005. What kind of mother am I? Impression management and the social construction of motherhood. *Symbolic Interaction* 28, no. 3: 327–347.

Conley, Dalton. 2000. *Honky*. Berkeley: University of California Press.

Constable, Nicole. 1997. *Maid to order in Hong Kong: Stories of Filipina workers*. Ithaca, NY: Cornell University Press.

Coontz, Stephanie. 2000. *The way we never were: American families and the nostalgia trap*. New York: Basic Books.

————. 1998. *The way we really are: Coming to terms with America's changing families*. New York: Basic Books.

Crais, Clifton, and Pamela Scully. 2008. *Sara Baartman and the Hottentot Venus: A ghost story and a biography*. Princeton, NJ: Princeton University Press.

Cunningham, Hugh. 1980. *Leisure in the industrial society*. London: Croom Helm.

Curry, Kathleen. 2001. Mediating *Cops*: An analysis of viewer reaction to reality TV. *Journal of Criminal Justice and Popular Culture* 8, no. 3: 168–185.

da Silva, Ana Paula, and Thaddeus Blanchette. 2009. Amor um real por minuto: A prostituição como actividade econômica no Brasil urbano [Love at one real per minute: Prostitution as an economic activity in urban Brazil]. Sexual

Policies Watch. www.sxpolitics.org/pt/wp-content/uploads/2009/10/sexualidade-e-economia-thaddeus-blanchette-e-ana-paula-da-silva.pdf.

Davies, Kim, and Lorraine Evans. 2007. A virtual view of managing violence among British escorts. *Deviant Behavior* 28:525–551.

Davis, Kathy. 1995. *Reshaping the female body: The dilemma of cosmetic surgery.* New York: Routledge.

Day, Sophie. 2007. *On the game: Women and sex work.* London: Pluto Press.

Day, Sophie, Akis Papataxiarchis, and Michael Stewart, eds. 1998. *Lilies of the field: Marginal people who live for the moment.* Boulder: Westview Press.

Day, Sophie, and Helen Ward, eds. 2004. *Sex work, mobility and health in Europe.* London: Kegan Paul.

Dean, Tim. 2009. *Unlimited intimacy: Reflections on the subculture of barebacking.* Chicago: University of Chicago Press.

DeMichelle, Matthew, and Richard Tewksbury. 2004. Sociological explorations in site-specific control: The role of the strip club bouncer. *Deviant Behavior* 25:537–558.

DeRiviere, Linda. 2006. A human capital methodology for estimating the life-long personal costs of young women leaving the sex trade. *Feminist Economics* 12, no. 3: 367–402.

Desmond, Jane. 1997. *Meaning in motion: New cultural studies of dance.* Durham, Duke University Press.

Dewey, Susan. 2008a. *Making Miss India Miss World: Constructing gender, power and the nation in postliberalization India.* Syracuse, NY: Syracuse University Press.

———2008b. *Hollow bodies: Institutional responses to the traffic in women in Armenia, Bosnia and India.* Sterling, VA: Kumarian Press.

Dixon Gottschild, Brenda. 2005. *The Black dancing body: A geography from coon to cool.* New York: Palgrave MacMillan.

Doezema, Jo. 1998. Forced to choose: Beyond the free v. forced prostitution dichotomy. In *Global Sex Workers: Rights, Resistance and Redefinition,* ed. Kamala Kempadoo and Jo Doezema, 34–50. London: Routledge.

Douglas, Mary. 2000 [1966]. *Purity and danger: An analysis of the concepts of pollution and taboo.* New York: Routledge

Dudley, Kathryn Marie. 1994. *The end of the line: Lost jobs, new lives in postindustrial America.* Chicago: University of Chicago Press.

Edin, Kathryn, and Maria Kefalas. 2007. *Promises I can keep: Why poor women put motherhood before marriage.* Berkeley: University of California Press.

Edin, Kathryn, and Laura Lein. 1997. *Making ends meet: How single mothers survive welfare and low wage work.* New York: Russell Sage.

Egan, R. Danielle. 2006a. *Dancing for dollars and paying for love: Relationships between exotic dancers and their regulars.* New York: Palgrave MacMillan.

————2006b. Resistance under the blacklight: Exploring the use of music in two exotic dance clubs. *Journal of Contemporary Ethnography* 35:201–219.

————2004. Eyeing the scene: The uses and (re)uses of surveillance cameras in an exotic dance club. *Critical Sociology* 30, no. 2: 299–319.

Egan, R. Danielle, and Katherine Frank. 2005. Attempts at a feminist and interdisciplinary conversation about strip clubs. *Deviant Behavior* 26, no. 4: 297–320.

Ehrenrich, Barbara, and Arlie Russell Hochschild. 2004. *Global woman: Nannies, maids and sex workers in the new economy.* London: Owl Books.

Ellicottville Town and Village Board. 1998. Adult business study: Town and village of Ellicottville, Cattaraugus County, New York. Town of Ellicotville. www.communitydefense.org/cdcdocs/landuse/pdf/nycattaraugus.pdf.

England, Paula, and Kathryn Edin. 2007. Unmarried couples with children: Hoping for love and the white picket fence. In *Unmarried couples with children,* ed. Paula England and Kathryn Edin, 3–23. New York: Russell Sage.

Enloe, Cynthia. 2007. *Globalization and militarism: Feminists make the link.* London: Rowman and Littlefield.

————. 2004. *The curious feminist: Searching for women in a new age of empire.* Berkeley: University of California Press.

Erickson, David, and Richard Tewksbury. 2000. The gentleman in the club: A typology of strip club patrons. *Deviant Behavior* 21, no. 3: 271–293.

Farley, Melissa, ed. 2004a. *Prostitution, trafficking and traumatic stress.* New York: Routledge.

————. 2004b. "Bad for the body, bad for the heart": Prostitution harms women even if legalized or decriminalized. *Violence against Women* 10, no. 10: 1087–1125.

Farquhar, Judith. 2002. *Appetites: Food and sex in post-Maoist China.* Durham, NC: Duke University Press.

Fernandez-Kelly, Patricia. 1983. *For we are sold, I, me and my people: Women and industry in Mexico's frontier.* Albany, NY: State University of New York Press.

Fernandez-Kelly, Patricia, and Saskia Sassen. 1995. Recasting women in the global economy: Internationalization and changing definitions of gender. In *Women in the Latin American development process,* ed. Christine Bose and Edna Acosta-Belen, 99–124. Philadelphia: Temple University Press.

Ferreday, Debra. 2008. "Showing the girl": The new burlesque. *Feminist Theory* 9, no. 1: 47–65.

FitzGerald, Sharon. 2008. Putting trafficking on the map: The geography of feminist complicity. In *Demanding Sex: Critical reflections on the regulation of prostitution,* ed. Vanessa E. Munro and Marina Della Giusta, 99–120. Burlington, VT: Ashgate Publishing.

Forsyth, Craig, and Tina Deshotels. 1997. The occupational milieu of the nude dancer. *Deviant Behavior* 18, no. 2: 125–142.

Frank, Katherine. 2002. *G-strings and sympathy: Strip club regulars and male desire.* Durham, NC: Duke University Press.

Freeman, Carla. 2000. *High tech and high heels in the global economy: Women, work and pink collar identities in the Caribbean.* Durham, NC: Duke University Press.

Gamburd, Michelle. 2000. *The kitchen spoon's handle: Transnationalism and Sri Lanka's migrant households.* Ithaca, NY: Cornell University Press.

Gerson, Kathleen. 2005. *The time divide: Work, family, gender inequality.* Cambridge, MA: Harvard University Press.

———. 1994. *No man's land: Men's changing commitments to work and family.* New York: Basic Books

———. 1986. *Hard choices: How women decide about work, career and motherhood.* Berkeley: University of California Press.

Gimlin, Debra. 2007. What is "body work"? A review of the literature. *Sociology Compass* 1, no. 1: 353–370.

———. 1996. Pamela's space: Power and negotiation in the hair salon. *Gender and Society* 10:505–526.

Glasscock, Jessica. 2003. *Striptease: From gaslight to spotlight.* New York: Harry N. Abrams.

Gordon, Avery. 1997. *Ghostly matters: Haunting and the sociological imagination.* Minneapolis: University of Minnesota Press.

Gray, Mary L. 2009. *Out in the country: Youth, media and queer visibility in rural America.* New York: New York University Press.

Green, James N. 1999. *Beyond Carnival: Male homosexuality in twentieth century Brazil.* Chicago: University of Chicago Press.

Hamper, Ben. 1992 [1986]. *Rivethead: Tales from the assembly line.* New York: Warner Books.

Hancock, Ange-Marie. 2004. *The politics of disgust: The public identity of the welfare queen.* New York: New York University Press.

Handler, Joel, and Yeheskel Hasenfeld. 1991. *The moral construction of poverty: Welfare reform in America.* Newbury Park, CA: Sage Publications.

Handler, Joel, and Lucie White. 1999. Preface to *Hard labor: Women and work in the post-welfare era,* ed. Joel Handler and Lucie White, ix–xvii. New York: M. E. Sharpe.

Hanna, Judith. 2005. Exotic dance adult entertainment: A guide for planners and policymakers. *Journal of Planning Literature* 20, no. 2: 116–134.

———. 1988. *Dance, sex and gender: Signs of identity, dominance, defiance and desire.* Chicago: University of Chicago Press.

———. 1987. *To dance is human: A theory of nonverbal communication.* Chicago: University of Chicago Press.

Haraway, Donna. 1988. Situated knowledges: The science question in feminism and the privilege of partial perspective. *Feminist Studies* 14, no. 3: 575–599.

Hart, Angie. 1997. *Buying and selling power: Anthropological reflections on prostitution in Spain.* Boulder: Westview Press.

Hartigan, John. 2005. *Odd tribes: Toward a cultural analysis of white people.* Durham, NC: Duke University Press.

Hays, Sharon. 1996. *The cultural contradictions of motherhood.* New Haven, CT: Yale University Press.

Henly, Julia. 1999. Barriers to finding and maintaining jobs: The perspectives of workers and employees in the low-wage labor market. In *Hard Labor: Women and Work in the Post-Welfare Era,* ed. Joel Handler and Lucie White, 48–75. New York: M. E. Sharpe.

Herdt, Gilbert. 1999. *Sambia sexual culture: Essays from the field.* Chicago: University of Chicago Press.

Hershatter, Gail. 1999. *Dangerous pleasures: Prostitution and modernity in twentieth century Shanghai.* Berkeley: University of California Press.

High, Steven, and David Lewis. 2007. *Corporate wasteland: The landscape and memory of deindustrialization.* Ithaca, NY: Cornell University Press.

Hill, Mike. 2004. *After whiteness: Unmaking an American majority.* New York: New York University Press.

Hochschild, Arlie. 2003. The second shift. New York: Penguin.

———. 1983. *The managed heart: Commercialization of human feeling.* Berkeley: University of California Press.

Hoigard, Cecilie, and Liv Finstad. 1992. *Backstreets: Prostitution, money and love.* University Park, PA: Penn State University Press.

Hollibaugh, Amber. 2001. *My dangerous desires: A queer girl dreaming her way home.* Durham, NC: Duke University Press.

Holloway, Susan, Bruce Fuller, Marylee Rambaud, and Costanza Pierola. 2001. *Through my own eyes: Single mothers and the cultures of poverty.* Cambridge, MA: Harvard University Press.

hooks, bell. 1999. *Black looks: Race and representation.* London: South End Press.

Howell, Joseph. 1991 [1973]. *Hard living on Clay Street: Portraits of blue collar families.* Prospect Heights, IL: Waveland Press.

Ignatiev, Noel. 1996. *How the Irish became white.* New York: Routledge.

Inhorn, Marcia. 2003. *Local babies, global science: Gender, religion and in vitro fertilization in Egypt.* New York: Routledge.

Irigaray, Luce. 1985. *Speculum of the other woman.* Trans. Gillian Gill. Ithaca, NY: Cornell University Press.

Jeffreys, Sheila. 2009. *The idea of prostitution.* 2nd ed. Melbourne, Australia: Spinifex Press.

———. 2008. *The industrial vagina: The political economy of the global sex trade.* New York: Routledge.

Johnson, E. Patrick. 2008. *Sweet tea: Black gay men of the South.* Chapel Hill: University of North Carolina Press.

Juffer, Jane. 2006. *Single mother: The emergence of the domestic intellectual.* New York: New York University Press.

Karayanni, Stavros Stavrou. 2009. *Dancing fear and desire: Race, sexuality and imperial politics in Middle Eastern dance.* Toronto: Wilfred Laurier Press.

Karsjens, Kari. 2002. Boutique egg donation: A new form of racism and patriarchy. *DePaul Journal of Health Care Law* 5:73.

Katsulis, Yasmina. 2009. *Sex work and the city: The social geography of health and safety in Tijuana, Mexico.* Austin: University of Texas Press.

Kaye, Kerwin. 2010. Sex and the unspoken in male street prostitution. In *Sex work matters: Exploring money, power, and intimacy in the sex industry,* ed. Melissa Hope Ditmore, Antonia Levy, and Alys Willman, 85–116. London: Zed Books.

Kelly, Patty. 2008. *Lydia's open door: Inside Mexico's most modern brothel.* Berkeley: University of California Press.

Kempadoo, Kamala. 2005. Victims and agents of crime: The new crusade against trafficking. In *Global lockdown: Race, gender and the prison industrial complex,* ed. Julia Sudbury, 35–56. New York: Routledge.

———. 2004. *Sexing the Caribbean: Race, gender and sexual labor.* New York: Routledge.

———. 1999. Continuities and change: Five centuries of prostitution in the Caribbean. In *Sun, sex and gold: Tourism and sex work in the Caribbean,* ed. Kamala Kempadoo, 3–36. Oxford: Rowman and Littlefield.

Kempadoo, Kamala, and Jo Doezema. 1998. *Global sex workers: Rights, resistance, and redefinition.* London: Routledge.

Kempadoo, Kamala, Jyoti Sanghera, and Bandana Pattanaik, eds. 2005. *Trafficking and prostitution reconsidered: New perspectives on migration, sex work and human rights.* Boulder, CO: Paradigm Publishers.

Keough, Leyla. 2006. Globalizing "postsocialism": Mobile mothers and neoliberalism on the margins of Europe. *Anthropological Quarterly* 79, no. 3: 431–461.

Kessler-Harris, Alice. 2006. *Gendering labor history.* Urbana-Champaign: University of Illinois Press.

———. 2003a. *Out to work: A history of wage-earning women in the US.* Oxford: Oxford University Press.

———. 2003b. *In pursuit of equity: Women, men and the quest for economic citizenship in twentieth century America.* Oxford: Oxford University Press.

Kibicho, Wanjohi. 2009. *Sex tourism in Africa: Kenya's booming industry.* Surrey, UK: Ashgate.

Kideckel, David A. 2008. *Getting by in postsocialist Romania: Labor, the body, and working class culture.* Bloomington: Indiana University Press.

Kielty, Sandra. 2008. Non-resident motherhood: Managing a threatened identity. *Child and Family Social Work* 13, no. 1: 13–40.

Kipnis, Laura. 1999. *Bound and gagged: Pornography and the politics of fantasy in America.* Durham, NC: Duke University Press.

Koken, Juline, David Bimbi, and Jeffrey Parsons. 2010. Male and female escorts: A comparative analysis. In *Sex for sale: Prostitution, pornography and the sex industry,* ed. Ron Weitzer, 205–232. New York: Routledge.

Komarovsky, Mirra. 1987. *Blue collar marriage.* New Haven, CT: Yale University Press.

Kondo, Dorinne. 1986. Dissolution and reconstitution of self: Implications for anthropological epistemology. *Cultural Anthropology* 1:74–88.

Kuczynski, Alex. 2008. Her body, my baby. *New York Times Magazine,* November 28. Reader responses to Kuczinsky, *New York Times Magazine,* December 14. www.nytimes.com/2008/11/30/magazine/30Surrogate-t.html.

Kulick, Don. 1998. *Travesti: Sex, gender and culture among Brazilian transgendered prostitutes.* Chicago: University of Chicago Press.

Kuo, Lenore. 2002. *Prostitution policy: Revolutionizing practice through a gendered perspective.* New York: New York University Press.

Laqueur, Thomas. 1992. *Making sex: Body and gender from the Greeks to Freud.* Cambridge, MA: Harvard University Press.

Lawson, Victoria. 1995. Beyond the firm: restructuring gender divisions of labor in Quito's garment industry under austerity. *Environment and Planning D: Society and Space* 13:415–444.

Lemke, Sieglinde. 1998. *Primitivist modernism: Black culture and the origins of transatlantic modernism.* Oxford: Oxford University Press.

Levy, Ariel. 2005. *Female chauvinist pigs: Women and the rise of raunch culture.* New York: Free Press.

Lewis, Jacqueline. 2000a. "I'll scratch your back if you'll scratch mine": The role of reciprocity, power and autonomy in the strip club. *Canadian Review of Sociology and Anthropology* 43, no. 3: 297–311.

———. 2000b. Controlling lap dancing: Law, morality and sex work. In *Sex for sale: Prostitution, pornography and the sex industry,* ed. Ronald Weitzer, 203–16. New York: Routledge.

Lewis, Oscar. 1975. *Five families: Mexican case studies in the culture of poverty.* New York: Basic Books.

Liepe-Levinson, Katherine. 2002. *Strip show: Performances of gender and desire.* New York: Routledge.

Lock, Margaret. 2007. Human body parts as therapeutic tools: Contradictory discourses and transformed subjectivities. In *Beyond the body proper: Reading the anthropology of material life*, ed. Margaret Lock and Judith Farquhar, 224–231. Durham, NC: Duke University Press.

Lock, Margaret, and Judith Farquhar, eds. 2007. Introduction. to *Beyond the body proper: Reading the anthropology of material life*, ed. Margaret Lock and Judith Farquhar, 1–16. Durham, NC: Duke University Press.

Lott, Eric. 1995. *Love and theft: Blackface minstrelry and the American working class.* Oxford: Oxford University Press.

Lowman, John. 2000. Violence and the outlaw status of (street) prostitution in Canada. *Violence against Women* 6, no. 9: 987–1011.

Lucas, Ann. 2005. The work of sex work: Elite prostitutes' vocational orientations and experiences. *Deviant Behavior* 26, no. 6: 513–546.

Lurie, Nancy Oestrich, ed. 1961. *Mountain Wolf Woman: Sister of Crashing Thunder.* Ann Arbor: University of Michigan Press.

Mayorga, Laura, and Pilar Velásquez. 1999. Bleak pasts, bleak futures: Life paths of thirteen young prostitutes in Cartagena, Colombia. In *Sun, sex and gold: Tourism and sex work in the Caribbean*, ed. Kamala Kempadoo, 157–182. Oxford: Rowman and Littlefield.

McDermott, Monica. 2006. *Working class white: The making and unmaking of race relations.* Berkeley: University of California Press.

Meyers, Marcia, Wen-Jui Han Bowling, Jane Waldfogel, and Irwin Garfinkel. 2001. Child care in the wake of welfare reform: The impact of government subsidies on the economic well-being of single mother families. *Social Service Review* 75, no. 1: 29–59.

Mies, Maria. 1999. *Patriarchy and accumulation on a world scale.* London: Zed Books.

Miller, Daniel. 1998. *A theory of shopping.* Cambridge: Polity Press.

Mills, Mary Beth. 1999. *Thai women in the global labor force: Consuming desires, contested selves.* New Brunswick, NJ: Rutgers University Press.

Mitchell, Gregory. 2009. Fare tales and fairy tails: How gay sex tourism is shaping the Brazilian dream. Presidential panel paper presented at the annual meeting of the American Anthropological Association, Philadelphia, December 2–6.

Mizejewski, Linda. 1999. *Ziegfeld girl: Image and icon in culture and cinema.* Durham, NC: Duke University Press.

Monaghan, Lee. 2002. Regulating "unruly" bodies: Work tasks, conflict and violence in Britain's night-time economy. *British Journal of Sociology* 53, no. 3: 403–429.

Montgomery, Heather. 1998. Children, prostitution and identity: A case study from a tourist resort in Thailand. In *Global Sex Workers: Rights, Resistance and*

Redefinition, ed. Kamala Kempadoo and Jo Doezema, 139–50. New York: Routledge.

Munro, Vanessa, and Marina Della Giusta. 2008. The regulation of prostitution: Contemporary contexts and comparative perspectives. In *Demanding sex: Critical reflections on the regulation of prostitution*, ed. Vanessa E. Munro and Marina Della Giusta, 1–12. Burlington, VT: Ashgate Publishing Company.

Nash, June. 1992. *I spent my life in the mines: The story of Juan Rojas, Bolivian tin miner*. New York: Columbia University Press.

———. 1988. *From tank town to high tech: The clash of community and industrial cycles*. Albany: State University of New York Press.

———. 1987. Corporate hegemony and industrial restructuring in a New England industrial city. In *Perspectives in U.S. Marxist anthropology*, ed. David Hakken and Hanna Lessinger, 321–258. Boulder, CO: Westview Press.

Nencel, Lorraine. 2001. *Ethnography and prostitution in Peru*. London: Pluto Press.

Neubeck, Kenneth, and Noel Cazenave. 2001. *Welfare racism: Playing the race card against America's poor*. New York: Routledge.

Newitz, Annalee. 1997. White savagery and humiliation, or a new racial consciousness in the media. In *White trash: Race and class in America*, ed. Matt Wray and Annalee Newitz, 131–154. New York: Routledge.

New York State Assembly. 2007. Bill number A06476A. assembly.state.ny.us/leg/?bn=A06476.

Newman, Katherine. 2008. *Chutes and ladders: Navigating the low-wage labor market*. Cambridge, MA: Harvard University Press.

———. 2000. *No shame in my game: The working poor in the inner city*. New York: Vintage.

Nixon, Kendra, et al. 2002. The everyday occurrence: Violence in the lives of girls exploited through prostitution. *Violence against Women* 8, no. 9: 1016–1043.

O'Connell Davidson, Julia. 2005. *Children in the global sex trade*. London: Polity Press.

Oerton, Sarah, and Johanna Phoenix. 2001. Sex/bodywork: Discourses and practices. *Sexualities* 4, no. 4: 387–412.

Ong, Aihwa. 1987. *Spirits of resistance and capitalist discipline: Factory women in Malaysia*. Albany: State University of New York Press.

Ortega, Mariana. 2006. Being lovingly, knowingly ignorant: White feminism and women of color. *Hypatia* 21, no. 3: 56–74.

Paap, Kris. 2006. *Working construction: Why white working class men put themselves—and the labor movement—in harm's way*. Ithaca, NY: Cornell University Press.

Padilla, Mark. 2007. *Caribbean pleasure industry: Tourism, sexuality and AIDS in the Dominican Republic*. Chicago: University of Chicago Press.

Pateman, Carol. 1988. *The sexual contract*. Stanford, CA: Stanford University Press.

Paul, Pamela. 2005. *Pornified: How porn is transforming our lives, our relationships and our families*. New York: Times Books.

Penley, Constance. 1997. Crackers and whackers: The white trashing of porn. In *White trash: Race and class in America*, ed. Matt Wray, and Annalee Newitz, 89–112. New York: Routledge.

Pfeffer, Naomi. 1993. *The stork and the syringe: A political history of reproductive medicine*. Cambridge: Polity Press.

Philaretou, Andreas. 2006. Female exotic dancers: Intrapersonal and interpersonal perspectives. *Sexual Addiction and Compulsivity* 13:11–52.

Pilzer, Joshua. 2006. The twentieth century disappearance of the Gisaeng during the rise of Korea's modern sex-and-entertainment industry. In *The courtesan's arts: Cross-cultural perspectives*, ed. Martha Feldman and Bonnie Gordon, 95–306. Oxford: Oxford University Press.

Pippert, Timothy. 2007. *Road dogs and loners: Family relationships among homeless men*. Lanham, MD: Lexington Books.

Porter, Judith, and Louis Bonilla. 2010. The ecology of street prostitution. In *Sex for sale: Prostitution, pornography and the sex industry*, ed. Ron Weitzer, 163–186. New York: Routledge.

Price, Kim. 2000. Stripping women: Workers' control in strip clubs. *Current Research on Occupations and Professions*, ed. Helena Lopata and Kevin Henson, 3–33. Vol. 11. Greenwich, CT & London: JAI Press.

Prieur, Annick. 1998. *Mema's house, Mexico City: On transvestites, queens, and machos*. Chicago: University of Chicago Press.

Puckett, Anita. 2000. *Seldom ask, never tell: Labor and discourse in Appalachia*. Oxford: Oxford University Press.

Pun, Ngai. 2005. *Made in China: Women factory workers in a global workplace*. Durham, NC: Duke University Press.

Radin, Margaret Jane. 1996. *Contested commodities: The trouble with the trade in sex, children, body parts and other things*. Cambridge, MA: Harvard University Press.

Radin, Paul. 1920 [1963]. *The autobiography of a Winnebago Indian: Life, ways, and the peyote cult*. Minneapolis: University of Minnesota Press.

Ragoné, Helen. 1999. The gift of life: Surrogate motherhood, gamete donation and constructions of altruism. In *Transformative motherhood: On giving and getting in a consumer culture*, ed. Linda Layne, 65–88. New York: New York University Press.

Rambo-Ronai, Carol, and Carolyn Ellis. 1989. Turn-ons for money: Interactional strategies of the table dancer. *Journal of Contemporary Ethnography* 18, no. 3: 271–298.

Raphael, Jody. 2004. *Listening to Olivia: Violence, poverty and prostitution.* Chicago: Northeastern University Press.

Raphael, Jody, and Deborah L. Shapiro. 2004. Violence in indoor and outdoor prostitution venues. *Violence against Women* 10, no. 2: 126–139.

Red Thread Women's Programme. 1999. Givin' lil' bit for lil' bit: Women and sex work in Guyana. In *Sun, sex and gold: Tourism and sex work in the Caribbean,* ed. Kamala Kempadoo, 263–290. Oxford: Rowman and Littlefield.

Ries, Nancy. 1997. *Russian talk: Culture and conversation during perestroika.* Ithaca, NY: Cornell University Press.

Robins, H. Franklin, and Stephen Mason. 2003. The law of obscenity—or absurdity? *St. Thomas Law Review* 15, no. 3: 517–544.

Roedlinger, David. 1991. *The wages of whiteness: Race and the making of the American working class.* London: Verso.

Rollins, Judith. 1987. *Between women: Domestics and their employers.* Philadelphia: Temple University Press.

Rosen, Ellen Israel. 1990. *Bitter choices: Blue-collar women in and out of work.* Chicago: University of Chicago Press.

Rosenberg, Tina. 2008. A payoff out of poverty? *New York Times Magazine,* December 19.

Rosenzweig, Roy. 1985. *Eight hours for what we will: Workers and leisure in an industrial city, 1870–1920.* Cambridge: Cambridge University Press.

Rotheram-Borus, Mary Jane, Karen A. Mahler, Cheryl Koopman, and Kris Langabeer. 1996. Sexual abuse history and associated multiple risk factors in adolescent runaways. *Journal of Orthopsychiatry* 66, no. 3: 390–400.

Rubin, Gayle. 1994. Thinking sex: Notes for a radical theory of the politics of sexuality. In *Pleasure and danger: Exploring female sexuality,* ed. Carol Vance, 267–319. London: Pandora.

Saeed, Fouzia. 2001. *Taboo! The hidden culture of a red light district.* Karachi: Oxford University Press.

Safa, Helen. 1995. *The myth of the male breadwinner: Women and industrialization in the Caribbean.* Boulder, CO: Westview Press.

Sanchez, Lisa. 1998. Boundaries of legitimacy: Sex, violence, citizenship and community in a local sexual economy. *Law & Social Inquiry* 22, no. 3: 543–580.

Sanders, Teela. 2009. Kerbcrawler rehabilitation programmes: Curbing the "deviant" male and reinforcing the "respectable" moral order. *Critical Social Policy* 29, no. 1: 77–99.

Sang, Tze-Lan D. 2003. *The emerging lesbian: Female same-sex desire in modern China.* Chicago: University of Chicago Press.

Scarry, Elaine. 1987. *The body in pain: The making and unmaking of the world.* Oxford: Oxford University Press.

Scheper-Hughes, Nancy. 2002. Bodies for sale—whole or in parts. In *Commodifying bodies*, ed. Nancy Scheper-Hughes and Loïc Wacquant, 1–9. London: Sage.

Schifter, Jacobo. 1998. *Lila's house: Male prostitution in Latin America*. New York: Haworth Press.

Scott, Joseph E. 1991. What is obscene? Social science and the contemporary community standard test of obscenity. *International Journal of Law and Psychiatry* 14:29–45.

Scott, Robert. 2007. Credit card use and abuse: A Veblenian analysis. *Journal of Economic Issues* 41, no. 2: 567–574.

Scoular, Jane. 2004. The "subject" of prostitution: Interpreting the discursive, symbolic and material position of sex/work in feminist theory. *Feminist Theory* 5, no. 3: 343–355.

Segawa Seigle, Cecile. 1993. *Yoshiwara: The glittering world of the Japanese courtesan*. Honolulu: University of Hawaii Press.

Setel, Philip W. 2000. *A plague of paradoxes: AIDS, culture and demography in northern Tanzania*. Chicago: University of Chicago Press.

Sharpley-Whiting, Tracy. 1999. *Black Venus: Sexualized savages, primal fears and primitive narratives in French*. Durham, NC: Duke University Press.

Shostak, Marjorie. 1981. *Nisa: The Life and Words of a !Kung Woman*. Cambridge, MA: Harvard University Press.

Shteir, Rachel. 2005. *Striptease: The untold history of the girlie show*. Oxford: Oxford University Press.

Silbert, Mimi, and Ayala Pines. 1981. Sexual abuse as an antecedent to prostitution. *Child Abuse and Neglect* 5:407–411.

Simons, Ronald, and Les Whitbeck. 1991. Sexual abuse as a precursor to prostitution and victimization among adolescent and adult homeless women. *Journal of Family Issues* 12, no. 3: 361–379.

Sloan, Lacey, and Stephanie Wahab. 2004. Four categories of women who work as topless dancers. *Sexuality and Culture* 8, no. 1: 18–43.

Sontag, Susan. 2001. The anthropologist as hero. In *Against interpretation and other essays*, 69–81. London: Picador.

Spar, Debora. 2006. *The baby business: How money, science and politics drive the commerce of conception*. Cambridge, MA: Harvard Business School

Spradley, James. 1999 [1970]. *You owe yourself a drunk: An ethnography of urban nomads*. Long Grove, IL: Waveland Press.

Standing, Guy. 1989. *Global feminization through flexible labor: A theme revisited*. Geneva: International Labor Organization.

Steinfatt, Thomas. 2002. *Working at the bar: Sex work and health communication in Thailand*. London: Ablex Publishing.

Sweet, Nova, and Richard Tewksbury. 2000. Entry, maintenance and departure from a career in the sex industry: Strippers' experiences of occupational costs and rewards. *Humanity and Society* 24:136–161.

Tambe, Ashwini. 2006. Brothels as families: Reflections on the history of Bombay's *kothas*. *International Feminist Journal of Politics* 8, no. 2: 219–242.

Taussig, Michael. 1983. *The devil and commodity fetishism in South America.* Chapel Hill: University of North Carolina Press.

Thompson, William, Jack Harred, and Barbara Burks. 2003. Managing the stigma of topless dancing: A decade later. *Deviant Behavior* 24, no. 6: 551–571.

Trotter, Henry. 2008. *Sugar girls and seamen: A journey into the world of dockside prostitution in South Africa.* Johannesburg: Jacana Media.

Tsuda, Takeyuki. 1998. Ethnicity and the anthropologist. *Anthropological Quarterly* 71, no. 3: 107–124.

Turnbull, Colin. 1996. Sex and gender: The role of subjectivity in field research. In *Self, sex and gender in cross-cultural fieldwork,* ed. Tony Whitehead and Ellen Conaway, 17–27. Champaign: University of Illinois Press.

Twigg, Julia, and Karl Atkin. 2000. Carework as a form of bodywork. *Ageing and Society* 20:389–411.

Tyler, Melissa, and Phillip Hancock. 2001. Flight attendants and the management of gendered "organizational bodies." In *Constructing gendered bodies,* ed. Kathryn Backett-Muilburn and Linda McKie, 25–38. London: Macmillan.

Urish, Ben. 2004. Narrative striptease in the nightclub era. *Journal of American Culture* 27, no. 2: 157–165.

U.S. Department of Health and Human Services. 2009. Administration for Children and Families, Office of Family Assistance. Mission statement. www.acf .hhs.gov/programs/ofa/about.html#mission.

van Nieuwkirk, Ingrid. 1995. *"A trade like any other": Female singers and dancers in Egypt.* Austin: University of Texas Press.

Vanderstaay, Steven. 2005. One hundred dollars and a dead man: Ethical decision making in ethnographic fieldwork. *Journal of Contemporary Ethnography* 34:371–409.

Venkatesh, Sudhir Alladi. 2006. *Off the books: The underground economy of the urban poor.* Cambridge, MA: Harvard University Press.

Visweswaran, Kamala. 1994. *Fictions of feminist ethnography.* Minneapolis: University of Minnesota Press.

Wacquant, Loïc. 2002. Whores, slaves and stallions: Languages of exploitation and accommodation amongst boxers. In *Commodifying bodies,* ed. Nancy Scheper-Hughes and Loïc Wacquant, 181–192. London: Sage.

Waddell, Charles. 1996. HIV and the social world of female commercial sex workers. *Medical Anthropology Quarterly* 10, no. 1: 75–82.

Wagner, David. 1997. *The new temperance: The American obsession with sin and vice.* Boulder, CO: Westview Press.

Waldby, Catherine, and Robert Mitchell. 2006. *Tissue economies: Blood, organs, and cell lines in late capitalism.* Durham, NC: Duke University Press.

Walkowitz, Judith. 1996. *City of dreadful delight: Narratives of sexual danger in late Victorian London.* London: Virago Press.

———. 1980. *Prostitution and Victorian society: Women, class and the state.* Cambridge: Cambridge University Press.

Weis, Lois. 2004. *Class reunion: The remaking of the American white working class.* New York: Routledge.

Weitzer, Ronald. 2009. Sociology of sex work. *Annual Review of Sociology* 35:213–234.

Wesely, Jennifer. 2006. Negotiating myself: The impact of studying female exotic dancers on a feminist researcher. *Qualitative Inquiry* 12:146–162.

———. 2003. "Where am I going to stop?": Exotic dancing, fluid body boundaries and effects on identity. *Deviant Behavior* 24:483–503.

———. 2002. Growing up sexualized: Issues of power and violence in the lives of female exotic dancers. *Violence Against Women* 8, no. 10: 1182–1207.

White, Lucie. 1999. Quality child care for low-income families. In *Hard labor: Women and work in the post-welfare era,* ed. Joel Handler and Lucie White, 116–142. New York: M. E. Sharpe.

Willis, Paul. 1981. *Learning to labor: How working class kids get working class jobs.* New York: Columbia University Press.

Wilson, Lisa. 2008. Letter in response to Alex Kuczynski, "Her body, my baby," *New York Times Magazine,* December 14. http://query.nytimes.com/gst/fullpage.html?res=9502E0DB143AF937A25751C1A96E9C8B63&sec=&spon=&pagewanted=all.

Wilson, William Julius. 1997. *When work disappears: The world of the new urban poor.* New York: Vintage Books.

Wolf, Diane. 1996. Situating feminist dilemmas in fieldwork. In *Feminist dilemmas in fieldwork,* ed. Diane Wolf, 1–55. Boulder, CO: Westview Press.

Wolkowitz, Carol. 2006. *Bodies at work.* London: Sage.

———. 2002. The social relations of body work. *Work, Employment and Society* 16:495–508.

Wood, Elizabeth. 2000. Working in the fantasy factory: The attention hypothesis and the enacting of masculine power in strip clubs. *Journal of Contemporary Ethnography* 29, no. 5: 5–31.

Wray, Matt. 2006. *Not quite white: White trash and the boundaries of whiteness.* Durham, NC: Duke University Press.

Wray, Matt, and Annalee Newitz, eds. 1997. *White trash: Race and class in America.* New York: Routledge.

Zelizer, Viviana. 2007. *The purchase of intimacy.* Princeton, NJ: Princeton University Press.

———. 1997. *The social meaning of money: Pin money, paychecks, poor relief and other currencies.* Princeton, NJ: Princeton University Press.

Zheng, Tiantian, ed. 2010. *Sex trafficking, human rights and social justice.* New York: Routledge.

———. 2009a. *Red lights: The lives of sex workers in postsocialist China.* Minneapolis: University of Minnesota Press.

———. 2009b. *Ethnographies of prostitution in contemporary China: Gender relations, HIV/AIDS and nationalism.* New York: Palgrave MacMillan.

Index

Text: 10/14 Palatino
Display: Univers Condensed Light 47 and Bauer Bodoni
Compositor: BookComp, Inc.

CPSIA information can be obtained
at www.ICGtesting.com
Printed in the USA
LVHW02s0733291217
561158LV00001B/58/P